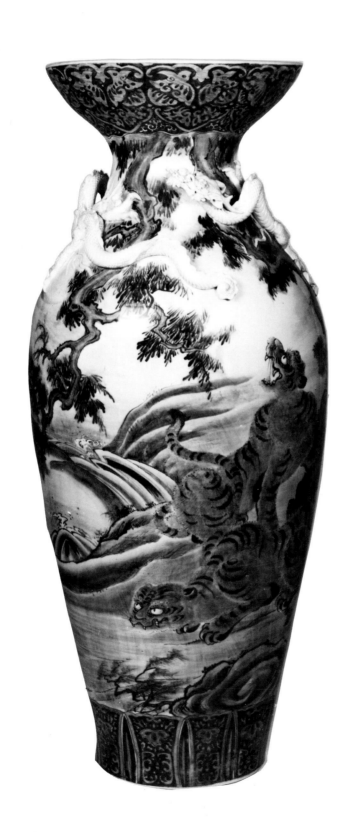

Japanese Porcelain

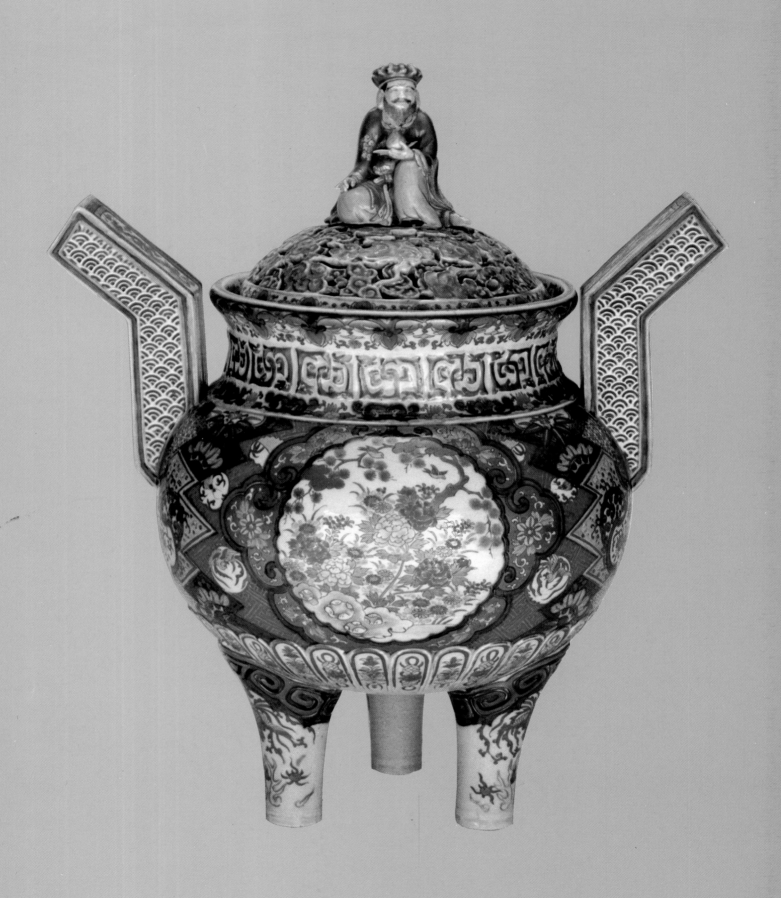

Japanese Porcelain
1800-1950

Nancy N. Schiffer

Expanded 2nd Edition

Schiffer ®
Publishing Ltd

4880 Lower Valley Road, Atglen, PA 19310 USA

This work is dedicated with appreciation to
Akira Fukagawa who caught an idea and made it grow.

The pleasure gained from handling and studying Japanese porcelain has been a growing benefit of this research. The art form is so deeply connected to historical and social history that deeper understanding necessitated a wider look at Japanese life. At the least, this book exposes the many aspects of the subject that require more study by a variety of people whose interests can contribute to our better understanding. Details must be researched while broad topics are refined.

The past work of many people has been the frame upon which this effort was begun. Over the years, many more people contributed to its progress.

My appreciation is directed first to my husband Peter, who believed in this project, provided all the creative inspiration, and attended to many business and household functions so I could proceed with the study.

Many people provided their skills, ideas, sources, examples and introductions that furthered the research. I am grateful to: Dr. and Mrs. Bernard F. Adami; Carol and Leon Altemose; Annette Kluss Alvarez, Sotheby's, New York; Sandra Andacht; Leopoldine Arz, The Walters Art Gallery, Baltimore; Dr. Frederick Baekeland, Toyobi Far Eastern Art, New York; Marvin Baer, Ivory Tower Antiques, Ridgewood, New Jersey; Margaret Bolbat; Jean Cline; Louise Cort, Freer Gallery of Art, Washington; J.D. Culverhouse, Burghley House, Stamford; Shirley Davis, Mandarin Antiques, Farmville; Robert Eskind, Port of History Museum, Philadelphia; Malcolm Fairley, Sotheby's, London; Myron S. Falk, Jr.; Rupert Faulkner, Victoria and Albert Museum, London; John Quentin Feller, University of Scranton; Dr. John K. Fong, Johnstone-Fong, Inc., Kennett Square; Edith and Joel Frankel, Oriental Art, New York; John Frazer; Akira, Iwago, Atsushi and Kazuta Fukagawa, Fukagawa Porcelain Manufacturing Company, Arita; James Galley, Rahns; Gene Galloway; Diane Genre; Mr. and Mrs. Richard T. Gibbons; Victor Harris, British Museum; Miss Hasada; Yutaka Hashiyama; Dr. Oliver Impey, Ashmolean Museum, Oxford; Sebastian Izzard, Christie's, New York; Miriam Jaberg, Asian Fine Arts, Minneapolis; Sissy Jackson; Juichi Kamikawa; Annette Pare Kechijian, The Pottery and Porcelain Club, Providence; Lyn Kelly; David H. King; Barbara Klein, Sotheby's, New York; Saburo Kuma, Kyushu Ceramic Museum, Arita; Louis D. Lawrence, Tempus Antiques, London; Dr. Professor Tsugio Mikami, The Idemitsu Museum of Arts, Tokyo; Dorothy Miller, House of Crispo, Monterey; Mel Mitchell; Susan Munro, Charlotte Horstmann and Gerald Godfrey, Ltd. Hong Kong; T. Nagatake, Arita Ceramic Museum; Kazunobu Nakanodo, National Museum of Modern Art, Tokyo; Dr. Hiroko Nishida, Nezu Institute of Fine Arts, Tokyo; Jacquelyn Y. Jones North; Koji Ohashi, Kyushu Ceramic Museum, Arita; Judy Pyle; Jean and Cliff Schaefer, Flying Cranes Antiques, New York; Karol A. Schmiegel, The Henry Francis duPont Winterthur Museum, Wilmington; Nobuyuki Shimizu, Oayama University, Tokyo; Lucy Short; Mrs. B. Stokhuyzen. Rijksmuseum, Amsterdam; Yukio Suzuta, Kyushu Ceramic Museum, Arita; Nina Sweet, The Metropolitan Museum of Art, New York; Sue Taylor; William Tilley, Christie's, London; Hiroshi Tomita, The Shinwa Bank Ltd. Sasebo; Phillip Van Brunt, House of the Black Ship, New London; Marsha L. Vargas, The Oriental Corner, Los Altos; Henry Woods Wilson, London; and Kanazawa Yoh, Idemitsu Museum of Arts, Tokyo.

Half title page:
Arita vase with relief dragons on shoulder, 19th century, 48 1/2" high, Christie's, London.

Title page:
Imari incense burner with reticulated top, 19th century, 14" high, Flying Cranes Antiques, New York.

Revised: 1999
Copyright © 1986 & 1999 by Nancy N. Schiffer.
Library of Congress Catalog Card Number: 99-62567

ISBN: 0-7643-0899-8
Printed in China
1 2 3 4

Published by Schiffer Publishing Ltd.
4880 Lower Valley Road
Atglen, PA 19310
Phone: (610) 593-1777; Fax: (610) 593-2002
E-mail: Schifferbk@aol.com
Please visit our web site catalog at
www.schifferbooks.com

This book may be purchased from the publisher.
Include $3.95 for shipping. Please try your bookstore first.
We are interested in hearing from authors
with book ideas on related subjects.
You may write for a free printed catalog.

In Europe, Schiffer books are distributed by
Bushwood Books
6 Marksbury Avenue
Kew Gardens
Surrey TW9 4JF England
Phone: 44 (0)181 392-8585; Fax: 44 (0)181 392-9876
E-mail: Bushwd@aol.com

Contents

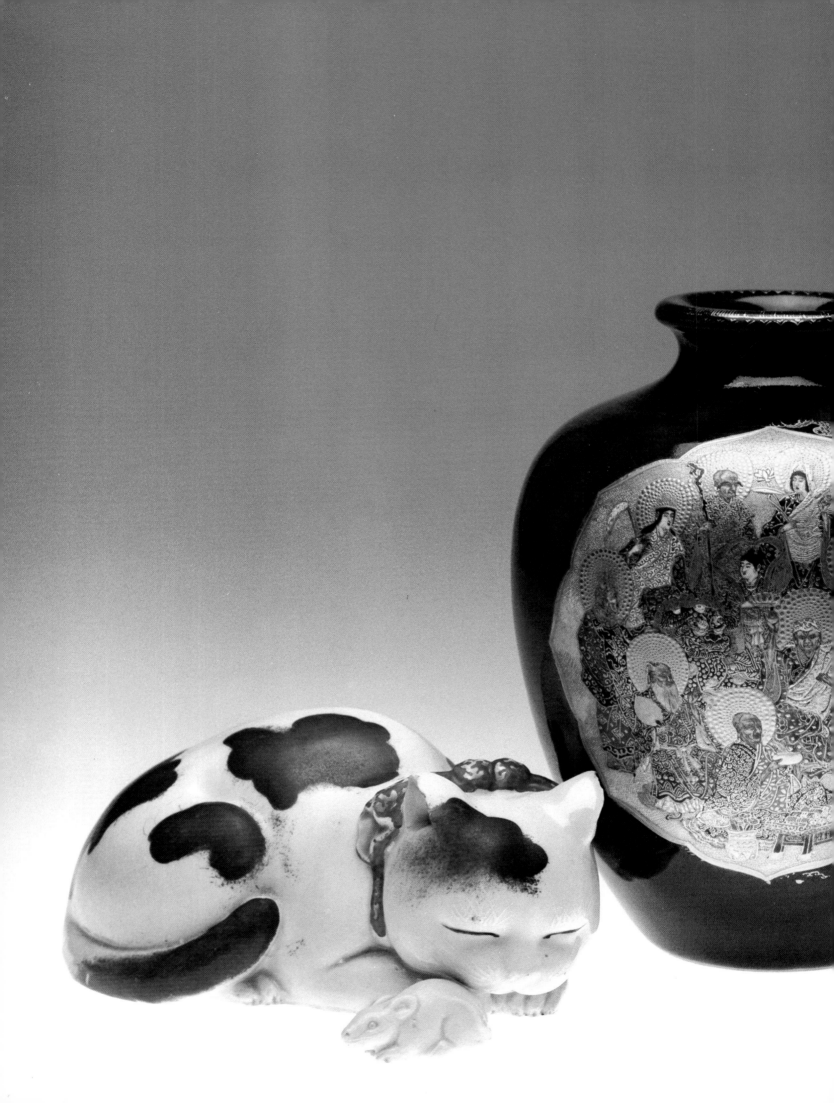

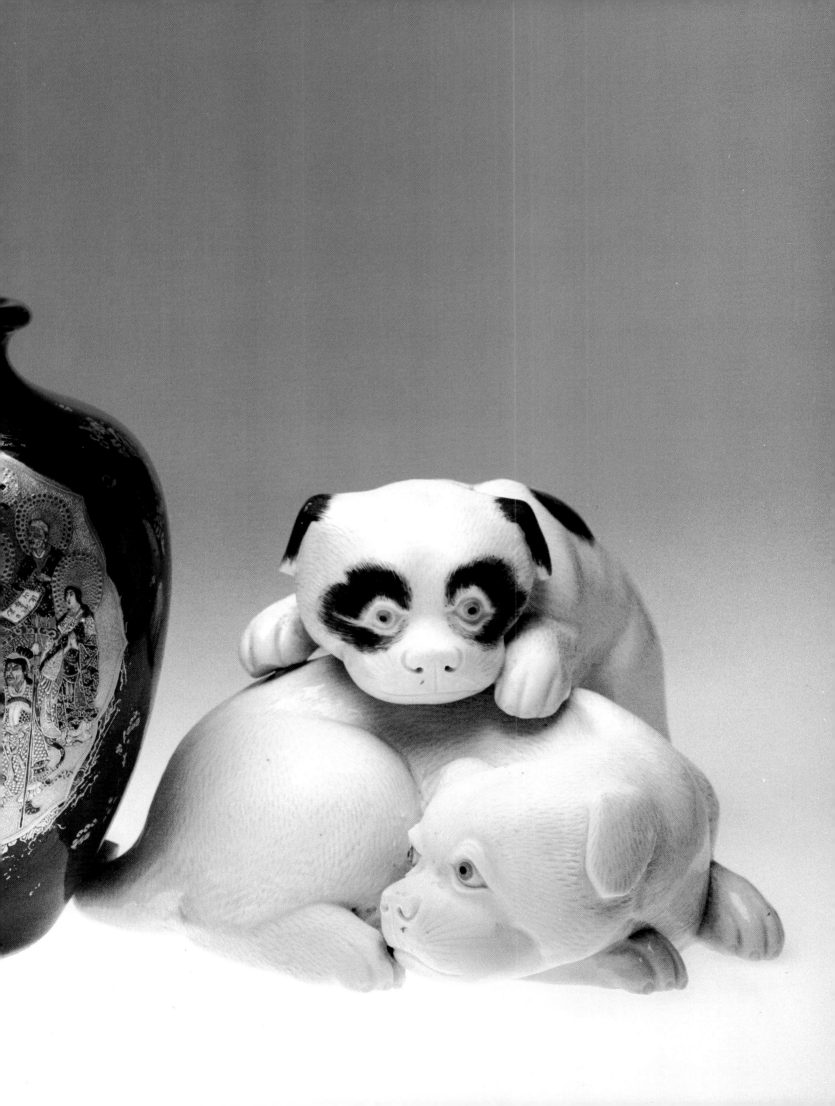

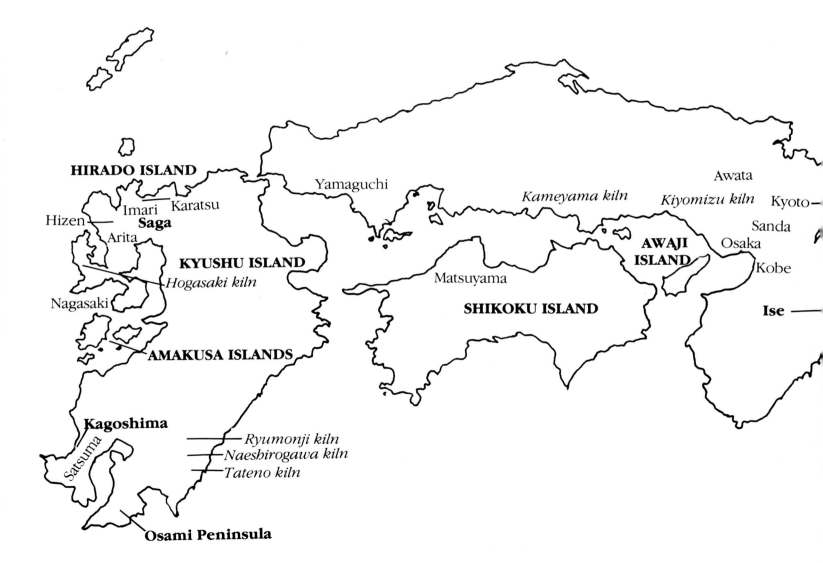

HIRADO ISLAND

Yamaguchi

Awata

Kameyama kiln

Kiyomizu kiln

Kyoto

Imari Karatsu

Hizen

Saga

Sanda

Arita

Osaka

KYUSHU ISLAND

AWAJI ISLAND

Kobe

Hogasaki kiln

Matsuyama

Nagasaki

SHIKOKU ISLAND

Ise

AMAKUSA ISLANDS

Kagoshima

Ryumonji kiln

Satsuma

Naeshirogawa kiln

Tateno kiln

Osami Peninsula

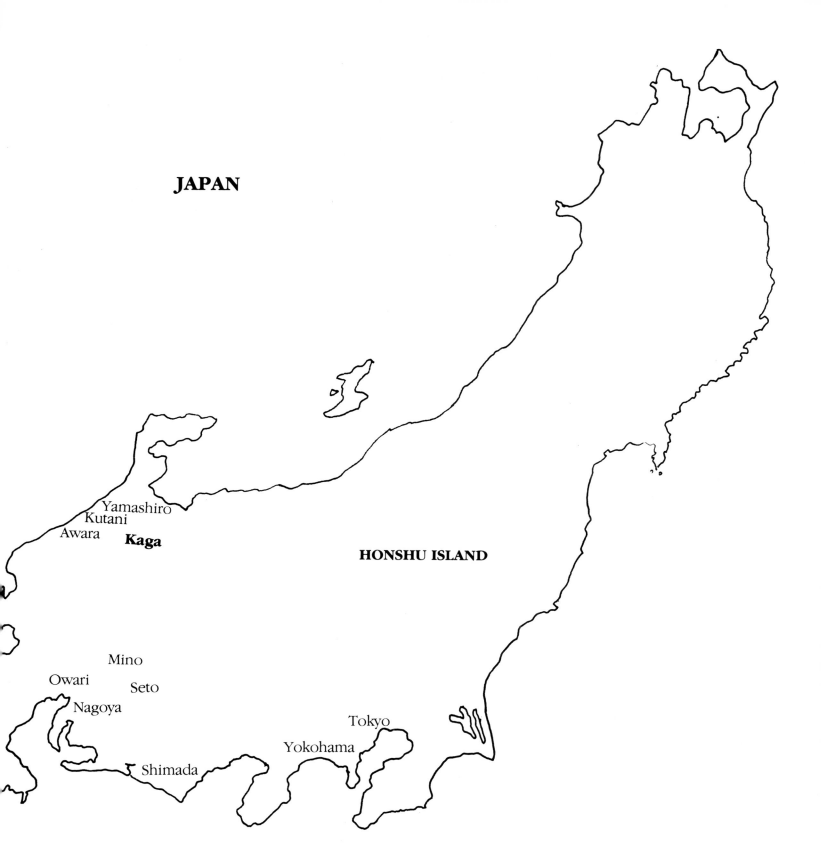

JAPAN

Yamashiro
Kutani
Awara **Kaga**

HONSHU ISLAND

Mino
Owari Seto
Nagoya
 Tokyo
 Yokohama
 Shimada

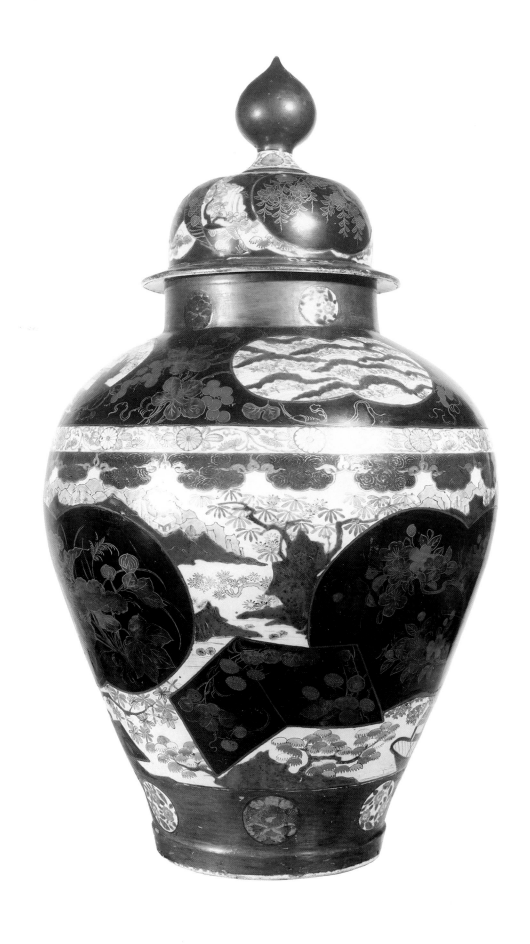

Imari covered jar with lacquered
panels, 18th century, 35'' high,
Henry Woods Wilson, London.

Japanese Political History and the West

The Portuguese Relations

In 1542, a Portuguese adventurer named Mendez Pinto accidentally landed on the shores of Kyushu Island and "discovered" Japan for the West. Pinto found a well-organized, cultivated people who enjoyed self-sufficiency and very different habits from those of his countrymen. The stories of this new land that reached the Portuguese at home inspired merchants as well as the Catholic Church to think of Japan as potential for new acquisitions.

By 1549, St. Francis Xavier and other Christian missionaries had landed in the province of Satsuma on Kyushu Island, and by 1600 there were over a million Japanese converts to Catholicism. Up to this period Buddhist and Shinto traditions in religious affairs had been customary in Japan since ancient time.

In the beginning, the Portuguese were welcome, in fact they were allowed to build a church and school in the capital city of Kyoto. "In 1582 three *daimyos* [local lords] from the island of Kyushu went as far as to send envoys to Europe who were received three years later by

The coastline near Shisa, north coast of Kyushu island.

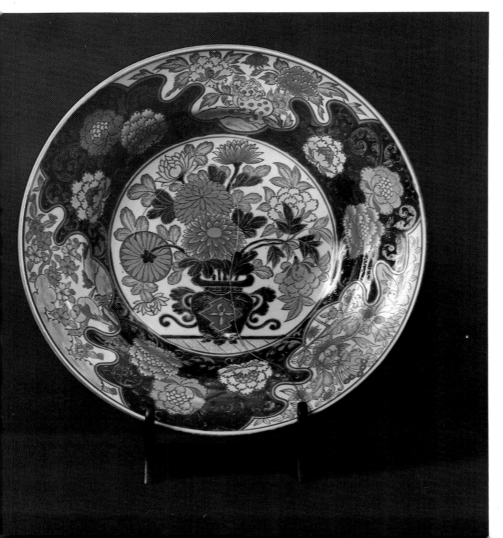

Imari charger with gold soldered repair, late 18th century, 19" diameter, House of the Black Ship, New London.

Pope Gregory XIII in Rome. At that time the missionaries already reported 150,000 converts." [Reichel, p.21] However, when the governing of Japan changed hands in 1600, the ruling Tokugawa family looked less favorably on Christianity since it divided loyalty away from the traditional powers. In 1614, the teaching of Christianity was officially banned and remained so until the mid-19th century when the government changed once more. All missionaries were exiled and repression of Japanese Christians was cruel and lasting.

After the Dutch East India Company had begun agreeable trade relations in Japan (see next section on Dutch relations), the Japanese were no longer dependant on the Spanish and Portuguese for this trade. The Dutch did not attempt any religious influence, and due to their hostile relations with Spain at the time, the Japanese received derogatory advise from the English. At first, the Japanese formulated a plan to control Portuguese dealings in Japan. In 1635, the Japanese dredged Nagasaki harbor and created an island called Deshima. Here they felt they could oversee and restrict the Portuguese affairs more carefully by confining them to this one island.

For two unhappy years the Japanese tried to tolerate this new arrangement. However, by 1637, an Imperial proclamation was made addressing, and concluding, this temporary arrangement.

Historian Kaempfer relates to us some of the Imperial proclamation of 1637 which pertains to these events:

> No Japanese ship, or boat whatever, nor any native of Japan, shall presume to go out of the country: who acts contrary to this shall die, and the ship, with the crew and goods aboard, shall be sequestered till further order.
>
> All Japanese, who shall return from abroad, shall be put to death.
>
> Whoever discovers a Priest shall have a reward of 400 to 500 *shuets* of silver, and for every Christian in proportion.
>
> All persons who propogate the doctrine of the Christians, or bear this scandalous name, shall be imprisoned in the *Ombra*, or common gaol of the town.

Imari bowl with Black Ship and Dutch merchants decoration, c. 1800, 3¼" high, 10" diameter, Victoria and Albert Museum, London.

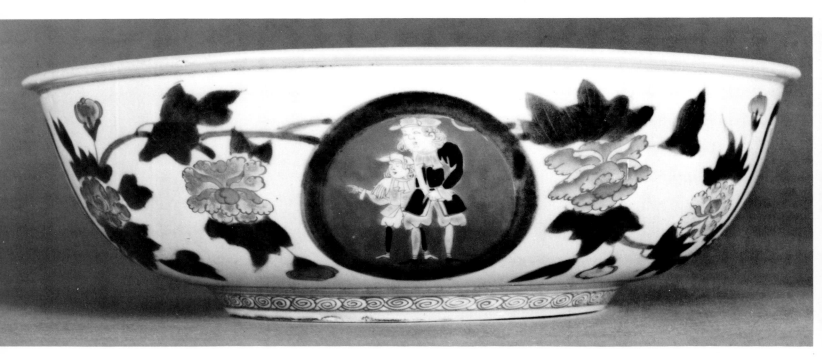

The whole race of the Portuguese with their mothers, nurses, and whatever belongs to them, shall be banished to *Macao*.

Whoever presumes to bring a letter from abroad, or to return after he hath been banished, shall die, with all his family; also, whoever presumes to intercede for them shall be put to death.

No nobleman, nor any soldier, shall be suffered to purchase anything of a foreigner, etc.

Given in the thirteenth year of our reign, *Quanje* 19, in the 5th month." (1637)

Signed,
[Audsley & Bowes, p. 138]

The Japanese officials had thereby responded to the Portuguese influences by legislating self-imposed isolationism from the rest of the world. Japan had not sought the outside influence, and the officials did all they could to prevent future intervention of this type and to wipe out the effects as they existed at that time. Persecutions of Japanese Christians are well known throughout this period.

The Dutch Relations

The Dutch merchants of the East India Company had been engaged in trade with China for silk, spices, tea and porcelain since the late 16th century. Hereby a few Western monarchs were presented with exotic Chinese porcelain and introduced to the wonders of the Orient. The tales which reached Europe from the merchants of "the silk road" whet the appetites of Westerners for any new Oriental goods.

When social upheavals took place at the end of the Ming dynasty (1368-1644), Dutch merchants trading in porcelain with the Chinese found their supplies from the Ching-te-Chen kilns dwindling in quality and quantity. The Dutch looked to Japan to fill their orders at a time when the porcelain industry in Japan was becoming better organized (see Arita chapter).

The Dutch were granted letters to trade in Japan in 1601. By 1609 (Bowes says 1611) a Dutch East India Company (Vereenidge Oost Indische Compagnie [VOC]) factory was set up at Hirado Island. When the Portuguese were banished from Deshima in 1637, the Dutch were permitted to remain in Japan, but only at Deshima Island in Nagasaki harbor.

For about a hundred years, the Dutch ordered large quantities of porcelain, which were shipped through the port of Imari, 25 miles north of Arita, by Japanese traders who brought it down by water to Deshima.

The English Relations

In 1600, William Adams, an English ship's captain, was ship-wrecked in Japan. He enjoyed the confidence of Tokugawa Tyeyasu (the first Imperial leader of the new era) and was retained in the Shogun's service as an advisor on European matters until the time of his death in 1620, at the age of 57.

The English also had a few traders at Hirado, but in December of 1623, they closed their office here. The English regretted this decision but were not again permitted trading rights with Japan until after the opening of the country in the late 19th century.

Thereafter, Japan enjoyed relative peace for 150 years while the Tokugawa family ran the country smoothly and enjoyed their command of power. The Japanese people maintained the continuity of isolation from the rest of the world, traditional values and a stable life style ensued. During the 18th century, the Japanese porcelain industry was in a period of relative decline, as will be explained in the chapter on ceramic history.

During the 19th century, Japanese life changed dramatically, due primarily to its contact with the outside world. By 1868, the Tokugawa government at Nara (or Kyoto) was overthrown and replaced by the Meiji restoration. The traditional feudal organization of government was replaced by a centralized government and the Emporer moved the capitol to Edo, renaming it Tokyo. Nothing of Japanese cultural life would ever be the same again.

This change in social organization enabled Western industrial and modern techniques to be shared with Japanese manufacturers who embraced the new ideas and refined them. This process has been repeated on a world scale to the present.

By the beginning of the 19th century, interest in Oriental styles was growing in Europe as the affluent middle class developed. Several attempts to open up trade with Japan were initiated by French, Russian, Dutch, British and United States diplomats, but none were successful. The Japanese refused to change their policy. Still, the West was anxious to benefit from trade with Japan. In the mid-1830's, Japanese economic conditions softened due to a few years of poor rice crops, poor land management, and excessively luxurious living by a few powerful political leaders. When Tokugawa Teyoshi succeeded his father as shogun in 1837, he did nothing to abate the growing unrest among the military and civil leaders. In some areas, powerful local leaders began a movement for reformation in their provinces which gradually spread to the central government. For example, Zusho Hiromachi (1776-1848 or 1853), a strong leader in Satsuma Province, made trade changes to permit Japanese trade with

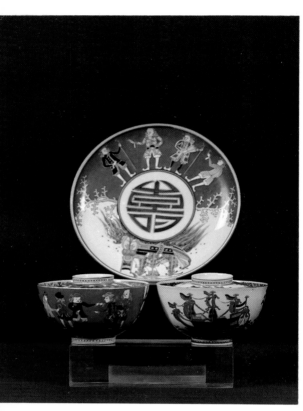

Imari plate and two covered bowls with Black Ship decoration, c. 1800, House of the Black Ship, New London.

Imari bowl with classic brocade background and Black Ship decoration, c. 1800, 9¾'' diameter, House of the Black Ship, New London.

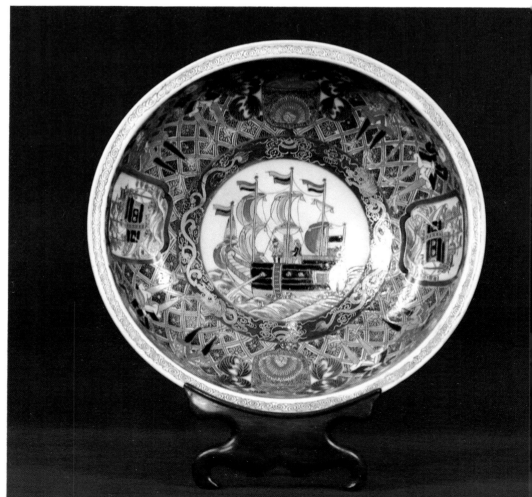

14

the Ryuku Islands to the south which were Japan's only source of sugar. Control of this trade would give the leaders of Satsuma a powerful monopoly and influence in the Imperial Court. Hiromachi died at a time when Japanese and European pressures to develop trade agreements were especially strong.

In the United States, Naval Commandore Matthew Calbraith Perry was asked in January, 1852, to negotiate a treaty with Japan. This already well-decorated emissary of naval encounters said he would go if the East India Squadron were significantly enlarged for the mission. The Secretary of the Navy agreed, and decided to send a large fleet, feeling that the show of strength would facilitate

Two plates with Imari Black Ship decoration, c. 1800; *left,* 9½'' diameter; *right,* 10¼'' diameter, House of the Black Ship, New London.

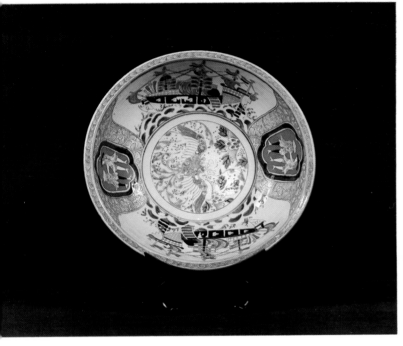

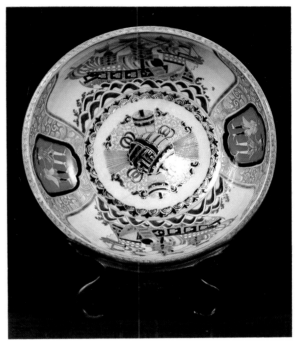

Imari Black Ship decoration, c. 1800; *left,* saucer, 5¾'' diameter; *center,* cup and saucer, 4½'' diameter; *right,* bowl, 6'' diameter, House of the Black Ship, New London.

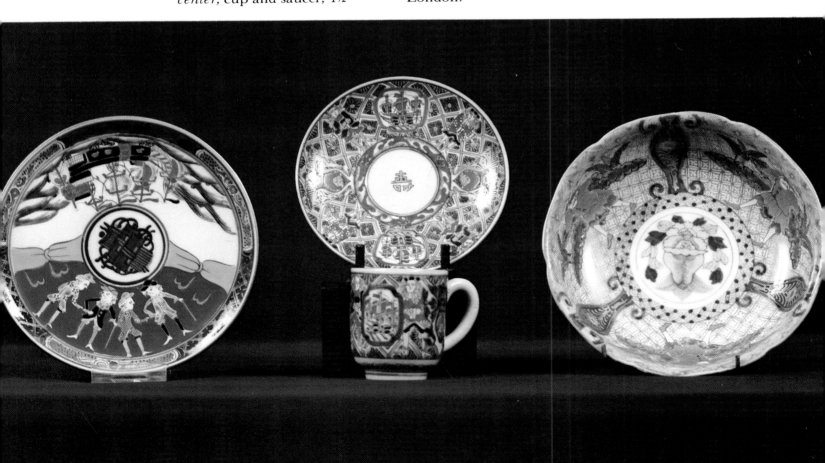

negotiations. Perry was to go to Japan with a letter from President Millard Fillmore to the Emporer and instructions from the State Department. Perry was instructed to try negotiations first, and if this failed, to use stronger methods, always bearing in mind that his mission was peaceful and that the President had no power to declare war. The whole world knew of his mission and awaited the outcome.

Perry sailed from Norfolk for China on November 24, 1852. After a few stops at small islands off the coast, Perry arrived at Yedo (Tokyo) Bay, 27 miles from the capitol, on July 8, 1853. Perry assumed a powerful attitude toward the Japanese by refusing to see any but "a dignitary of the highest rank." The Japanese official answered that the fleet must go to Nagasaki, the only place in Japan where business with foreigners was transacted. This same exchange was repeated the following day and Perry added that he would go ashore with sufficient force to deliver his letters, whatever the consequences would be. Finally, on July 14, his determination was successful as he personally delivered his letters with elaborate ceremonies on shore at the village of Kurihama to the princes Idzu and Iwami, representatives of the Emporer.

President Fillmore's letter was written on vellum, sealed with gold, and presented in a rosewood box. The letter said:

> Great and Good Friend! I send you this public letter by Commodore Matthew C. Perry, an officer of the highest rank in the Navy of the United States, and commander of the squadron now visiting your Imperial majesty's dominions.
>
> I have directed Commodore Perry to assure your Imperial Majesty that I entertain the kindest feelings towards your Majesty's person and government; and that I have no other object in sending him to Japan, but to propose to your Imperial Majesty that the United States and Japan should live in friendship, and have commercial intercourse with each other.
>
> The constitution and laws of the United States forbid all interference with the religious or political concerns of other nations. I have particularly charged Commodore Perry to abstain from every act which could possibly disturb the tranquility of your Imperial Majesty's dominions.
>
> The United States of America reach from ocean to ocean, and our territory of Oregon and state of California lie directly opposite to the dominions of your Imperial Majesty. Our steam-ships can go from California to Japan in eighteen days.
>
> Our great state of California produces about sixty millions of dollars in gold, every year, besides silver, quicksilver, precious stones, and many other valuable articles. Japan is also a rich and fertile country, and produces many very valuable articles. Your Imperial Majesty's subjects are skilled in many of the arts. I am desirous that our two countries should trade with each other, for the benefit both of Japan and the United States.
>
> We know that the ancient laws of your Imperial Majesty's government do not allow of foreign trade except with the Dutch. But as the state of the world changes and new governments are formed, it seems to be wise from time to time to make new laws. There was a time when the ancient laws of your Imperial Majesty's government were first made.

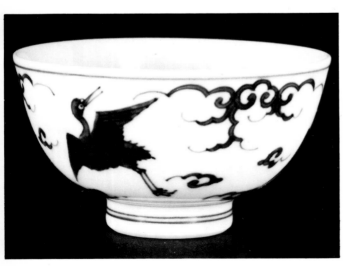

Tea bowl in imitation Shonsui style, late 19th century, 3¼" diameter, British Museum, London.

About the same time, America, which is sometimes called the New World, was first discovered and settled by the Europeans. For a long time there were but a few people, and they were poor. They have now become quite numerous; their commerce is very extensive; and they think that if your Imperial Majesty were so far to change the ancient laws as to allow a free trade between the two countries, it would be extremely beneficial to both.

If your Imperial Majesty is not satisfied that it would be safe, altogether, to abrogate the ancient laws which forbid foreign trade, they might be suspended for five or ten years, so as to try the experiment. If it does not prove as beneficial as was hoped, the ancient laws can be restored. The United States often limit their treaties with foreign states to a few years, and then renew them or not, as they please.

I have directed Commodore Perry to mention another thing to your Imperial Majesty. Many of our ships pass every year from California to China; and great numbers of our people pursue the whale fishery near the shores of Japan. It sometimes happens in stormy weather that one of our ships is wrecked on your Imperial Majesty's shores. In all such cases we ask and expect, that our unfortunate people should be treated with kindness, and that their property, should be protected, till we can send a vessel and bring them away. We are very much earnest in this.

Commodore Perry is also directed by me to represent to your Imperial Majesty that we understand there is a great abundance of coal and provisions in the empire of Japan. Our steam-ships, in crossing the great ocean, burning a great deal of coal, and it is not convenient to bring it all the way from America. We wish that our steam-ships and other vessels should be allowed to stop in Japan and supply themselves with coal, provisions and water. They will pay for them, in money, or anything else your Imperial Majesty's subjects may prefer; and we request your Imperial Majesty to appoint a convenient port in the southern part of the empire, where our vessels may stop for this purpose. We are very desirous of this.

These are the only objects for which I have sent Commodore Perry with a powerful squadron to pay a visit to your Imperial Majesty's renowned city of Yedo; friendship, commerce, a supply of coal, and provisions and protection for our shipwrecked people.

We have directed Commodore Perry to beg your Imperial Majesty's acceptance of a few presents. They are of no great value in themselves, but some of them may serve as specimens of the articles manufactured in the United States, and they are intended as tokens of our sincere and respectful friendship.

May the Almighty have your Imperial Majesty in his great and holy keeping!

In witness whereof I have caused the great seal of the United States to be hereunto affixed, and have subscribed the same with my name, at the city of Washington in America, the seat of my government, on the thirteenth day of the month of November, in the year one thousand eight hundred and fifty-two.

<div align="right">

Your Good Friend,
Millard Fillmore

</div>

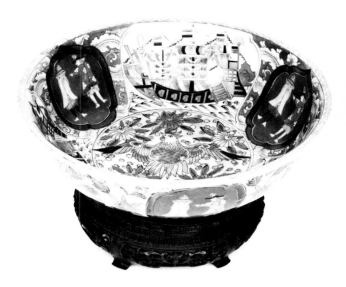

Imari bowl with Black Ship decoration, mid-19th century, 10" diameter, Flying Cranes Antiques, New York.

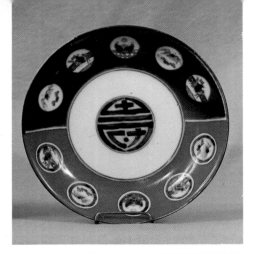

Imari plate for the Chinese market, c. 1800, House of the Black Ship, New London.

Imari bowl with Black Ship and Dutchmen decoration, c. 1800, 12¼" diameter, House of the Black Ship, New London.

To give the government time to make the new arrangements, Perry informed the princes that he would return the next year. He sailed on to China after staying in Tokyo Bay only 9 days.

The following year, Perry returned to Tokyo Bay in February, and by then the Japanese were agreeable. The Emperor had given orders to receive the Americans in a friendly fashion and had appointed five commissioners to meet with Perry and discuss the President's letter. On March 31, 1854, at Yokohama, a treaty of peace was signed granting the United States trading rights at the ports of Hakodate and Shimoda. The Japanese officials reluctantly accepted the outcome. After 1854, Japanese merchants gradually developed the much sought-after trade relations with the West.

The great reforms which are the contribution of the Meiji era (1868-1912) included moving the capitol city to Edo (now Tokyo) as though to sweep away the Tokugawa-dominated past and establish a new Japan with many Western ideas. As the Meiji era advanced, political factors contributed to change in Japan through the Taisho (1912-1926) and Showa (1926-present) periods, but the artistic climate for growth continued. Trade with Europe was curtailed by The First World War, when renewed contact with the West brought Japanese prints, textiles and ceramics back into favor with the Art Deco and Modern movements.

The continual progress of Japanese technology advanced, so that in fewer than ninety years Japan posed threats to world stability during the Second World War. During the aftermath, Western markets, especially in the United States, contributed significantly to Japan's recovery. During the period of American occupation from 1945-1952, much aid was furnished by United States military personnel while great hardships were suffered through economic strife by the Japanese people. However, the country gradually rebuilt its business relations and trade flowed out of the country at ever-accelerating rates. The century since Japan's release from isolation has been its most dramatic period of change.

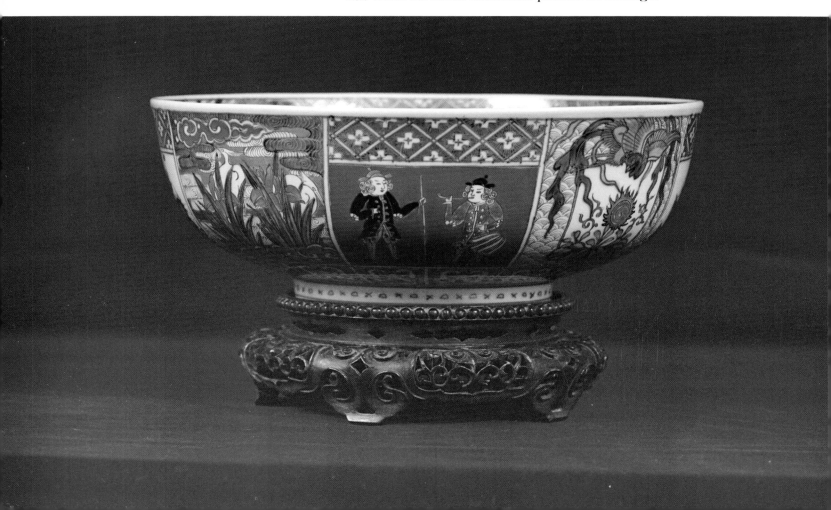

History of Porcelain in Japan

It will be useful to briefly consider some of the earlier phases of the Japanese porcelain industry before going into more detail for the main period of this study.

Ceramics have a long history in Japan, beginning in the seventh century A.D. Since then, table wares were made from coarse Japanese clays and these early earthenware objects are highly prized in Japan. Much research has been done and continues to identify the many styles of ancient wares.

Chinese ceramics have also been highly prized in Japan for many centuries. The rich heritage of many kinds of Chinese wares has directly influenced Japanese ceramics, either from Chinese sources themselves or through Korean potters in Japan. Japan's first glazed ceramics were made at Seto in the 13th century (see Seto section).

Ceramics are divided into types by the temperatures required to fuse the clays. Earthenwares fuse at relatively low temperatures, stonewares at higher temperatures, and porcelain at the highest temperatures. Our focus in this study is primarily on porcelain of two kinds: the soft-paste, lower-fired wares of Satsuma and Kutani, and the hard-paste, high-fired wares of Arita and other areas.

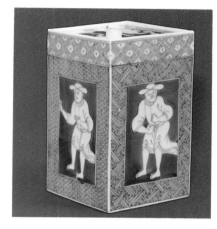

Arita bottle with European figures decoration, 18th century, 9½" high, 5" square, Lyman Allyn Museum, New London.

Mark on the base of the bottle.

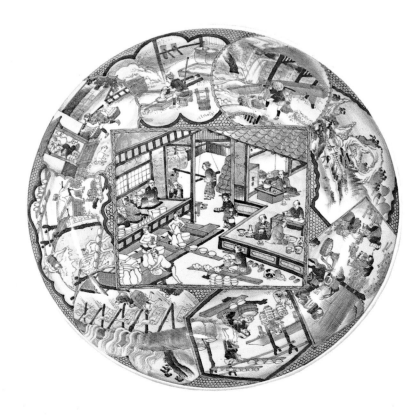

Arita plate with early porcelain manufacturing process decoration: Rim panels beginning with *upper right,* digging clay at Izumiyama quarry, pounding machine for preparing clay, mixing and working clay, carrying clay to potter, stacking the kiln, firing the kiln, applying underglaze blue decoration, gathering pine to burn in the kiln; *Center,* potters in the foreground, decorators to the left and selling to the right on raised platform with Tatami mat floor coverings. Early 19th century, 12" diameter, Private collection in Japan.

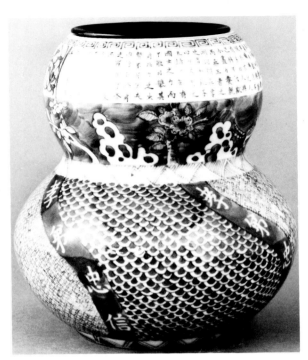

Double gourd vase and lacquered lid, underglaze blue decoration, name Kodai Tadanobu and Bunka (1804-1818) mark, imitation Shonsui ware, 4 2/3'' high, British Museum, London.

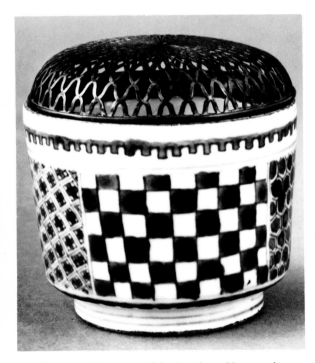

Incense burner of imitation Shonsui ware, Fuku mark, early 19th century, 2½'' high, British Museum, London.

Kidney-shaped dish with pawlonia sprays and Shonsui style roundels in underglaze blue and enamels, Fuku mark, early 19th century, 9½'' long, British Museum, London.

The birth of porcelain in Japan is relatively recent and still undergoing scrutiny by dedicated scholars. It will be some time yet before scientific research can establish the age of the "first" Japanese porcelain kilns—yet the traditional legends have not been proved entirely wrong.

As the ceramic history of Japanese ware is still being analyzed so carefully, only an outline of the historical facts can be presented. Upon this framework, archaeological evidence and detailed analysis of remaining examples may build a body of knowledge sufficient to identify origins of the pieces. It is more a Western passion to want to know where, when and by whom an article was made. Most Japanese publications merely describe an article literally without any attempt to fix it in time or locale. Perhaps this Japanese tendency for general descriptions is the result of the potters' reverence for and attempts to preserve older styles by accurately copying them—with all due respect for the originals. In striving for complete accuracy in replicating the older works, the later potters have succeeded many times. Their interests are not in determining which is "original" or which is the "copy", but in preserving the masters' work through their own. The challenge is in recreating accurately. This tendency in Japanese ceramics makes the job of the Western scholar nearly impossible. The Westerner wants to know the facts, clear and simple. But Japanese potters did not have them in mind when they went about their work.

Today we are still trying to find fast answers, even though the historical facts are few. The history of porcelain manufacturing in Japan began, according to tradition, in Hizen province. In the introductory remarks to the Japanese section of the catalog for the Philadelphia Centennial Exhibition in 1876, Japanese authors relate the history of their porcelain as it was believed at that time:

> The most important progress which was realized in ceramic art, was the beginning of the making of real porcelain, under the direction of Gorodayu Shonsui, a native of Ise, who went to China for the purpose of studying this branch of trade. After his return, between 1580 and 1590 A.D., he settled in the province of Hizen, at present the most important centre of the porcelain industry. With the excellent material found in this country, he succeeded in making all the different kinds of porcelain which even to-day form the staple produce of Hizen.

These claims may be exaggerated, but the existence of Gorodayu Shonsui is more real than legend. Signed examples of his work are well documented [72 pieces were exhibited at the Osaka Art Club in 1954].

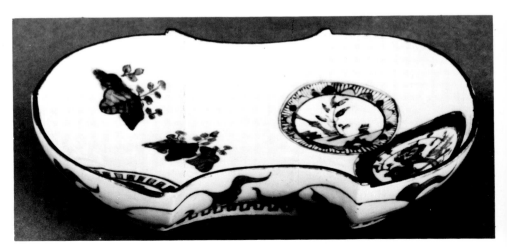

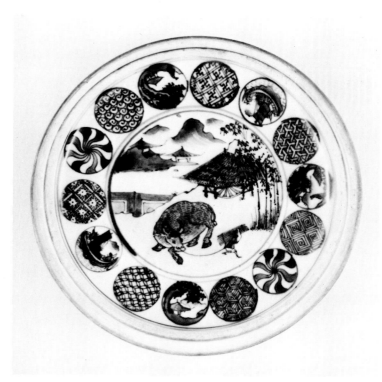

Lid of a water carrier decorated with imitation Shonsui style roundels, early 19th century, British Museum, London.

Water carrier with lid, decorated with imitation Shonsui style, early 19th century, British Museum, London.

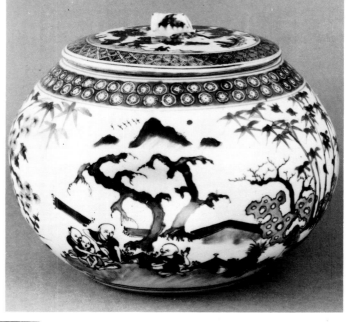

Tea bowl in imitation Shonsui style, blue Fuku mark, early 19th century, 4¾" diameter, British Museum, London.

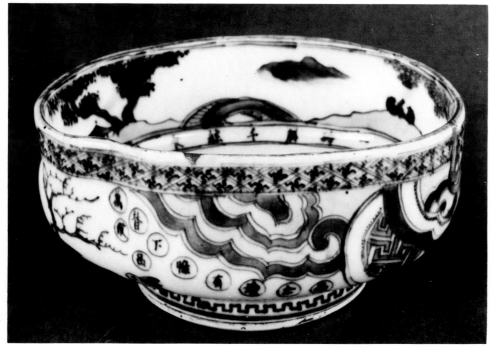

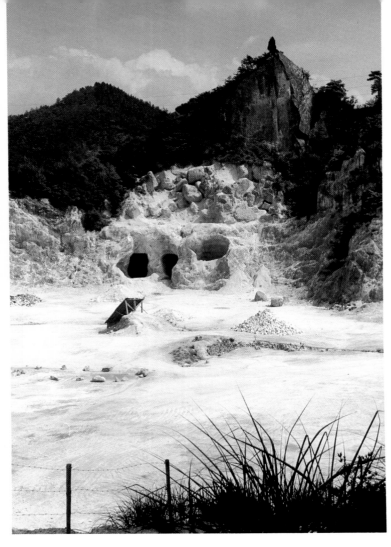

Izumiyama porcelain clay quarry, once a huge mountain, is now beginning to be worked below ground level.

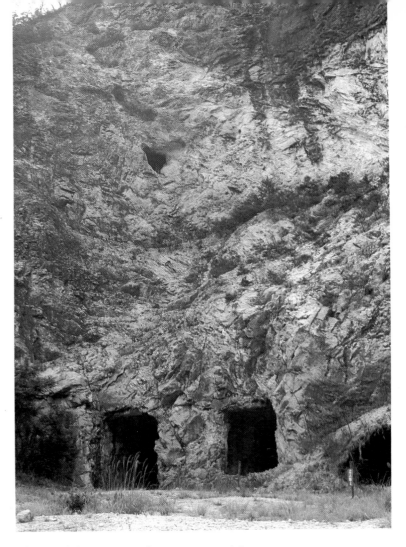

Views of Sarayama clay quarry with tunnels inside the mountain. This clay is used for glaze production.

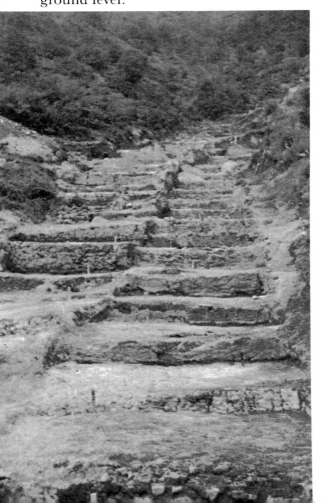

The excavations in 1972 of the step-style Tengudani kiln at Arita which dates to the first two decades of the seventeenth century.

About the year 1597, Japanese lord Toyotomi Hideyoshi returned to Hizen from an unsuccessful invasion of Korea. He brought back with him several Korean potters, including an expert named Ri Sampei. For many years Ri Sampei searched for fine porcelain clay. Finally, he found the clay he desired at Izumiyama at the southern foot of Mt. Kurokami near Arita town. The traditional story places this event about 1616, but modern research suggests it may have been a decade earlier. Ri Sampei worked then at a kiln near Arita, most frequently identified as the Tengudani kiln. He eventually became a Japanese citizen using the name Sampei Kanegae, and was probably buried north of Arita. Ri Sampei's death record of 20 September 1655 was found at a Buddhist temple near Arita in 1967, reading "Sampei from the Kamishirakiawa River." This river runs near the Tengudani kiln site.

Ceramics were carried first to Europe by Portuguese merchants between 1550 and 1637, [see Political History section]. Since 1637, the

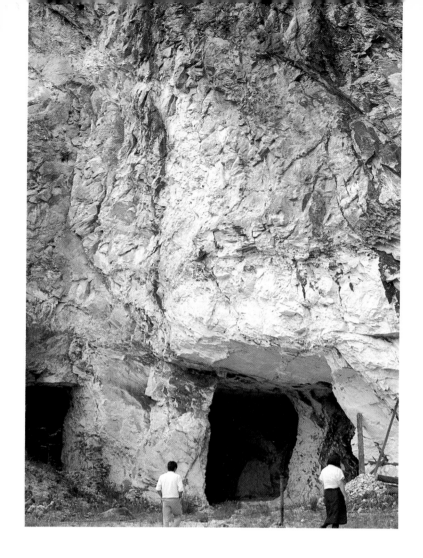

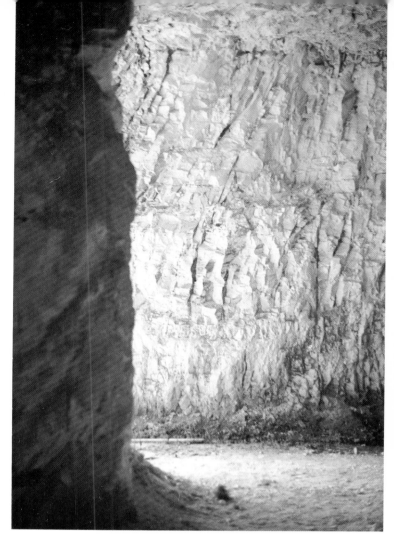

Japanese government had practiced self-isolationism by excluding all foreigners from its shores. Only one small window was opened at Deshima Island in Nagaskai harbor, where a small settlement of Dutch and a few Chinese merchants were allowed to engage in licensed trade. Nagasaki is about 45 miles south of Arita in Hizen province on Kyushu Island. This one place was considered too minor to influence Japanese life-style and culture. This and previous contact with China enabled Chinese porcelains to be admired and copied by the potters at Arita, and the Dutch traders gave a market for the Arita porcelains in the West.

The porcelain orders from the Dutch at Deshima Island were first for the blue and white styles they had previously obtained from China, but gradually more orders were for overglaze decorations that the Europeans loved. As gold, red, and blue all-over floral and landscape decorations became progressively more popular in Europe, orders for these were increased through the eighteenth century. The porcelain industries in Hizen province grew to meet the Western demand and also assimilated some Western designs into their patterns. Through contact with the Dutch, European figures, landscapes and symmetrical floral motifs were incorporated into some of the decorations.

Princes and noblemen of Europe in the late 17th and 18th centuries were eager to obtain Oriental porcelain. Members of the Hapsburg, Bourbon, Hanover, and other powerful families were fascinated by this porcelain and valued it very highly. Frederick Augustus

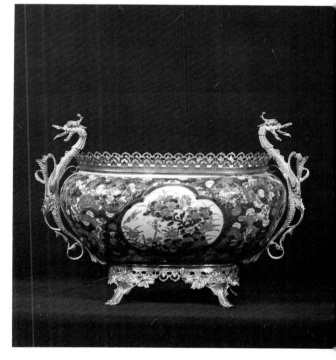

Imari bowl ornamented with German ormolu mounts, 18th century, 16" long, House of the Black Ship, New London.

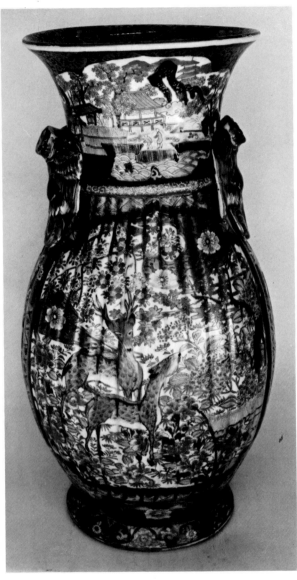

Imari vase with ribbed sides and finely painted decoration, 18th century, 22" high, Flying Cranes Antiques, New York.

(Augustus the First, 1670-1733), the King of Saxony, was a fanatical collector who built a ceramic museum with Japanese style exterior and interior. Even today pieces from his magnificent collection can be seen at the Dresden Art Museum, which has over twelve hundred articles of Arita-made porcelain of several styles. By 1713, Augustus the First also built a ceramic factory at Meissen to try to copy the Oriental porcelain. This was among the first of many European porcelain manufacturing centers, which developed to imitate Chinese and Japanese porcelain. Others were established at Sevres, Chantilly, Worcester, and elsewhere.

The manufacture of porcelain objects was a well organized "team" system in Arita by the seventeenth century. Workmen had specific jobs and took pride in their contributions to the process. In fact, whole families participated in the scheme and passed along their specialized skills to successive generations. The process included specialized jobs such as digging the clay, pounding, cleaning, mixing, forming, painting and firing it. When the pieces were complete, the porcelain was packed in straw wrappings and wooden boxes and taken to Imari for distribution.

When economic conditions in China once again stabalized toward the end of the 17th century, the kilns at Ching-te-Chen were once again able to produce large quantities of high quality porcelain. The Chinese competed against the Japanese for the Western porcelain trade. Eventually, when the Chinese prices became more attractive, Dutch traders abandoned the Japanese suppliers. Without another foreign market, the kilns at Arita died back to supply primarily only what could be absorbed in Japan.

When the charter of the Dutch East India Company to conduct trade in Japan expired in 1795 and was not renewed, an era of international trade was ended. By then, the Dutch East India Company was doing very little business in Japan. There is an interesting camparison among the shipping records of the Dutch East India Company and those of the Japanese shippers to suggest that apart from official company supplies, the Dutch traders were allowed to conduct a certain amount of trading privately, and that this private trade carried the Japanese porcelain supplies to the West a little longer than the official documents show. However, by the end of the 18th century, this trade, too, was next to nothing.

During the seventeenth and eighteenth centuries, in provinces other than Hizen, where the proper clays were found, ceramics were being produced. At Satsuma, Kaga, Owari, Mino and Kyoto, ceramics and some semi-porcelain wares were made. These centers have contributed greatly to Japanese ceramics styles, and grown to be important areas for nineteenth and twentieth century wares. The common names used today for different wares have grown from the names of trading towns, manufacturing towns, provinces, clan names and kiln names.

By the early years of the nineteenth century, porcelain production in Japan was conducted for domestic use exclusively, because of Japan's official isolationist policies. There was a small appreciation for the exported types of overglaze enamels in Japan, but the preference was, by far, for earthenware food vessels of traditional ceramics styles. The kilns were small and run by families of traditional craftsmanship, some with clan support. The social climate in Japan was peaceful and prosperous under the tight feudal system.

At the beginning of the nineteenth century, porcelain manufacturing continued in Hizen and Satsuma provinces as it had for two

hundred years. Besides here, however, porcelain manufacturing spread quickly throughout the country with the establishment of hundreds of new kilns in nearly every part of Japan. One of earliest of these "new" kilns outside Kyushu Island was the Toby kiln, founded in 1777 near Matsuyama on Shikoku Island. From there, porcelain production quickly grew to Sanda (1804) and Kyoto. In 1807, the first porcelain factory was begun in the Seto area. Here, Kato Tamikichi, a potter who had studied porcelain making in Arita, made blue and white wares in the Arita style. On Kyushu Island itself, new kilns for porcelain were started at Kameyama (1804) and Hogasaki (1823) both near Nagasaki. These kilns were surely influenced by their proximity to the one export trade center.

The domestic markets of Japan both welcomed and encouraged this growth of the porcelain manufacturing, for gradually tastes were changing away from earthenwares towards the less natural and more contrived ceramic wares of porcelain for daily use. Once reserved for the ruling families alone, porcelain was appealing more widely to the general population. This shift in taste is, of course, linked with the overall change in social and economic factors within Japan, and also to growing pressures to integrate with the rest of the world.

When Japan's policy of isolationism was finally broken in 1853 with Admiral Perry's adventures into Tokyo Bay, [see Political History section] the porcelain industry in Japan was awakened. Quick adaption to the new and widespread Western markets insured porcelain's commercial success for the next five decades.

Taking full advantage of these events, ceramic businesses were set up in the late 19th century to make porcelain tablewares in Western taste specifically for the Western markets. These included Western style painting decoration at factories around Nagoya. The enormous quantities of these that sold ensured low prices and good distribution systems worldwide. In the 1860's, Yokohama and Kobe import/export businesses were opened by Japanese and Western firms alike. A very interesting collection of etchings of business establishments at Yokohama during the second half of the nineteenth century is preserved at the Yokohama museum and reproduced in book form. Here porcelain manufacturers and shippers are represented among the etchings that show an assortment of Western style buildings, Japanese style packaging methods, and groups of people in Western and Japanese dress.

The Japanese readily studied all the technical skills and use of industrial machinery as it was developed in the West. The Japanese were good students. Very quickly they learned and improved upon many industrial methods, including those applicable to porcelain manufacture. Many European experts added substantially to the industrialization process.

Gottfried Wagener (1831-1892), a German chemist and craftsman who had studied chemistry at Goettingen University, was invited by the Japanese government to come to Japan in 1870 to instruct Arita potters in new chemical aspects of ceramics. In 1871, he went to Tokyo, where he instructed at the Kaisei School, the forerunner of Tokyo University.

Around 1887, Wagener created his own new style of Azuma ware, later renamed Asahi, by applying an underglaze pigment to white earthenware. Through Wagener and like Westerners, modern factory equipment was introduced and the old wood burning kiln techniques were replaced by coal-burning kilns. A dramatic expansion of ceramic production resulted. Later, Japanese students of Dr. Wagener went to Germany to continue to learn new methods.

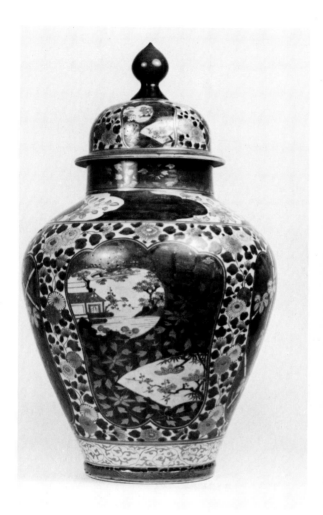

Imari covered jar with paneled decoration, 18th century, Henry Woods Wilson, London.

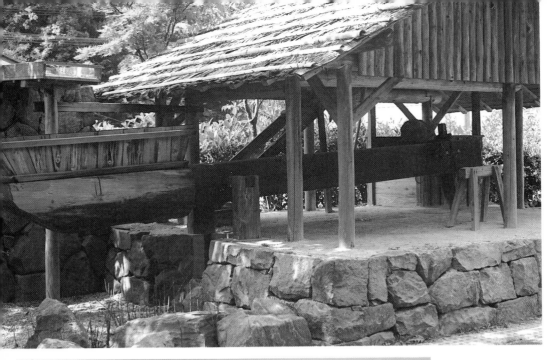

Water-powered crusher of porcelain stone used throughout the Arita area before being replaced in the late 19th century by a stamper-style crusher, and eventually by electrically-powered crushers.

Four molds for porcelain dishes on display at the Arita Folklore Museum.

Mold of coarse clay upon which porcelain was formed. When baked, porcelain shrinks about 15%; from display at Kyushu Ceramic Museum, Arita.

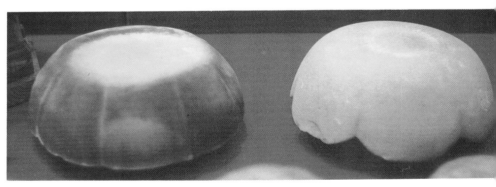

Model at the Arita Folklore Museum of a step-type kiln typically found in the Arita area.

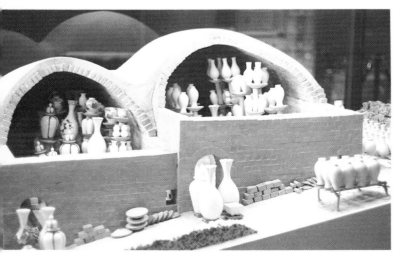

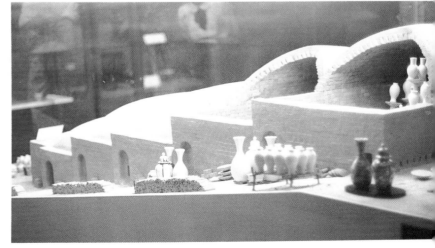

Shobun Murashima, expert potter at the Fukagawa Porcelain Manufacturing Company in Arita.

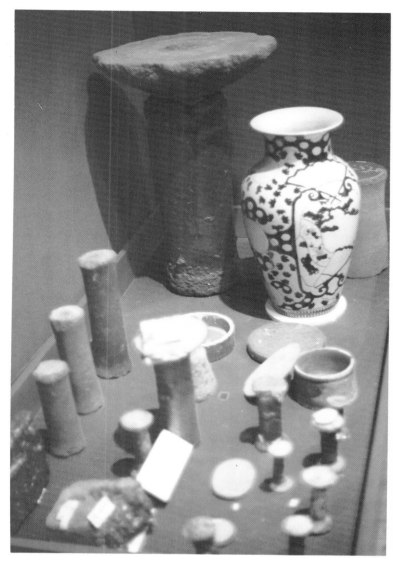

Kiln stacking supports on display at the Arita Folklore Museum.

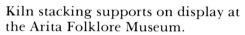

The new Tani kiln at Arita built in traditional step-syle and using pine fuel.

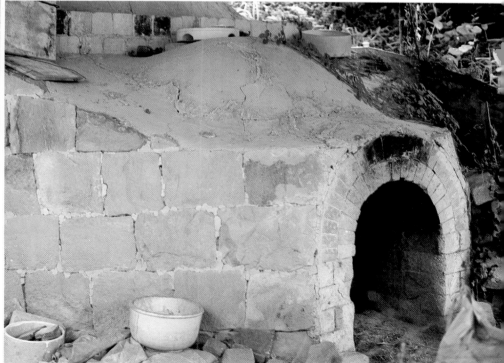

Exhibitions

The Japanese arts had an immediate and profound influence on European art circles after 1854. The sudden release of paintings, lacquerware, textiles and ceramics into the West on a popular level caused a sensation for all things Oriental. Paramount in transmitting this Japanese influence were the European International Exhibitions held in London in 1862, Paris in 1867, Vienna in 1873, and Philadelphia in 1876.

Japanese porcelain manufacturers who exhibited at the Vienna World Exhibition of 1873 found that Europeans were far more interested in the native Japanese wares than in imitation European wares. Therefore, after some attempts at European copies, the trend was toward preserving the genuine character of Japanese art. By the 1876 Centennial Exhibition in Philadelphia, most all wares exhibited were based in Japanese traditions. While Japanese manufacturers became introduced to a great variety of raw materials at these Western exhibitions which they did not utilize, still they were inspired to create some new articles of artistic value.

The Preface to the "Official Catalog of the Japanese Section" of the International Exhibition of 1876 in Philadelphia officially explains the condition of Japanese participation at these events and is quoted directly:

> Never until the year 1873, had Japan participated to any great extent in the various European International Exhibitions. Up to that time she had been merely represented by some of the provincial governments, acting independently of the central Government. However, the Government determined to be worthily represented at the Vienna International Exhibition of 1873, and notwithstanding the numerous difficulties in the way, measures were taken to exhibit a very complete collection of the produce and manufactures of the country. The Commission was not appointed until June, 1872, owing to which fact there was but little time allowed for preparations; and further, the Japanese manufacturers being as yet ignorant of the beneficial results to be obtained, were unwilling to send their goods to a place so far away as Vienna. Consequently the Government was obliged to send officials into the various provinces with orders to buy and to collect such goods as might be suitable for exhibition.

In 1876, the United States staged a celebration of its 100th anniversary of independence (its Centennial celebration) by mounting an International Exhibition in Philadelphia. This was an important event for the introduction of many technical advances by many nations of the world, and Japan participated with an important display. The Preface to the "Official Catalog", quoted above, goes on to explain the conditions of the Japanese involvement as follows:

> With regards to the Philadelphia Centennial Exhibition the case was entirely different. As early as June, 1873, the Government received official intimation that an exhibition would take place at Philadelphia in 1876, and in June, 1874, it was definitely decided that Japan should participate in the said Exhibition. This was officially notified to the American Government by the Japanese Minister in Washington in Nov., 1874, and in the last month of the same year the preparations were actively entered upon. These were entrusted chiefly to those persons who, as

Vase with iris and kingfisher decorated with blue, brown and green on a yellow ground. Marked "Made in Japan by Kozan," Kozan's work was exhibited at the Philadelphia Centennial Exhibition. 10⅞" high, British Museum, London.

members of the Commission of 1873, had obtained experience in the matter of exhibitions at Vienna. The office was organized in January, 1875, and established at Tokio, in a quarter of the town most conveniently situated for the despatch of goods either by rail or by water. It was decided to constitute the Imperial Commission as a department of that division of the ministry of the Interior which is especially charged with the promotion of Industry, Commerce, and Agriculture, differing in this respect from the Vienna Commission, which was a separate department, receiving its instructions direct from supreme authority.

His Excellency Okubo, Minister of the Interior, was appointed President of the Commission in April, 1875, General Saigo receiving his nomination as Vice-President one month later.

The provincial authorities were instructed to do their utmost to induce the leading manufacturers to participate in the Exhibition, and to assist them in their preparations for the same, both with money and advice. Those of the Commissioners who had an opportunity of acquiring experience in exhibition matters at Vienna, were now able to assist the manufacturers, both in the preparation of the necessary designs and in the selection of the goods.

Moreover, the rewards the successes and good results obtained at Vienna, had the effect of encouraging the private people to participate very largely in this Exhibition.

The value of the goods sent by them to Philadelphia is estimated at $200,000. The Government has spent about $30,000 in forming a government collection, and another sum of $70,000 in making advances to various manufacturers so as to assist them in the production of such pieces of workmanship as would do credit to Japanese Art and Industry; in addition to this, a sum of $300,000 has been appropriated for general expenses, including the cost of transport and freight.

The Government has determined not only to pay the cost of transport of all the goods to and from Philadelphia, but even to charge itself with the traveling expenses of all such exhibitors as might wish to accompany their goods. Aided in this manner by the liberality of its government, and the exertions of private people, Japan will doubtless make a creditable show of its industrial products at Philadelphia, and there is much reason for hoping that those who visited the Vienna Exhibition will be able to notice the progress effected in the short space of three years. Any opinion to this effect will be highly appreciated by both the Government and the Commission; but at the same time the latter will gladly lend an ear to any competent criticism, and will be grateful to those who will consent to assist them with their advice, and in this manner aid the Japanese nation in making a few more steps forward in the path of improvement and progress.

It is significant for Japanese porcelain discussions to note that Dr. Gottfried Wagener, who had been advising the ceramics industries in Japan to develop Western methods, was a member of the Imperial Japanese Commission to this event and is listed in the "Official Catalog" as "Foreign Advisor to the Board of Agriculture, Industry and Commerce."

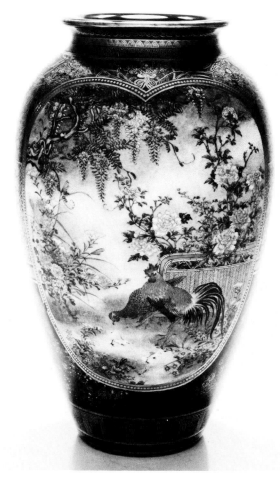

Satsuma vase with court ladies, cockerel, hen and chicks, impressed mark and seal of Kinkozan, mid-19th century. Kinkozan's work was exhibited at the Philadelphia Centennial Exhibition. 10" high, Flying Cranes Antiques, New York.

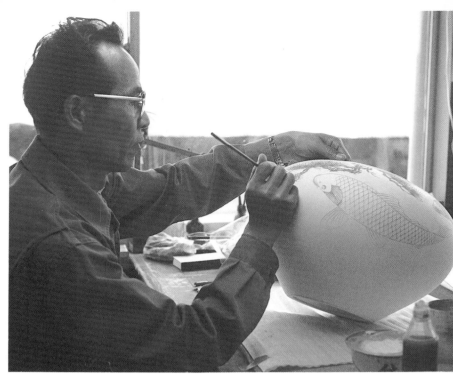

Decorating enamels and brushes on display at the Arita Folklore Museum.

Noboue Yamaguchi, expert painting decorator at the Fukagawa Porcelain Manufacturing Company in Arita.

Michi Shinohara, expert dani drawing specialist at the Fukagawa Porcelain Manufacturing Company in Arita.

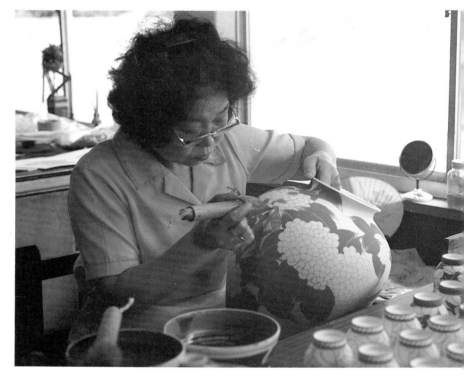

Glazed and partially decorated molded dishes on display at the Kyushu Ceramic Museum, Arita.

The list of exhibitors for classes 206-213, Ceramics—Pottery and Porcelain, includes:

—*for class 210-212, Stoneware, Faience, etc.:*
Kashiu Sampei, Iganomura, Prov. of Awaji
Nakashima Riyokei, Kagoshima, Prov. of Satsuma
Suzuki Yasubeye, Yokohama

—*for class 213 Porcelain:*
Cha-ki-shosha (tea set manufactory), Kiyoto
Fukihara Shoroku, Tokio
Hiyo-chi-yen-sha (painted Porcelain manufactory), Tokio
I-ida Jubei, Nagoya, Province of Owari
Kanzan Denshichi, Kiyoto
Kato Gosuk , Tajimimura, Province of Mino
Kinkozan Sobei, Kiyoto
Kiriu-Kocho-Kuwaisha, (First Japanese Manufacturing and Trading
 Co.), Tokio
Koran-sha (Porcelain Manufactory), Arita, Province of Hizen
Murunaka Magohei, Kanazawa, Province of Kaga
Mashimidsu Zoroku, Kiyoto
Minoda Chiojiro, Tokio
Miyagawa Toranosuke [Makuzu Kozan] Ota, near Yokohama
Miro Yogoyemon, Yokkaichi, Province of Ise
Nakayama Magoshichi, Kuwana, Province of Ise
Seifu Yoheye, Kiyoto
Shimidshu Kamishichi, Kiyoto
Shimidshu Rokubeye, Kiyoto
Shimidshu Shichibeye, Kiyoto
Shippo Kawaisna (Cloisonne Enamel Manufactory), Nagoya,
 Province of Owari
Shitomi Sohei, Yokkaichi, Province of Ise
Taizan Yoheye, Kiyoto
Takahashi Dohachi, Kiyoto
Tanzan Seikai, Kiyoto
Tsuji Choyemon, Kiyoto
Yeiraku Zengoro, Kiyoto
Wage Kitei, Kiyoto.

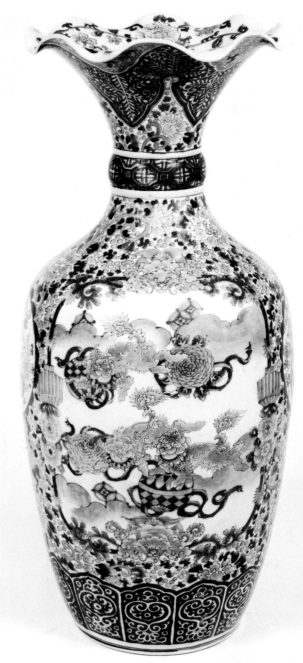

Arita vase with dogs playing with balls in the decoration, late 19th century, 36" high, © 1986, Sotheby's, Inc.

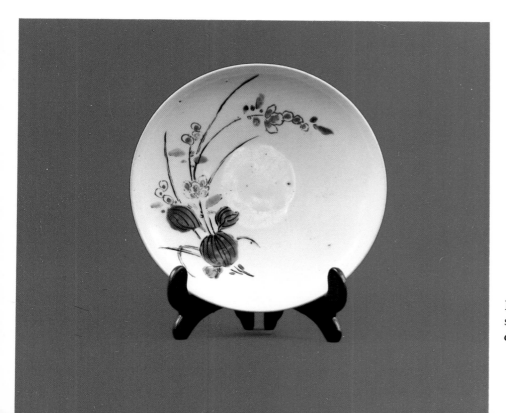

Imari dish decorated in Kakiemon style, 6" diameter, Gibbons collection.

31

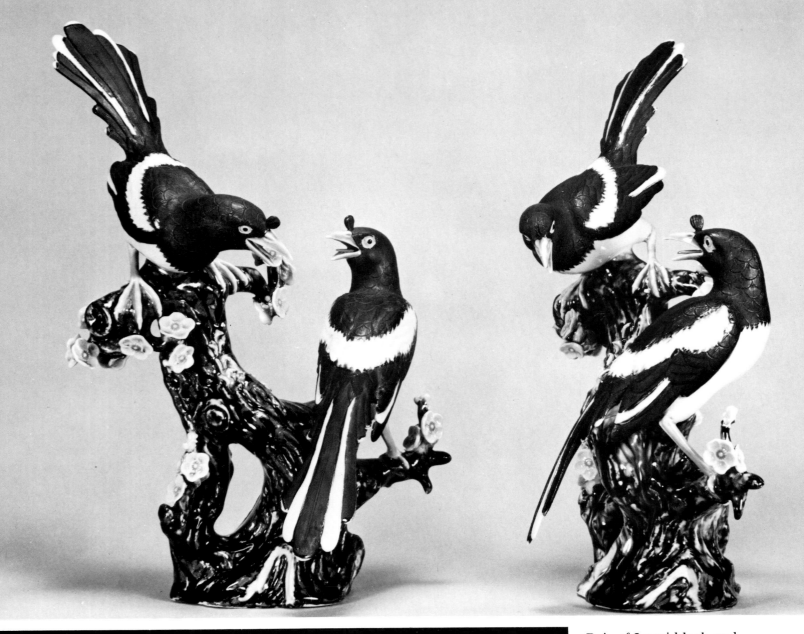

Pair of Imari black and white magpies on prune tree trunks, 13'' high, Johnstone-Fong, Philadelphia.

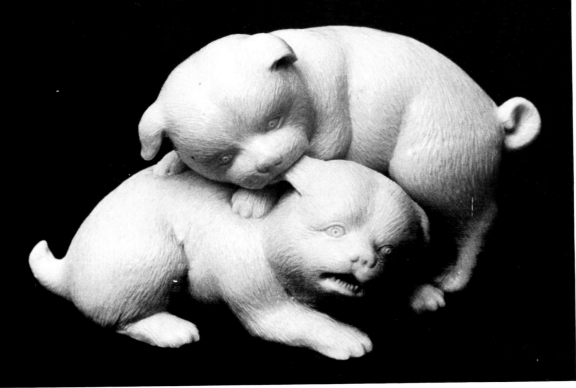

Hirado figures of puppies, 19th century, 3⅞'' high, 7½'' long, Johnstone-Fong, Philadelphia.

Inspection of the floorplan of the Japanese section in Philadelphia's Centennial Hall (still standing and used for public functions) shows display areas for the following groups of ceramics:

A Historical Collection of Pottery and Porcelain
Arita Porcelain
Tokio Porcelain
Satsuma Faience
and other porcelains

Satsuma Ware
Kutani Porcelain
Seto Porcelain

Western response to the Exhibition at Philadelphia was immediate and highly respectful. Books were published with illustrated critiques of the displays to extend the experience beyond those who could visit the display buildings. One such book documented the Japanese porcelain exhibit as follows:

The exhibit made by the Empire of Japan deserves special mention, not only for its great variety, beauty and cost but also for the evidence it furnished of the skill and patience of the Japanese workman. The first participation by this nation in an International Exhibition was at Vienna, and the result was so satisfactory, in every sense of the word, that when notified by the United States Government, in 1873, of the proposed exhibition at Philadelphia, the invitation was at once accepted, and an able and experienced commission was appointed to superintend the selection and the arrangement of the articles selected. The value of the goods sent was estimated at over a quarter of a million dollars, and the Japanese Government appropriated over three hundred thousand dollars, which covered the traveling and other expenses of even private exhibitors. The result of this liberality was that, financially, the Japanese made a great success, disposing of the greater part of their wares at very fair prices, and opening a large and growing trade with the United States, three Japanese firms having already established themselves satisfactorily in the city of New York. The exhibits comprised bronzes, porcelain, enamel ware, ancient copper utensils, embroidered lace, silk fabrics, gold and silver ware, etc., etc. In ceramics could be found flower-vases, tea-jars, coffee-sets, censers, bottles, plates, braziers, water-jugs, etc., being representations of the famous manufactories of Tokio-Satsuma and Kutani.

This display of porcelain may be considered the finest and most complete ever before brought together, and to the amateur and connoisseur in old china, it was the most attractive part of the entire exhibition. The finest of these works came from the manufactory of Arita. The Satsuma ware is large and costly, a pair of vases being valued at four thousand dollars. The two vases presented to the Pennsylvania Museum and School of Industrial Arts are specially beautiful; they are nearly two feet high, formed like jars with covers, on which appear the figures of tigresses and their young. Some of these vases were made in the shape of shells, and although but a foot in height, were valued at five hundred dollars, and readily disposed of at that price [C.B. Norton, ed., *Treasures of Art...* "Japan", plate 31.]

Another source tried to instruct its readers beyond the experience of seeing the displays by comparing the virtues of Eastern art as opposed to Western in passionate terms:

Vase in blue and white marked by Makuzu Kozan, circa 1900, 11¼" high, © 1986, Sotheby's, Inc.

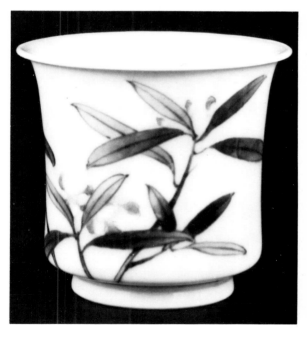

Kakiemon dish with painted floral decoration, 5⅞" diameter, early 18th century, Gibbons collection.

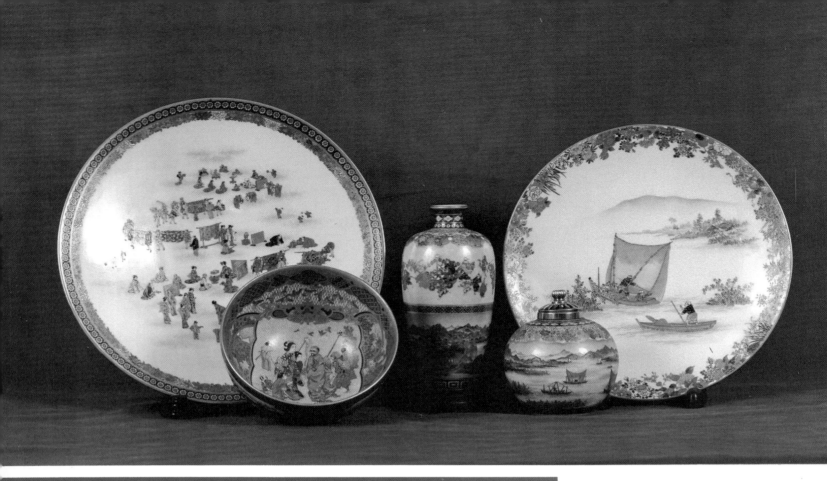

Group of Kyoto Satsuma plates and
vessels, each marked Yabu Meizan,
late 19th century, *left,* plate, 8¼"
diameter; bowl, 4¼" diameter; vase,
4¾" high; jar with brass lid, 2½"
high; plate, 7¼" diameter, Flying
Cranes Antiques, New York.

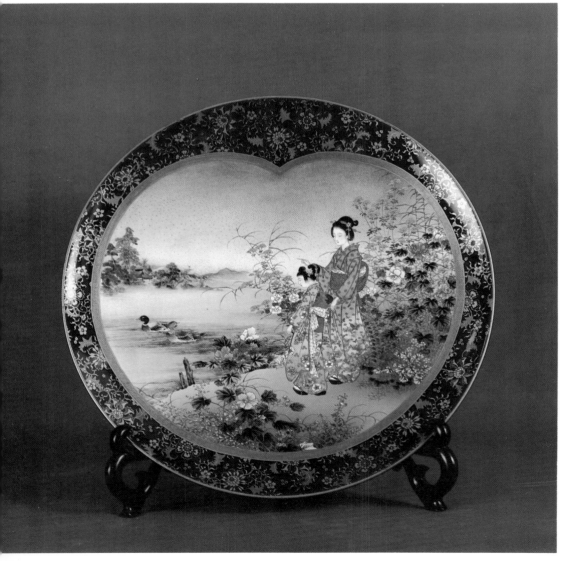

Kyoto Satsuma plate by Kinkozan,
late 19th century, 15" diameter,
Flying Cranes Antiques, New York.

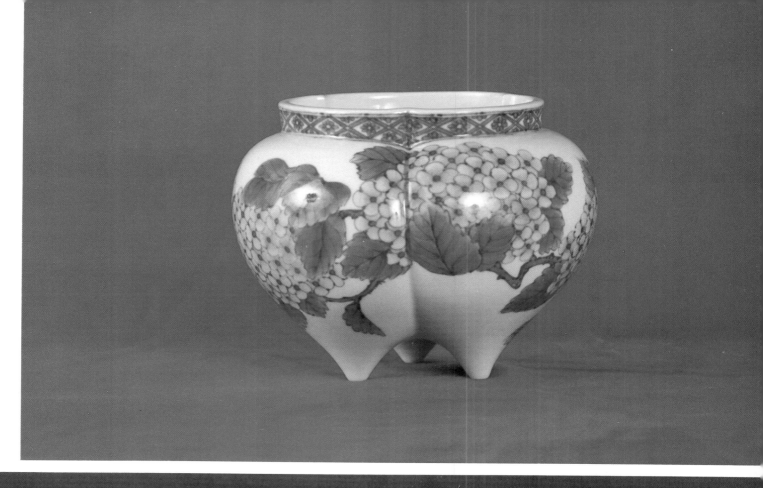

Three Kyoto Satsuma vessels, late 19th century, *left*, cup and saucer signed by Kinkozan, cup 1¾" high, saucer 4¼" diameter; *center*, vase signed by Kinkozan, 3⅝" high; *right*, vase signed Yabu Meizan, 3" high, Flying Cranes Antiques, New York.

Incense burner lacking a lid with hydrangea decoration by Miyagawa Kozan, circa 1900, 4½" high, 5¾" diameter, Private collection.

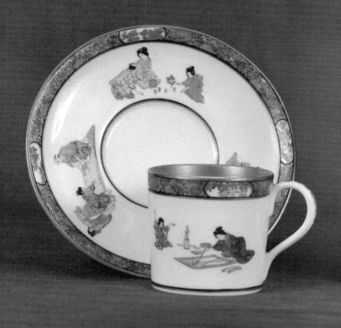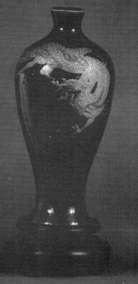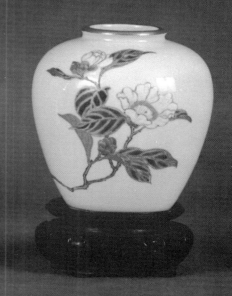

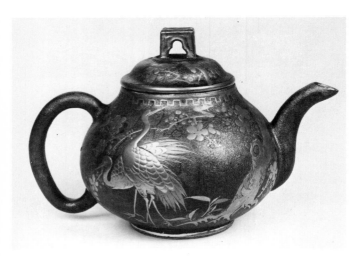

Teapot and cover glazed black to imitate iron and inlaid with gold storks and blossoming trees. Made by Kanzan of Kyoto, c. 1860-1870. Kanzan's work was exhibited at the Philadelphia Centennial Exhibition. 5¾" high, Victoria and Albert Museum, London.

It is easily within the knowledge of the present generation when the average conception of Japan, even among people, was that of a half-barbarous nation, not without certain distinct conditions of prosperity, indeed, but still vitally inferior to Western races. The association of Art with Japan and China involved such monstrous and grotesque images as served principally to suggest use in a collection of ethnic curiosities, whose sole object should be the mere study of national characteristics. The recognition of the fact that Japan and China, particularly the former, possess schools of Art distinct and noteworthy in themselves, is quite recent in Europe and America. Lovers of the beautiful are now quite ready to indulge in enthusiasm as ardent over the products of hand and imagination that so brilliantly characterize these peoples as once they could find expression solely for ignorant contempt. There is hardly any theme in which average criticism indulges in so much mere conventional cant and rubbish as in judgments of Art. . .

. . .In brief this nation conceives Art as best fulfilling its function when it affects the imagination by a limitless suggestiveness, rather than when pleasing the senses by superior skill in imitation or illusion. As a corollary of this, it may be noticed that the forms in Japanese art, however grotesque or unnatural, are marked by amazing vigor and vitality. This is one secret of the attainments of this people in purely decorative art. Every line and tint has a direct and energetic meaning.

It is in the use of color that the aesthetic temperament of a nation is most strongly manifested. In dealing with this element, the artist has only to consult its relations to his purpose, how best to oppose, balance, graduate, heighten, or tone its qualities, so as to produce the effect. It is, in short, the most absolute and free factor in artwork. Among the Orientals there seems to be a simple delight in color, for its own sake, which rises to a passionate satisfaction. In Japan, especially, it rises to the dignity of a distinct, independent faculty, sometimes sensuously strong and deep, sometimes extremely delicate and varied, then again reaching an absolute splendor. They appear to have solved the problem of color in a way which the European has never dared to attempt. Their combinations, balancing of masses, fineness of gradation, variety, intensity, boldness, command over chemical secrets, and fertility of device, are such as to astonish the unaccustomed eye. This is particularly noticeable in the painting of their porcelain, in which every resource of color is exhausted, and in a way never to shock the artistic sense—when it studies the harmony of effects, even when based on the most strong and vivid tints. However the Japanese extravagance of design may be open to objection, their richness and balance of color are felt to be beyond criticism. No faint intermediate lines, but got direct, by some strange alchemy, from the very reality of Nature, their colors have a brilliant sheen throughout; and their humming-birds and birds-of-paradise fairly sparkle in the sunlight; and the flowers are so clear and vivid that they seem fairly redolent of perfume. This is equally the case, whether it be in gold or silver enameling on bronze, lacquerwork, painted screens, or porcelain. Color is often, indeed, made to perform the office of perspective, so that it suggests

the foam and movement of water, misty landscape, far-away peaks. Even wall-screens are decorated on this principle, with suggestions of romance and myth, in which the whole eloquence of delineation is found in the handling of color, and the meaning growing out of it.

A third characteristic in both Japanese and Chinese art is the remarkable knowledge shown of the capacity and composition of material. The effects of color, as modified by the process of firing, as, for example, in porcelain, are among the most elusive mysteries of decorative art. These far-away Orientals have absolutely mastered the secret. So in the composition of a dark, rich bronze, on which moulded relief has the finer effects of light and shade, and great beauty of enameling in gold and silver on bronze, particularly in the process known as *cloisonne*, till recently never successfully imitated in Europe, with all its boasts of chemical and mechanical skill. The clearest insight into means and effects, within the sphere of his work, is a notable characteristic of the Japanese artcraftsman.

Having said so much about the general features of Art in Japan, let us turn the attention of the reader to the illustrations of the exhibits at the late Exposition. The Japanese section was rich in the extreme in their peculiar art-products, and no department of the great fair attracted such throngs of admirers. As great a variety of forms of beautiful and careful workmanship as there was, these can be referred to as a few representative examples, that give a sufficiently general idea of the scope of Japanese mind in this direction. Our artist has grouped some characteristic forms, that illustrate this very happily...

The objects in the foreground show us a piece of porcelain, of straw-colored diaper-work, on an azure ground, delicately rich in color; and two more bronzes, an oblong basin, and a graceful basket or flower-receptacle. As is general in all the bronze and cabinet work of Japan, which with porcelain are the methods of expression by which we principally know the art of Eastern Asia, the supreme excellence will be conceded to the workmanship rather than to the conception, in representing the lower and inanimate forms of Nature, rather than the passions and aspirations of man, for the Oriental ideal differs radically from that of the Occident. This is illustrated in the vase. In the feeling for graceful form and curve, so striking in Japanese art, in all matters aside from the human figure, the objects represented were noticeable even among the great variety of similar works at the Exhibition.

In another example, the porcelain vase, six feet in height, has a grayish-white body-hue, painted so richly in colors and gold as to fascinate one with an eye for effects in color. The side ornaments are grotesque marine monsters, and on the body are delineated various graceful plants." [*Gems of the Centennial Exhibition*, p. 78-83.]

Such were the terms used to describe these Japanese porcelains to Western readers.

Today, a less aesthetic but more historical view of this porcelain is attempted in most art history circles.

The group of Japanese porcelain from the Philadelphia Centennial was bought by Sir A. W. Franks of London for the Victoria and Albert Museum. Besides porcelain, there were displays of lacquer, metals,

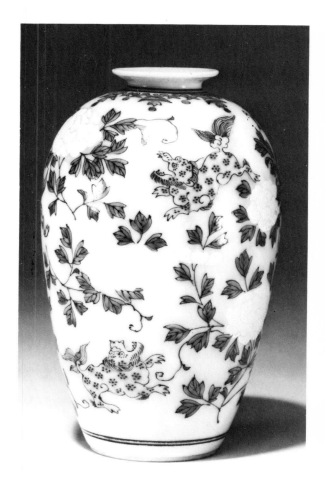

Vase painted in enamels with foo-lions and peonies, signed Seifu, circa 1900, Seifu's work was exhibited at the Philadelphia Centennial Exhibition. 5" high, © 1986 Sotheby's, Inc.

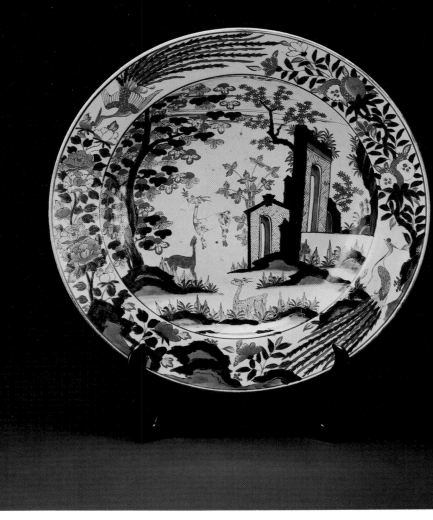

Imari plate, 18th century, 12"
diameter, Charlotte Horstmann and
Gerald Godfrey, Hong Kong.

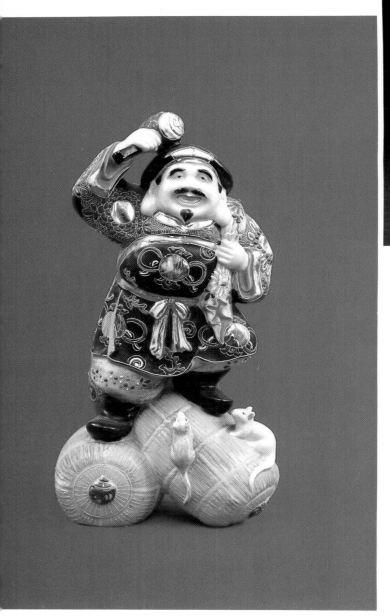

Kyoto Satsuma Daikoku figure with
rice sacs and two mice, late 19th
century, 10" high, Gibbons Mrs.
collection.

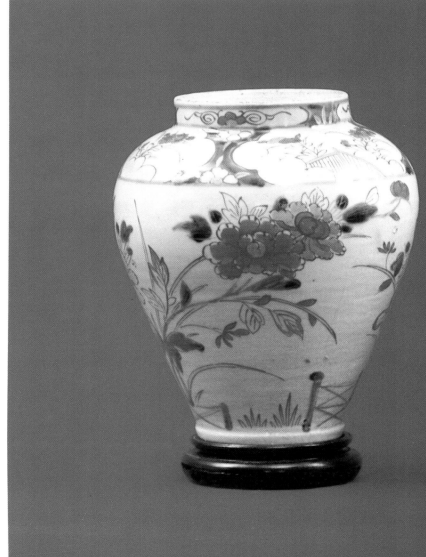

Two Imari vases, 18th century,
Gibbons collection.

One of a set of five Satsuma
condiment dishes in the shape of a
crane, 19th century, Philip Van
Brunt collection.

Imari tea caddy, early 19th century,
Lyman Allyn Museum, New
London.

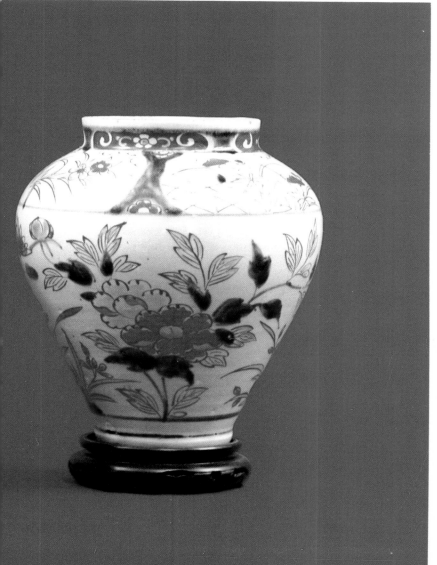

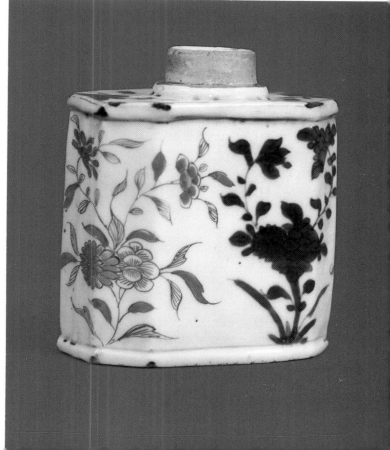

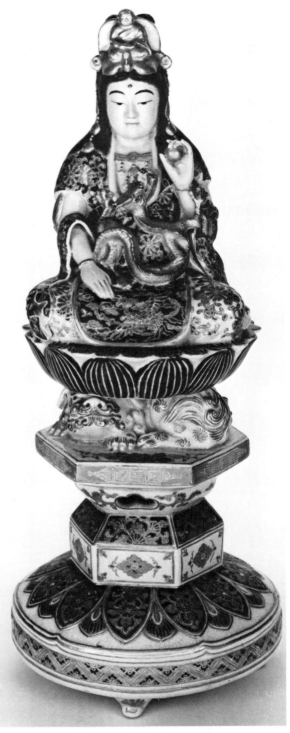

Satsuma figure seated in lotus
position above a lion-dog on a
pedestal, late 19th century, 16" high,
Flying Cranes Antiques, New York.

Kyoto Satsuma figure of a man
seated on a rush mat with dog, late
19th century, 4" high, 5" long.
Flying Cranes Antiques, New York.

textiles, graphic arts, and scientific and philosophical instruments.

The Japanese exhibited again in the West at the Paris Exposition in 1878, [Le Japan, Exposition catalog, Paris, 1878, parts I and II.] at the Chicago World's Fair in 1893, and another Paris Exhibition in 1900.

All over Japan, in Kyoto, Tokyo, Satsuma, Hizen and Kaga provinces, the expansion of ceramics as an art form was immediate. Potters, who were becoming recognized as individual craftsmen experimented with new ideas and continued to perfect the traditional skills all at the same time. Therefore, a large quantity of exceptionally fine ceramic ware was made by many craftsmen who now tended to sign their names to their work.

Jenyns succinctly presents an explanation for this relatively sudden emergence of potters marks:

Before the nineteenth century, ...the better factories were directly under the patronage of a feudal chief who did not permit the workmen's names to appear on the wares. Thus, it is not till the 19th century that true potters' marks are common on Japanese porcelain; and much of the older wares have no mark at all. Marks beginning with "Dai Nippon" may be safely regarded as nineteenth century in date. [Jenyns, *Japanese Porcelain.*]

(It may be added, the "Dai Nippon" indicates manufacture after 1891 and for the U.S. market, as explained in the paragraphs below.)

The results of the expanded trade overall produced large quantities of inferior porcelain at the end of the nineteenth and early twentieth centuries, with a few brilliant pieces mixed in. The West saw a mixed lot that has done much to cloud the work of brilliant potters by the more numerous inferior examples. But with time, these pieces are being sorted out and many fine pieces can today be recognized from the masses. As more knowledge of the wares is made available, and more work is done in Japan and the West to identify old and new pieces, the best work will be recognized and appreciated.

In 1893, the U.S. Customs Department required the country of origin to appear on all imports to the USA. Therefore, marks such as

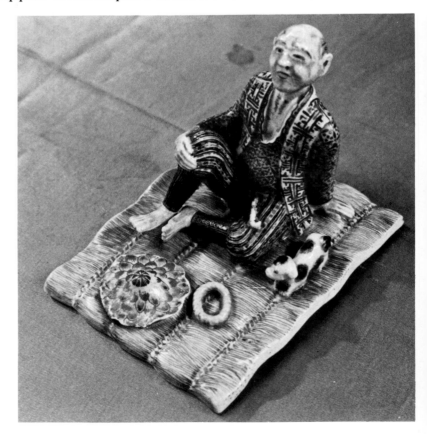

"Japan" or "Nippon" (the Japanese word for their country) are subsequent to this date.

During the First World War, 1914-1918, the production of European porcelains in Europe was halted. During this period, Japanese porcelains with European decorations were exported to the West in large quantities. Also, at this time and extending until about 10 years after this war, undecorated porcelain and Satsuma-style pieces were exported. Self-decorating porcelain became a popular hobby in the West at this time. Between 1918 and 1928, Art Nouveau and Art Deco designs were popular in the West. Their influence can be seen on Japanese products of these years.

In porcelain, trade was continued in the traditional Imari overglaze decorations to a limited extent while individual artists continued to experiment.

The international and political events of the 1940's brought significant change to the Japanese porcelain trade as all Japanese goods fell out of favor with her adversaries. After the war, many concessions were made by some Japanese porcelain manufacturers in order to build up a new trade with the rest of the world. At Nagoya, vast quantities of inexpensive wares were exported to the United States with European style decorations. Some of these exports were marked "Made in Occupied Japan" which became abbreviated to "Occupied Japan" or just "Japan". These were made until the occupation was over in 1952. Thereafter, some of the old porcelain producing companies were again manufacturing quality wares for use in Japan and for export, and many new companies were established.

The variety of fine porcelain from Japan continues to grow in the second half of the twentieth century with new designs and inspired decorations. Today, traditional methods survive in small and specialized family kilns right next to some of the most modern factories. In the large factories, gas-fired kilns are used, while pine splint is still burned in some small kilns. Today, old and new porcelain can be seen as part of the same rich artistic heritage that has existed in Japan for twelve hundred years.

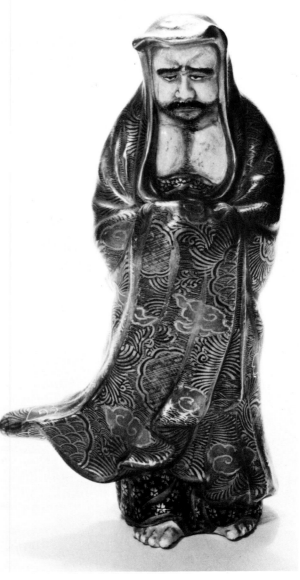

Satsuma figure of Duruma, late 19th century, 9" high, Flying Cranes Antiques, New York.

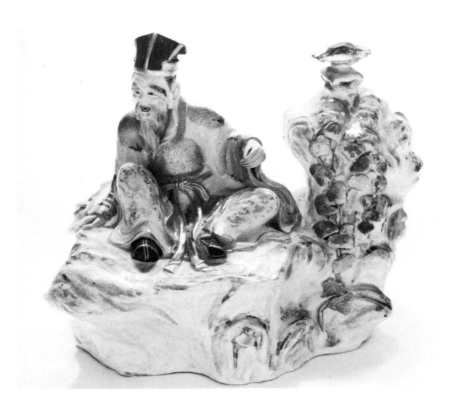

Satsuma figure of a Buddhist priest, 19th century, 9" high. Flying Cranes Antiques, New York.

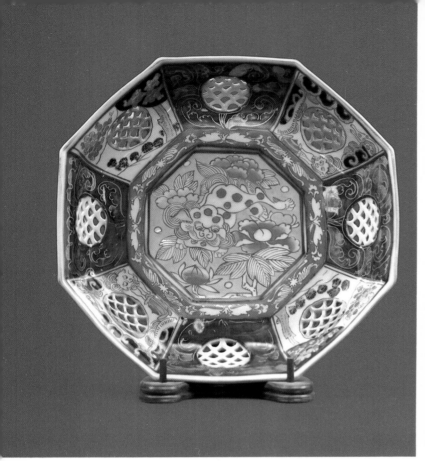

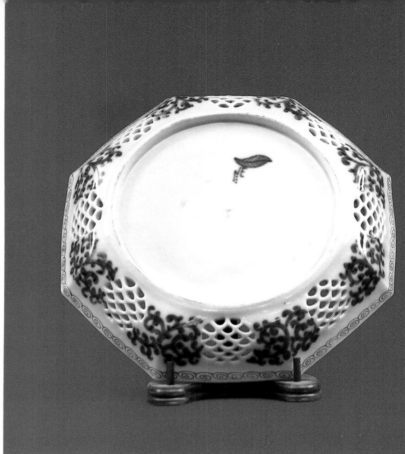

Front and back views of an Imari octagonal dish with pierced rim, 9" diameter, late 18th century, Gibbons collection.

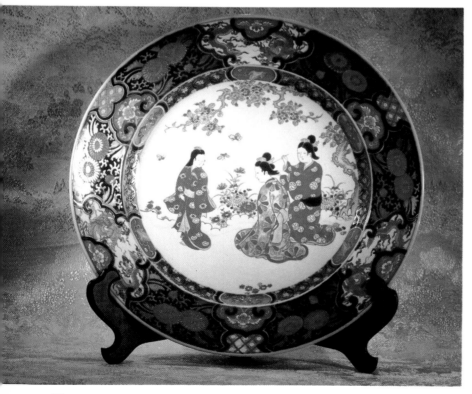

Imari plate with red Fuku mark, 15⅞" diameter, The Oriental Corner.

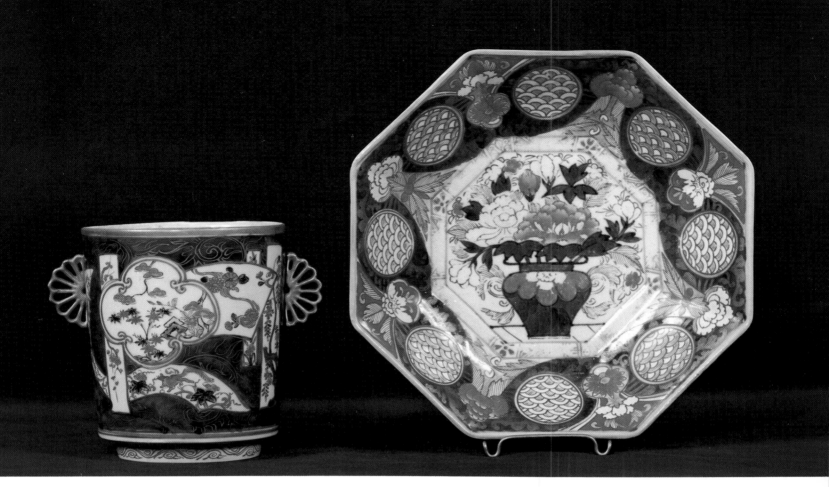

Imari cache pot and octagonal dish with pierced rim, made for the European market, compare with figure 43, Reichel. *Early Japanese Porcelain* which is in a 1779 inventory, 18th century, House of the Black Ship, New London.

Front and back views of an Imari plate, 8¼'' diameter, late 18th century, Gibbons collection.

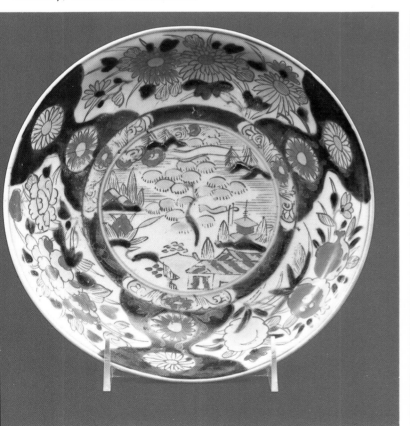

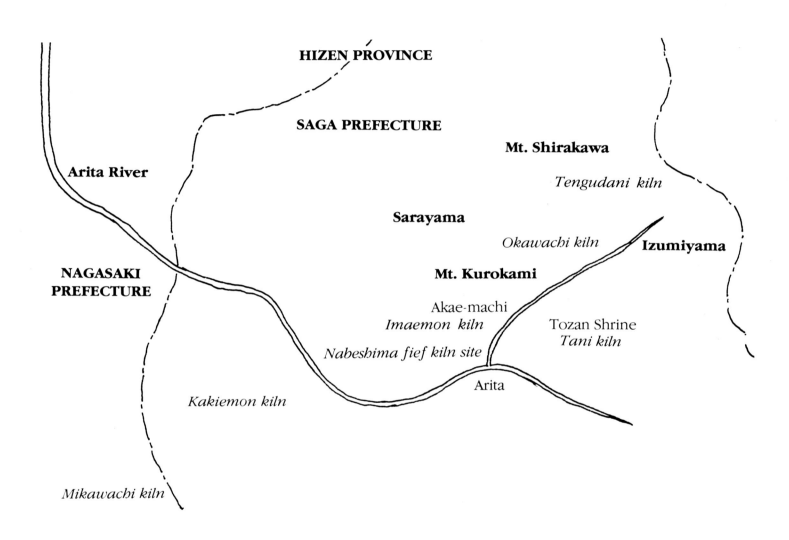

HIZEN PROVINCE

SAGA PREFECTURE

Mt. Shirakawa

Tengudani kiln

Arita River

Sarayama

Okawachi kiln

Izumiyama

NAGASAKI PREFECTURE

Mt. Kurokami

Akae-machi
Imaemon kiln

Tozan Shrine
Tani kiln

Nabeshima fief kiln site

Arita

Kakiemon kiln

Mikawachi kiln

Arita and Imari

Arita is a small town nestled in a valley of high-rising mountains in Saga prefecture, Hizen Province, on Kyushu Island, the westernmost part of Japan. Ceramics have been made here for hundreds of years and since the early seventeenth century, porcelain has been its primary product.

The main ports of Hizen Province are Imari in the north and Nagasaki in the south. Through these ports, boats bringing rice from the main rice-producing regions to the east took with them, in exchange, local products including porcelain, to the other areas of Japan.

The porcelain products from this area, which have become so famous worldwide, have been called by other authors variously "Arita", "Imari", and "Hizen" wares—from their supposed origins. The terms need to be clarified. In this discussion, "Arita" will be used for articles with underglaze blue decoration only. "Imari" will be used for overglaze enamel decoration including red, gold, blue, and other enamel colors. "Hizen" will not be used to define a porcelain decoration style; but only the geographic region of which we speak.

Three Arita export wares from the 17th century in European-inspired shapes, Henry Woods Wilson, London.

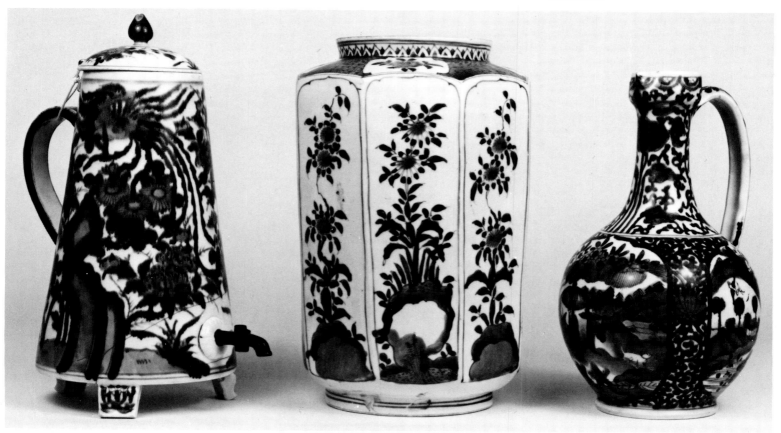

The town of Arita, Saga prefecture,
Kyushu Island.

Arita plate with decoration probably
intended for the Chinese market,
18th century, Gibbons collection.

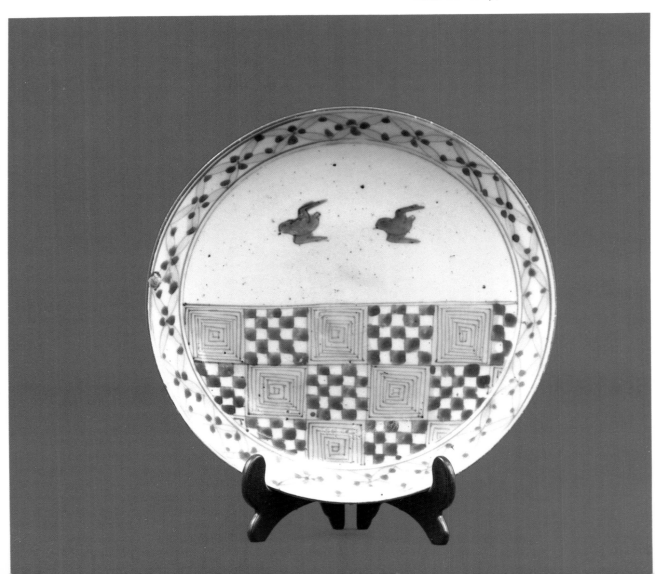

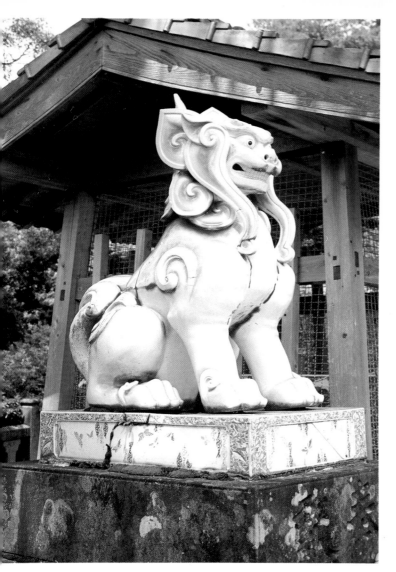

Arita figure of a Chinese dog at the
Tozan shrine at Arita, after 1888.

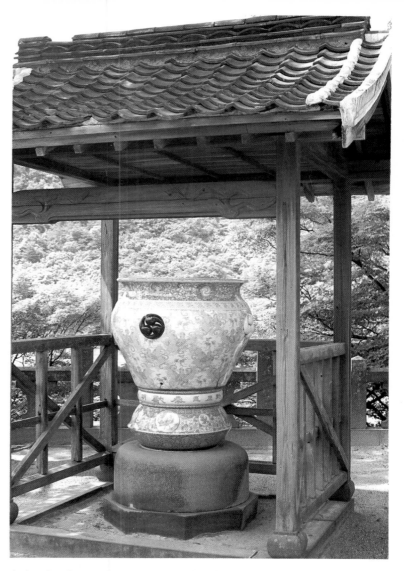

Arita basin at the Tozan shrine in
Arita dedicated to Emperor Ojin,
after 1888.

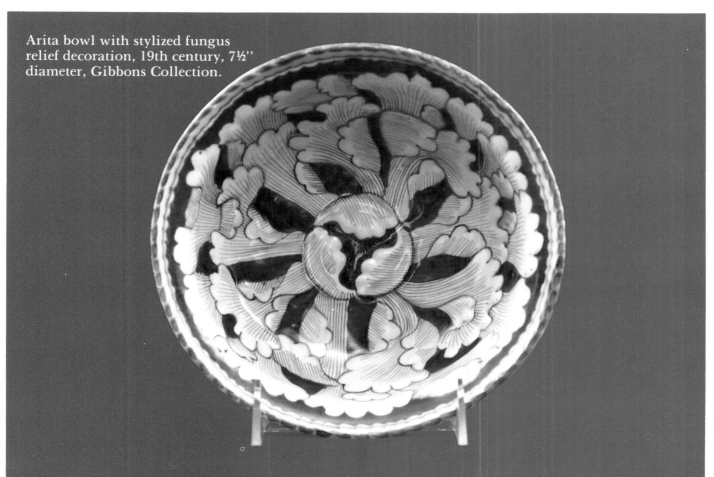

Arita bowl with stylized fungus
relief decoration, 19th century, 7½"
diameter, Gibbons Collection.

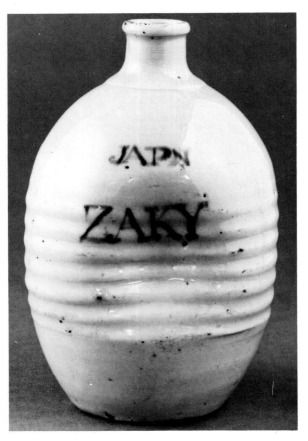

Arita Ware

The seventeenth and eighteenth century Arita wares are currently undergoing close scrutiny by curators, archaeologists and scholars in Japan and the West and these studies have already gained a tremendous body of information toward the classification of the wares by their origins and appearances. [see O.R. Impey, "Some Categories of Early Enamelled Porcelain, *Essays in Honour of Prof....Mikami...*, p. 293; H. Nishida, *Japanese Export Porcelain....*; and others in the Bibliography] This work is essential to continue so that an historical perspective can be gained and accurate identifications can be made.

Excavations of early kiln sites near Arita have dated some of the oldest to the early seventeenth century, at the time of Ri Sampei (see Porcelain History section). There have been eleven kilns identified in Arita which produced porcelain wares of the kind that were exported by the Dutch East India Company between about 1650 and 1730. [see O. Impey, article for Mikami.] Shards of several types of ceramics have come from these sites, including high-fired porcelain with underglaze blue decorations of floral designs.

The Dutch East India Company was well established at Hirado in the early 17th century, and by 1637 at Deshima Island in Nagasaki harbor (see Political History chapter). Their orders for porcelain from Japan offically began in 1653 when the company records at Deshima record 2,200 medicine bottles being exported to a pharmaceutical merchant in Batavia. These records, now in the Hague National Library, report fine-quality porcelain exported regularly from 1660 with the largest quantities between 1663 and 1672. The exports continued until 1757, and then merely small quantities with the personnel of the company trading independently, not as representatives of the company. By the late 17th century, China was able to compete in the porcelain markets against Japan, and many of the Dutch East India Company orders went there for fulfillment.

The Nabeshima lords, in whose feif the towns of Arita, Imari and Nagasaki lay, recognized the potential for increased taxation revenues from a developed porcelain industry whose natural resources and trade avenues were in their realm. Therefore, they encouraged and

Arita bottle marked 'Japn Zaky'. This type was made at the Hasami kiln at Arita for export to Holland where they are common, early 19th century, 6¾" high, British Museum London.

Arita bowl with blue fishnet decoration and Gorota-Shozui mark, circa 1900, 14½" diameter, © 1986 Sotheby's, Inc.

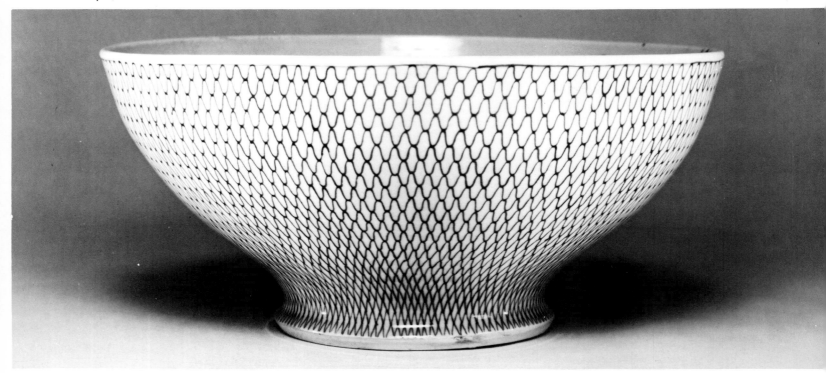

upported this business which they could nearly monopolize by controlling the clay deposits, kiln operations, and trading relations.

At Imari, boats were loaded with porcelain and other trade items for shipment to ports throughout Japan and to Nagasaki for exchange with the Chinese and Dutch merchants there. The one place of export enabled Japanese porcelain to be distributed to China, through Southeast Asia, and into Europe. The water route from China, Nagasaki, and other ports in Southeast Asia, across the Indian Ocean to Cape Town in South Africa, and on to Amsterdam has been called "the Ceramic Road."

By inspecting Japanese porcelain items which have been in European collections since the seventeenth century, and comparing them with shards excavated from the kiln sites in Arita, some knowledge of the porcelain industry and the trading mechanisms of the day can be established. Luckily, also, there are a few wonderfully accurate written records still remaining in Europe. The Burghley collection outside London, Augustus the Strong's collection at Dresden, and the Charlottenberg collection in Berlin are among the most prominent collections of early Japanese porcelain in Europe. Readers are recommended to pursue further study at these places. [the Burghley Catalog, Volker, Reishel's book] Fascinating and rewarding studies are being undertaken in these areas and should be continued for some time until a clearer picture of the porcelain history can be made.

In the late 18th century, demand for porcelain from Arita increased in Japan while it continued to lessen in the export markets. The popularization of porcelain in Japan between the 1760's and 1820's caused significant changes in the manufacturing businesses in Arita. The kilns could not keep up with the demand, so new kilns were established raising the number of private kilns from 150 to 220 during this period. The eleven original enamel decorating studios in Arita (see section on Imari decoration) were also overwhelmed, so in 1770 five new decorating households were added here. The increased demand also took a toll on the quality of the porcelain and its decoration. Large volume brought about compromises in quality, which fell sharply. Still, by the early 19th century, Arita-made oil lamps and common noodle cups were used throughout Japan.

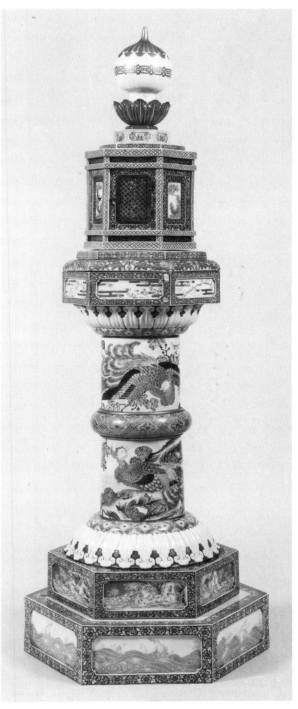

Arita lantern marked by Yamamoto Shuzo and Arita mark, late 19th century, 67" high, © 1986 Sotheby's, Inc.

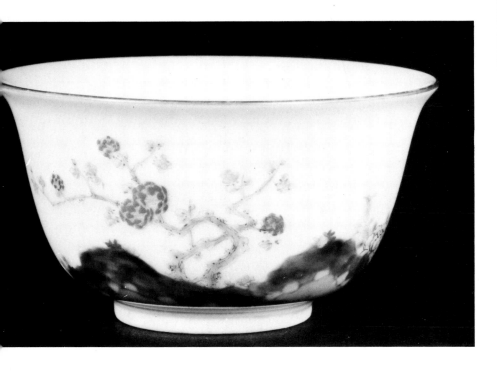

Tea bowl with Fukagawa trade mark, made for export, early 20th century, 3" diameter, British Museum, London.

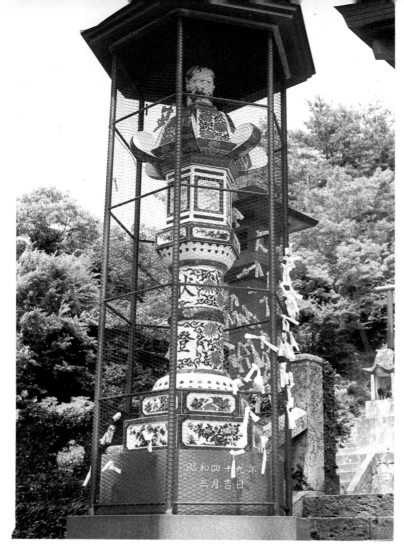

Arita lantern at the Tozan shrine in Arita, after 1888.

Arita plate with map decoration showing Japan and the Asian coast with a mileage chart, mid-19th century, 19" diameter, House of the Black Ship, New London.

Bottle with transfer printed map of Japan, 19th century, 7½" high, House of the Black Ship, New London.

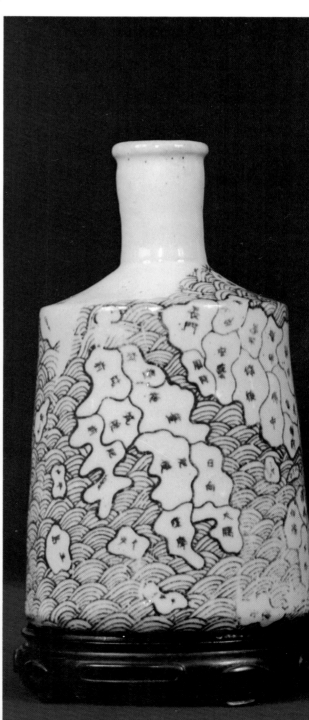

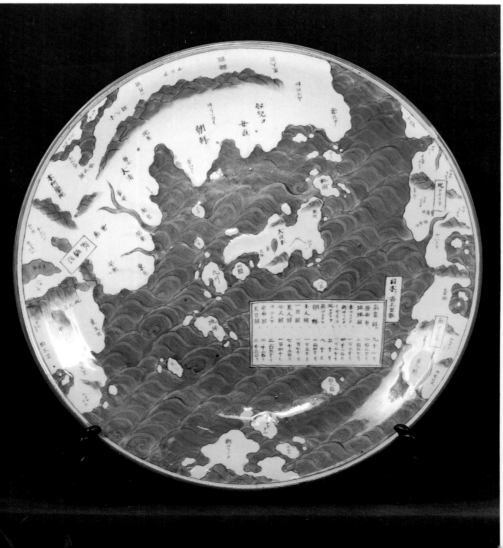

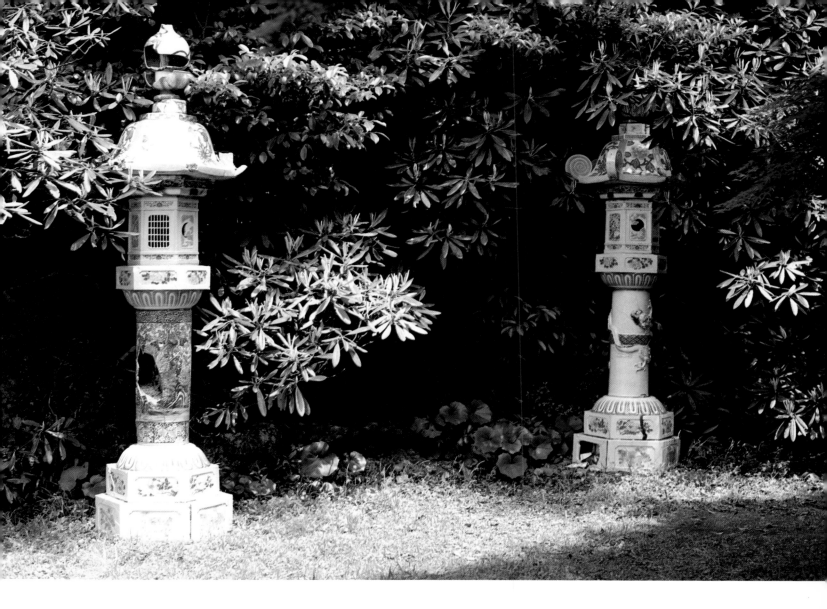

Two Arita lanterns in a private garden in Japan, late 19th century.

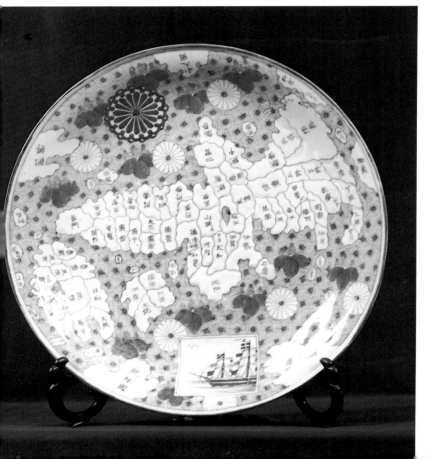

Arita plate with map of Japan decoration, chrysanthemum pattern forms the seas, European ship in rectangular reserve, 1830-1840, 18⅞'' diameter, House of the Black Ship, New London.

51

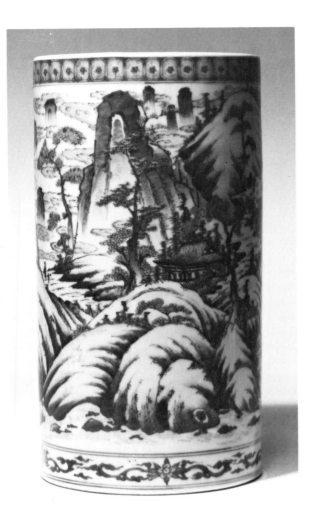

Blue and white brush pot with mountainous landscape, 19th century, 13⅞'' high, © 1986 Sotheby's, Inc.

Arita map plate of Japan with provinces named in Kaisho characters, early 19th century, 12¾'' long, Christies', London.

In 1828, a very serious fire destroyed most of the kilns in the Arita Valley and curtailed all production here. The potters and decorators were helped by the Nabeshima lord, Naomasa, who sent quantities of rice to the stricken neighborhood. Gradually, the porcelain industry was rebuilt here, but many kilns ceased to operate further.

During the period of 1830-1844, rectangular and round plates decorated in underglaze blue and raised relief work were made showing maps of Japan, Southeast Asia, and the World. Shards of these plates have been recovered from the site of the Ohoyama kiln at Arita, and many of them bear date marks to this time.

The political events of the mid-19th century in Japan affected every phase of life because they changed the structure of the government. After 1854, when Commodore Perry secured an agreement for trade with the Japanese officials, businessmen in Japan saw opportunity staring them in the face. The Nabeshima and Satsuma lords were among the leaders advocating wholesale export of goods, including porcelain. Based on their past experience in foreign trade, they assumed a large market existed abroad for their wares. The continuing popularity of porcelain at home encouraged them to work toward expanding the industry.

Between 1848 and 1859, when Western trade was imposed upon Japan, the period was noted in Japan as the time when the "Black Ships" arrived. When the Edo period finally ended in 1868, the new Meiji government pressed for full-scale development of the export business through private enterprise rather than the old clan-sponsored system. In Arita, this meant new family-run businesses could be established. The Saga Fief Merchants' Association was established at Nagasaki as part of a well-organized wholesaling system. Two Arita porcelain merchants, (Tashiro Monzaemon of Honhobira and Hisadome Yojibei of Nakanohara) were granted permission from Nabeshima fief authorities to trade directly with retail establishments in Japan and to conduct business overseas.

In the 1870's, the Shimpo company of decorators in Arita started to export brightly colored wares from Yokohama to the United States and Istanbul where their strong pink tones were admired.

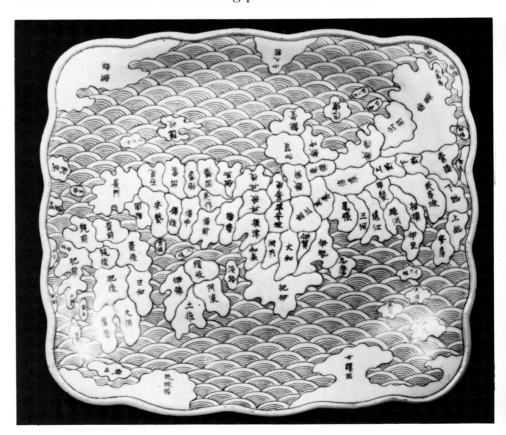

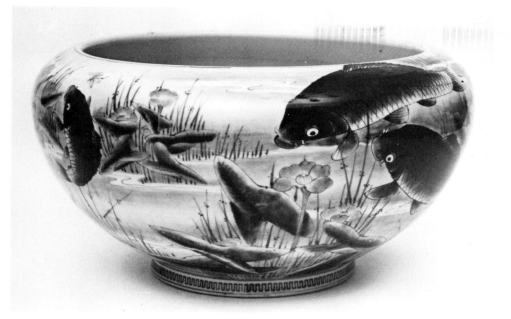

Arita blue and white bowl with fish decoration, early 20th century, 18'' diameter, Flying Cranes Antiques, New York.

Arita double gourd, octagonal bottle, early 19th century, 3½'' high, British Museum, London.

Blue and white jardiniere with landscape and relief decoration, circa 1900, 21'' diameter, © 1986, Sotheby's, London.

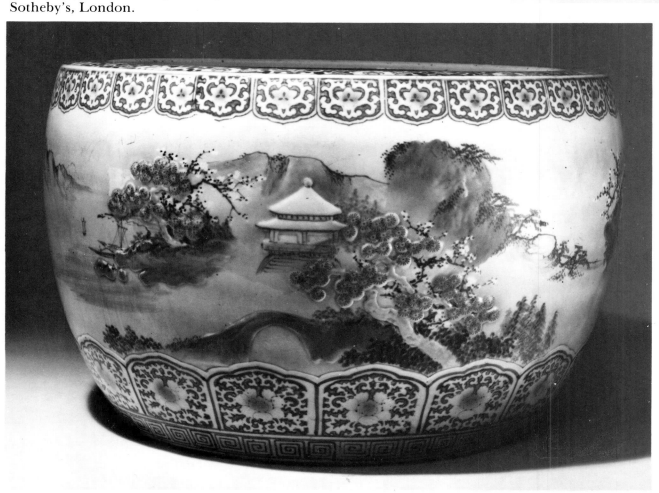

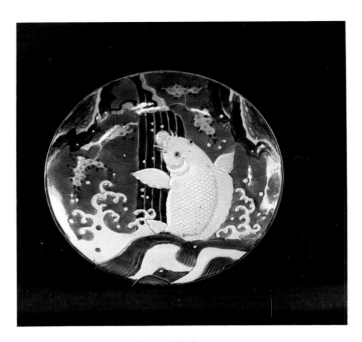

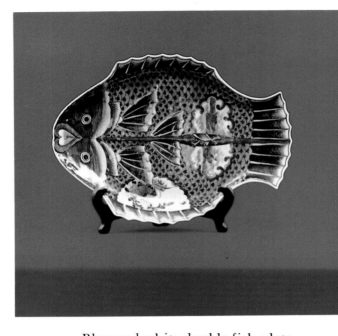

Arita plate with white relief carp leaping waterfalls, 6 character mark on back, 1830-44, 17'' diameter, Norwich Free Academy, Norwich, Connecticut.

Imari fish-shaped dish, 13¼'' long, 19th century, Gibbons collection.

Blue and white double fish plate, 1830-1844, 15½'' long, Gibbons Collection.

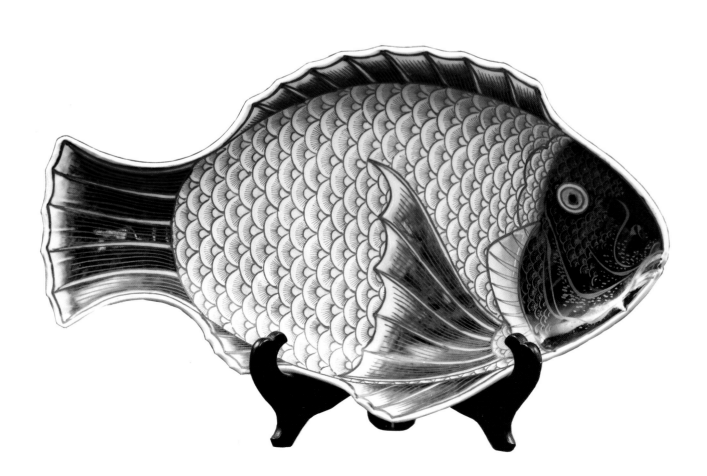

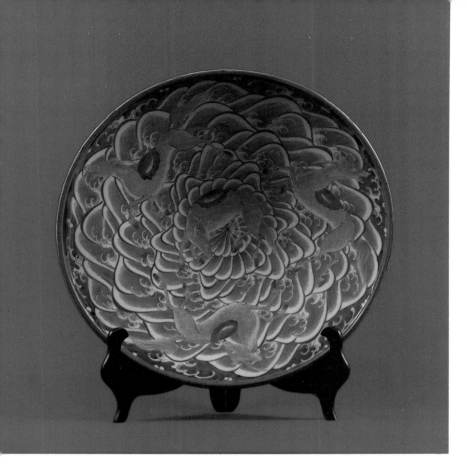

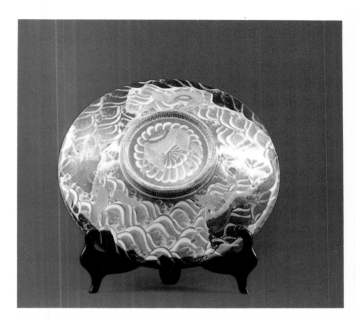

Arita dish with spiral blue
underglaze horse and waves
decoration. The back shows how the
transparent glaze pulled during
firing, and the side view displays
warp, 19th century, 19½" diameter,
Gibbons Collection.

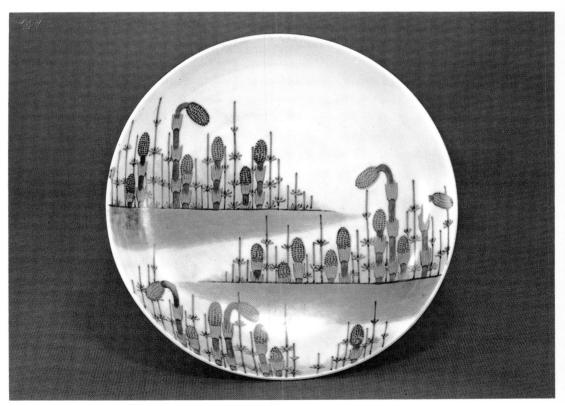

Arita plate with horsetails
decoration, early 19th century.

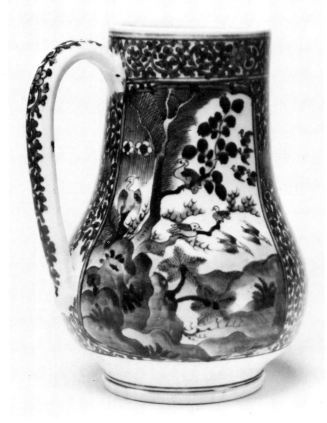

European shaped blue and white
tankard, mid-19th century, 19½"
high, © 1986 Sotheby's, Inc.

Three panels of blue and white
landscape decoration, 18th or 19th
century, 14 1/3" long, 2¾" wide,
Rijksmuseum, Amsterdam.

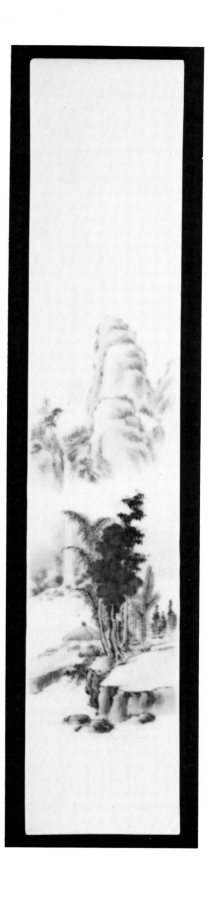

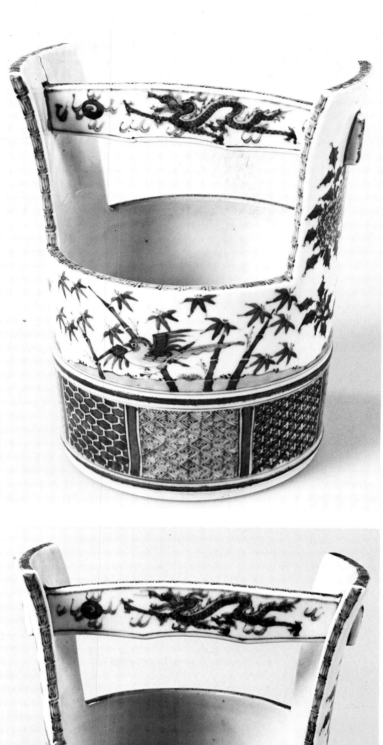

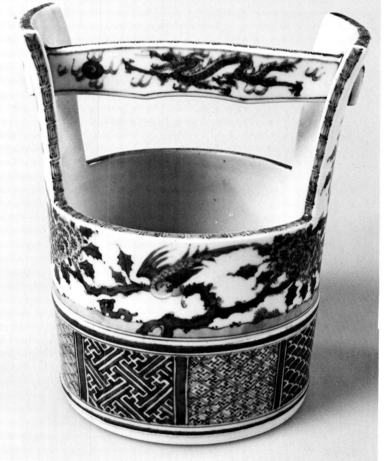

Bucket shaped dish with blue and
white decoration, 18th or 19th
century, 8½'' high, Rijksmuseum,
Amsterdam.

Arita scroll weights, 1½'' long, Gibbons Collection.

Bottle with transfer printed decoration and silver repair. This type was often made in Arita and also was imported from China, early 19th century, 12¾'' high, House of the Black Ship, New London.

Blue and white bowl to wash saki cups, 19th century, 3¼'' high, 5¼'' diameter, Gibbons Collection.

Two blue and white shaped dishes: *left,* bat shape and painting with deer and landscape decoration, 19th century, 7½'' long; *right,* boat shape, 18th century, 6¾'' long. House of the Black Ship, New London.

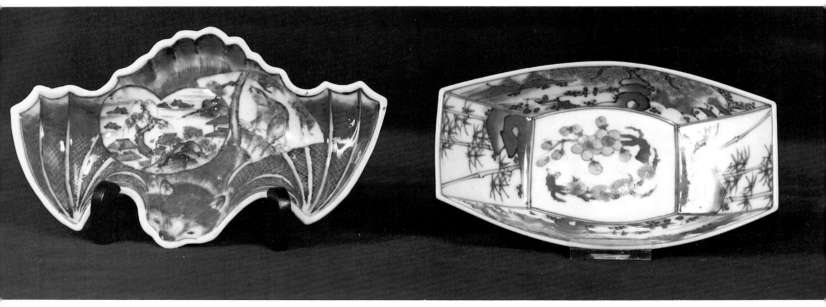

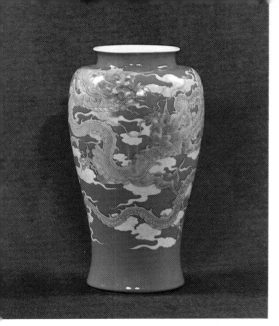

Imari vase with dragon decoration,
late 19th century, 12¼" high,
Norwich Free Academy, Norwich,
Connecticut.

Arita double gourd bottle with horse
decoration, mid-19th century, 9"
high, Lyman Allyn Museum, New
London.

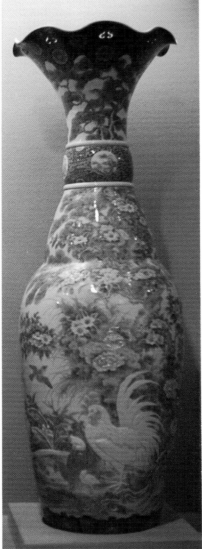

Arita blue and white
vase with some pink
and green and chickens
in relief, late 19th
century, 70" high,
Kyushu Ceramic
Museum, Arita.

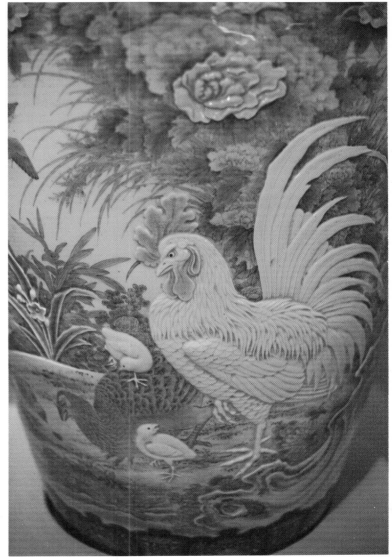

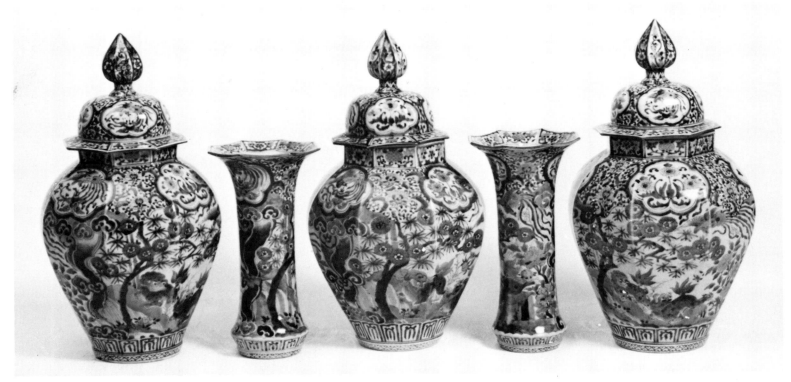

Arita garniture with three octagonal covered jars and two octagonal vases, decorated with lions in a stylized landscape, early 19th century, Henry Woods Wilson, London.

Arita ware decoration

The blue and white designs which comprise Arita ware decoration are derived from Chinese styles of porcelain and painting, lacquer ware designs, and textile patterns. Influences of these diverse art forms evolved through the artists over the years to produce a style that is recognizably Japanese.

Floral patterns, Chinese style landscapes, bird-and-flower designs, human and animal figures, as well as calligraphy marks signifying long life, prosperity or happiness, are found in different combinations in traditional-style decoration.

Blue and white plate with fishing village decoration, mid-19th century, 22" diameter, © 1986 Sotheby's, Inc.

Arita plate with pine, plum and bamboo (3-friends) decoration, 19th century, Rijksmuseum, Amsterdam.

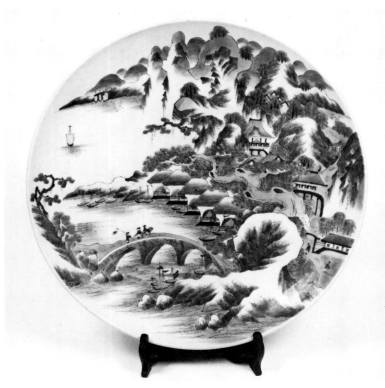

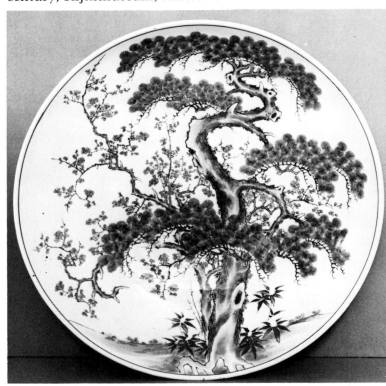

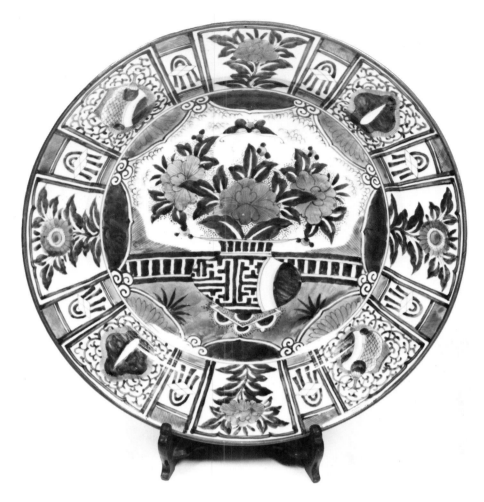

Arita plate with European-inspired
rim panel decoration, early 19th
century, 21½" diameter, © 1986
Sotheby's, Inc.

In 1875, Eizaimon Fukagawa started a porcelain-making company
in Arita known as Koransha (the Company of the Scented Orchard).
While begun as a new family-owned company, it stemmed from a
legacy of ceramic craft.

Since about 1650, the art of making porcelain had been in the
Fukagawa family. The family kiln, Tanigama, may have been started
in the late 17th or early 18th century when Dutch orders for porcelain
came to Arita. Located on a mountainside above Arita, the kiln was
built upward in steps, perhaps extending 100 feet long.

Excavations of the Tanigama site in the 1970's uncovered eight-
eenth and nineteenth century shards and the existence of an earlier
kiln beneath the one excavated. Professor Dr. Tsugio Mikami, who
conducted the excavations, is Japan's foremost authority on Chinese
and early Japanese porcelain. Shards from this excavation are now
deposited at Aoyama University's Hon-Atsugi campus outside
Tokyo. Examples of blue and white decorated wares from the first
firing indicate that overglaze decoration may have been applied at a
different location. Cups, bowls, small vases and plates are represented
in styles for export during the late eighteenth and nineteenth
centuries. Blue transfer-printed decoration and ribbed as well as
smooth bodies are represented in the shards, indicating that experi-
mentation was taking place. The kiln seems to have produced a large
quantity and variety of wares. Examples with pseudo-Chinese
underglaze blue six-character marks are prevalent among the shards
recovered. Publication of the excavations report by Professor Mikami
is anticipated and will be a welcome addition to the scholarship of
this period. Fukagawa family records show that the Western export
trade for Tanigama wares was conducted through the port of
Nagasaki and later at Yokohama.

Blue and white ware shards from the
excavation of Tani kiln at Arita.

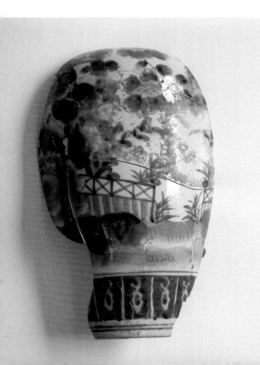

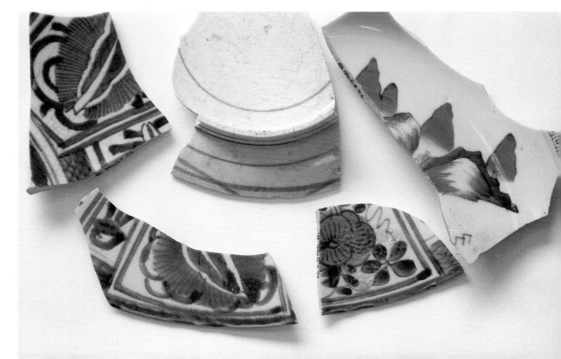

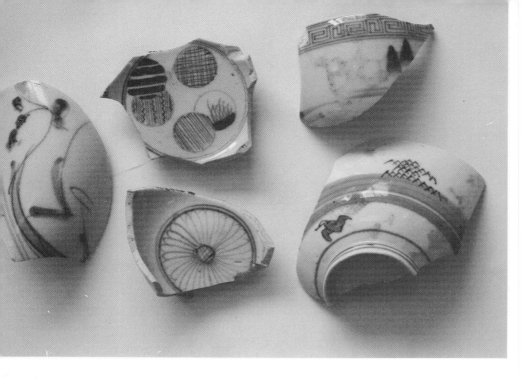

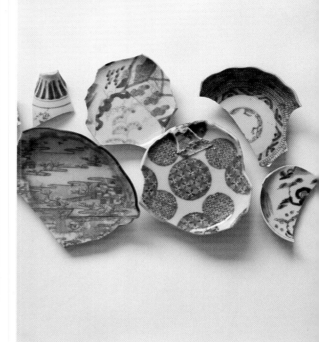

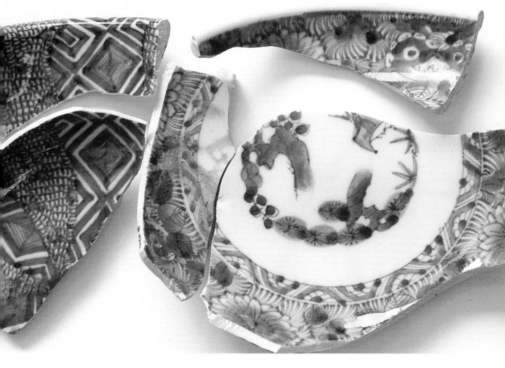

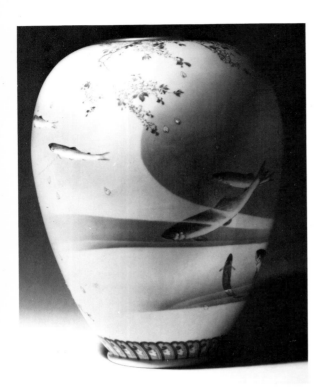

Vase with Fukagawa mark, early 20th century, 13½" high, © 1986, Sotheby's, Inc.

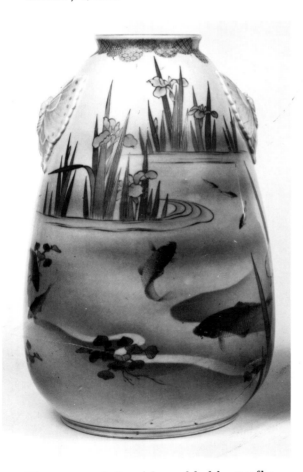

Two vases, *left*, with molded butterfly handles, signed, "Made in Japan at Arita by Chuji Fukagawa Nishikide Ware", circa 1900, 14 1/3" high; *right*, Made by Fukagawa, circa 1900, 8" high, Christies', London.

When the ceramic traditions of Japan were transformed with the advent of the Meiji restoration, the Tanigama works were apparently affected, too. Modern methods were employed by the Fukagawa family in their new business, Koransha. Eventually, industrial ceramics were added to the production of table and decorative wares. In 1876, the Koransha Porcelain Manufactory exhibited at the Japanese section of the Centennial Exhibition in Philadelphia, and in 1878 they had an exhibit in Paris. "In 1879, an independent firm called the Seiji Kaisha was formed by members of the Koransha. It is said that the work of both these firms at that time was excellent." [*Japanese Painted Porcelain*, p. 20.] Koransha continues to the present, having become an important supplier of industrial ceramics and high quality, but limited production, tablewares.

In 1894, Koransha was being run by two brothers of the Fukagawa family. The second son, Chuji, wanted to expand sales to foreign markets and therefore broke away from Koransha to found the Fukagawa Porcelain Manufacturing Company at Arita. As its first President, Chuji Fukagawa traveled to Europe four times by ship to study and establish new markets for his porcelain. He was not only a daring businessman, but also a talented designer. He had been a student of Miyagawa (Makuza) Kozan. His three remaining design books from the 1894 period show meticulous colorful designs (reproduced here), many of which were put into production and can be found on existing vases, plates and bowls.

The designs reflect European influence in their symmetrical organization. Chuji Fukagawa's travels to Europe may have included study of the European ceramic traditions of Spode, Wedgwood, Meissen and Royal Copenhagen wares. In Europe he would have gained knowledge of Western taste which has continued to influence his company's decorations to the present.

Since their first exports in 1900, the Fukagawa Porcelain Manufacturing Company quickly achieved a high level of competence and recognition. During the first exporting year, the Gold Medal of Honor was awarded to Fukagawa at the International Exposition in Paris. In 1904, at the Louisiana Purchase Exposition in St. Louis, Fukagawa also won First Prize for a beautiful five-foot high covered vase which is now in the Port of History Museum in Philadelphia and illustrated here. In 1910, the company was appointed Purveyor to the Imperial Household. The International Expostition to Commemorate the opening of the Panama Canal in 1915 gave the Grand Prize to Fukagawa. Over the years, fifty-seven other prizes, both foreign and domestic, have been awarded to the company.

As is traditional in Japanese families, the presidency of his company passed to Mr. Fukagawa's son, and eventually to his grandson. Today, Akira Fukagawa is the third president and business leader of his company, while his brother Iwao Fukagawa is their very talented chief designer. The next generation of business leader and chief artist are being trained to succeed their fathers in this important work.

Through the twentieth century, many porcelain-producing companies have grown-up in Arita to provide wares for the world market. The Arita Ceramics Fair has been held on the sidewalks and in the storefront shops of Arita from May 1 to May 5 for the last eighty years. Here visitors from all over Japan and abroad crowd the streets to find bargains and see new products introduced.

Porcelain designs by Chuji Fukagawa of Arita about 1895.

Bust sculpture of Chuji Fukagawa
at Arita Park.

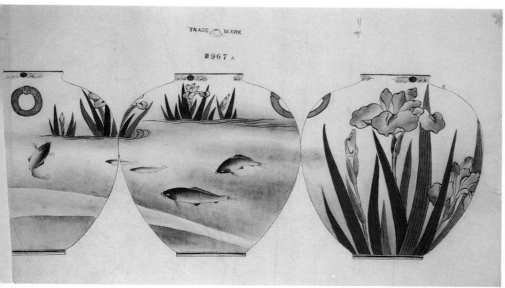

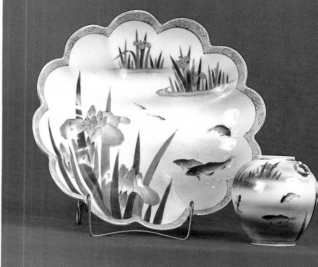

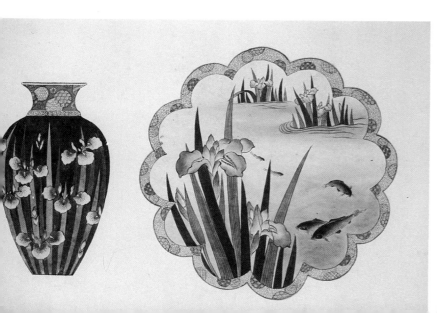

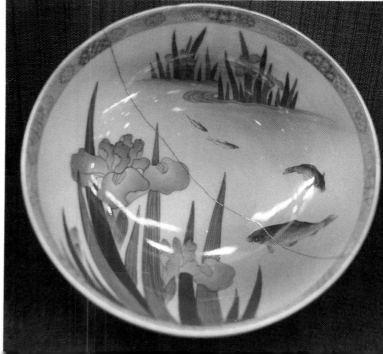

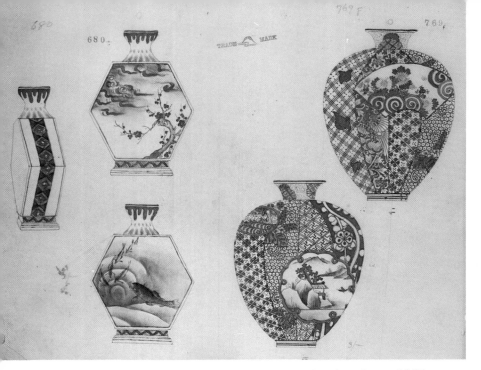

Porcelain designs by Chuji Fukagawa of Arita about 1895.

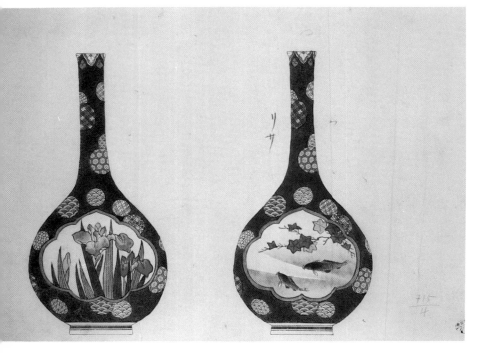

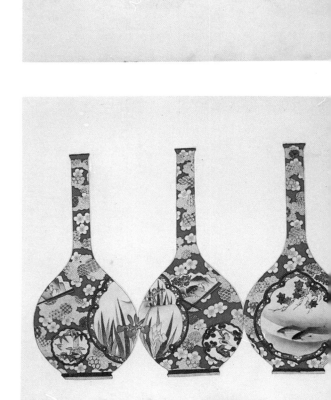

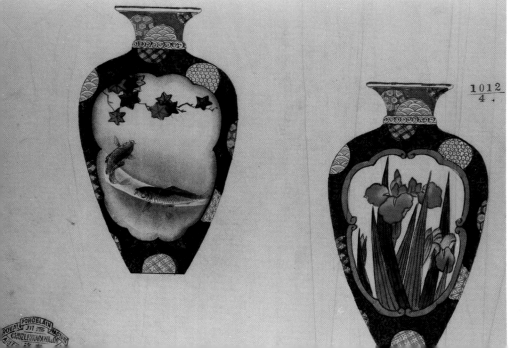

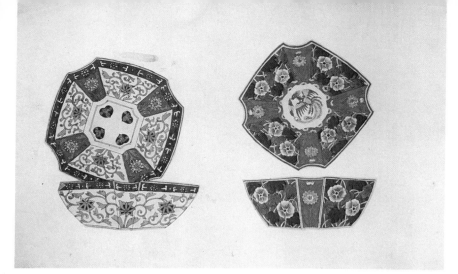

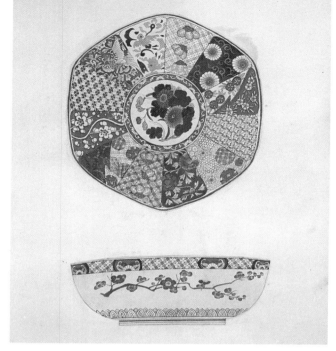

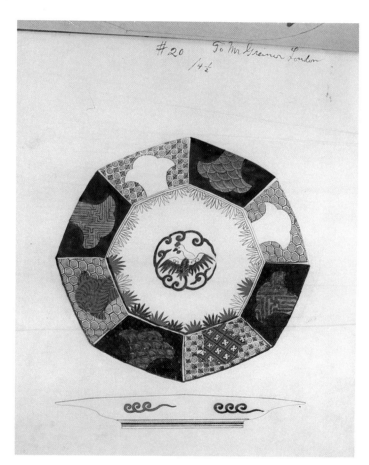

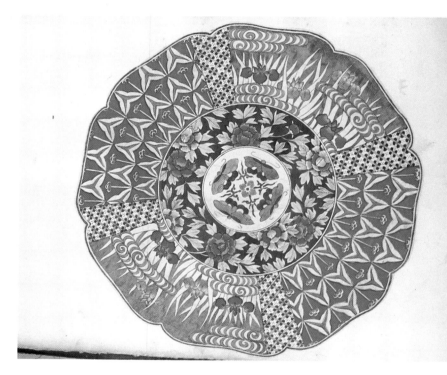

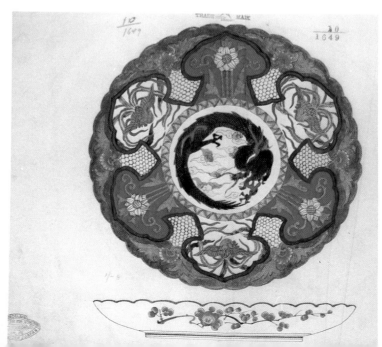

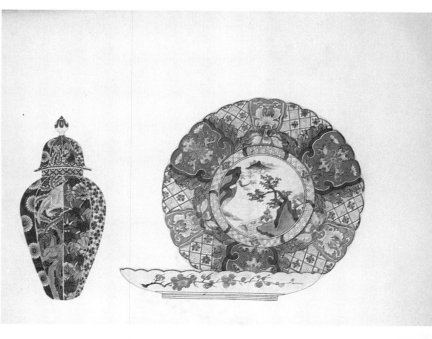

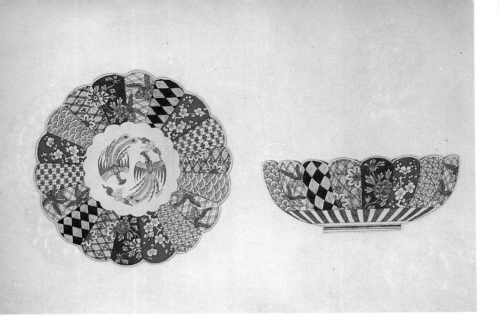

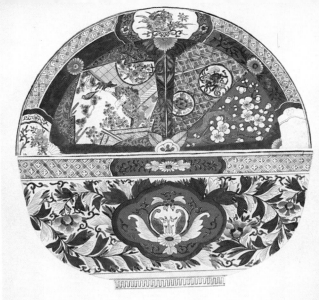

Porcelain designs by Chuji Fukagawa of Arita about 1895.

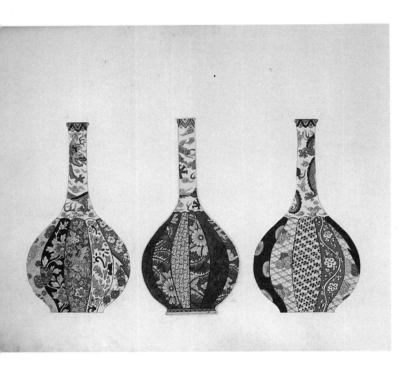

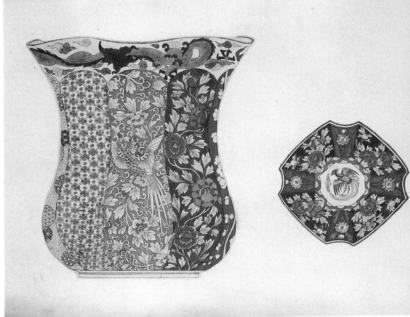

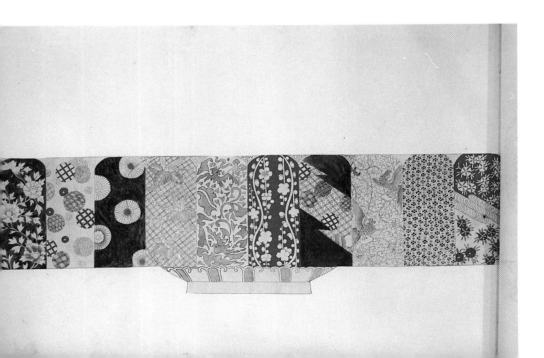

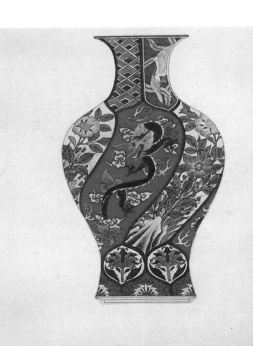

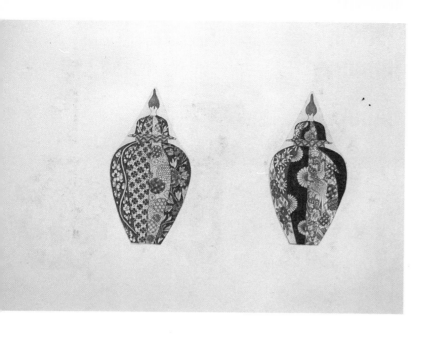

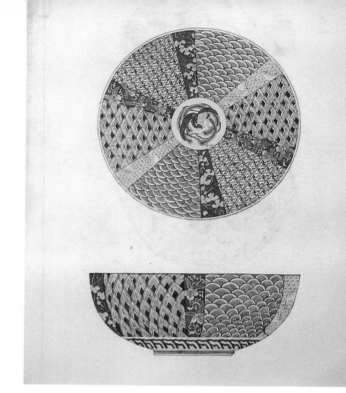

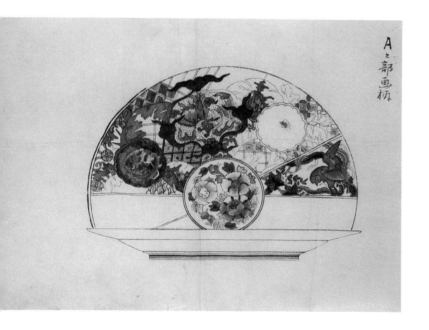

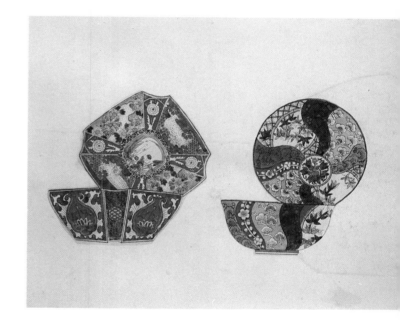

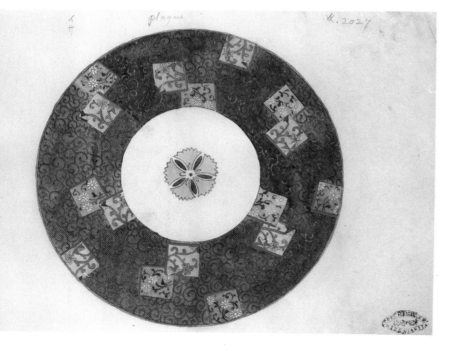

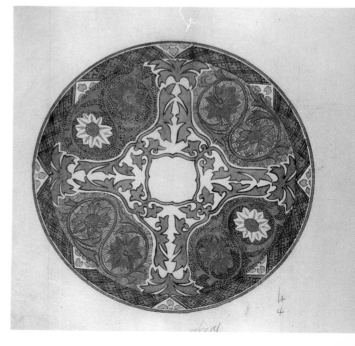

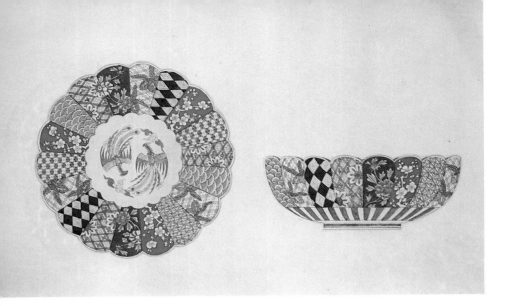

Porcelain designs made by Chuji
Fukagawa of Arita about 1895.

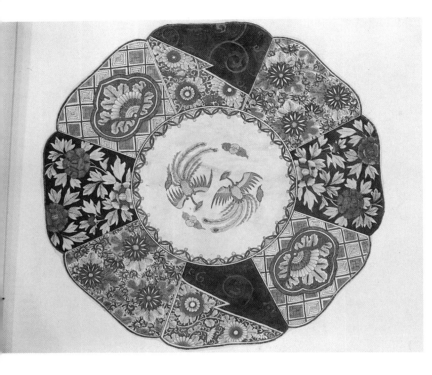

No. 1060
C

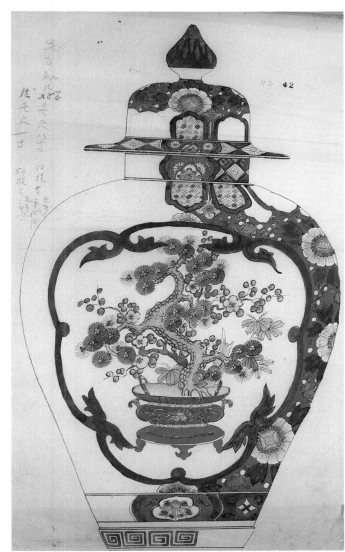

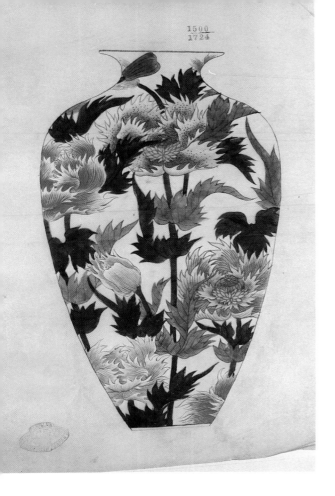

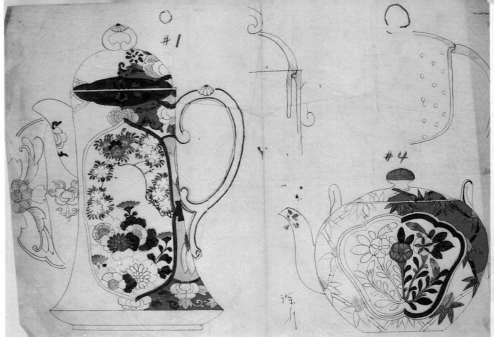

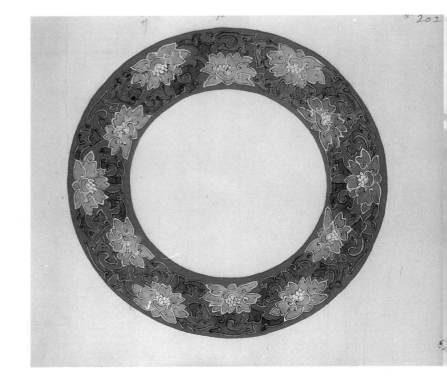

Porcelain designs by Chuji Fukagawa
of Arita about 1895.

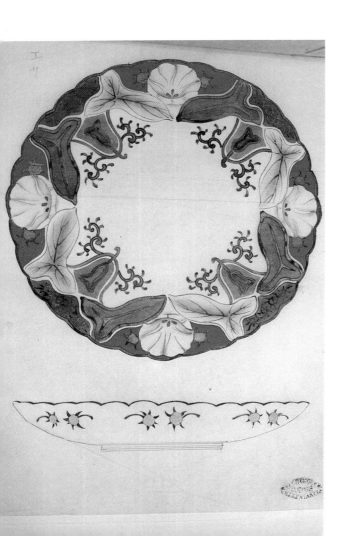

#3

#5

#2

72 72

59

59

678 678

678 678

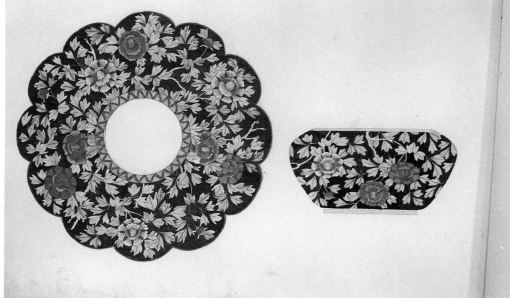

Porcelain designs by Chuji Fukagawa of Arita about 1895.

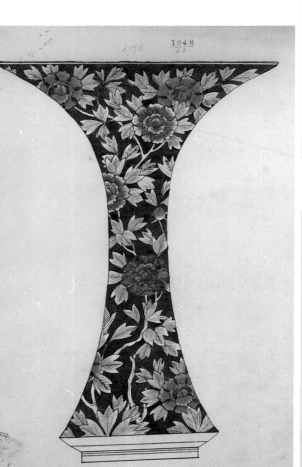

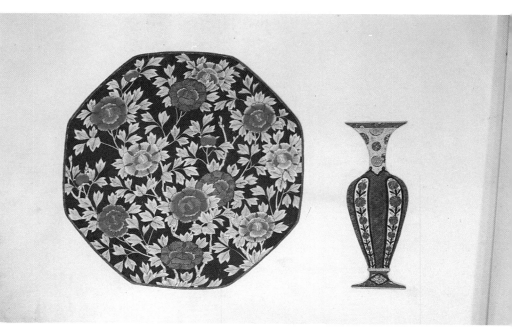

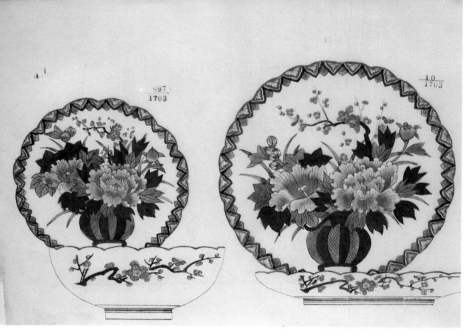

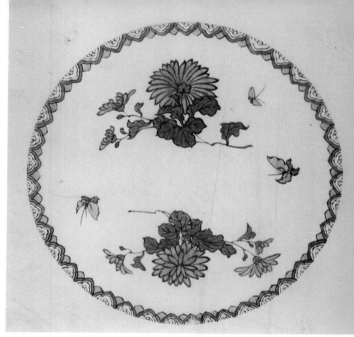

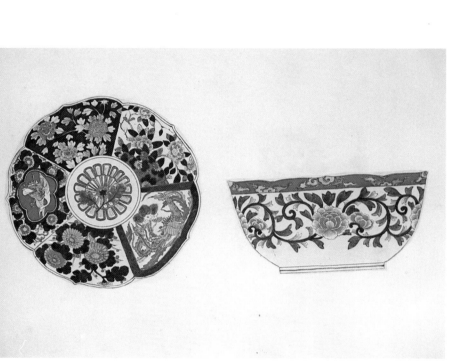

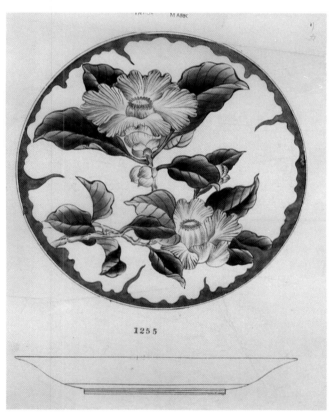

1255

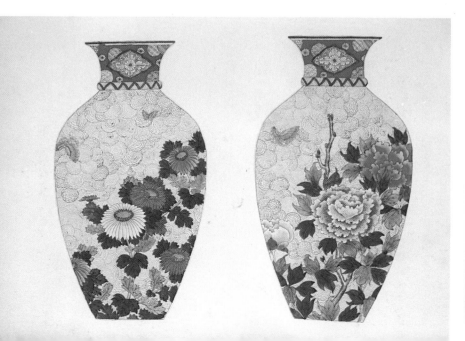

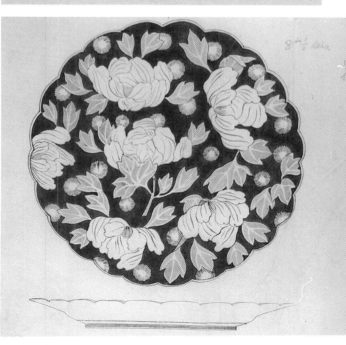

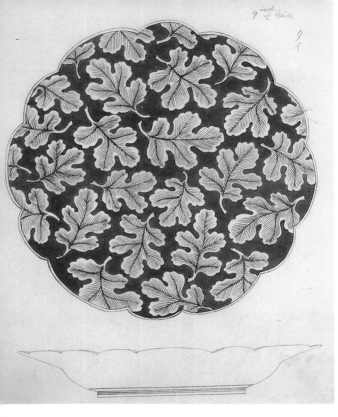

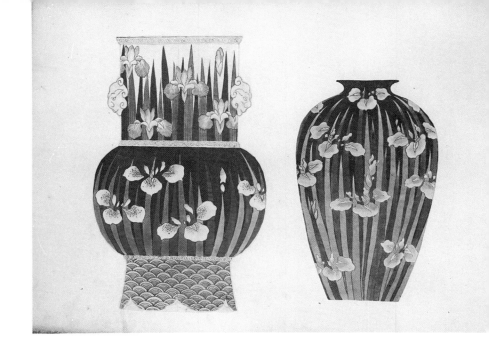

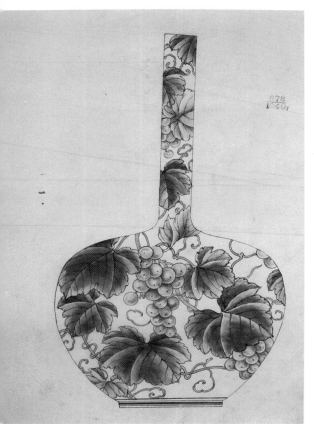

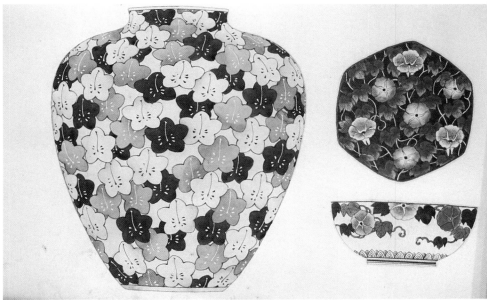

Porcelain designs by Chuji Fukagawa of Arita about 1895.

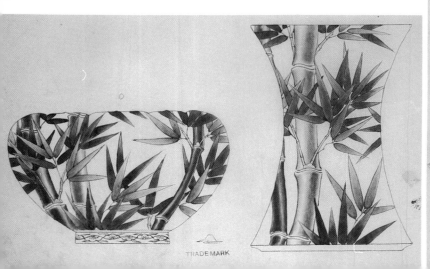

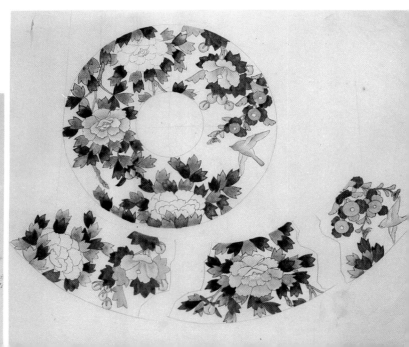

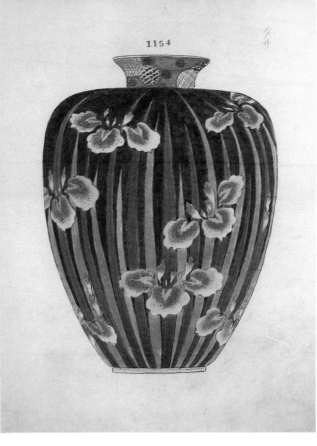

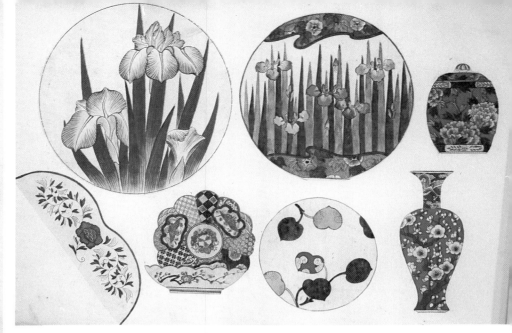

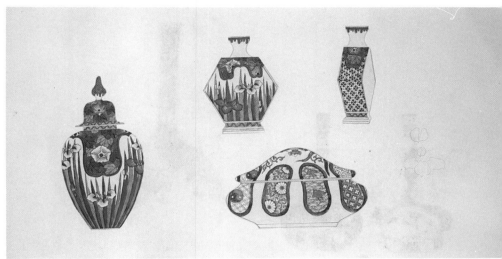

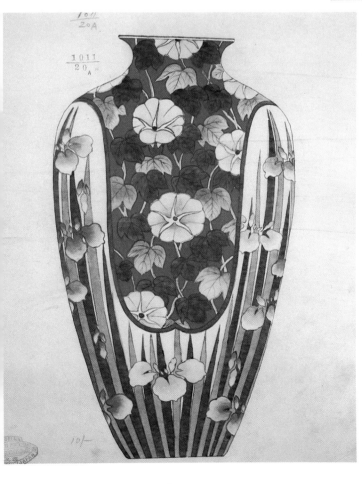

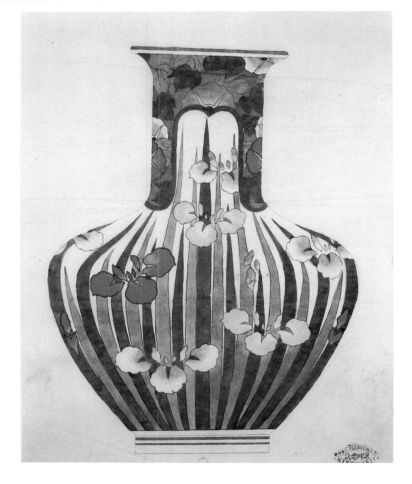

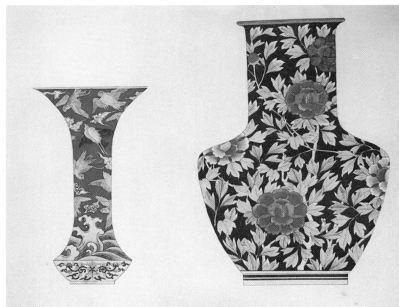

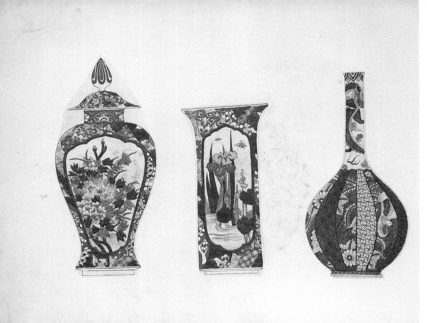

Porcelain designs by Chuji Fukagawa of Arita about 1895.

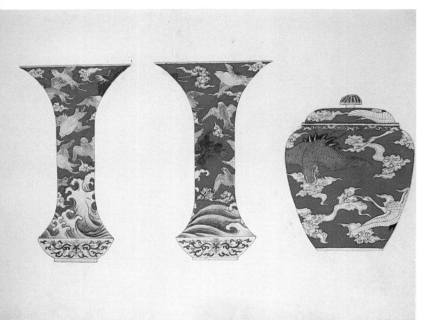

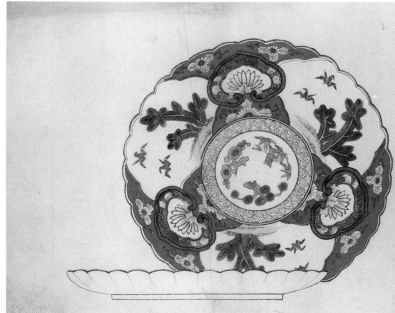

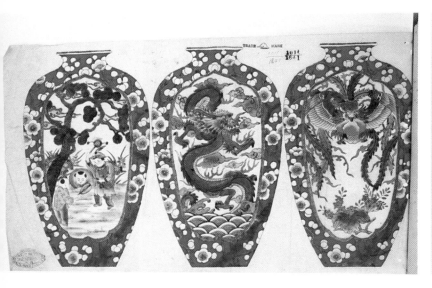

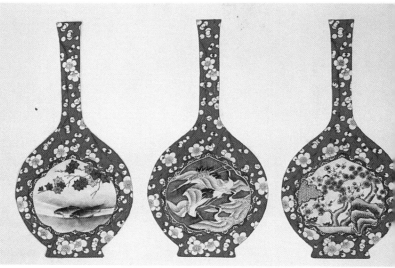

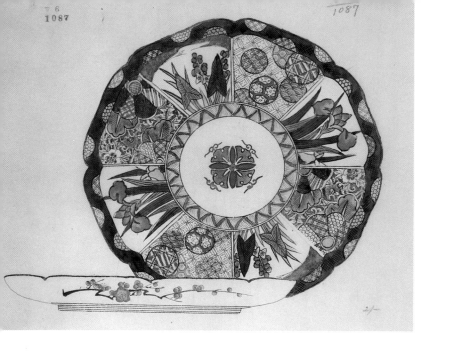

1087

2/-

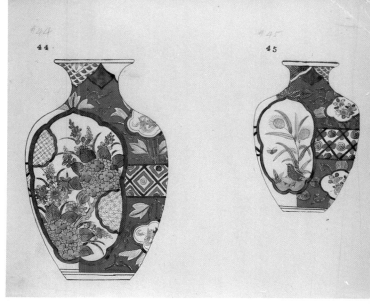

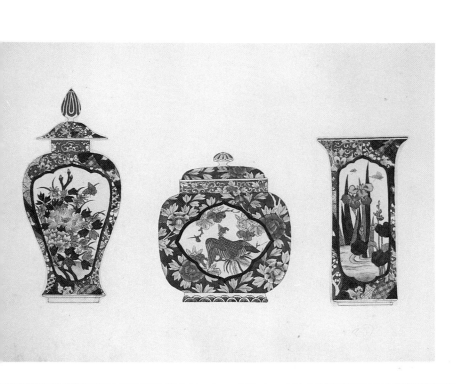

64

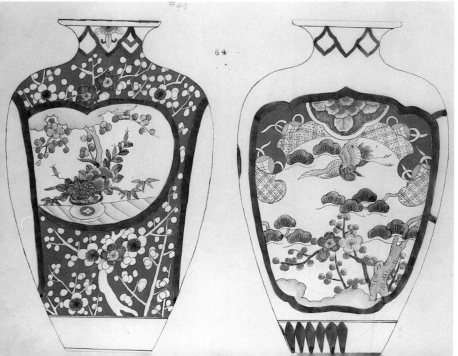

TRADE MARK

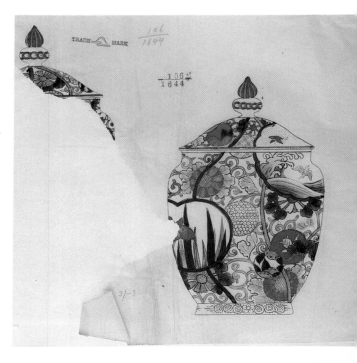

3/-3

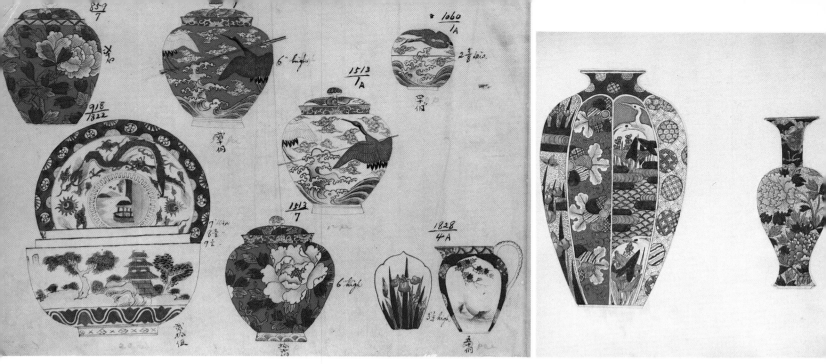

Porcelain designs by Chuji Fukagawa of Arita about 1895.

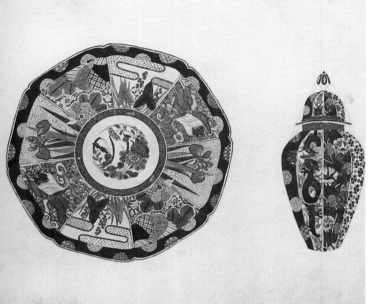

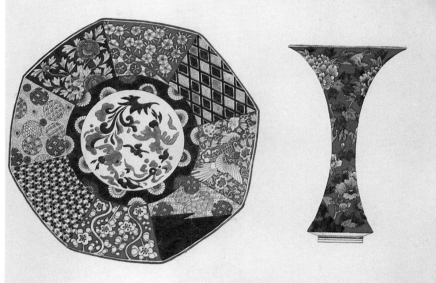

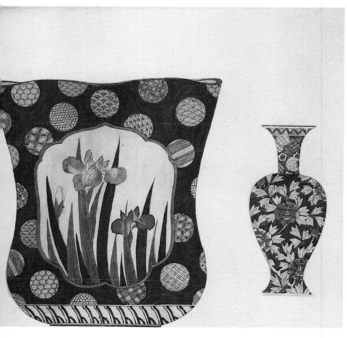

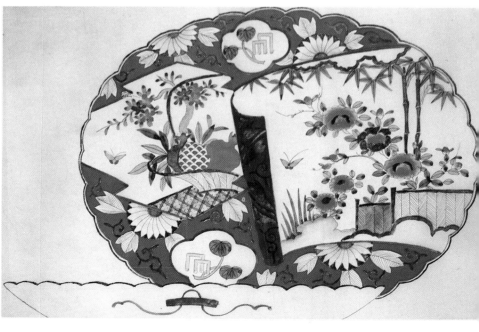

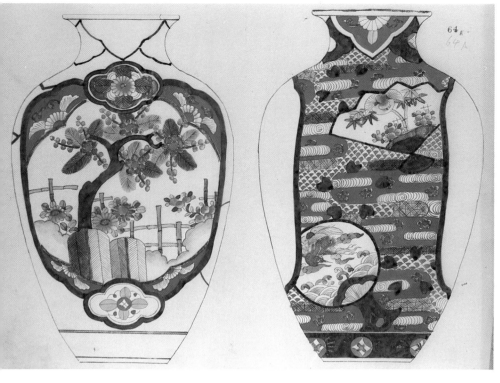

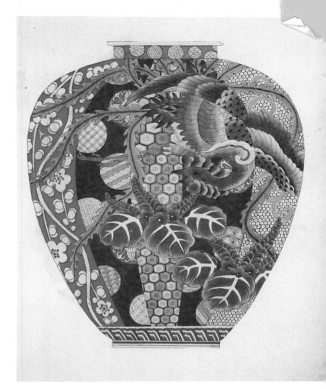

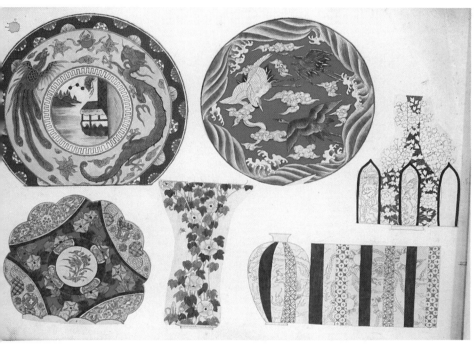

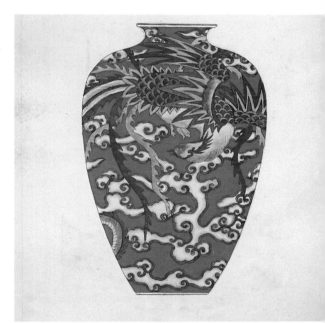

10
1506

10
1506

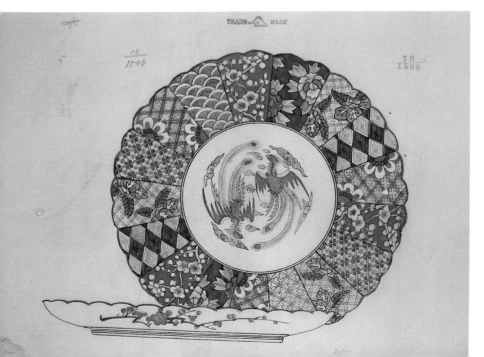

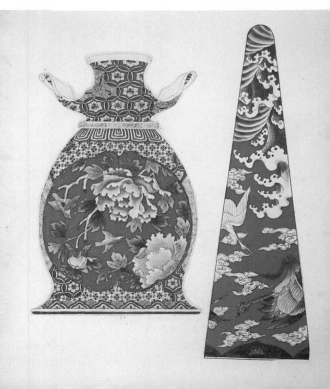

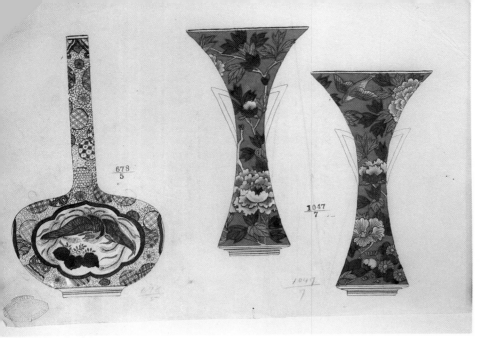

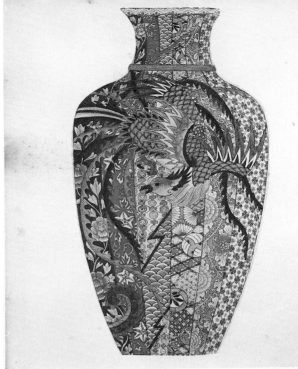

Porcelain designs by Chuji Fukagawa of Arita about 1895.

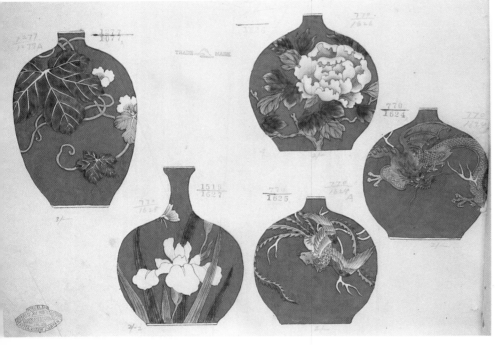

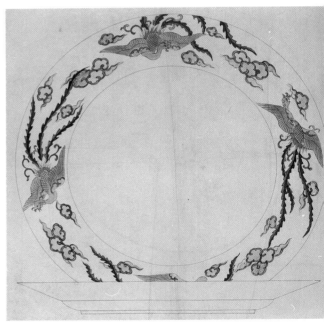

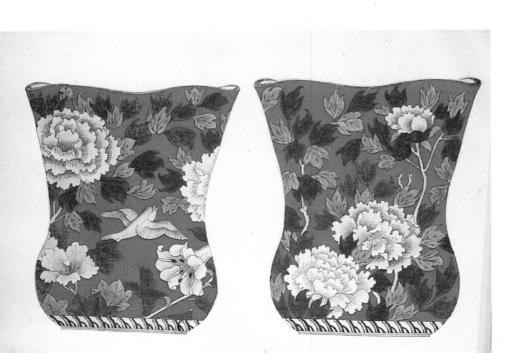

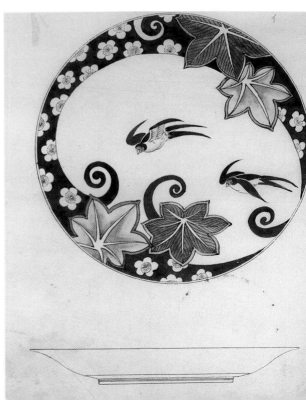

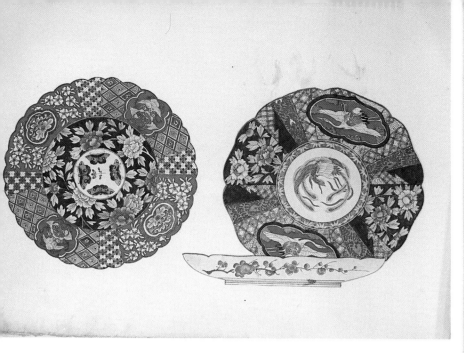

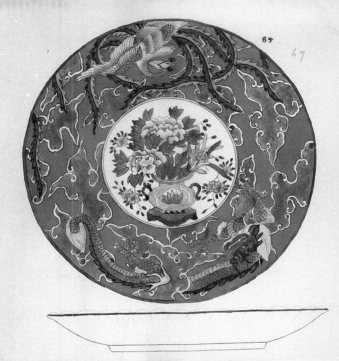

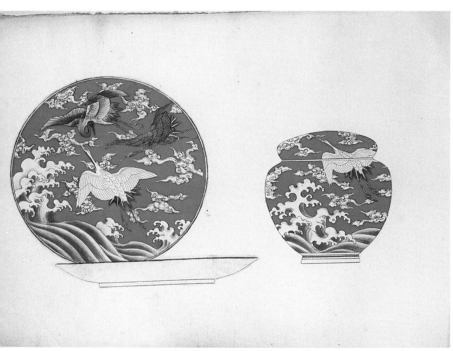

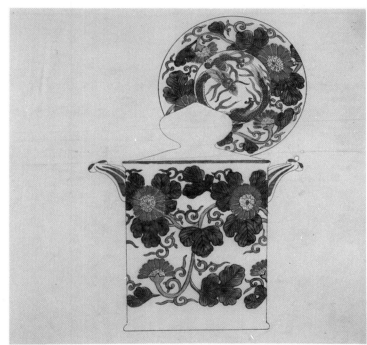

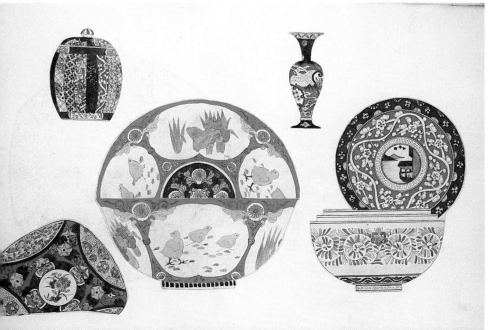

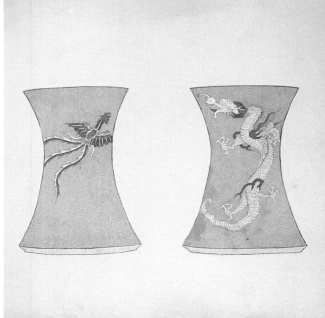

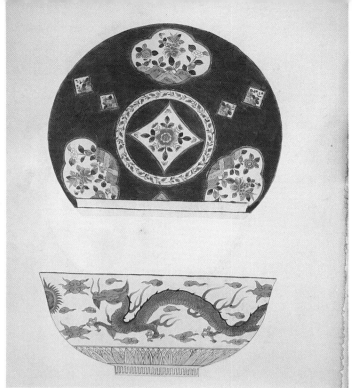

Porcelain designs by Chuji Fukagawa of Arita about 1895.

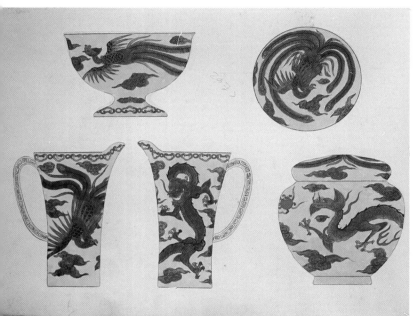

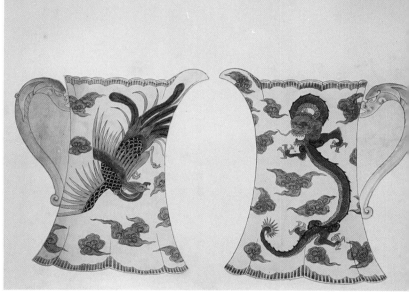

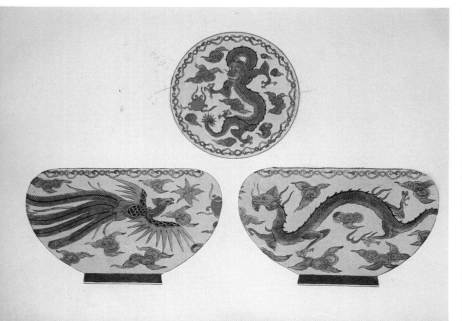

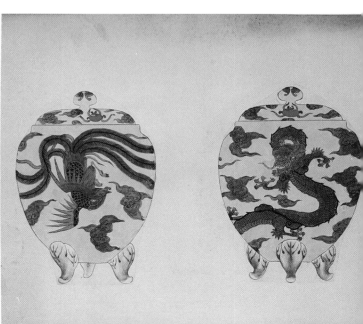

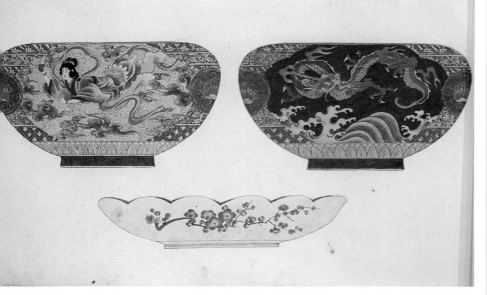

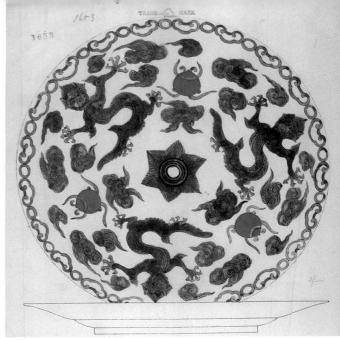

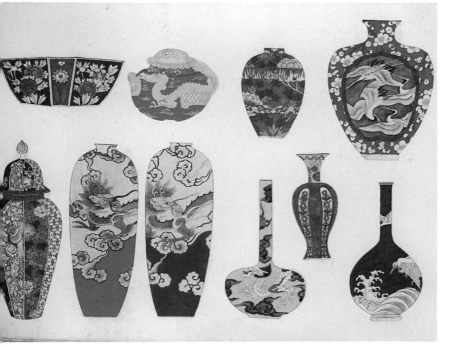

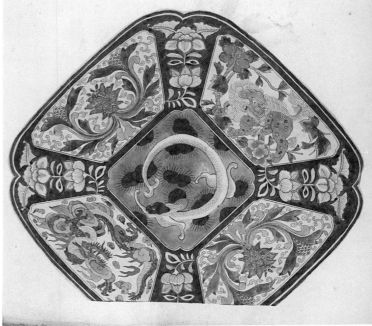

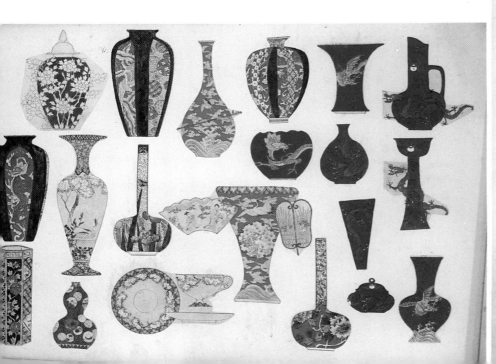

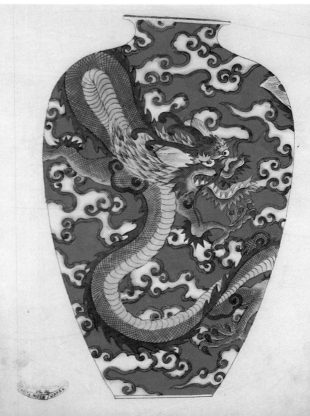

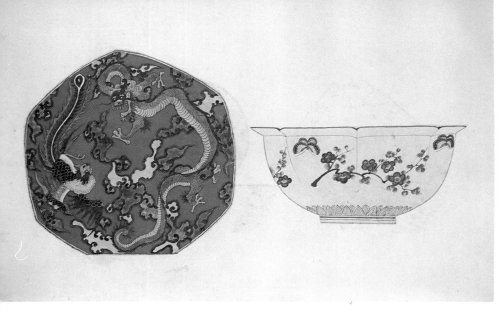

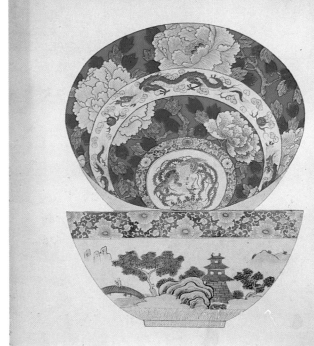

Porcelain designs by Chuji Fukagawa of Arita about 1895.

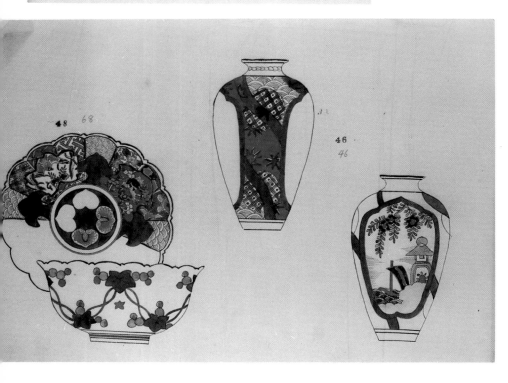

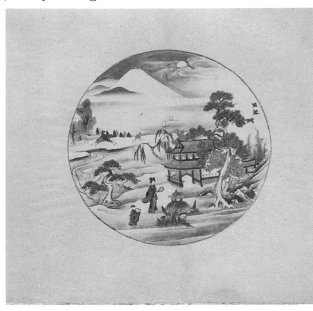

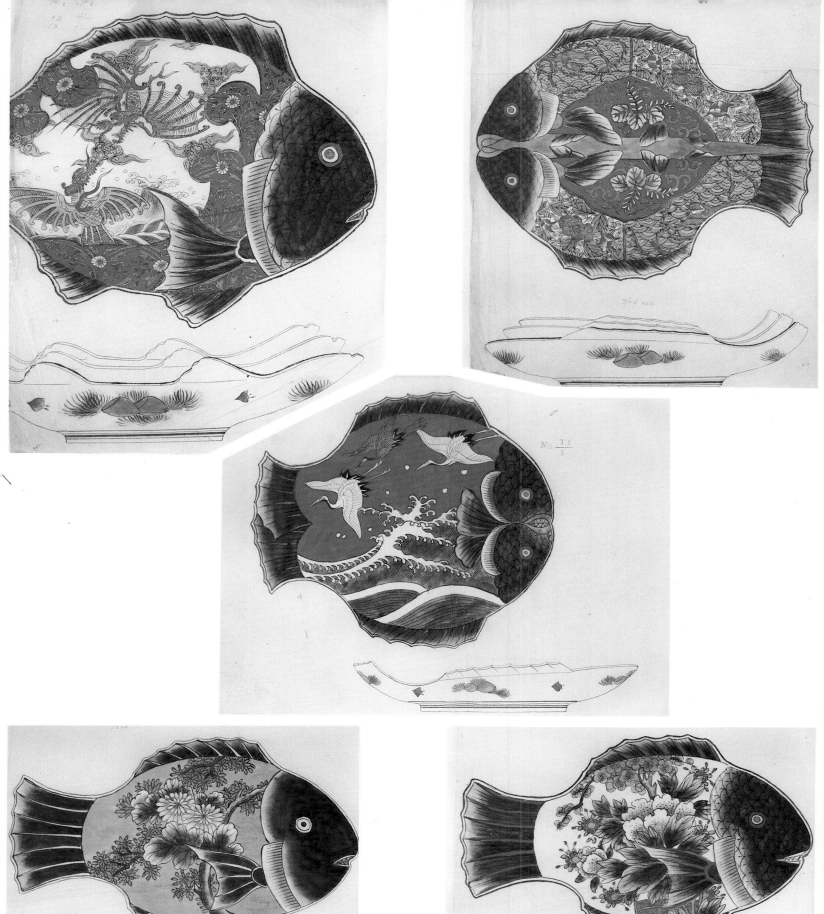
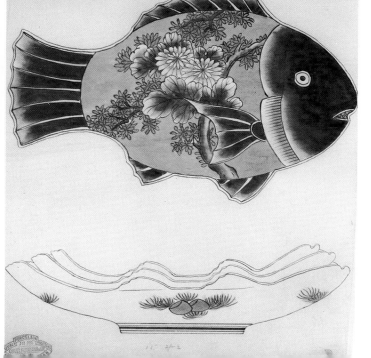
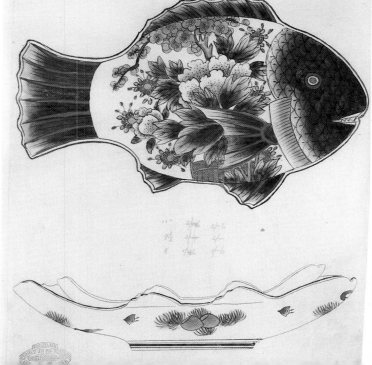

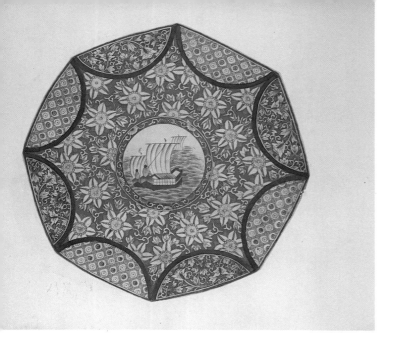
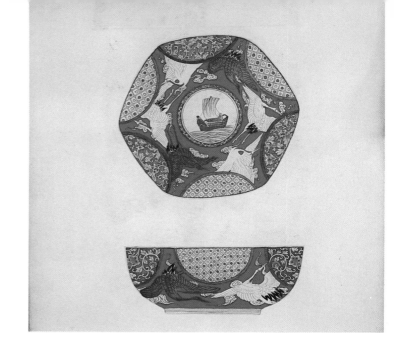

Porcelain designs by Chuji Fukagawa of Arita about 1895.

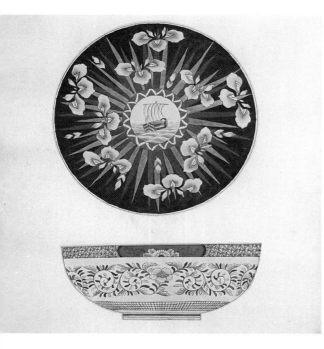
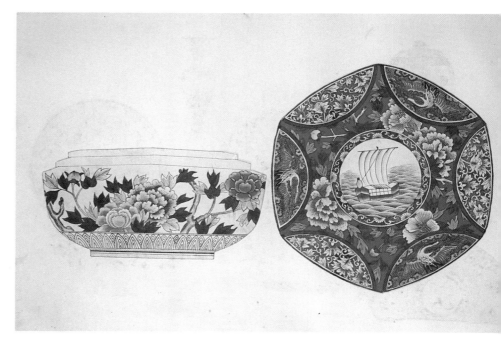
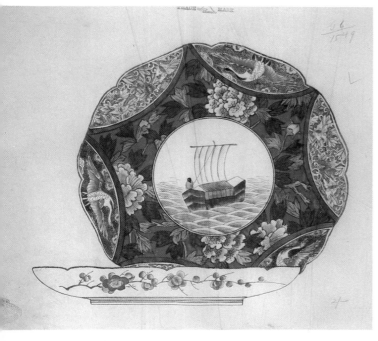
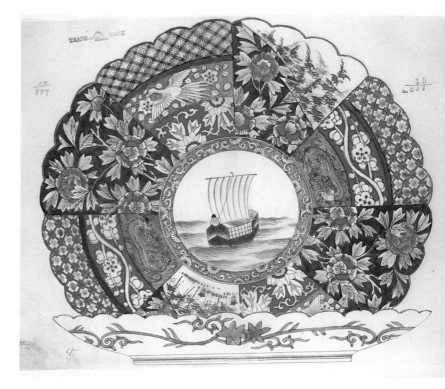

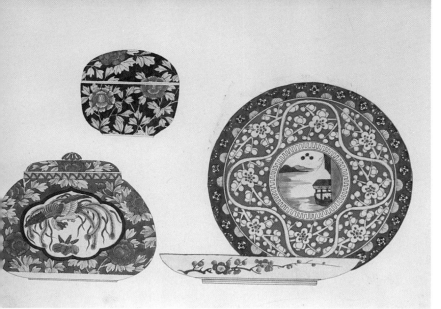

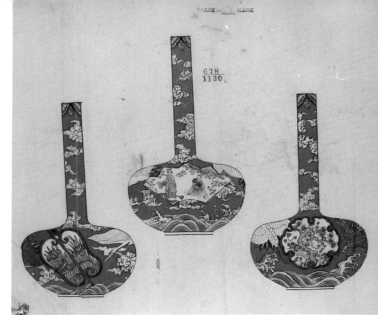

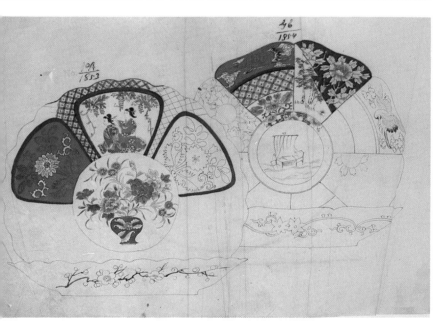

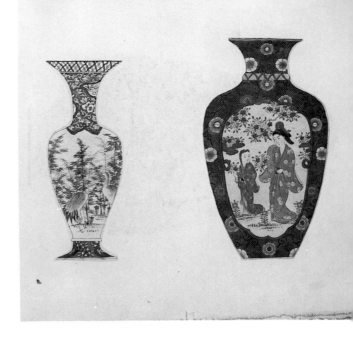

Porcelain designs by Chuji Fukagawa of Arita about 1895.

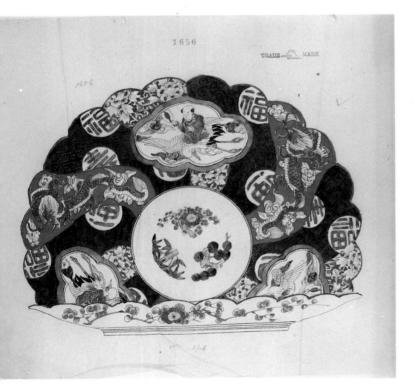

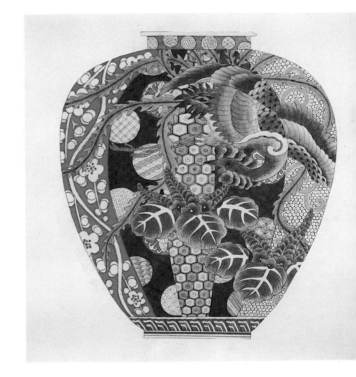

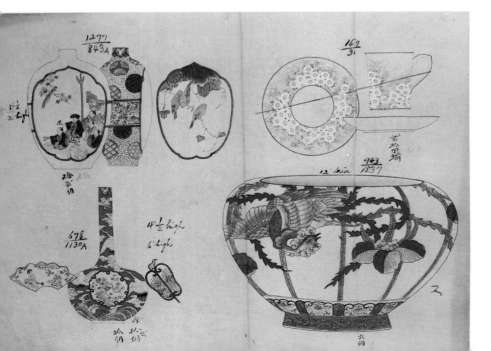

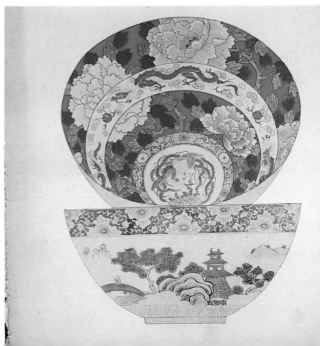

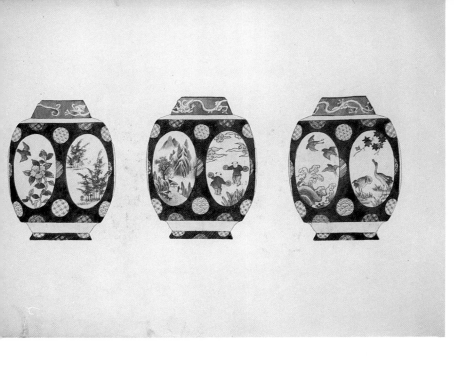

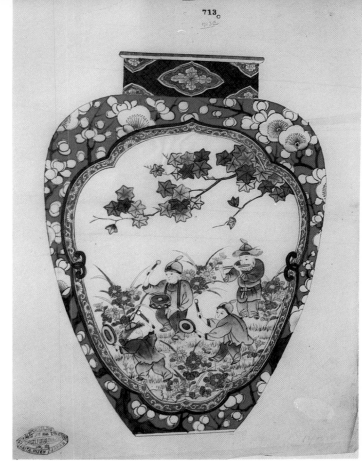

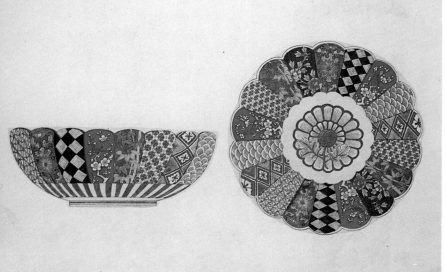

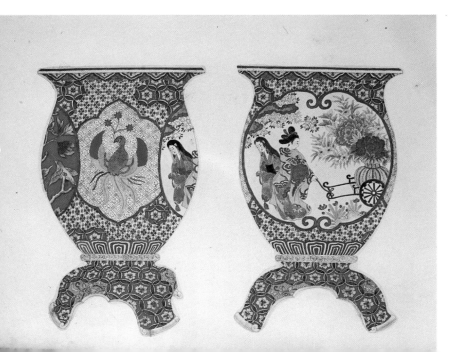

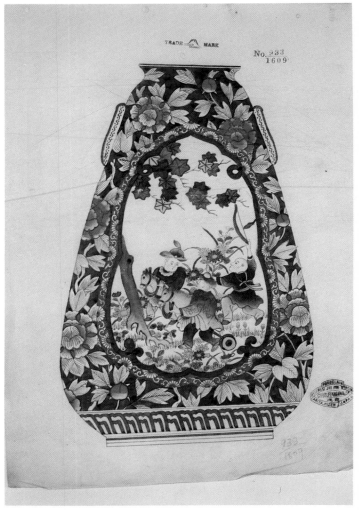

TRADE MARK No. 933
1609

TRADE MARK

1256

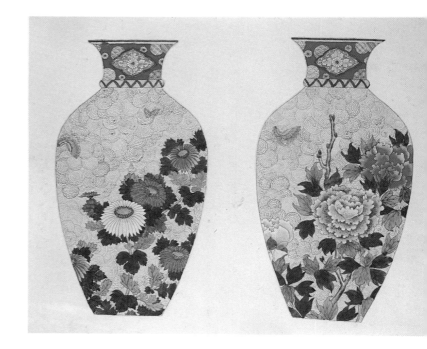

Porcelain designs by Chuji Fukagawa of Arita about 1895.

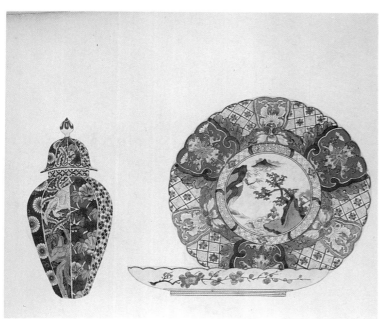

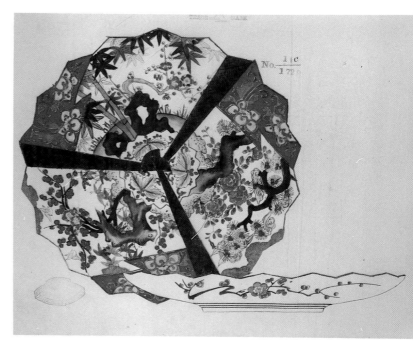

No. 1|C / 1729

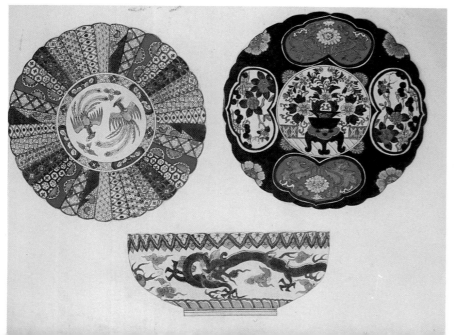

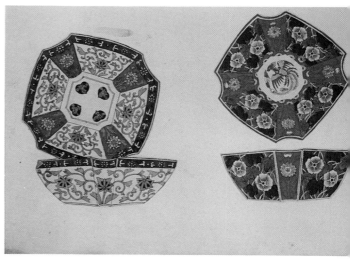

Fukagawa mark on a wooden food box, *Fuka* means "mountain", *Gawa* means "river".

Made by Fukagawa

Made by Fukagawa, with hat mark that was used at the Fukagawa Porcelain Manufacturing Company for a year, 1894, before the trademark sign was adopted.

Made in 1899 by Chuji Fukagawa at Arita, Hizen, Japan.

Made by Fukagawa, Hichozan (Mountain butterfly), Hizen area.

Fukagawa, Arita

Made by Fukagawa

Made by Fukagawa

Made by Fukagawa

Fukagawa trademark of a mountain and a river introduced in 1895 and used to the present.

C. Fukagawa and Co., Arita (with trademark)

Made by Fukagawa (with trademark)

Made in Japan at Arita by Fukagawa (with trademark)

Made by Fukagawa (with trademark)

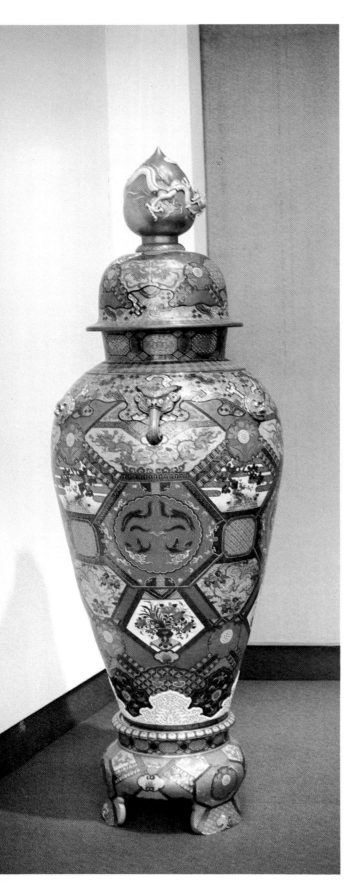

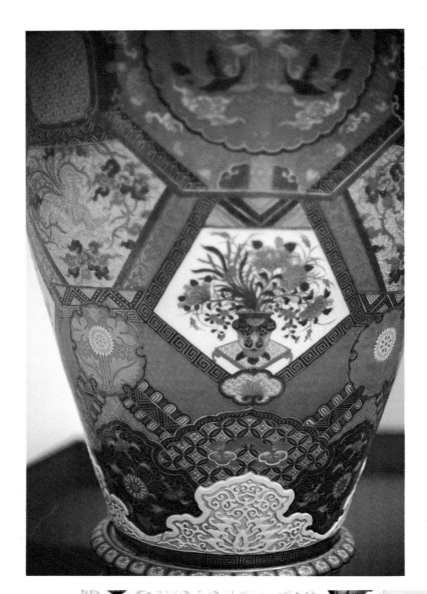

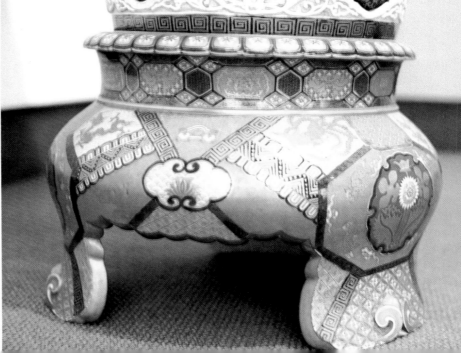

Purchase International Exposition competition in St. Louis, Missouri in 1904, by the Fukagawa Porcelain Manufacturing Company, 65" high, Port of History Museum, Philadelphia.

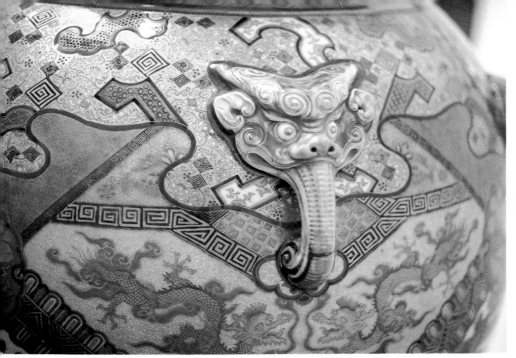

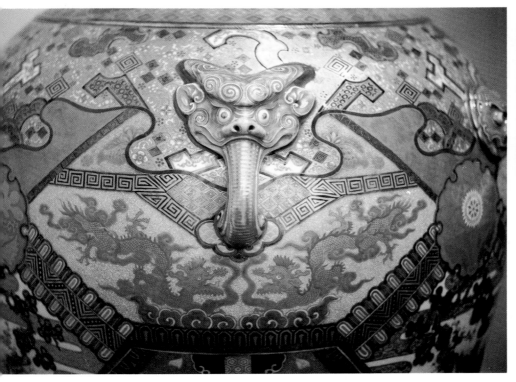

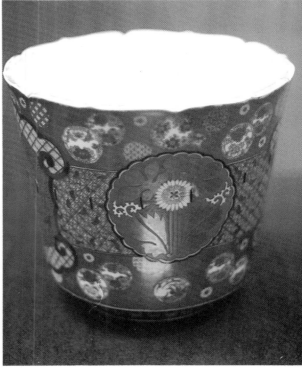

Jardiniere made for export by
Fukagawa, circa 1900.

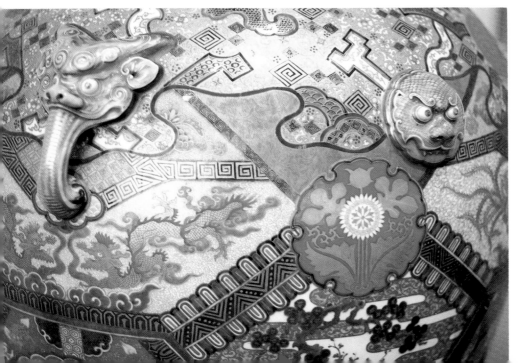

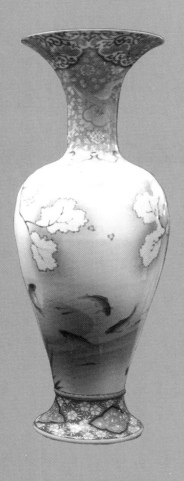

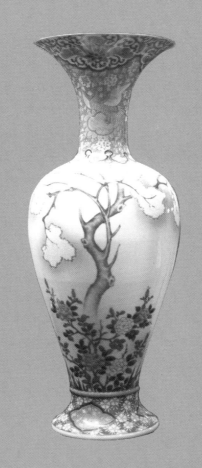

Front and back views of a vase with floral and fish decoration and Fuku mark made by Fukagawa circa 1900, purchased in London, 30" high, rim, 10" diameter, Collection of the Shinwa Bank, head office, Sasebo, Japan.

Dinner service made for use in the officers' mess of the Japanese Navy. The design was copied from an English Spode pattern which had been used aboard Japanese naval vessels until the Fukagawa company was commissioned to make this set in the early 20th century.

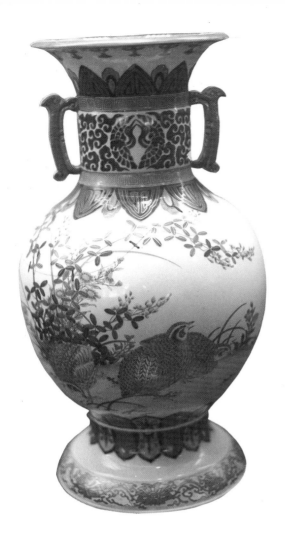

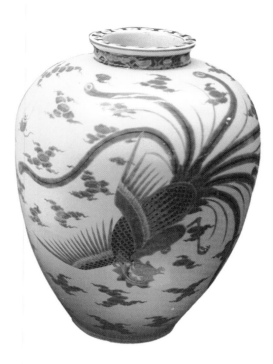

Vase and bowl made for export by
Fukagawa, early 20th century.

Vase with quail design made for
export by Fukagawa, early 20th
century.

Chamber pot and lid, wash
basin and water pitcher in
European shapes made by
Fukagawa for export, early
20th century.

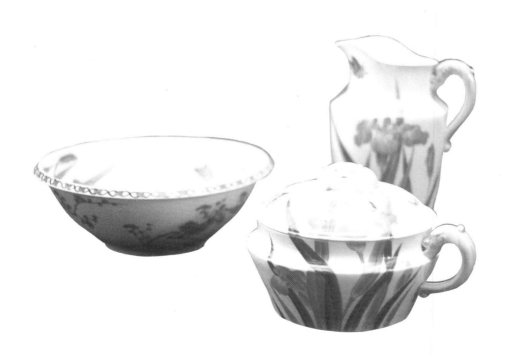

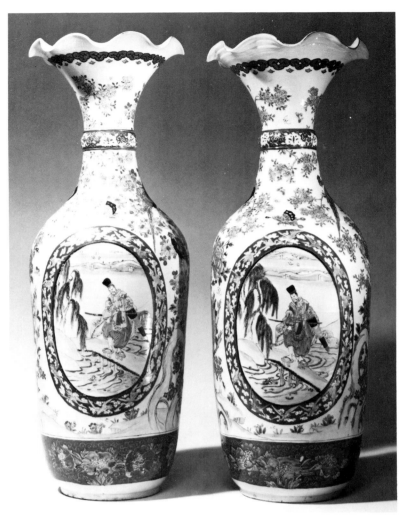

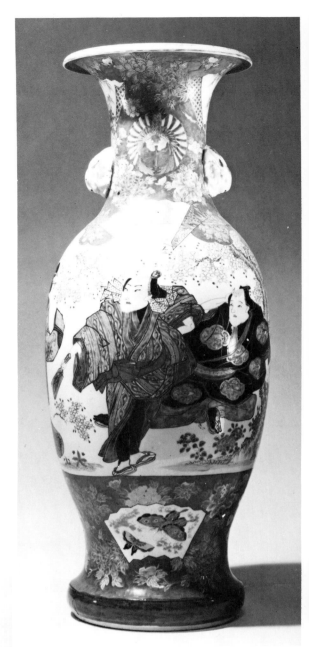

Pair of vases with Samurai in the decoration, made by Fukagawa, early 20th century, 29'' high, © 1986, Sotheby's Inc.

Vase with ladies and gentlemen in the decoration and rabbit-head handles, circa 1900, 29½" high, © 1986, Sotheby's, Inc.

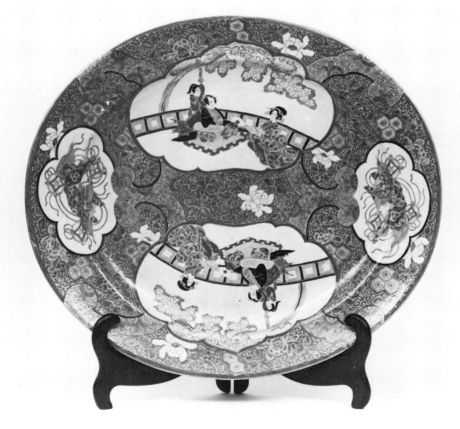

Oval plate made for export by Fukagawa, early 20th century, 26'' wide, Flying Cranes Antiques, New York.

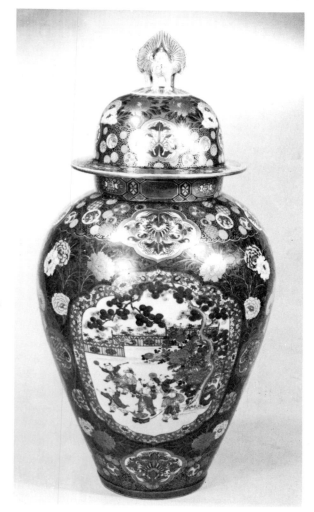

Covered jar inscribed inside the lid "Fukagawa of Okawachi", late 19th century, 43" high, Christies', London.

Pair of vases decorated with panels depicting the Seven Sages of the Bamboo Grove, and boys playing in a garden, signed Fukagawa, late 19th century, 22" high, © 1986, Sotheby's, Inc.

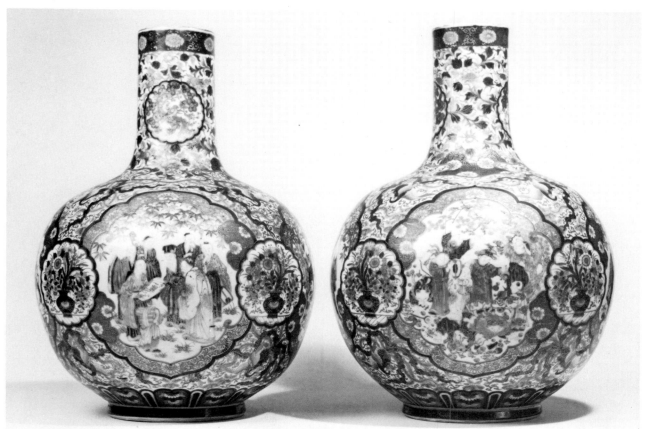

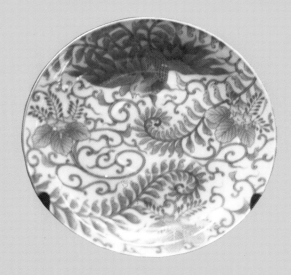

Plate made for export by Fukagawa, early 20th century.

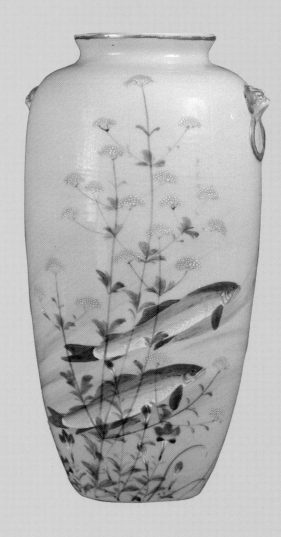

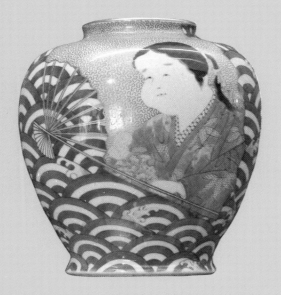

Vase made for export by Fukagawa, circa 1900.

Vase made for the Japanese market by Fukagawa, circa 1900.

Imari vase with fish and floral decoration, early 20th century, Flying Cranes Antiques, New York.

Underglaze blue decorated plate with scalloped rim, made for export by Fukagawa, circa 1900.

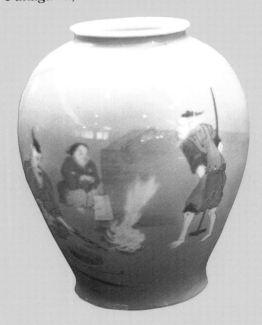

Tea pot made for export by
Fukagawa, circa 1900.

Plate with scalloped rim, dragon
and fanciful bird in the decoration,
made by Fukagawa for export, early
20th century.

Plate made for export by Fukagawa,
early 20th century.

Vase made by Fukagawa for export,
circa 1900.

Underglaze blue plate in packing
box, made for export by Fukagawa,
early 20th century.

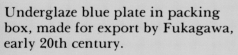

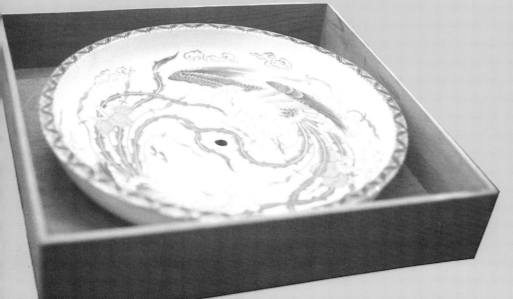

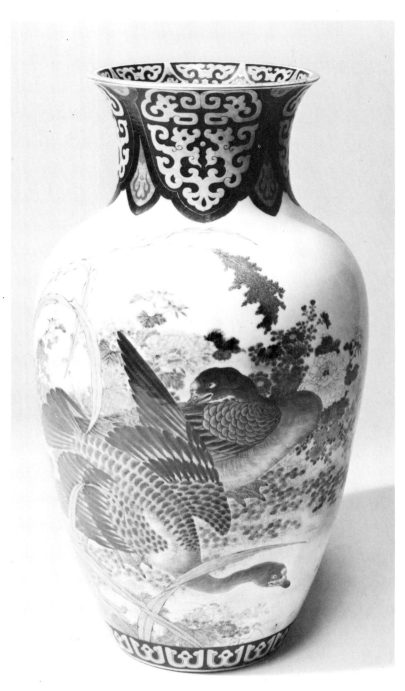

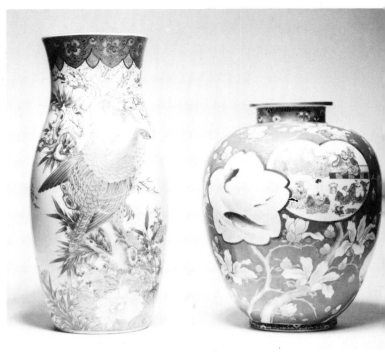

Left, Imari vase, late 19th century, 24¼" high; *right*, vase marked with Fukagawa trademark, circa 1900, 18¾" high, © 1986, Sotheby's, Inc.

Imari vase with geese in the decoration, marked Fukagawa, 30½" high, late 19th century.

Fish bowl, interior and exterior views marked with Fukagawa trademark, circa 1900, 16½" diameter, Sotheby's, London.

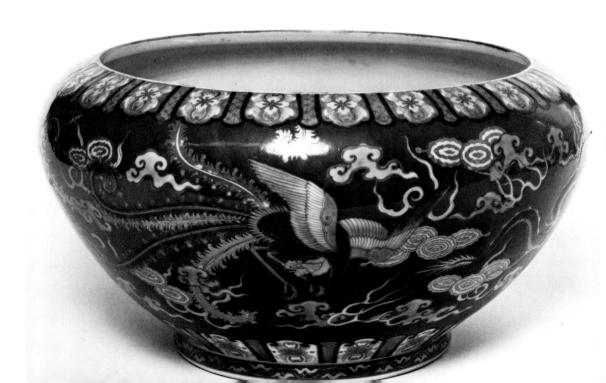

102

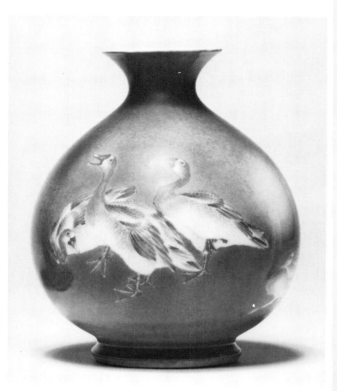

Vase with grey background and standing geese signed by Makuzu Kozan, 8'' high, © 1986, Sotheby's, Inc.

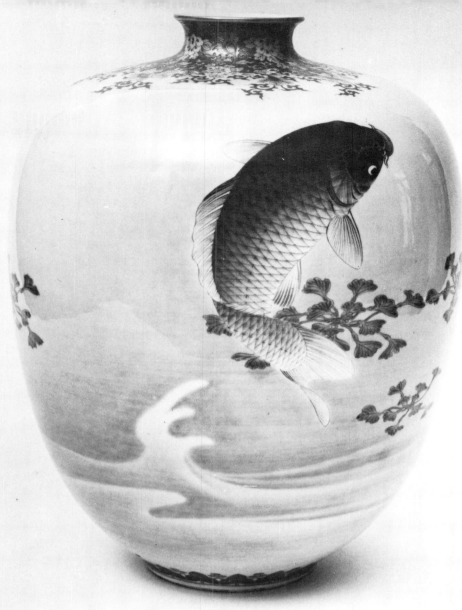

Vase made by Fukagawa, circa 1900, 12'' high, Flying Cranes Antiques, New York.

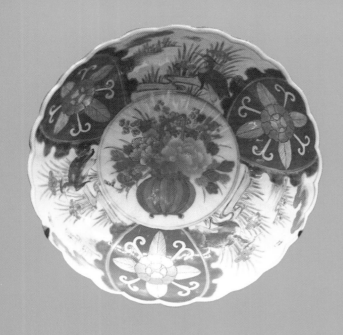

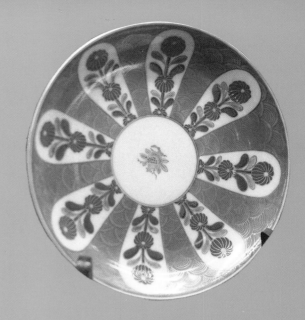

Two plates made for export by Fukagawa, early 20th century.

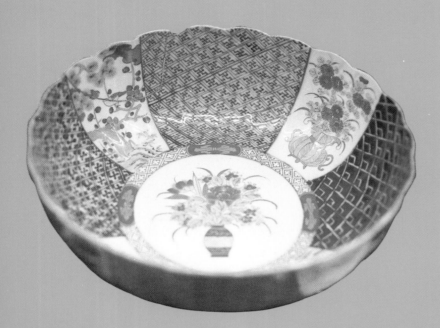

Two bowls made for export by Fukagawa, early 20th century.

Bowl made for export and marked by Fukagawa with its trademark and its nine character mark, early 20th century.

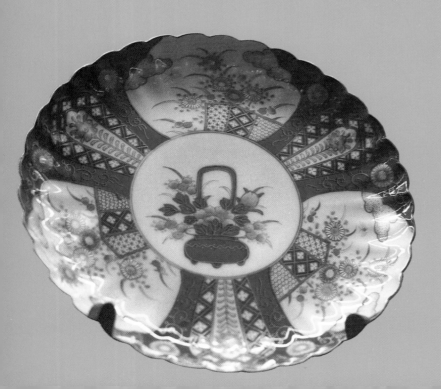

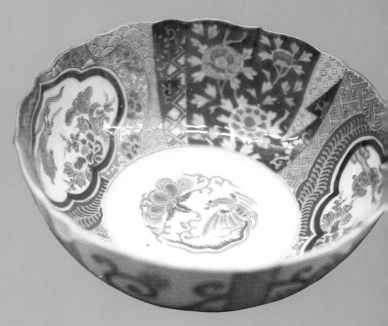

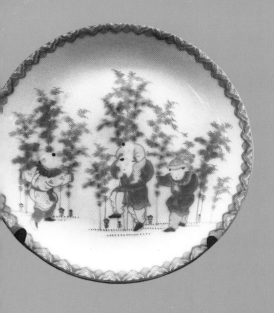

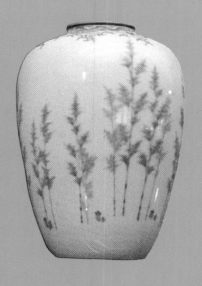

Plate and vase made for export by Fukagawa, early 20th century.

Imari melon-shaped bottle and stopper with red 6-character mark, mid-19th century, 11" high, Gibbons collection.

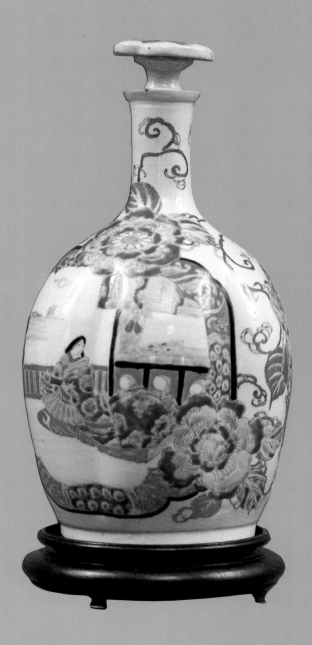

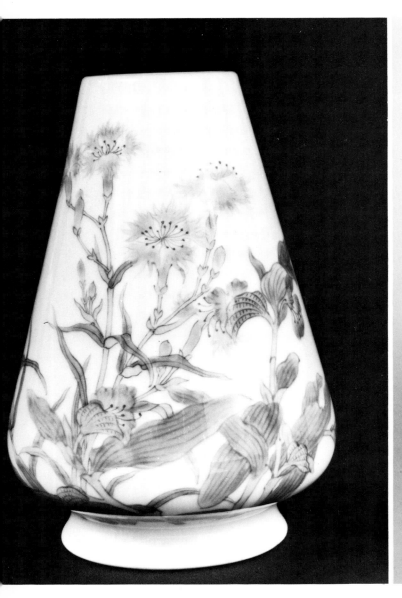

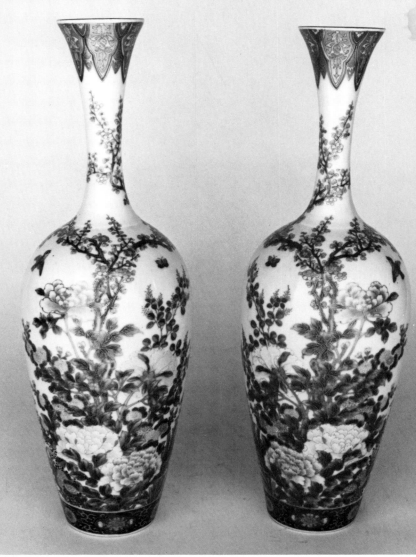

Pair of vases by Fukagawa, early 20th century, 14¾" high, Flying Cranes Antiques, New York.

Vase with blue and white floral decoration, bearing the mark of the Genroku period (1688-1703), but made in the late 19th century, 6¾" high, British Museum, London. Map design

Plate with brushwood fence decoration and Fukagawa trademark, 20th century, 4¾" diameter, British Museum, London. The similarity of this decoration with that on a Nabeshima plate at the Tokyo National Museum from the early 18th century and illustrated as figure 223 in the catalog of the Great Japan Exhibition at the Royal Academy of Arts, London, 1981-1982, indicates that Fukagawa revived this decoration in the early 20th century.

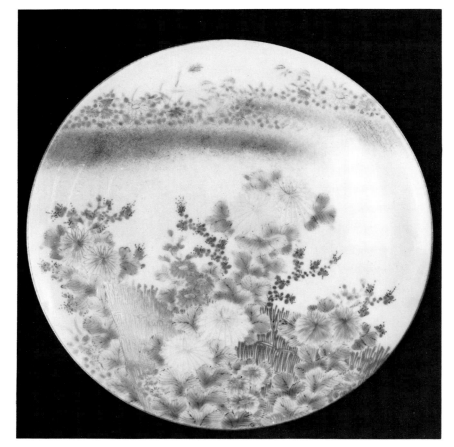

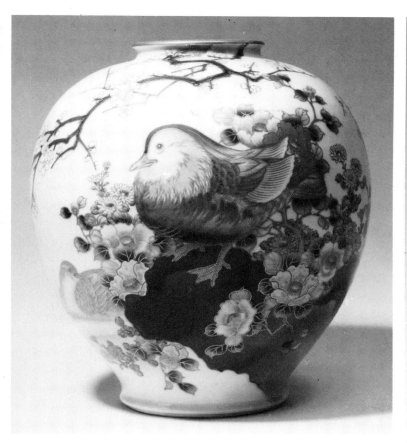

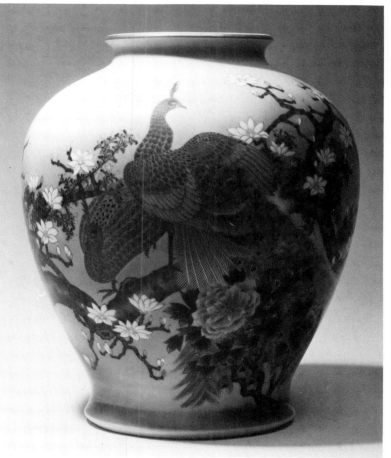

Vase with Fukagawa trademark,
19th century, 12'' high, © 1986,
Sotheby's, Inc.

Three forms with underglaze blue
bamboo decoration made by
Fukagawa, early 20th century, jar 9''
high, plate 16'' diameter, bowl 10''
diameter, Flying Cranes Antiques,
New York.

Vase with Fukagawa trademark and
signature, early 20th century, 12½''
high, © 1986, Sotheby's, Inc.

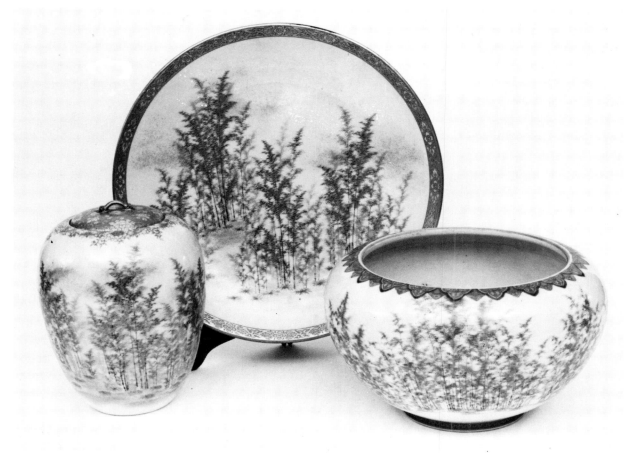

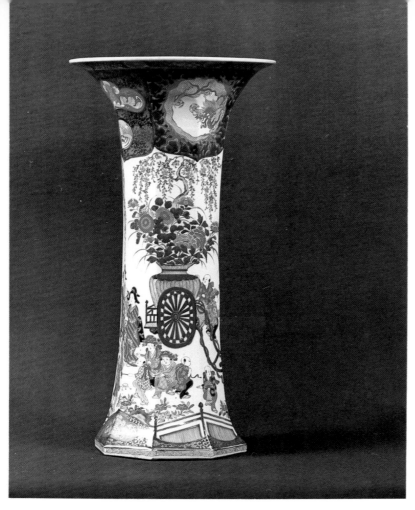

Imari umbrella stand with flower cart decoration, 19th century, 24½'' high, Norwich Free Academy, Norwich, Connecticut.

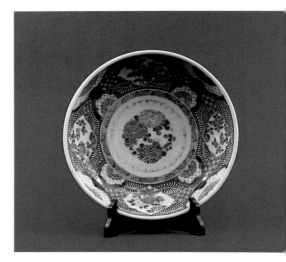

Imari bowl with crysanthemum and brocade decoration, late 19th century, 14¼'' diameter, Gibbons Collection.

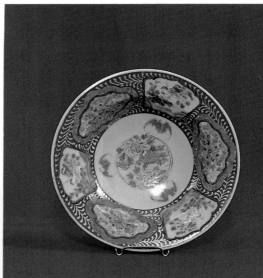

Imari rimmed plate, mid-19th century, 9⅞'' diameter, Lyman Allyn Museum, New London.

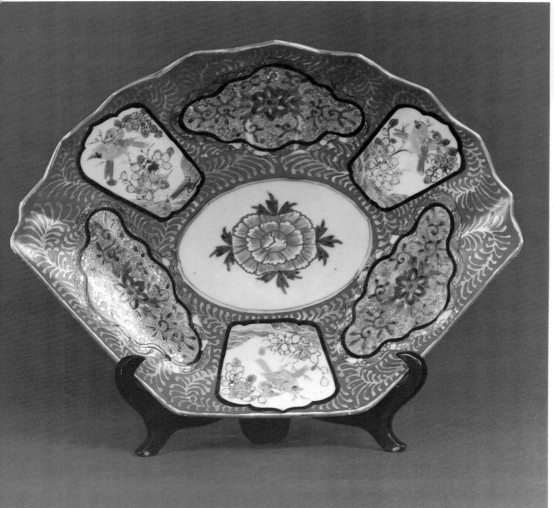

Imari dish in fan shape, late 19th century, Flying Cranes Antiques, New York.

Imari ware decoration

The colored enamel, overglaze decorated pots made in and around Arita are known as Imari ware, the name derived from the port of Imari where the pots were sold. Enameled wares, tradition has told us, were begun in Japan by Kakiemon I in 1643. Until documented evidence verifies this, it will suffice to estimate that enameled wares have been produced in Japan, and probably Arita, from about 1650. Since then, the use of enamels grew in popularity only as the carefully guarded secrets of its application leaked out or potters elsewhere developed it from Chinese sources themselves. By the early 19th century, enamels were used in various ways throughout Japan.

Enamel decoration was applied to pieces from various kilns at a single area along one street in Arita where a hand-full of decorators and their families lived and worked. This small area was protected by the Nabeshima officials from intruders so that the secrets of their art were preserved. In the seventeenth century there were eleven families occupied with enamel decorations here; in 1770 the number was raised to sixteen.

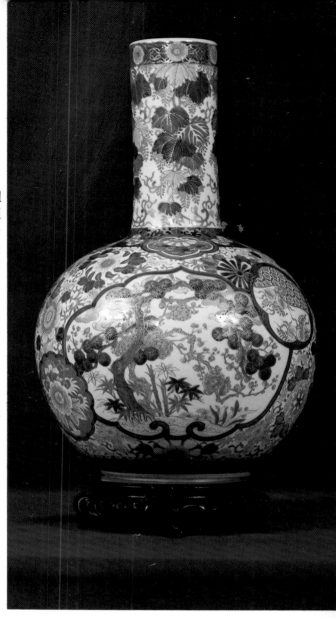

Imari plate and two covered bowls, *left*, bowl, circa 1800, 4½" diameter; plate early 19th century; *right*, bowl for the Chinese market, early 19th century, 4½" diameter, House of the Black Ship, New London.

Imari bottle with pine, plum and bamboo (3-friends) decoration, early 19th century, 14½" high, House of the Black Ship, New London.

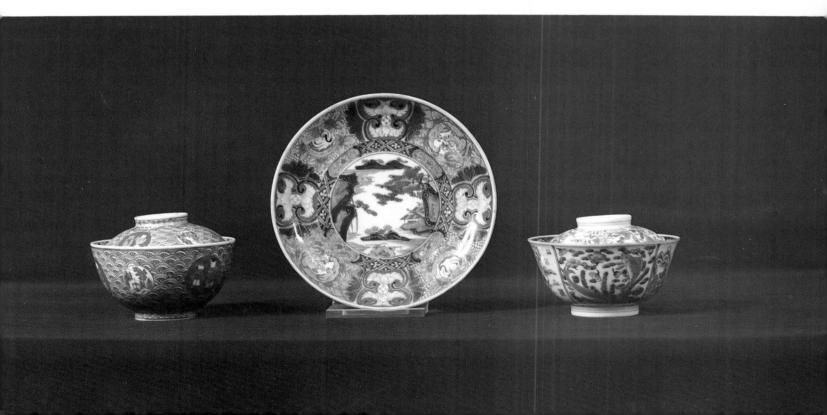

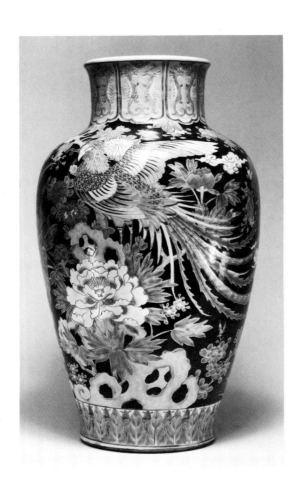

In Imari decorations, influences derived from European art traditions are found. Symmetry, Western-style landscapes and bright colors identify Imari ware. To plain white ware or underglaze blue designs were added gold highlights, red outlines and details, and blue, yellow, black, green and light purple coloring—not all on the same piece necessarily, but variously on different pieces.

In the late 19th century, new manufacturing and decorating methods allowed for larger and ever more elaborate decorations to be made. The first record of the importation of Western-style overglaze color materials into Japan is related to the Edo (the present Tokyo) merchant Usaburo Shimizu, who attended the World Exposition in Paris in 1867. In addition to emissaries from the national government, representatives of the clan governments of Nabeshima and Satsuma attended this exposition where richly decorated Satsuma and Arita wares were displayed. Shimizu acquired some of the Western overglaze color materials and brought them back to Japan with him. These metallic-oxide powders made possible overglaze painting much thinner than could be achieved with traditional Oriental vitreous glazes. At Shimizu's request, in 1869, Kyoho Hattori tested the glazes and found them satisfactory, as he relates in a book he published in 1874. As soon as it was learned that the tests had been successful, the Saga clan invited both Shimizu and Hattori to come to Arita to instruct local potters in their use. [*Japanese Painted Porcelain*, p. 19]

Imari vase with black background, circa 1900, 22" high, © 1986 Sotheby's, Inc.

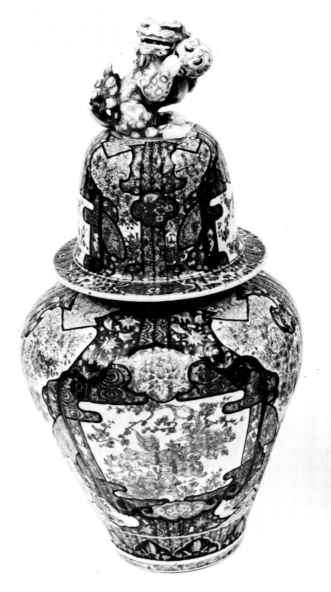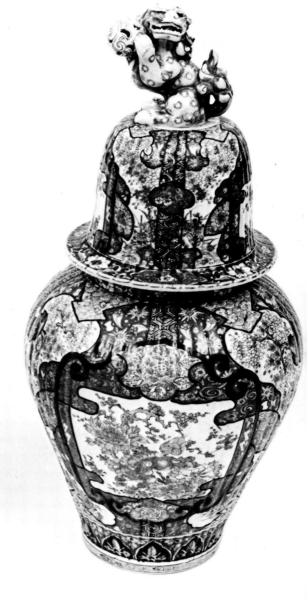

Pair of Imari covered jars with ribbed sides, late 19th century, Flying Cranes Antiques, New York.

Imari Decorative Motifs

"The designs of...Japanese Imari...shows that they were taken in fact from textiles" [Jenyns; p.53] The Japanese customs of covering jars with fabric tied at the neck (see the Kyoto Satsuma jar by Kanzan illustrated on p. 243) and covering gifts with fabric for presentation gave rise to the use of textile patterns as ceramic decorations. Floral and animal designs, landscapes, and illustrations of people became the most common forms of porcelain decoration.

Of the flower patterns, the flower basket is a common motif with many variations suitable to different positions on plates, bowls and vases. Here, a wicker basket with a high handle contains an assortment of flowers. One of the most common flowers found is the chrysanthemum, derived from the Japanese Imperial crest of round shape divided into sixteen petals. Another flower decoration is the paulownia blossom, with three spikes above a leaf with three lobes. The "three friends" decoration combines a plum blossom, a pine branch, and bamboo. The plum blossom may be shown alone, also, as may the peony blossom. The iris is often shown as well.

The animals often represented are the five fabulous creatures of Chinese tradition: the dragon (ryu); the Japanese unicorn (kirin); the Buddhist lion (shishi); the water tortoise with long weed growing from its tail (minogame) and the phoenix bird or bird of Paradise (hoho). Other animals include the tiger and the hare. Also shown are the grasshopper and cicada.

Birds often depicted are ones with a very long tail, cocks and hens, egrets, herons, pheasants, cranes and quail. Fish appear occasionally. Fruits used in decorations include the pomegranate and the chestnut.

Landscapes are less common than the decorations described above, but they appear in both Chinese and in Western styles.

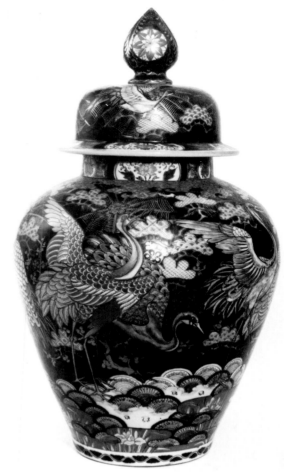

Imari covered jar with cranes in the decoration, late 19th century, 20⅞" high.

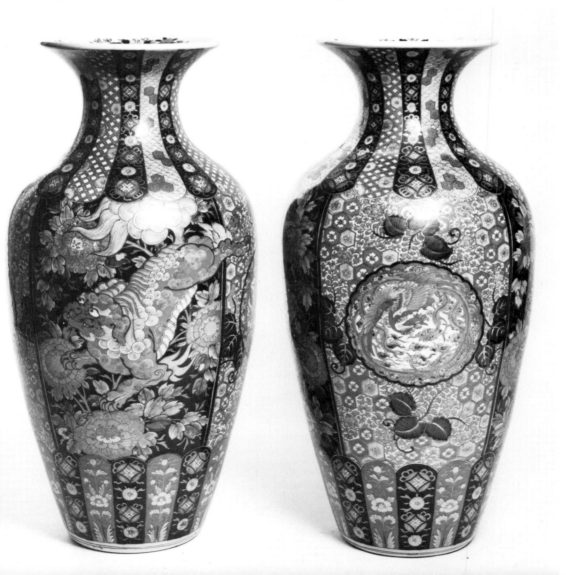

Pair of Imari vases, 93.5 cm high, late 19th century, Christie's, London.

111

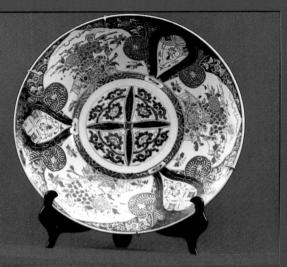

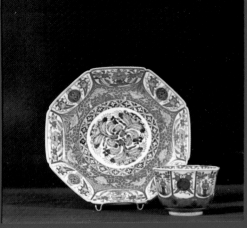

Imari octagonal plate and bowl, early 19th century, plate 8½'' diameter, bowl 3½'' diameter, House of the Black Ship, New London.

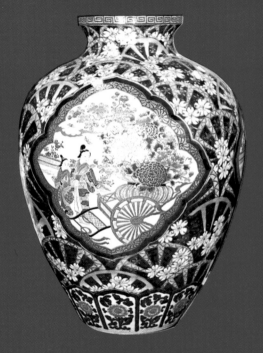

Imari bowl, mid-19th century, 10⅞'' diameter, 5½'' high, Lyman Allyn Museum, New London.

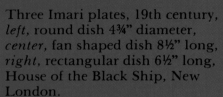

Imari plate with central good luck symbol and spiral ribbons of brocade decoration, early 19th century, 12¾'' diameter, Lyman Allyn Museum, New London.

Imari vase with floral cart decoration, mid-19th century, 25'' high, The Oriental Corner, Los Altos, California.

Three Imari plates, 19th century, *left,* round dish 4¾" diameter, *center,* fan shaped dish 8½" long, *right,* rectangular dish 6½" long, House of the Black Ship, New London.

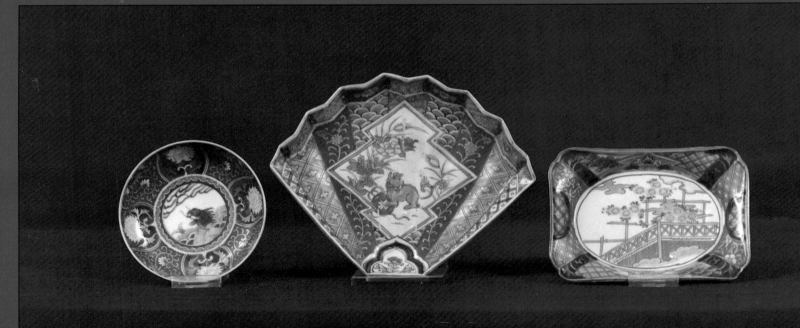

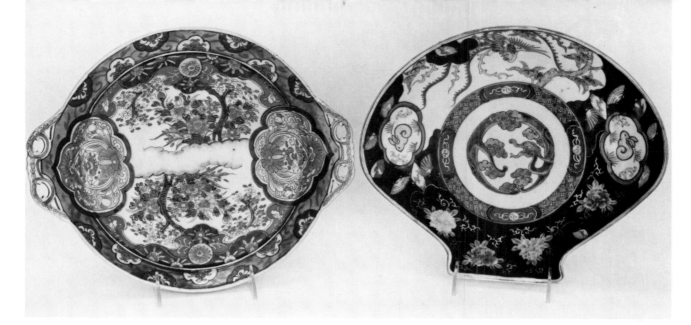

Two Imari dishes, each 12" wide, 19th century, Flying Cranes Antiques, New York.

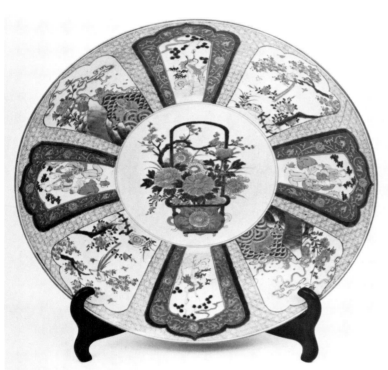

Imari plate with rim panels and floral basket, 19th century, 21" diameter, Flying Cranes Antiques, New York.

Pair of Imari plates with pierced rims, 8" high, 12" wide, late 19th century, Flying Cranes Antiques, New York.

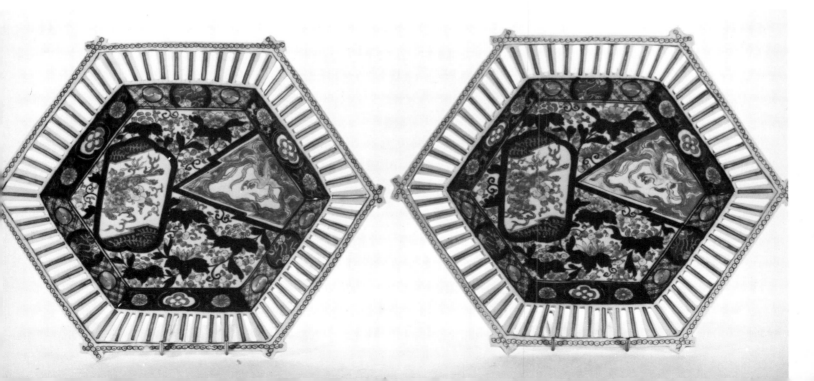

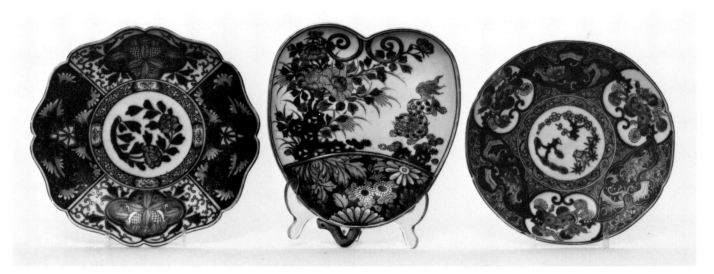

Three Imari dishes, late 19th century, plate on right with three friends decoration in center; heart-shaped dish, 9 2/3'' long, Sotheby's, London.

Imari bottle with bouquet and streamers in floral decoration, 19th century, 29¾'' high, Christie's, London.

Pair of Imari plates with cart decoration, 19th century, 16'' diameter, Flying Cranes Antiques, New York.

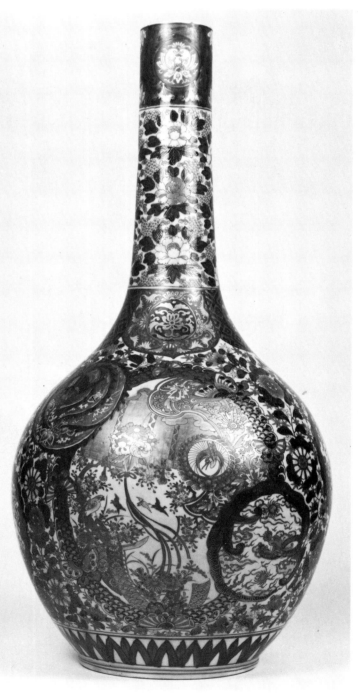

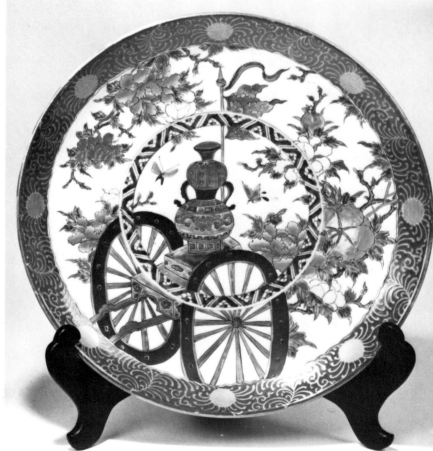

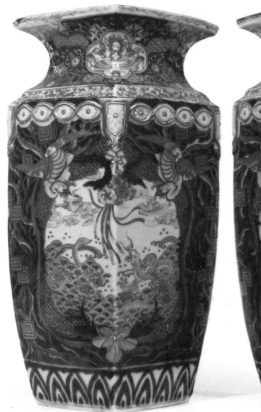
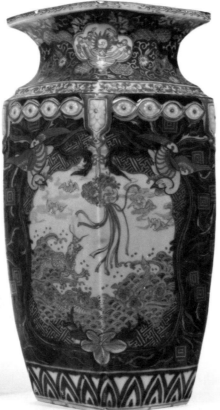

Imari vases with bouquet and streamers in bird and floral decoration and some relief design, late 19th century, 14¾'' high, Sotheby's, London.

Imari vase with bouquet and streamers in landscape with table decoration, late 19th century, 48'' high, © 1986 Sotheby's, Inc.

Imari plate with garden scene including floral carts, early 19th century, 23½'' diameter, Sotheby's, London.

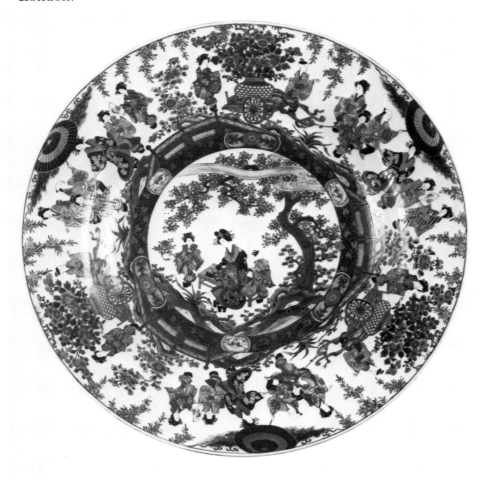

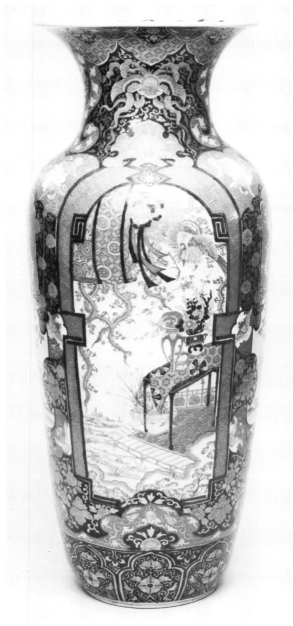

115

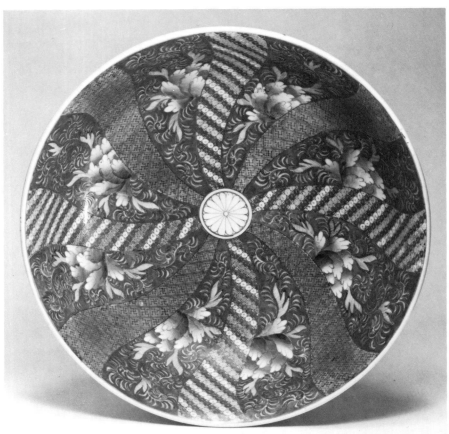

Imari bowl of swirled ribbon decoration on floral ground, late 19th century, 16½'' diameter, © 1986 Sotheby's, Inc.

Center left:
Imari fish bowl with floral decoration, late 19th century, 15'' diameter, Flying Cranes Antiques, New York.

Bottom left:
Imari jardiniere with ribbed sides and stylized floral decoration, late 19th century, 18'' diameter, Flying Cranes Antiques, New York.

Imari umbrella stand, 24'' high, 19th century, Flying Cranes Antiques, New York.

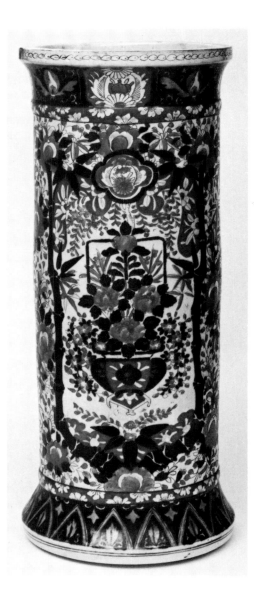

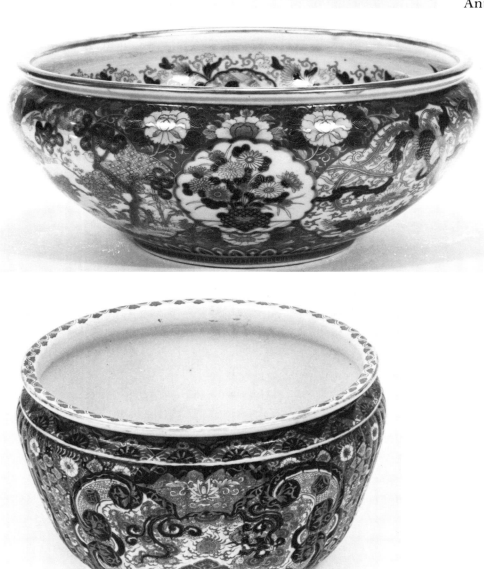

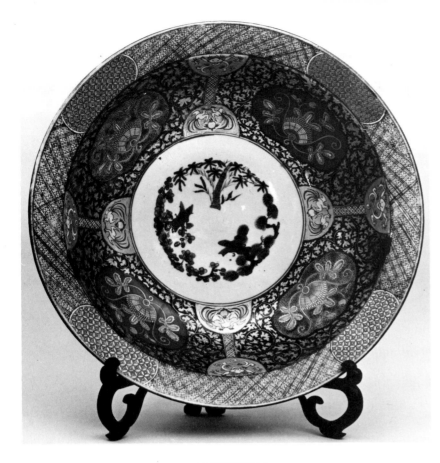

Imari bowl with three friends decoration in center, 19th century, 18'' diameter, Flying Cranes Antiques, New York.

Center left:
Imari bowl, floral and textile designs, late 19th century, 12'' diameter, Flying Cranes Antiques, New York.

Bottom left:
Imari bowl with stylized floral decoration, late 19th century, 16'' diameter, 7½'' high, Flying Cranes Antiques, New York.

Imari umbrella stand with poppies decoration, late 19th century, 24'' high, © 1986 Sotheby's, Inc.

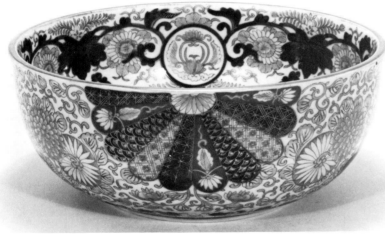

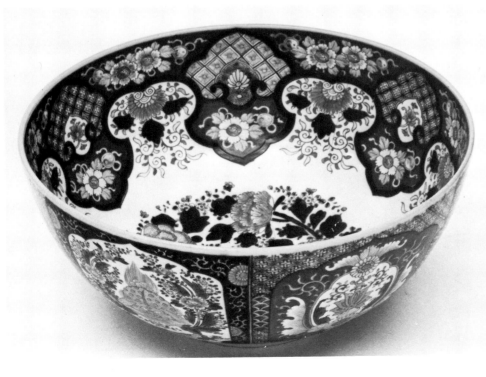

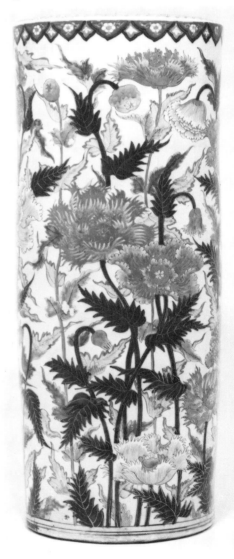

117

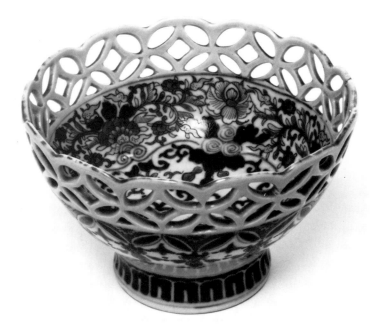

Imari bowl with tall foot rim and pierced rim, late 19th century, 5⅞'' diameter.

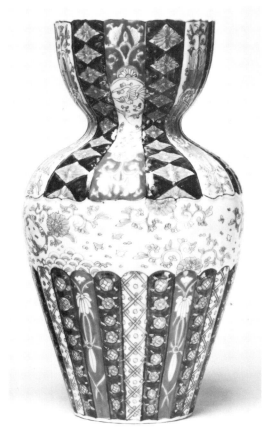

Pair of Imari vases with fluted sides, late 19th or early 20th century, 14¼'' high, © 1986 Sotheby's, Inc.

Imari covered jar, 19th century, Henry Woods Wilson, London.

Imari 10-sided bowl with paneled floral decoration, 19th century, 10'' diameter, Flying Cranes Antiques, New York.

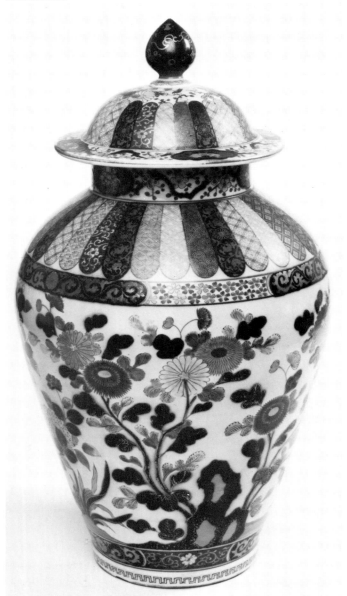

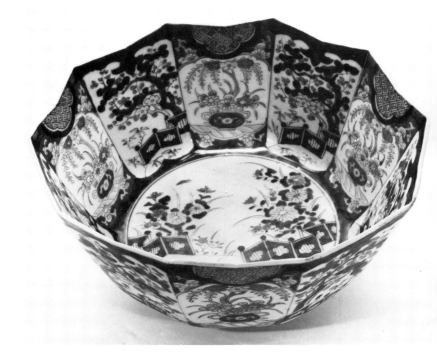

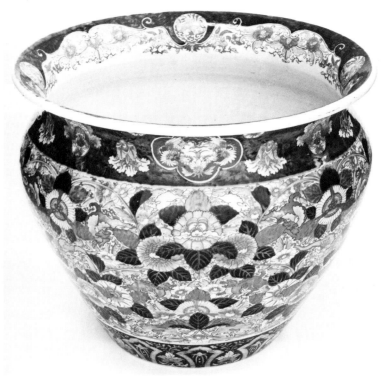

Imari fish bowl with animal and floral decoration, c. 1880, 22" diameter, 24" high, Flying Cranes Antiques, New York.

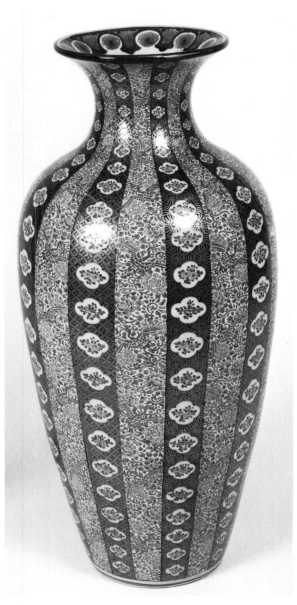

Imari vase, 19th century, 31" high, © 1986 Sotheby's, Inc.

Pair of Imari vases, 19th century, 13" high, © 1986 Sotheby's, Inc.

Imari bowl with floral decoration, late 19th century, Flying Cranes Antiques, New York.

119

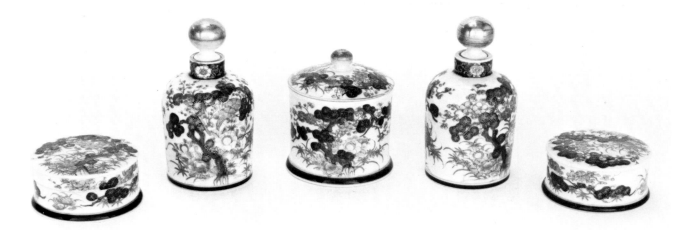

Imari cosmetics set with pine, plum and bamboo (3-friends) decoration, circa 1870-1880, bottles 5'' high, Flying Cranes Antiques, New York.

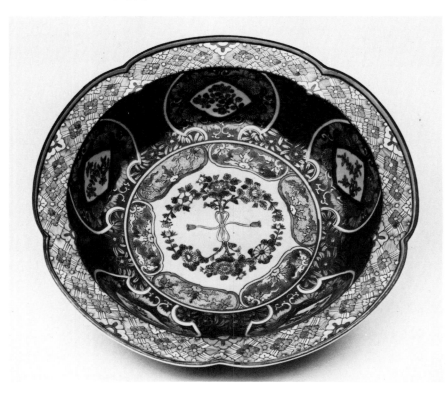

Imari bowl, early 19th century, 16'' diameter, Flying Cranes Antiques, New York.

Imari tray with garden scene, 19th century, 12'' long, 9'' wide, Flying Cranes Antiques, New York.

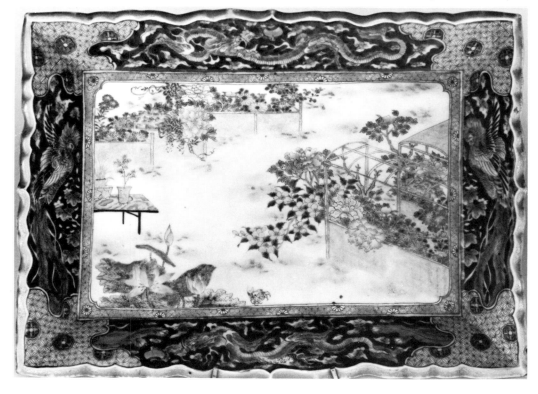

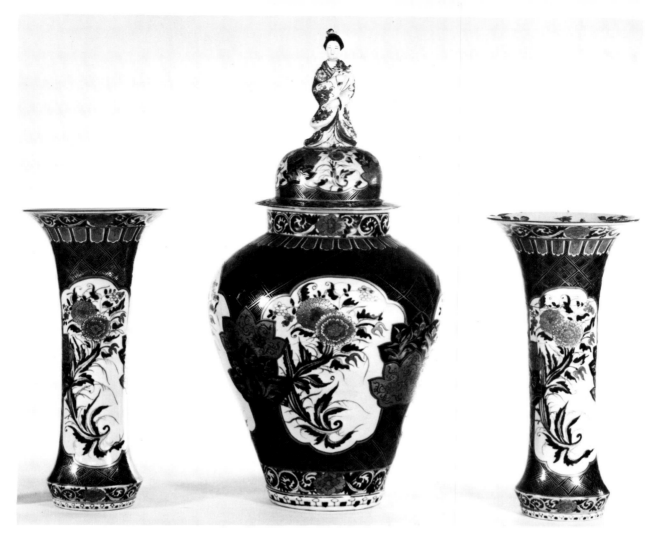

Imari covered jar and two vases, late
19th century, jar 25 1/3'' high, vases
16'' high, British Museum, London.

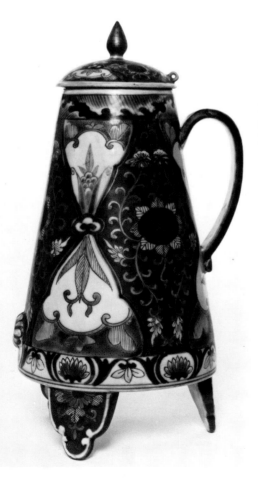

Imari covered jar, early 19th
century, Henry Woods Wilson,
London.

Ewer and cover with stylized
floral decoration on three
blade feet, late 19th century,
13½'' high, Sotheby's,
London.

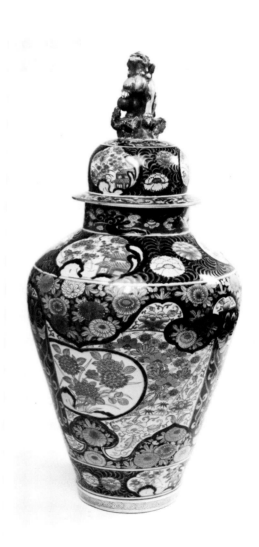

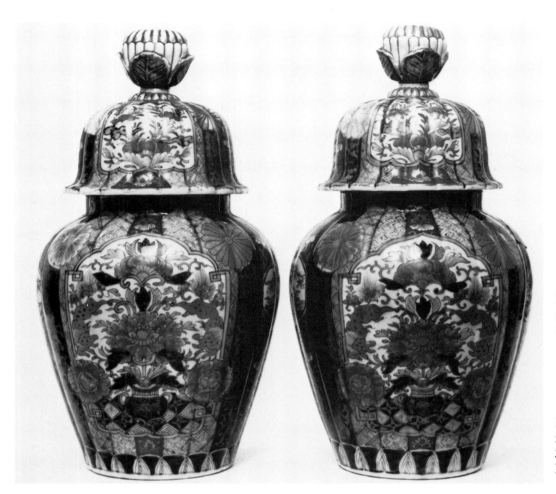

Pair of Imari covered jars with lobed sides, late 19th century, 14½'' high, Sotheby's, London.

Pair of Imari vases with naturalistic floral decoration, early 20th century 37'' high, Henry Woods Wilson, London.

Imari bowl with floral decoration inside and spiral ribbons of brocade decoration outside, late 19th century, 16¼'' diameter, Sotheby's, London.

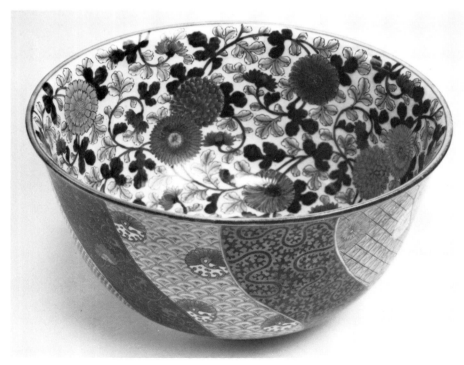

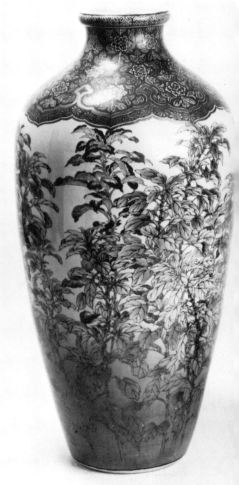

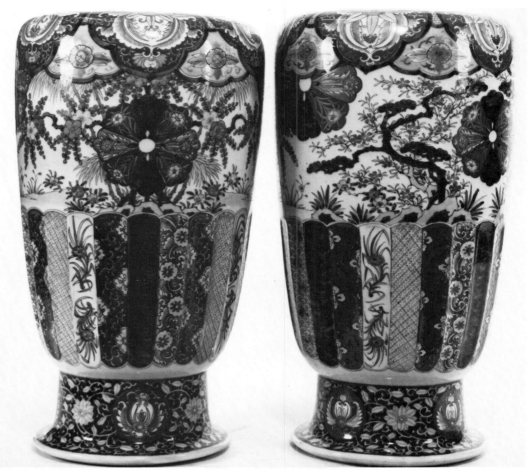

Pair of Imari vases with pine, plum and bamboo (3-friends) decoration and fluted, brocade paneled sides, late 19th century, 18¼'' high, Sotheby's, London.

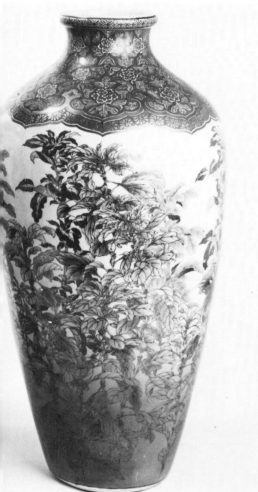

Imari incense burner and cover, 8¾'' high, late 19th century, © 1986 Sotheby's, Inc.

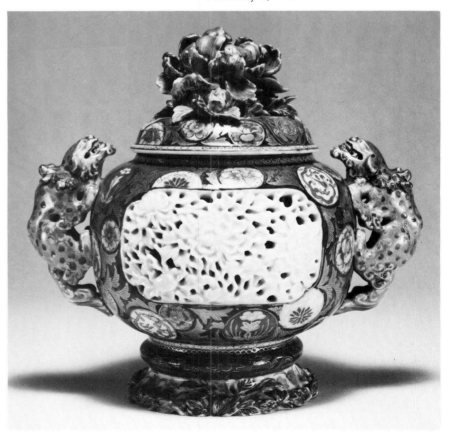

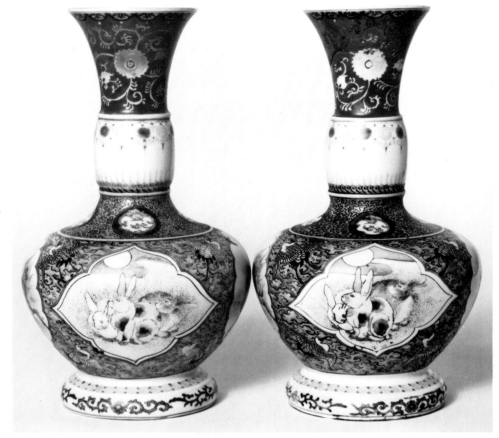

Pair of Imari vases with rabbits in panels, c. 1900, 11 2/3" high.

Imari covered jar, 19th century, 24" high, Flying Cranes Antiques, New York.

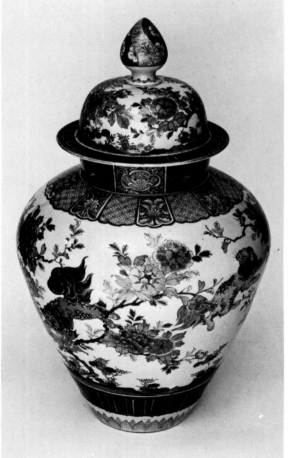

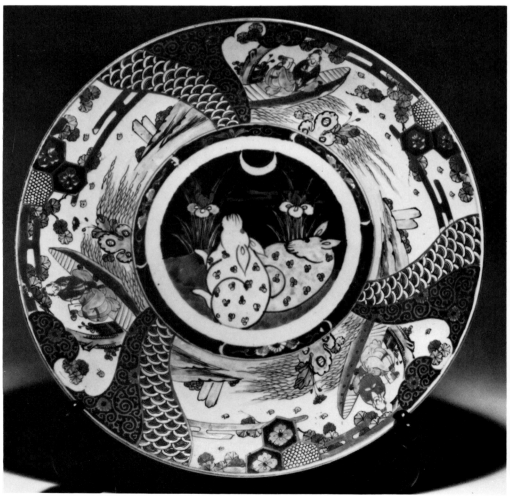

Imari plate, early 19th century, 18" diameter, Flying Cranes Antiques, New York.

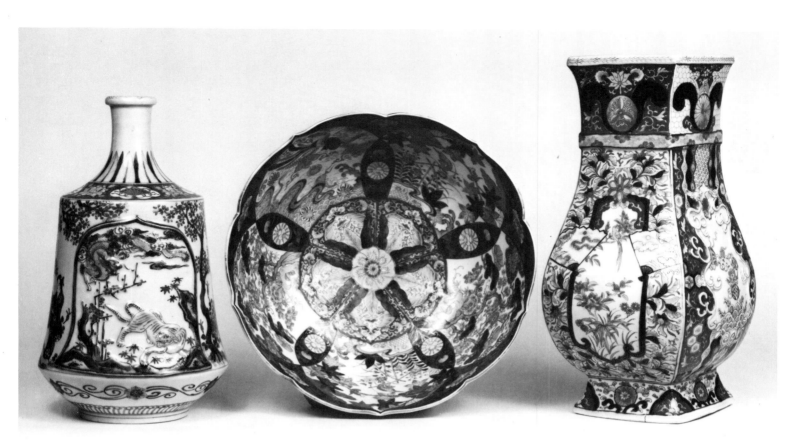

Three Imari forms, 19th century, *left*, bottle with relief decoration and six-character mark on base, 12¼" high; *center*, bowl, 11⅞" diameter; *right*, four-sided, pear shaped vase with relief decoration, 14" high, Christie's, London.

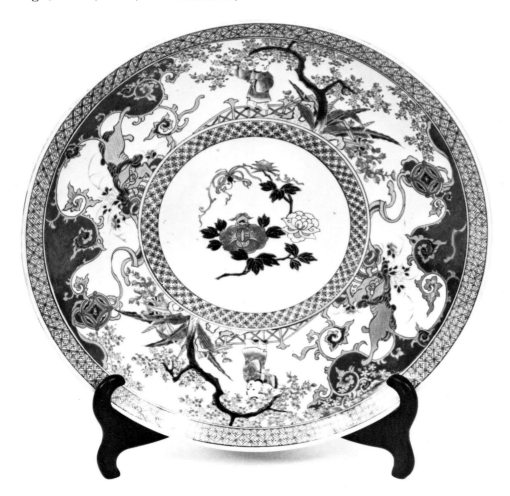

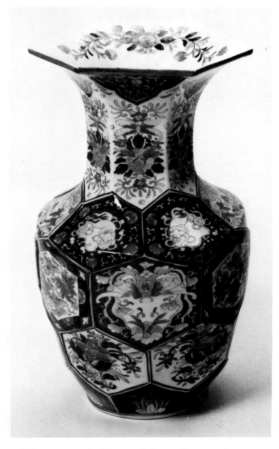

Hexagonal, faceted Imari vase, late 19th century, 18½" high, Sotheby's, London.

Imari plate, 21" diameter, late 19th century, Flying Cranes Antiques, New York.

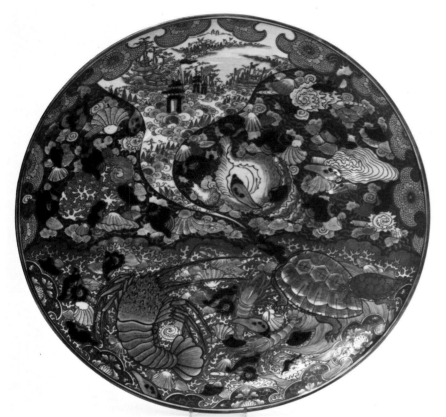

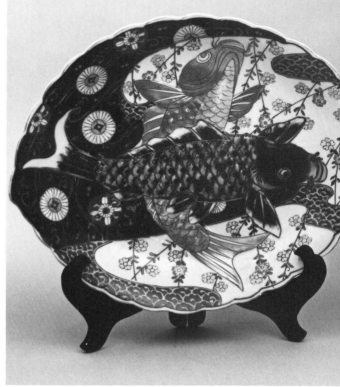

Pair of Imari plates with fish and stylized floral decoration, late 19th century, 10'' long, Flying Cranes Antiques, New York.

Imari plate with mythological underwater scene of a turtle describing life on land to a lobster, late 19th century, 24⅜'' diameter, Sotheby's, London.

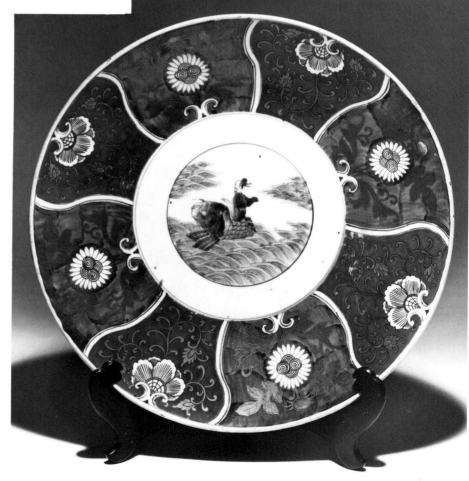

Imari plate with decoration of an Immortal riding a fish, paneled border, 19th century, Flying Cranes Antiques, New York.

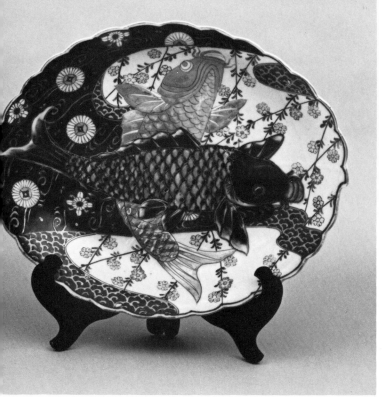

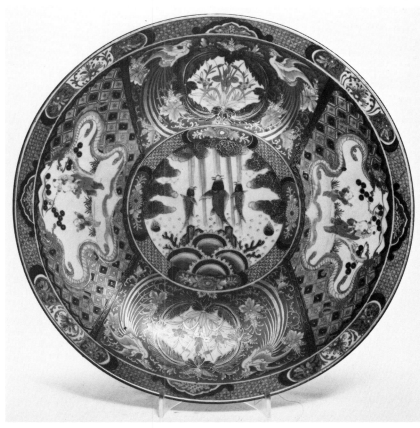

Imari bowl decorated with three
carp jumping a waterfall and panels
of small boys playing in a garden,
late 19th century, 24⅛" diameter,
Sotheby's, London.

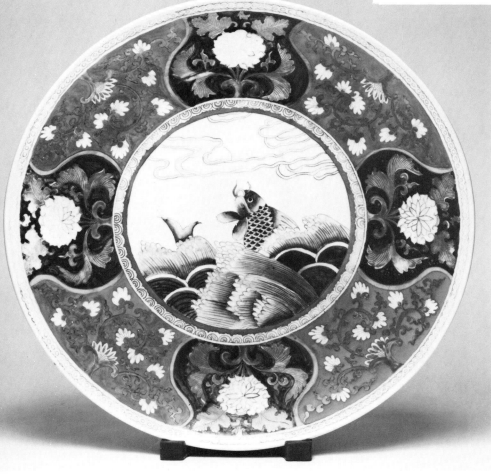

Imari plate decorated with a fish
leaping from ocean waves and a
floral paneled border, circa 1900,
21" diameter, © 1986 Sotheby's, Inc.

127

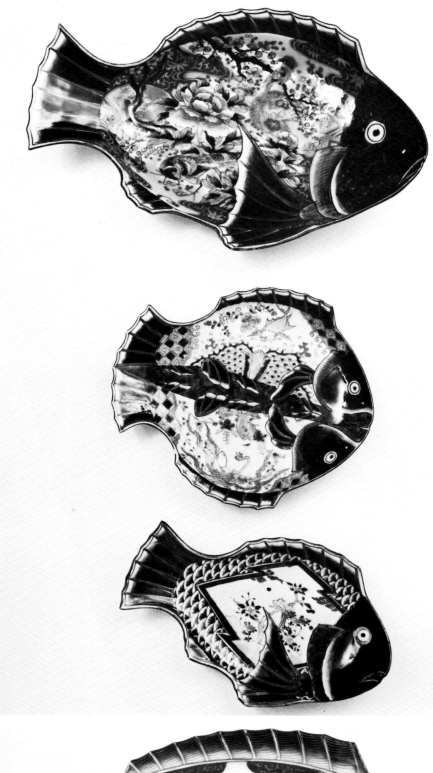

Three Imari fish-shaped dishes late 19th century, double fish plate 10½' long, Flying Cranes Antiques, New York.

Imari fish-shaped dish, late 19th century, 16'' long, Flying Cranes Antiques, New York.

Imari fish-shaped dish, late-19th century, 13¾'' long, British Museum, London.

Two Imari fish-shaped dishes, 12'' long, late 19th century, Flying Cranes Antiques, New York.

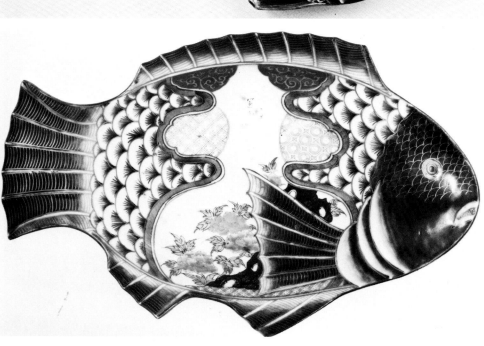

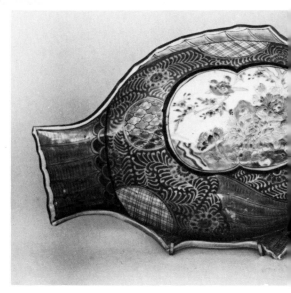

Imari plate decorated with two carp jumping a waterfall, 19th century, 21½" diameter, Gibbons Collection.

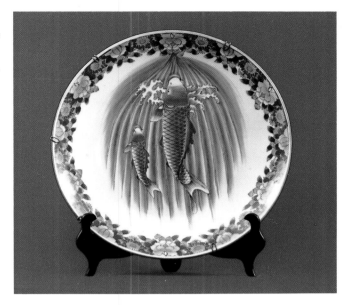

Imari fish-shaped dish decorated with a scene of three people fishing, mid-19th century, 16¾" long, House of the Black Ship, New London.

Imari fish-shaped dish with fish scales pattern, 13¼" long, Gibbons Collection.

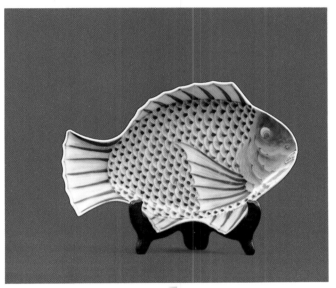

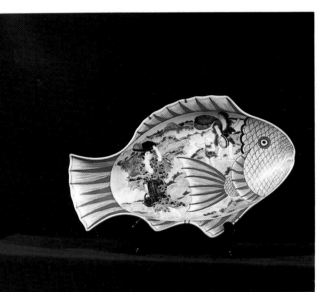

Imari fish-shaped dish with pine, plum and bamboo (3-friends) decoration, mid-19th century, 13" long, House of the Black Ship, New London.

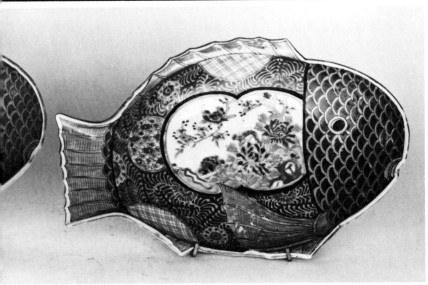

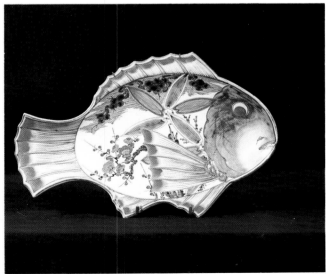

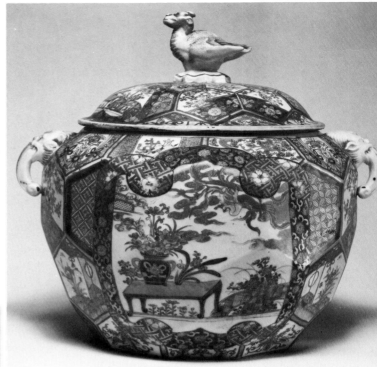

Imari tureen and cover of faceted hexagonal form with large floral and bird decorated side panels and two gremlin's head handles, bird finial; mid-19th century, 14″ diameter, © 1986 Sotheby's, Inc.

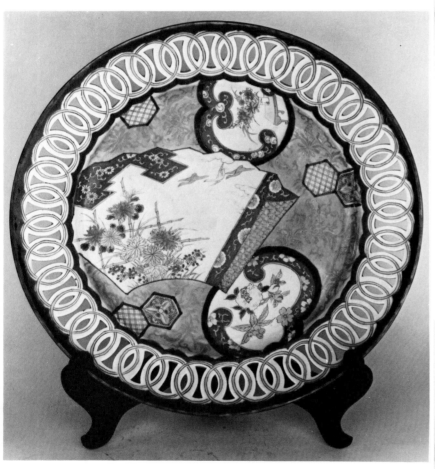

Imari plate with pierced, connected ring design on rim, 19th century, 16″ diameter, Flying Cranes Antiques, New York.

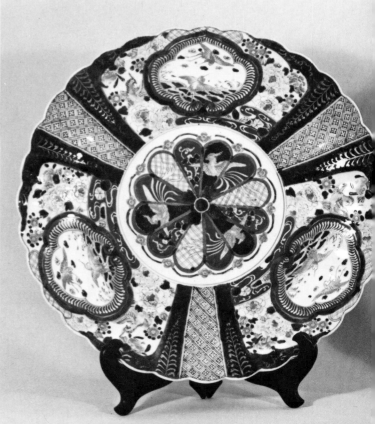

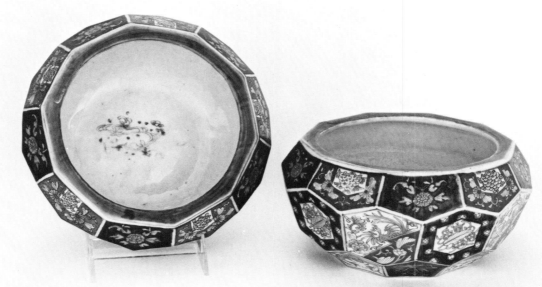

Pair of Imari bowls of dodecahedron shape, mid-19th century, 4½" high, opening 6" wide, Flying Cranes Antiques, New York.

Two Imari plates with scalloped rims, *left,* with Western-inspired symmetrical and paneled decoration; *right,* with traditional Japanese asymmetrical fan decoration, each 18" diameter, 19th century, Flying Cranes Antiques, New York.

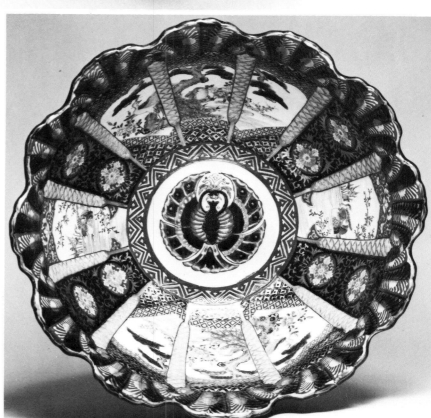

Imari bowl with scalloped rim, mid-19th century, 16½" diameter, © 1986 Sotheby's, Inc.

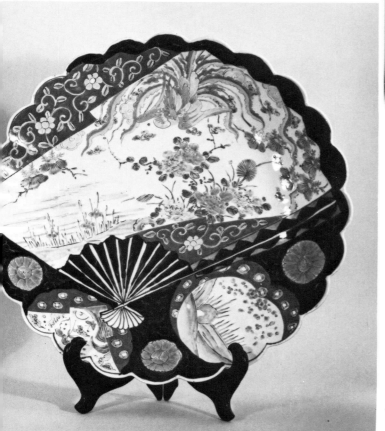

131

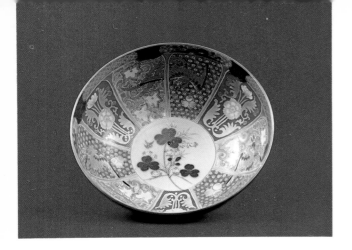

Imari bowl with brocade decorated
panels, early 19th century, Gibbons
collection.

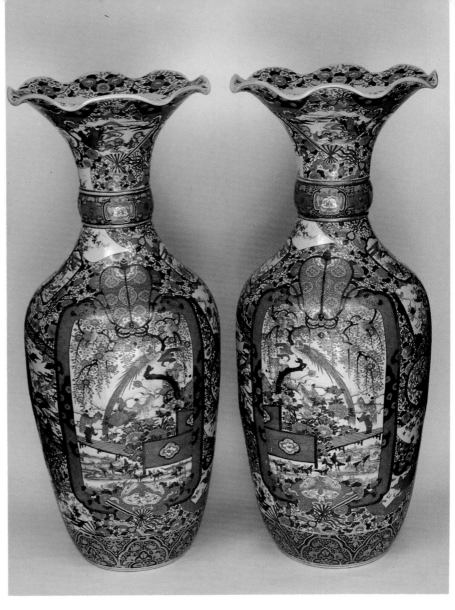

Pair of Imari vases, 19th century,
50'' high, Private Collection.

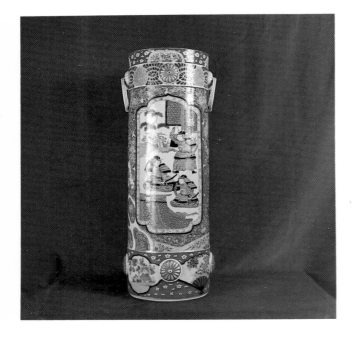

Imari umbrella stand with Samurai
in the decoration, late 19th century,
30'' high, Flying Cranes Antiques,
New York.

Imari plate, late 19th or early 20th
century, 13'' diameter, Gibbons
Collection.

Imari platter, late 19th or early 20th
century, Philip Van Brunt
Collection.

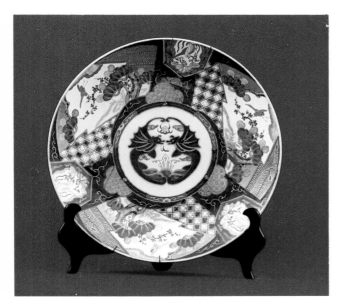

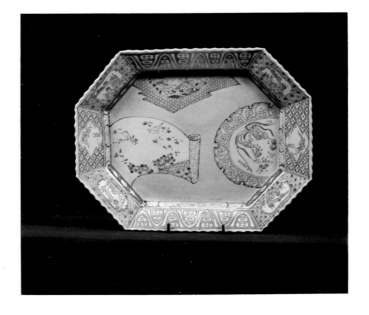

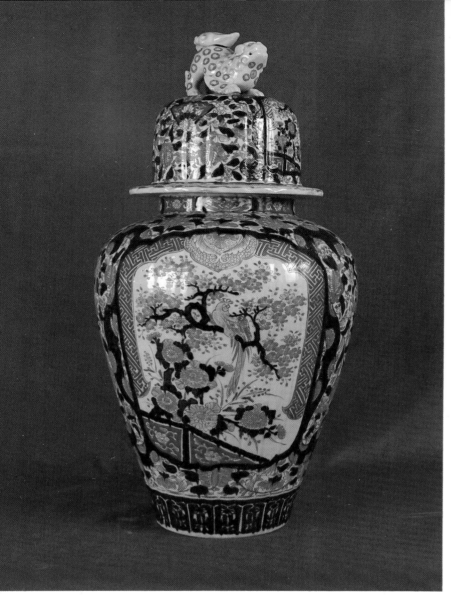

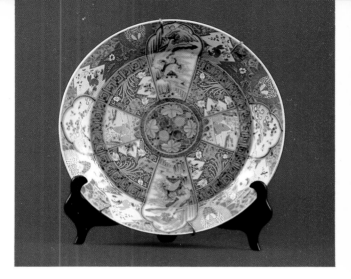

Imari plate, early 19th century, 17½"
diameter, Gibbons Collection.

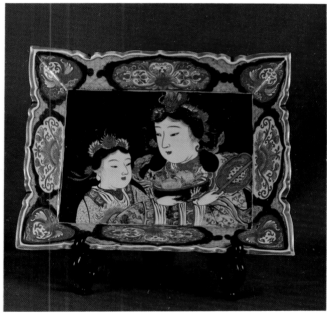

Imari covered jar with ribbed sides,
19th century, 24" high.

Three Imari dishes, *left*, tea cup, 4"
diameter, House of the Black Ship,
New London; *center*, ovoid dish, 8"
long, Philip Van Brunt Collection;
right, square dish, 5¼" wide, House
of the Black Ship, New London.

Imari tray with matte brown
background, Courtesan lady and
child decoration, mid-19th century,
13⅞" wide x 11¾" high. Flying
Cranes Antiques, New York.

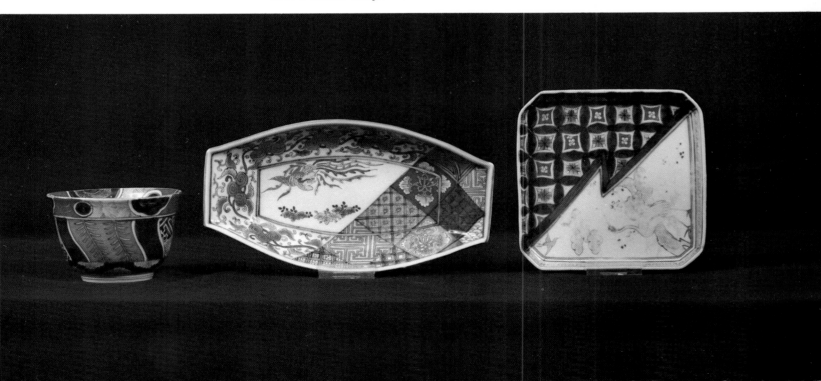

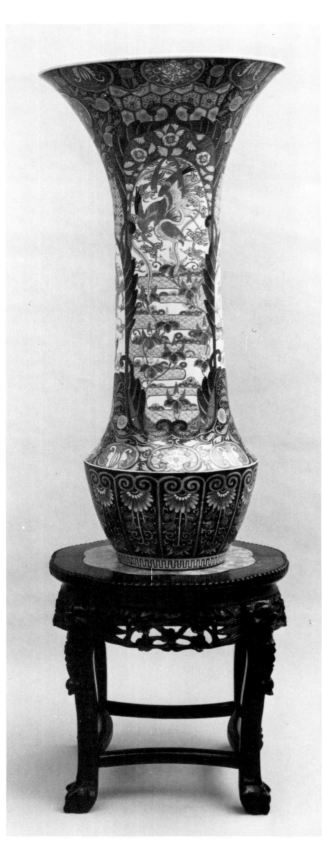

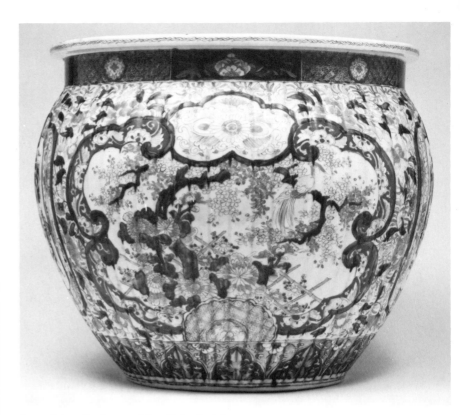

Imari jardiniere with ribbed sides, late 19th century, 16'' high, 17'' diameter, © 1986 Sotheby's, Inc.

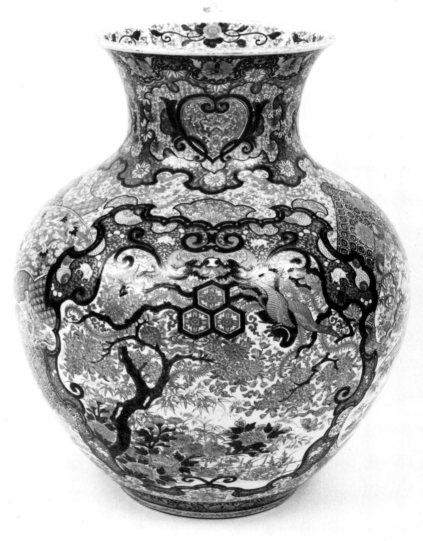

Imari vase, late 19th century, 37½'' high, Flying Cranes Antiques, New York.

Imari vase with brocade and floral decoration, 19th century, Flying Cranes Antiques, New York.

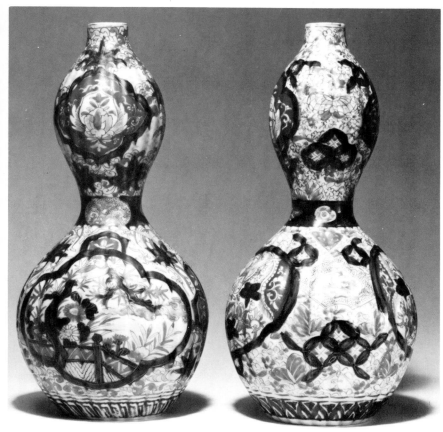

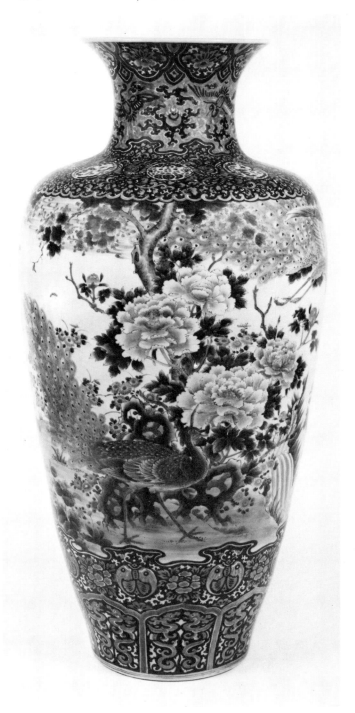

Pair of Imari double gourd vases with ribbed sides, circa 1900, 12½'' high, © 1986 Sotheby's, Inc.

Imari vase, late 19th century, 46'' high, © 1986 Sotheby's, Inc.

Imari bowl, mid-19th century, 12'' diameter, 10'' high, Flying Cranes Antiques, New York.

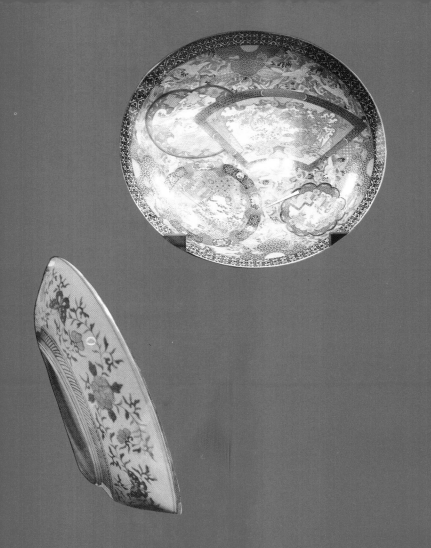

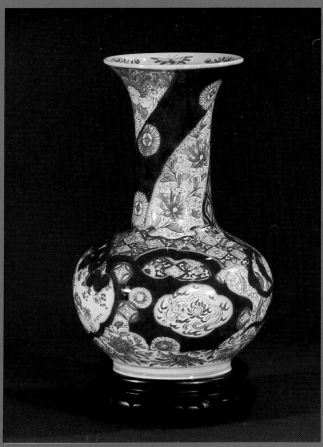

Imari vase, early 19th century, 9½"
high, 6" wide, Asian Fine Arts,
Minneapolis.

Two Imari plates, mid-19th century,
left, 8" diameter, House of the Black
Ship, New London; *right*, 7¾"
diameter, Philip Van Brunt
Collection.

Imari plate dated 1878 found in
London, 35 1/3" diameter, Kyushu
Ceramic Museum, Arita.

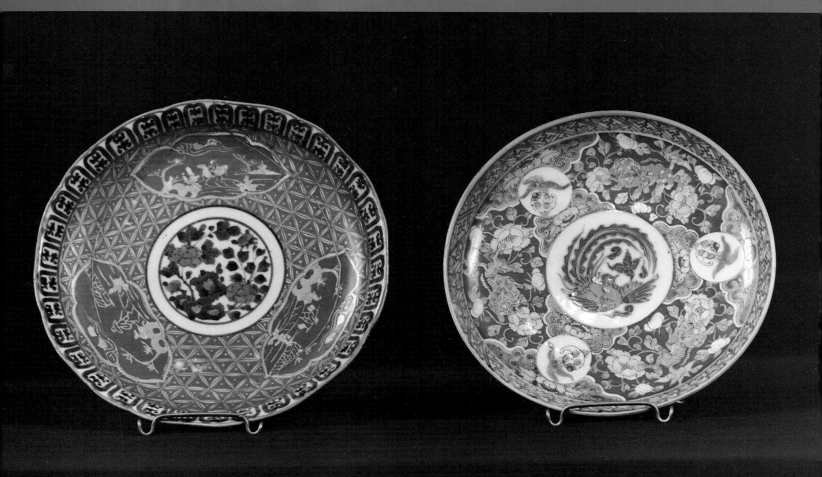

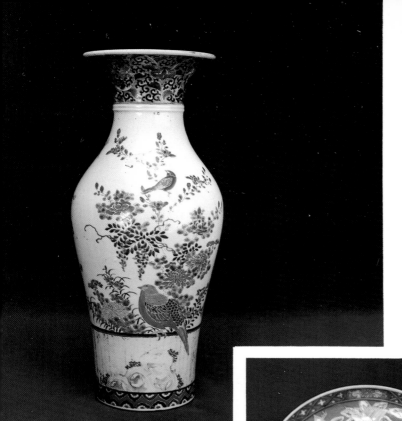

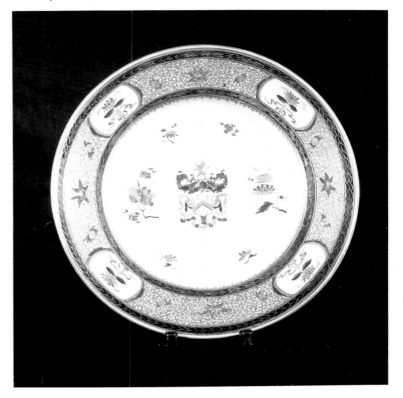

Imari water jar, circa 1880, 10½''
high, Flying Cranes Antiques, New
York.

Imari vase with Chinese style
decoration, late 19th century, 15½''
high.

Imari plate, bowl and lid decorated
with fanciful coat of arms, not
identified, 19th century, plate 7''
diameter, lid 4¾'' diameter, House
of the Black Ship, New London.
Imari floral dec.

Imari plate with Nichols family coat
of arms, late 18th or early 19th
century, 15¾'' diameter, James
Galley Antiques, Rahns,
Pennsylvania.

Imari plate with unidentified
European coat of arms, late 18th or
early 19th century, 15½'' diameter,
James Galley Antiques, Rahns,
Pennsylvania.

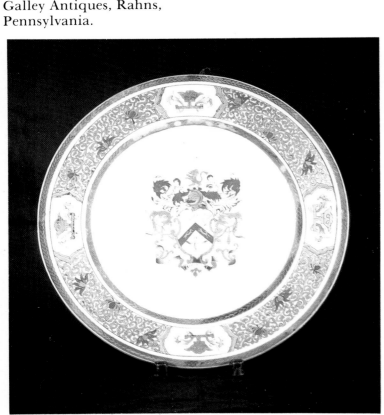

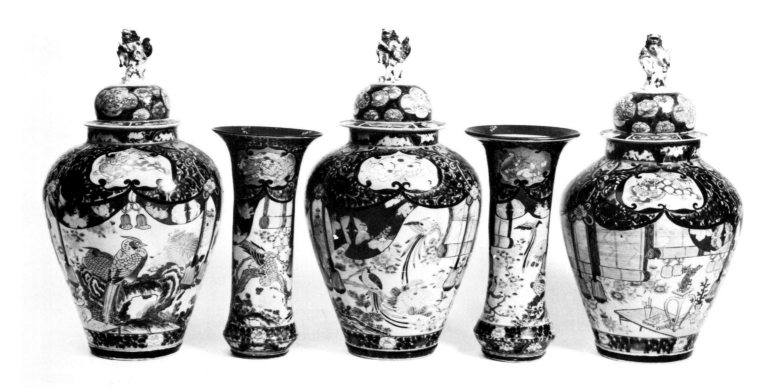

Imari 5-piece garniture of three covered jars and two vases, 19th century, Henry Woods Wilson, London.

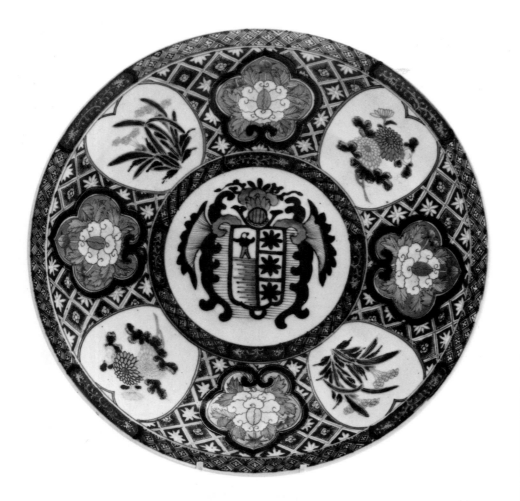

Imari plate with fanciful coat of arms, not identified, six-character mark of Ch'eng Hua, 19th century, 14½'' diameter, Sotheby's, London.

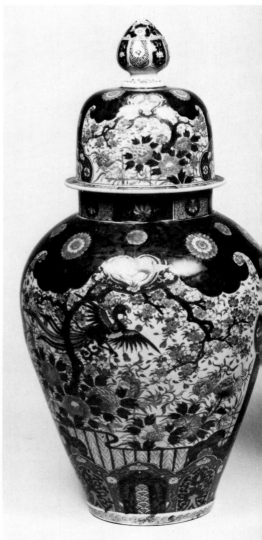

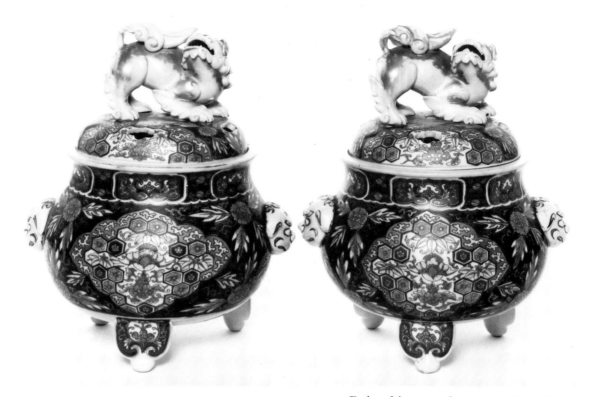

Pair of incense burners with pierced covers, late 19th century, 13 1/3'' high, Sotheby's, London.

Left, Imari jar and cover, 30¾'' high, *right*, Imari vase, 27¼'' high, both 19th century, Christie's, London.

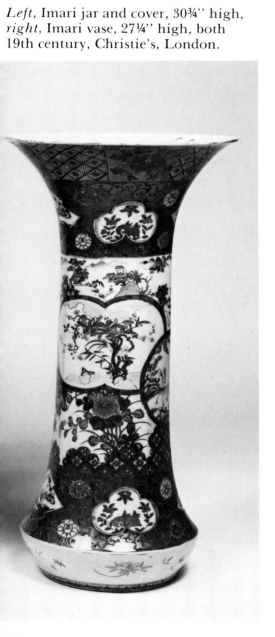

Pair of Imari covered jars, late 19th century, 51'' high, Christie's, London.

Imari or Kutani chicken, 7'' high, House of the Black Ship, New London.

Imari or Kutani seated dog, unmarked, 6'' high, late 19th century, Private collection.

Imari or Kutani hawk, unmarked, bisque body, 14'' high, late 19th or early 20th century, Private collection.

Imari figure of a parrot, 19th century, 11¼" high, James Galley Antiques, Rahns, Pennsylvania.

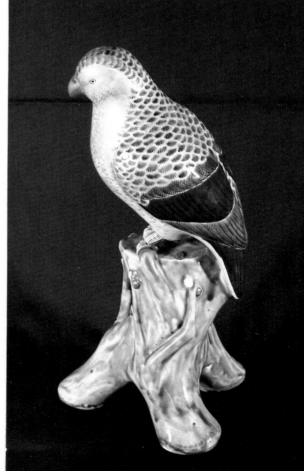

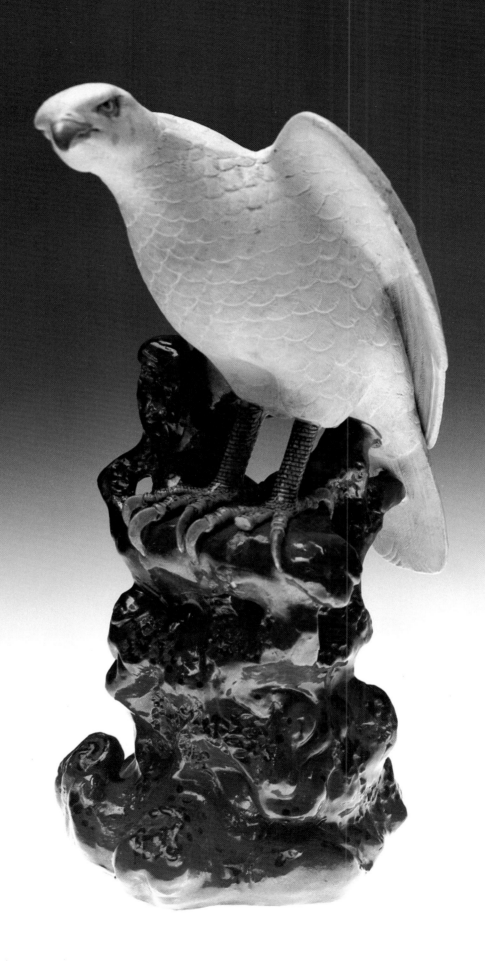

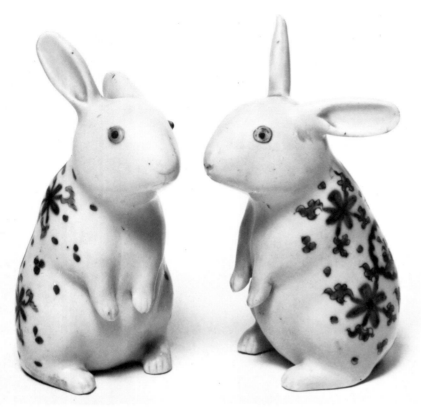

Pair of Imari rabbit figures with enamel floral decoration, late 19th century, 6¼" high.

Pair of duck shaped pitchers, mid-19th century, 8¾" high, Sotheby's, London.

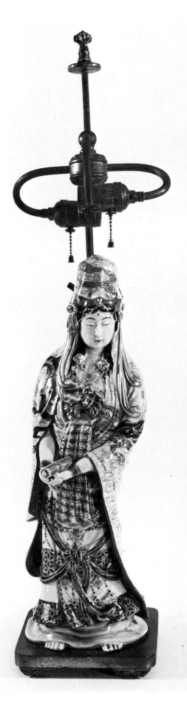

Imari figure of a courtesan, 16" high, Flying Cranes Antiques, New York.

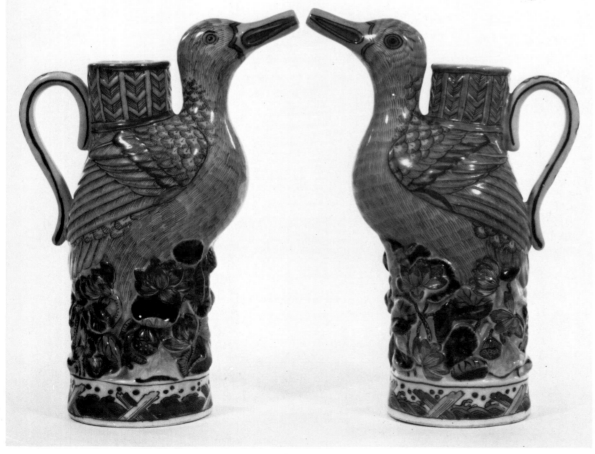

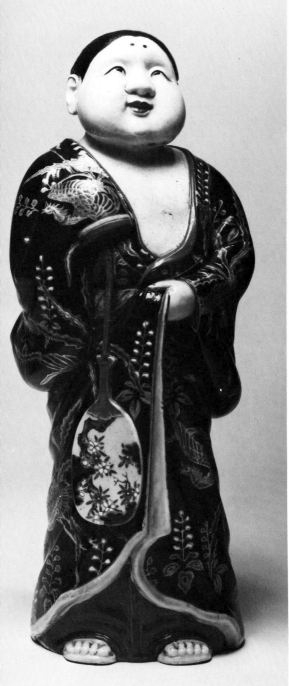

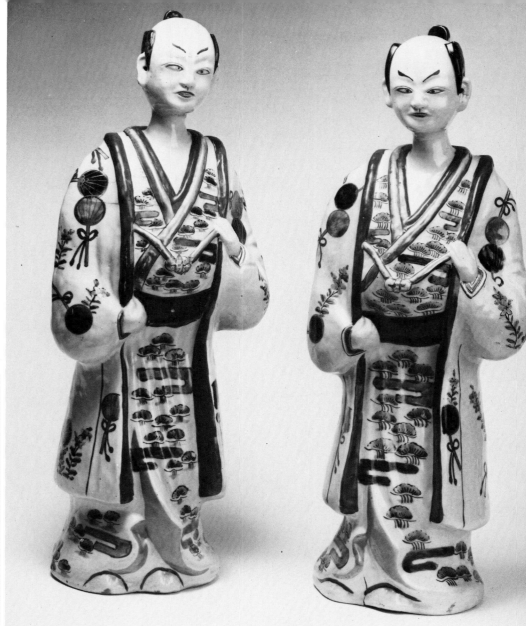

Pair of Imari figures, early 19th century, Henry Woods Wilson, London.

Imari figure of Okame, 19th century, 18⅞" high, © 1986, Sotheby's, Inc.

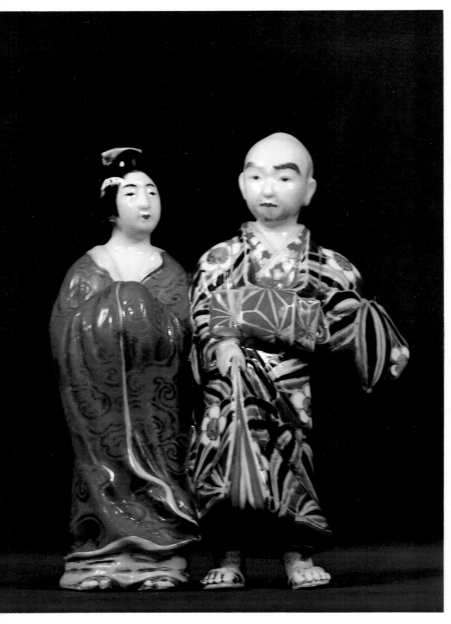

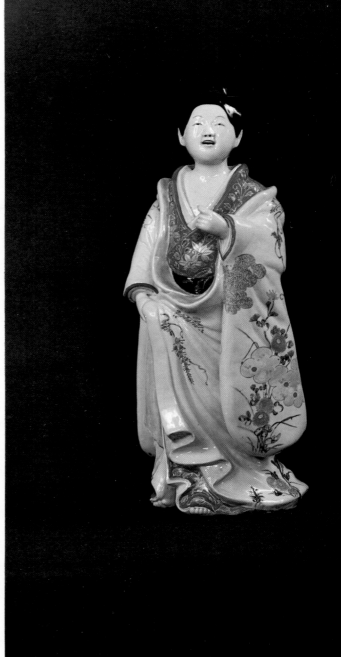

Two Imari figures of a gentleman and geisha, early 19th century, 9" high, House of the Black Ship, New York.

Imari figure of a courtesan, 19th century, 19" high, Norwich Free Academy, Norwich, Conn.

Imari bowl with landscape decoration including European-style buildings and hay stacks, base with blue Dutch-style mark, crack repaired with gold solder. 11" diameter, House of the Black Ship, New London.

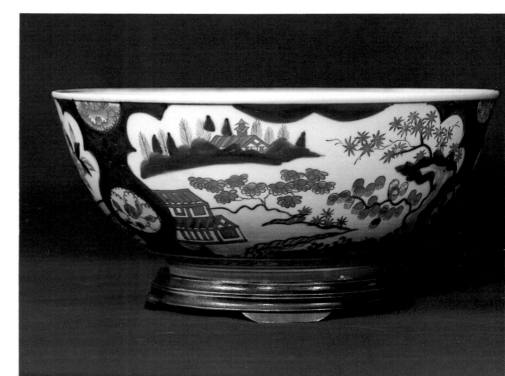

144

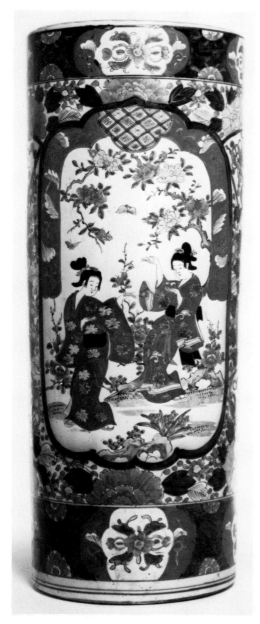

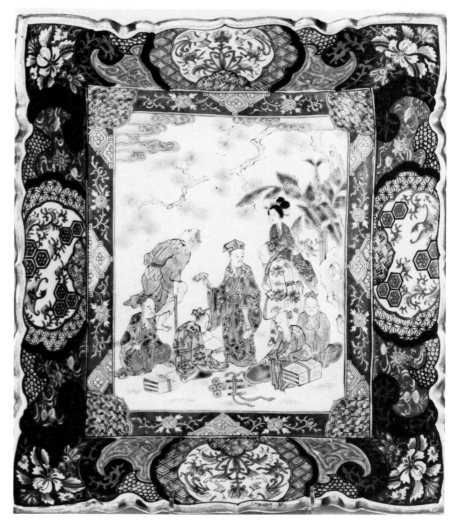

Imari umbrella stand, late 19th century, 24½" high, Sotheby's, London.

Imari rectangular tray with pastel colored robes on the 8-Immortals shown, 11½" high, 14" wide, late 19th century, Flying Cranes Antiques, New York.

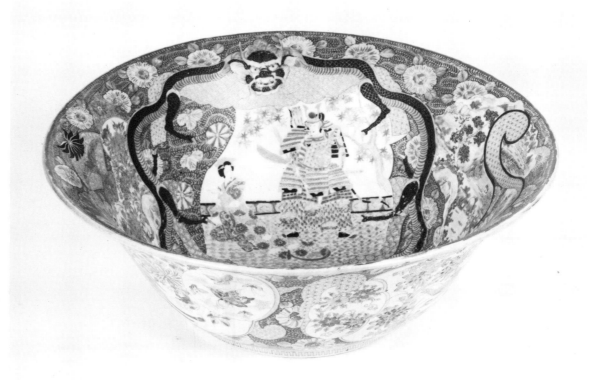

Imari bowl with Samurai in the decoration, mid-19th century, 24" diameter, © 1986, Sotheby's, Inc.

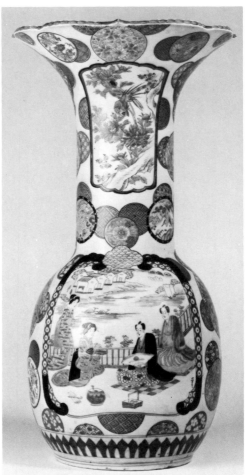

Imari vase, mid-19th century, 25½"
high, © 1986. Sotheby's, Inc.

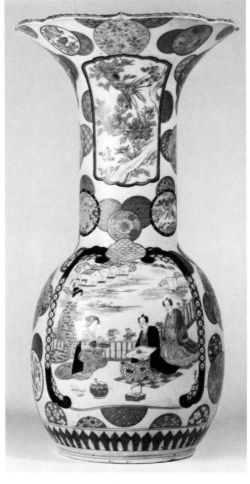

Pair of Imari vases with women by
the seashore and cranes in
decoration, late 19th century, 24"
high, © 1986, Sotheby's, Inc.

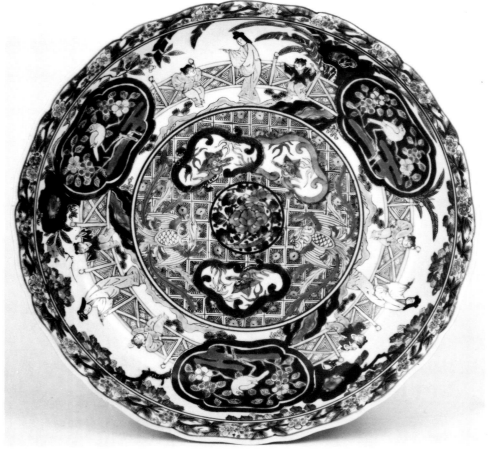

Imari plate with gently scalloped
rim, marked Fukki Chosmun
(riches, honor and enduring spring),
attributed to Okawachi kiln, 12¼"
diameter, Victoria and Albert
Museum, London.

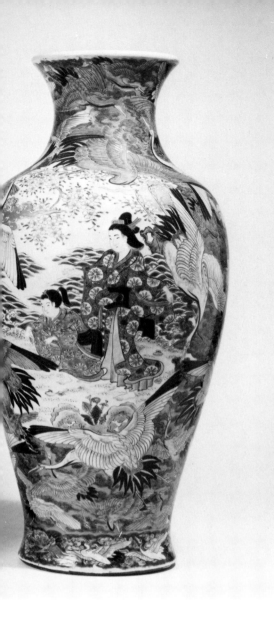

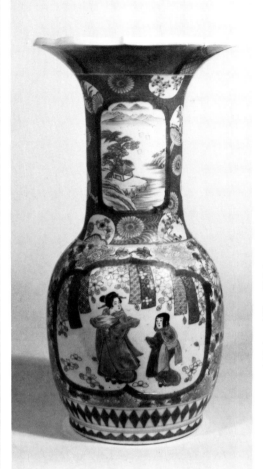

Imari vase reputed to have been brought to the United States from Japan about 1858 by Admiral Samuel F. duPont, 21⅝" high, top-11⅞" diameter, Courtesy of The Henry Francis duPont Winterthur Museum.

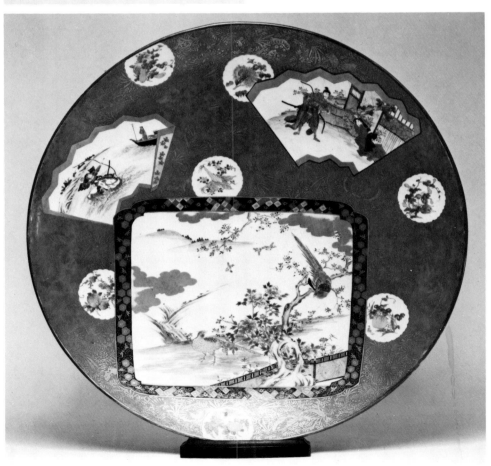

Imari plate with panels of decoration including birds and archers, late 19th century, 25½" diameter, © 1986, Sotheby's, Inc.

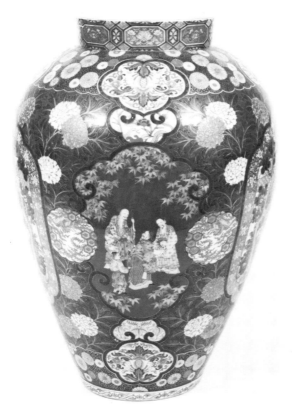

Imari jar, late 19th century, 31"
high, © 1986, Sotheby's Inc.

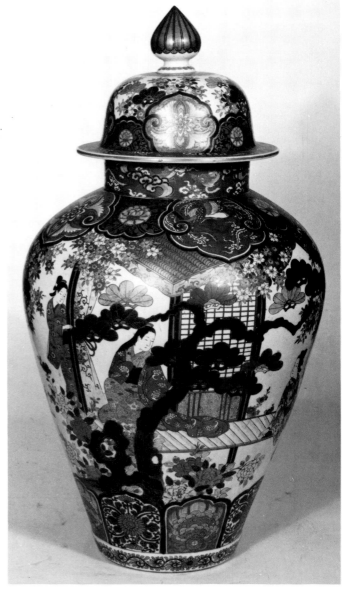

Imari covered jar, mid-19th century,
37¾" high, Sotheby's, London.

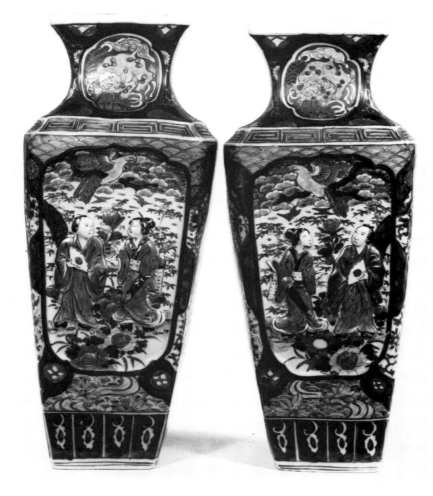

Pair of Imari vases with recessed
panels containing relief figures, late
19th century, 18¾" high, Sotheby's,
London.

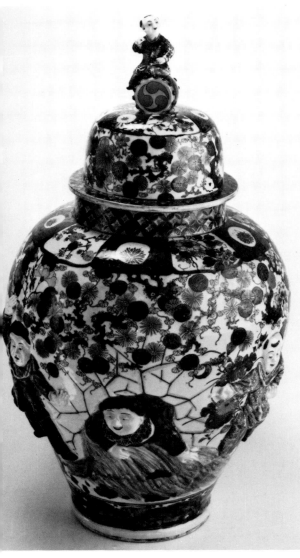

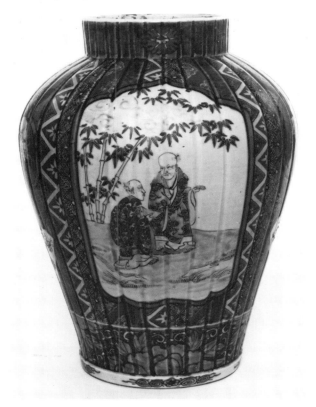

Imari jar with ribbed body, late 19th century, 14½" high, Sotheby's, London.

Imari covered jar with relief decoration of boys playing by a stream, one falling into the water, and others pulling a wagon, late 19th or early 20th century, 30⅓" high, Sotheby's, London.

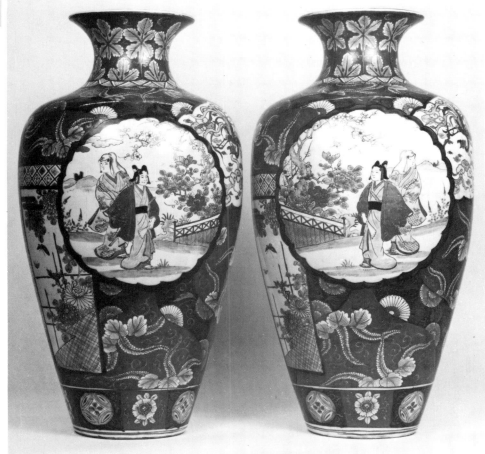

Pair of Imari vases, late 19th century, 23¼" high, Christies', London.

Imari octagonal jar, mid-19th century, 26 1/3'' high, Christie's, London.

Imari bowl, mid-19th century, 22'' diameter, © 1986 Sotheby's, Inc.

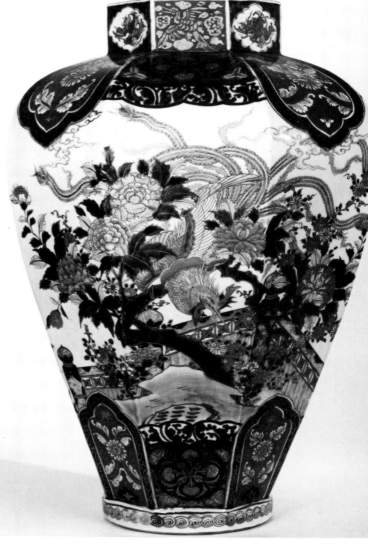

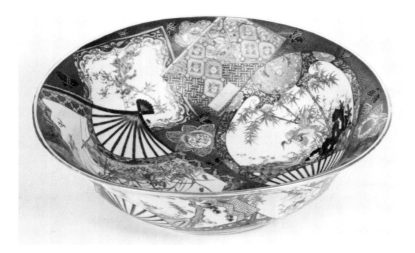

Pair of Imari cache pots and underplates, circa 1900, 13¼'' diameter, © 1986 Sotheby's, Inc.

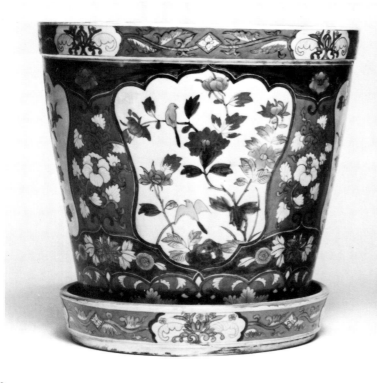

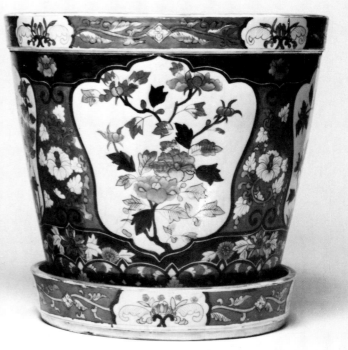

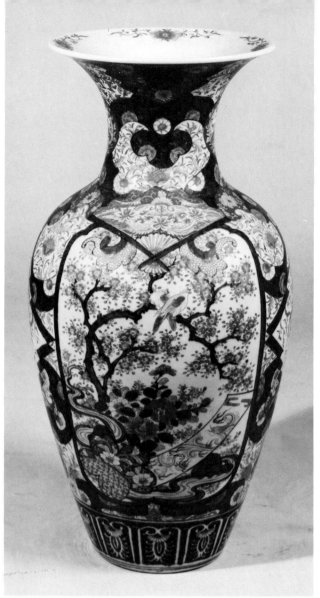

Imari vase, late 19th century, 29½"
high, © 1986, Sotheby's, Inc.

Imari bowl and cover, late-19th
century, 12½" diameter, Flying
Cranes Antiques, New York.

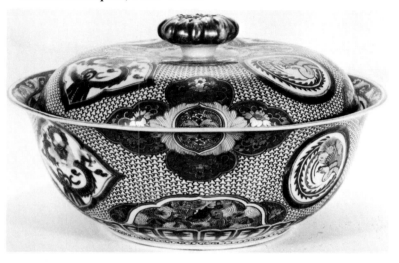

Pair of Imari covered jars with eagle
and landscape decoration, signed on
the base Zoshuntei Mitsuhozo, 19th
century, 18¾" high, Christie's,
London.

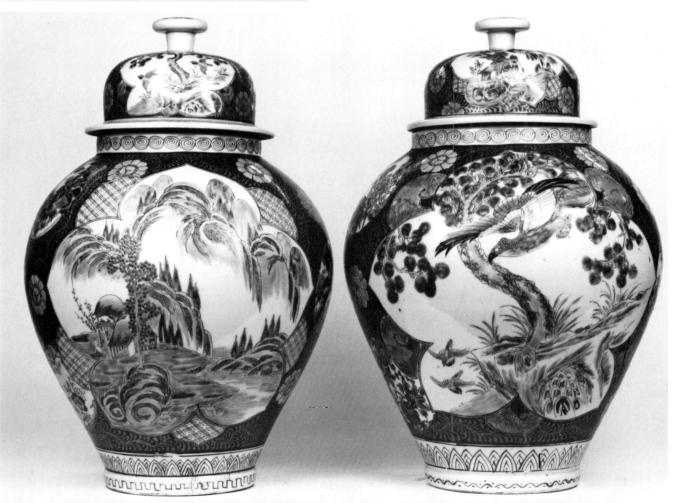

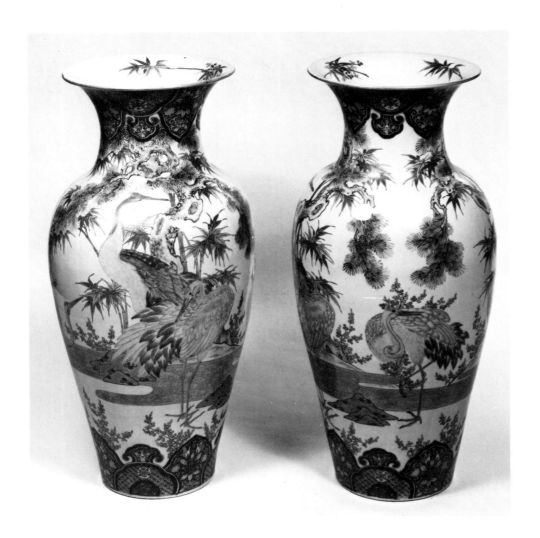

Pair of Imari vases with cranes in the decoration, late 19th century, 35⅞'' high, Christie's, London.

Two Imari trays from a graduated nesting set of five, 19th century, Flying Cranes Antiques, New York.

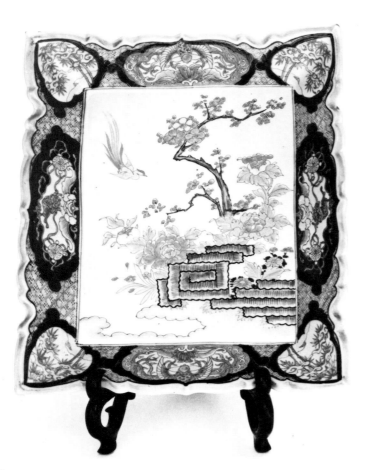

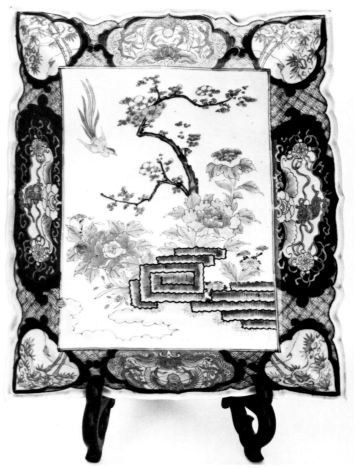

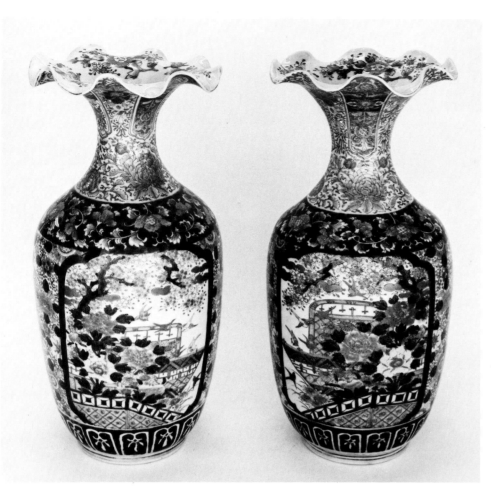

Pair of Imari vases with fluted rims, 19th century, Flying Cranes Antiques, New York.

Imari vase, late 19th century, 12'' high, Flying Cranes Antiques, New York.

Set of Imari plates, mid-19th century, 9'' diameter, Flying Cranes Antiques, New York.

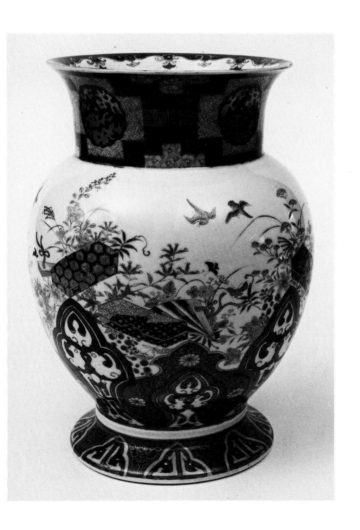

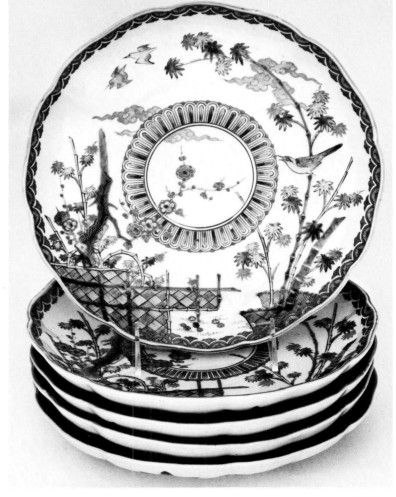

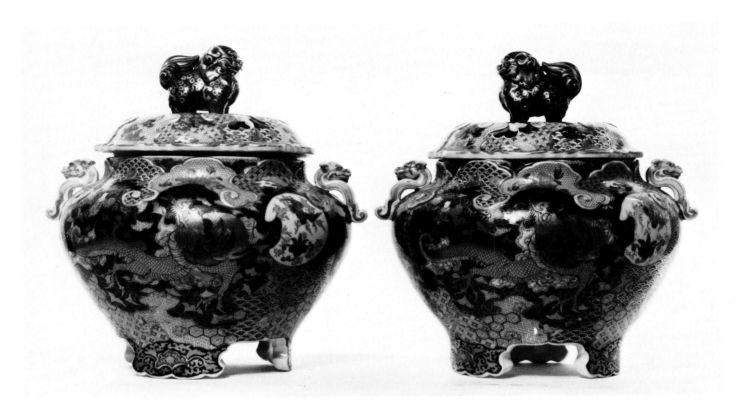

Imari bottle with stopper, mid-19th century, 14" high, Flying Cranes Antiques, New York.

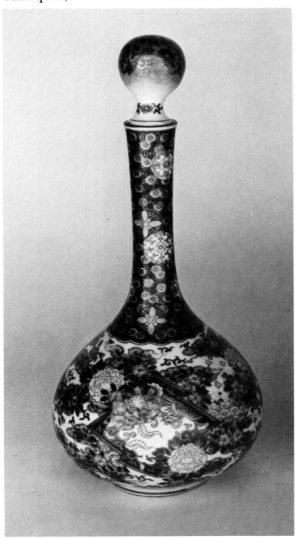

Imari covered jar with a blue and green background for red and gold dragon design, late 19th century, 33" high.

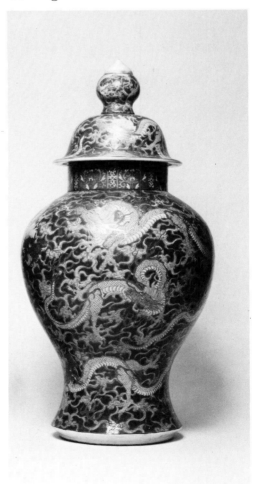

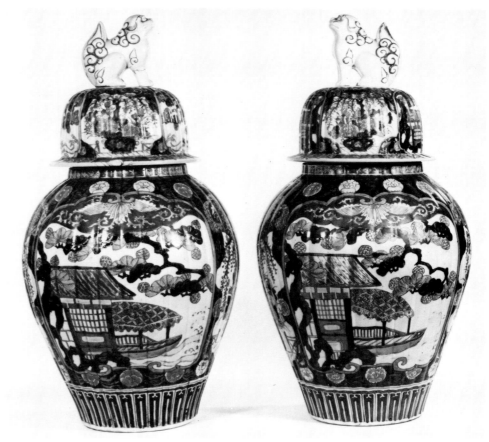

Opposite:
Pair of Imari incense burners with pierced lids, animal's head handles and foo dog finials, late 19th century, 13½" high, Sotheby's, London.

Pair of covered jars with ribbed bodies and lids, late 19th century, 25½" high, Sotheby's, London.

Imari bulb pot with five openings around the tall neck, late 19th century, 15½" high, Sotheby's, London.

Octagonal Imari garden seat, late 19th century, 18½" high, Sotheby's, London.

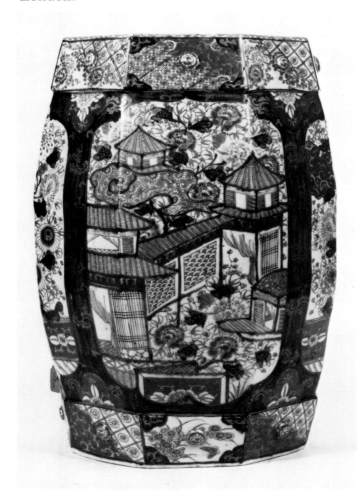

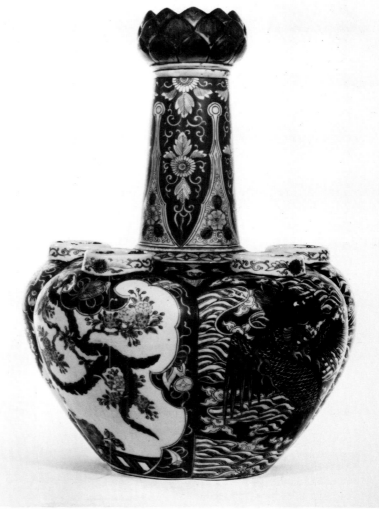

155

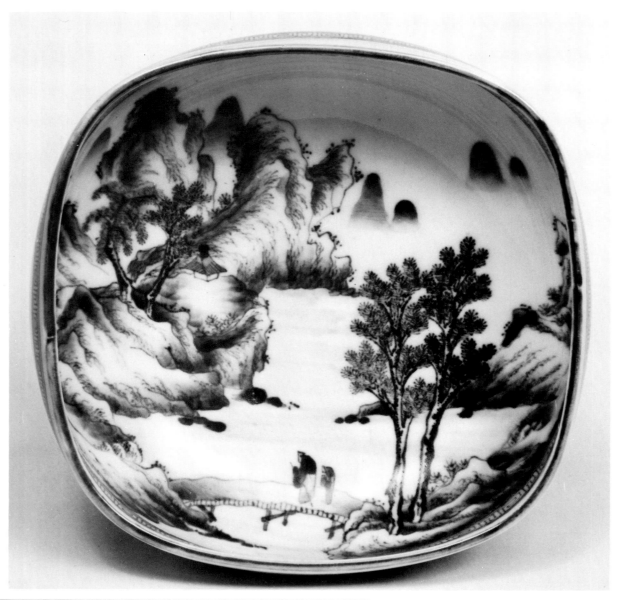

Kameyama bowl in underglaze blue, c. 1840-1850, Victoria and Albert Museum, London.

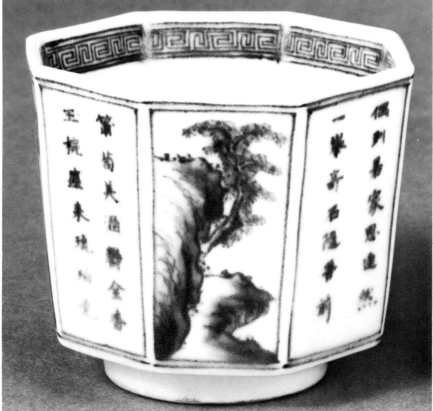

Octagonal cup with Kameyama mark, early 19th century, 2⅜" high, British Museum, London.

Hirado

Like so much of early Japanese porcelain, the history of Hirado ware is presently clouded in speculation, but through the fog a general outline can be attempted. Bushell records that a Korean potter, whose name is now unknown, was brought by the Prince of Hirado of the house of Matsuura from battle-ravaged Korea to Hirado Island in about 1598. There the potter set up a kiln at Nakano (spelled Nanko by Jenyns, p. 249). This potter's son was Sonnojo who, with his son Jo-en, established a kiln at Oriose called "Hirado kiln". Here they made blue and white faience from clay they found at Egami. Later, their descendents moved to Kiwara (Jenyns spells it Kihara) and Enaga, which, included with Oriose, became known as the "three porcelain hills" of Hirado.

Jenyns relates that a group of potters is said to have moved from Nanko to Kihara in 1603, where six kilns existed. Jenyns carries the story forward that about 1622 some of the Nanko potters were moved to Mikawachi kilns near Arita on Kyushu Island by Matsuura Takemoto and that by 1700, Mikawachi-made porcelain was being sent to the Emporor as gifts. It must have been of high quality by this time.

Bushell [p.367] states that in the period 1711-15, a potter working at Hirado, named Yokoishi Toshichibei, made the first fine porcelain there by mixing local Izumiyama clay with a clay he obtained from Amakusa Island to the south.

The significance and validity of Amakusa clay being introduced about this period and used at Mikawachi for the duration of the pottery-making period is fairly well accepted. The superior qualities of this clay are substantiated at the present by modern potteries in Arita. These potteries use it alone or in combination with Izumiyama clay and, to this day, complain about its higher cost and transportation difficulties [conversations with A. Fukagawa at Arita, June 1986].

The Mikawachi kilns used clay from Amakusa Island because of its superior white color, lack of imperfections and ability to hold details when fired. The Hirado porcelain made from this clay is clear white and if decorated, the underglaze blue is a medium tone with soft edges, the color having seeped into the clay somewhat. When pierced or decorated with relief designs, the clay holds the sharp edges of the design through firing. This allowed for elaborate applied details and large, ornate forms in the mid-nineteenth century. The examples show a wide range of very high quality pieces, which Jenyns called "probably the best Japanese porcelain of its time." [Jenyns, *Porcelain*, p. 6.]

In the period 1751-63, the Prince of Hirado, of the Matsuura family, took over patronage of the Mikawachi kilns in order to have porcelain objects made as gifts for the Shogun and his friends. The Matsuura family continued this patronage until 1843.

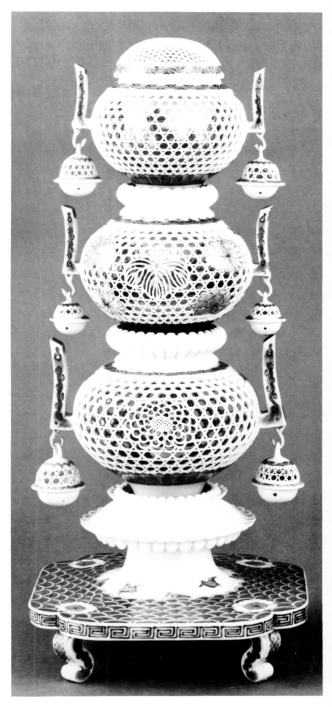

Hirado openwork lantern in three tiers, 14¾" high, early 19th century, British Museum, London.

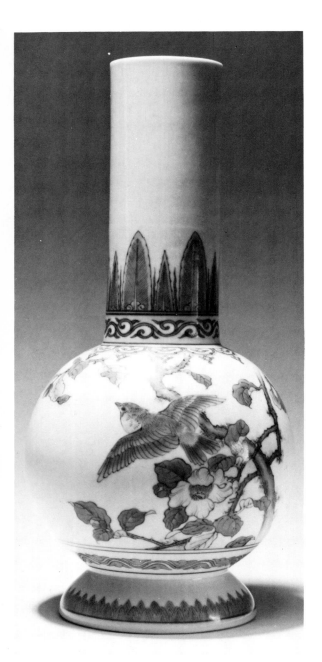

Hirado vase, late 19th century, 13⅛"
high, © 1986, Sotheby's, Inc.

It is not known how much of the production of this kiln was used as gifts and how much was made for sale either to Japanese markets or for export. In 1971, Oliver Impey of the Ashmolean Museum at Oxford, England, obtained shards from two kiln sites at Mikawachi. From one of them (Sangama) came coarse examples of the common ceramic wares of the 18th century; from the other (Saya) came shards of refined clay with delicate blue underglaze decoration. [D.H. King "Hirado Porcelain"] This latter group represents the wares now famous as "Hirado" ware, which are shown in the following examples and discussion. These pieces are thought to have been made for the Prince of Hirado's exclusive use until the mid-19th century, when production increased and evidence of their being exported exists.

Smith [L. Smith, p. 60-61.] points out that production at Mikawachi was underway by 1790, since the site was listed, but not as new, in a 1798 list of kilns. Mikawachi is there noted as one of only two (the other being Okawachi kiln of the Nabeshima clan) clan-sponsored kilns in Japan at that time.

From about this period, Hirado ware of clear white body are found with decorations in underglaze blue and relief work of subjects such as landscapes and Chinese boys playing.

The fire which destroyed the town of Arita in 1828 probably also caused extensive damage to the kilns at Mikawachi, for they were on fairly low ground and just a few miles from the town center. Also, there is an apparently significant change noted in the quantity and type of ware produced just after this time. From approximately 1830 until the end of the nineteenth century, pieces are found, with increasing frequency, marked "Mikawachi" and "Hirado", and often with a date and a potter's name. Examples of these marked pieces have aided David H. King's extensive study of Hirado ware and helped him to suggest a framework upon which to date unmarked pieces. [D.H. King, "Hirado Porcelain..."]

Bushell corroborates a decline in the quality of Hirado ware by 1830, and also says that some very good quality pieces were made during that general time at Sarugama kiln (is this Saya, where O. Impey found the "Hirado" shards?) and Mikawachi, by the potter, Tokio Nakagata, with every piece signed "Hirado Gosho."

Nagatake [in *Toki Koza* (New Series) IV, p. 386; and Smith, p. 122] mentions that in 1830 the Matsuura clan set up a trade monopoly with the Hirado Produce Association in Nagasaki. We must assume this was for export dealings at least in part, and seen as an attempt to increase profits for their kilns. From around 1837, egg-shell porcelain in large quantities, especially coffee sets for Europe, were made at Mikawachi by Yasugiro Ikeda. [Jenyns, *Japanese Porcelain*, p. 252]

Jenyns also states that there were 37 porcelain factories at Mikawachi by 1840—a statement which appears to need some justification; but the evidence all seems to indicate that a good deal of porcelain was being made here at that time.

It is reasonable to assume that the egg-shell ware was made at Mikawachi for the ability of Amakusa clay to hold its shape and details, and its flawless purity when refined, are characteristic of the pierced work and relief detail for which Hirado ware is famous. These qualities would be exactly appropriate for eggshell.

All must not have been well, however, in the porcelain business, or at least in the Matsuura family business affairs, for the clan suspended their patronage of the kilns at Mikawachi in 1843. The reasons can be guessed at, but the fact remains, the kiln continued with some very different products after this date. Although eggshell

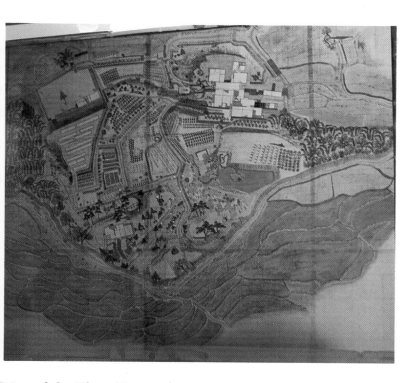

Map of the Plum House site at Hirado Island with rice fields next to the shoreline.

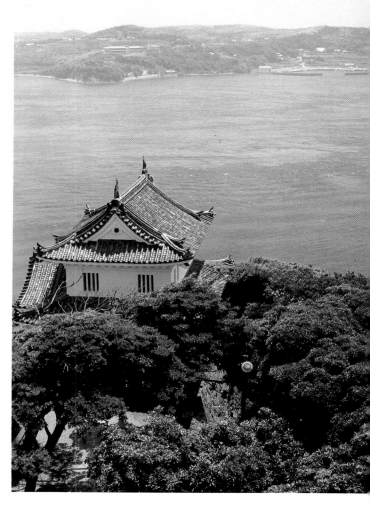

Museum at Hirado-Jyo Castle.

Two views of a Hirado plate at the Hirado-Jyo Castle.

161

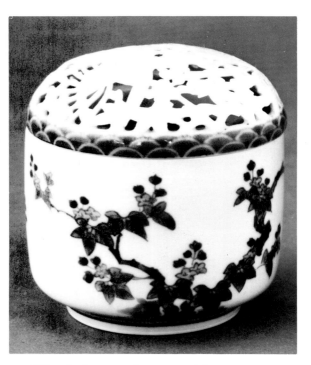

Hirado incense burner with openwork lid, early 19th century, 3½" high, British Museum, London.

Hirado incense burner with openwork lid, circa 1830, Victoria and Albert Museum, London.

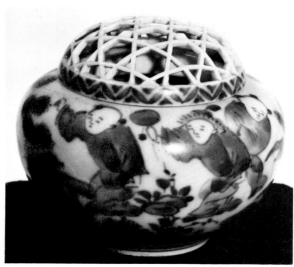

Hirado teapot, early 19th century, 2⅛" high, British Museum, London.

continued, the fine quality blue and white wares underwent some variations. Jenyns tells us, "by 1865 the kiln had invested in twice-baked *kinrande* porcelain, decorated in red and green enamels" [Jenyns, p. 253].

When the Meiji restoration began its new system of private enterprise rather than clan monopolies to handle exports, the Mikawachi kilns continued in business in these various porcelain types. Jenyns says "both these (enameled wares) and the white egg-shell were supplied to the Imperial Court and included in The Paris Exhibition of 1875, although neither was of any real interest or merit. By 1878 the kilns had degenerated still further, making porcelain in polychrome enamels for the general industrial market." [Jenyns, p 253]

Around 1900, the Fukagawa Porcelain Manufacturing Company of Arita bought out the stock of Hirado ware, marked it with their own trademark, and sold it. [Conversations with I. Fukagawa, chief designer and descendant of the founder. He did not mention their acquiring the Hirado molds.]

This brief outline of Hirado wares has been interpreted by L. Lawrence [in *Hirado*] and D.H. King [in *Transactions...*] with some slight variations, into the following chronologies:

King refers to: First Period—1760-1830, Second Period—1830-1870, Third Period—1870-1910; and Lawrence refers to Early Matsuura Period—1750-1810, Late Matsurra Period—1810-1843, Final Period—1843-1900.

David King has likened a Hirado plate with wave decoration of the 1900-1909 period to Royal Copenhagen designs [King, p. 29] copied from Arnold Krog's 1887 Royal Copenhagen design (a plate in the Kunstindustrimuseum, Copenhagen). This source is a distinct possibility, but so are the travels of Arita designers such as C. Fukagawa, who went to Europe to study porcelain in the late 19th century. His porcelain designs (shown in Arita chapter) display several similar style, European-inspired patterns which were produced in Arita, and could have been seen and copied by the decorators of late Hirado ware so close by.

So far, the cross-fertilization theories continue as intriguing material for discussion, but final conclusions cannot yet be made. One looks forward to finding primary source information upon which to establish the relationships of one design to another.

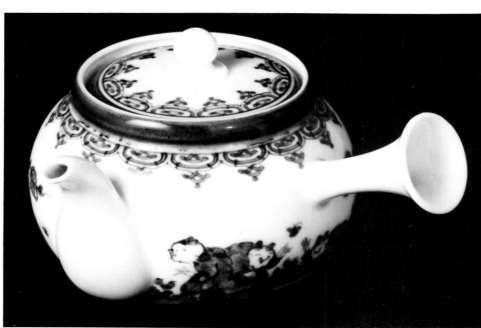

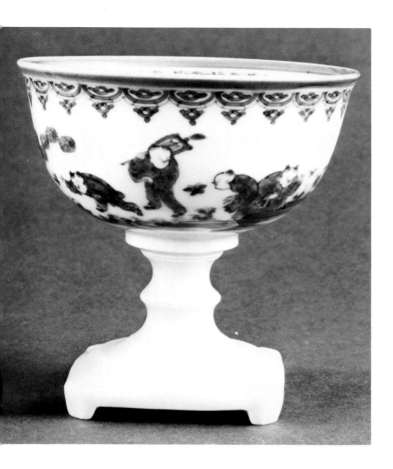

Hirado goblet of European shape after rummer glass forms of the late 18th century, made probably at Mikawachi kiln in the early 19th century (see plate 48 and page 63, L. Smith, "Japanese Porcelain..."), 41/3" high, British Museum, London.

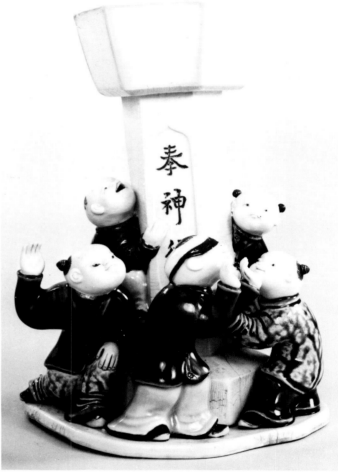

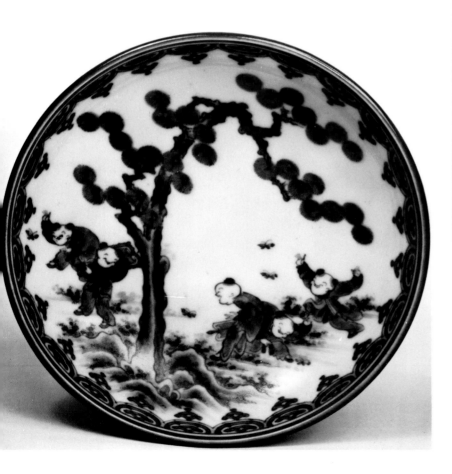

Hirado lantern with fine three-dimensional figures of boys playing blind man's bluff, early 19th century, 10" high, British Museum, London.

Hirado plate, five boys chasing butterflies in the decoration, late 18th century, Victoria and Albert Museum, London.

163

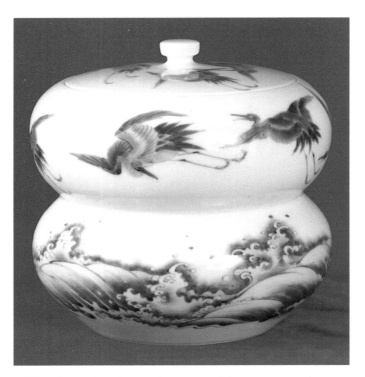

Hirado water jar and cover with cranes and sea foam in the decoration, 7" high, Private Collection.

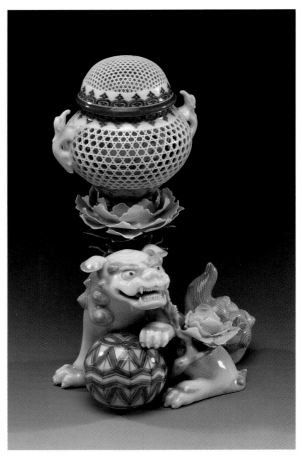

Hirado porcelain censer with blue details in the form of a *shishi* seated among peony blossoms, 19th century. Height, 9.75". Courtesy of Flying Cranes Antiques Ltd., New York.

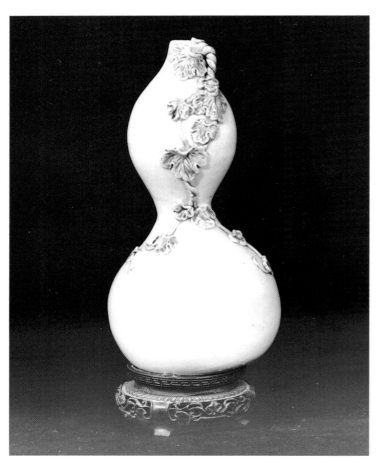

Hirado double gourd bottle with relief vine decoration, 9" high, Philip Van Brunt.

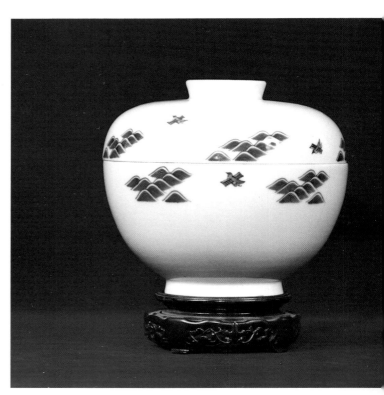

Hirado covered bowl, early 19th century, 7" high, House of the Black Ship, New London.

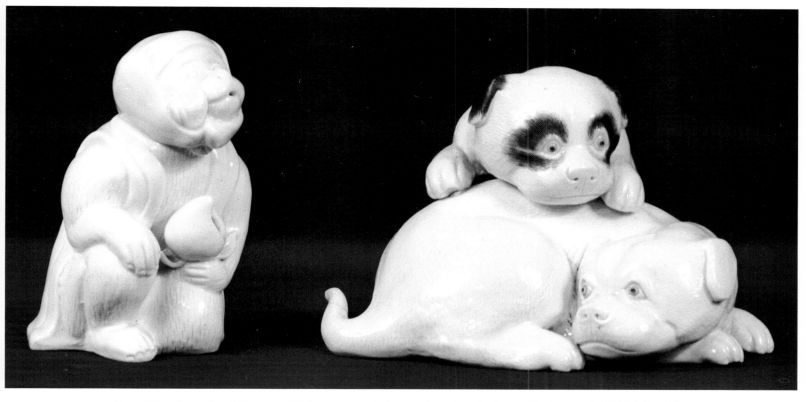

Two Hirado animal figures, 19th century, *left,* monkey in a jacket with hood, 5 1/2" high; *right,* two dogs playing, 5 1/4" high, House of the Black Ship, New London.

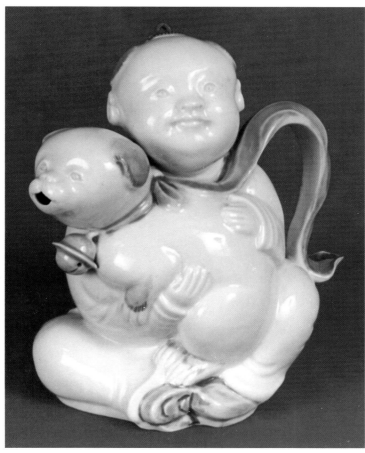

Hirado sake pitcher in the form of a boy and dog, 19th century, matching one at the Hirado Island Museum, Flying Cranes Antiques, New York.

Hirado porcelain cricket cage in the form of a lantern with two dragons encircling the stepped base. The door is intricately reticulated, 19th century. Height, 18". Courtesy of Flying Cranes Antiques Ltd., New York.

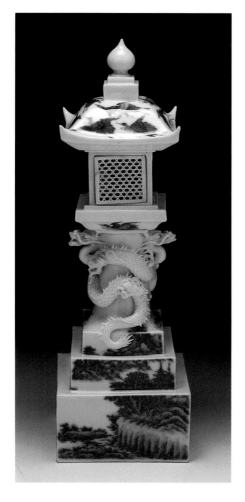

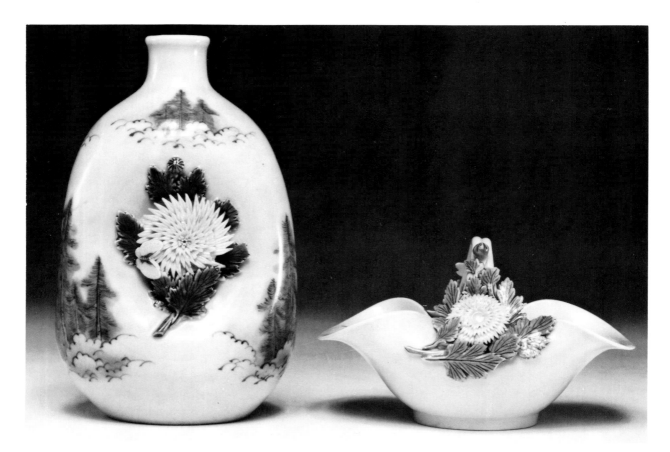

Two Hirado dishes with relief chrysanthemum decoration, 19th century, *left*, bottle, 6⅞" high; *right*, basket, 5½" long, © 1986, Sotheby's, Inc.

Hirado covered water bowl, 62/3" high, Rijksmuseum, Amsterdam.

Hirado plate, early 19th century, 6¼" diameter, British Museum, London.

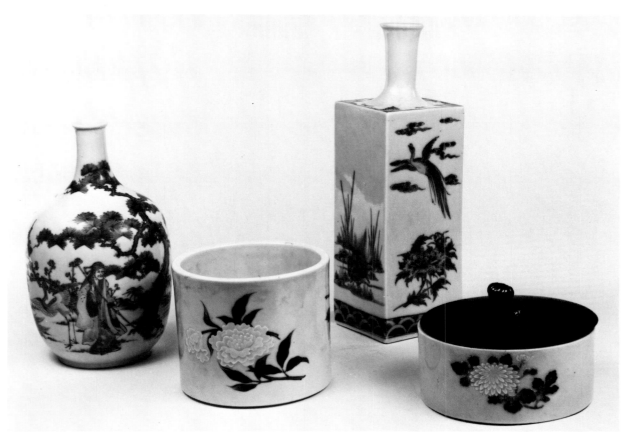

Four Hirado containers, 19th century, *left,* bottle with an Immortal and crane, pine, bamboo and plum in the decoration, 91/3" high; *second,* brush pot with floral low relief decoration, base marked Hirado; *third,* bottle 12½" high; *right,* covered dish with floral low relief decoration, 6⅛" diameter, Christie's, London.

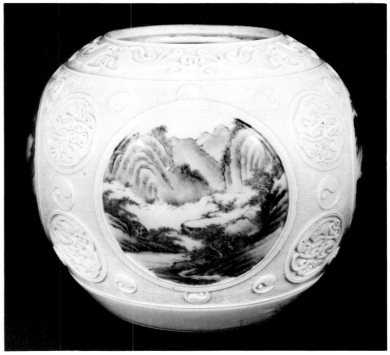

Hirado covered jar in the form of an ancient bronze vessel with four landscape roundels among relief decorations, late 19th century, 6½" high, British Museum, London.

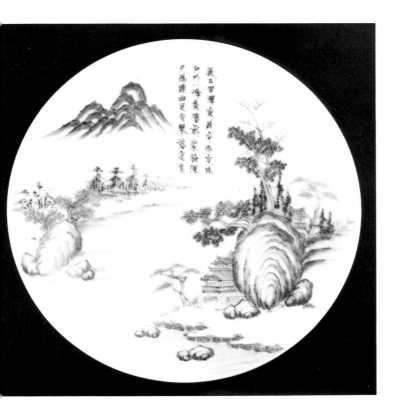

Hirado plate with Mikawachi kiln mark, circa 1850, 7¼" diameter, British Museum, London.

Hirado incense burner in the form of a duck,
9" high, mid-19th century.

Hirado miniature vase and water ewer, late 18th or
early 19th century, *left,* water ewer for mixing cosmet-
ics with leaf design, probably a family crest, 3 1/4"
high; *right,* vase with snowflake design, 2 7/8" high,
Private Collection.

Hirado celadon incense
box in the form of a squir-
rel and grapes, 19th cen-
tury, 2 1/2" high, 5 1/2"
long, Private Collection.

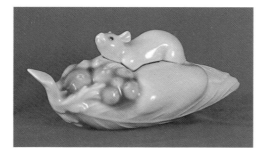

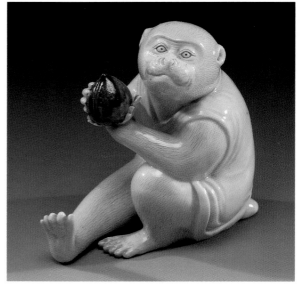

Hirado porcelain figure of a monkey with
a brownish stain at this mouth, evidence
of the tasted fruit he grasps, 19th century.
Height, 6"; width, 6". Courtesy of Flying
Cranes Antiques Ltd., New York.

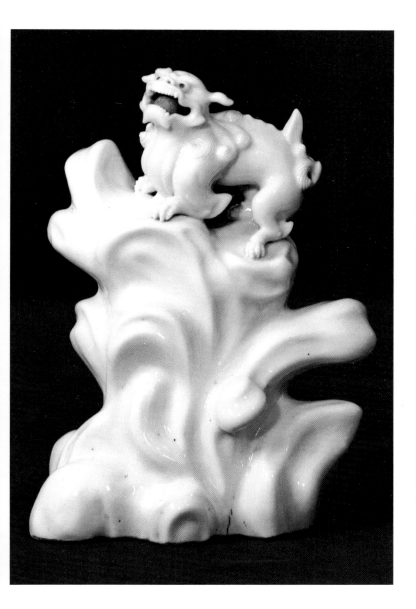

Hirado figure of a foo-dog on a tree trunk, 8" high, mid-19th century, House of the Black Ship, New London.

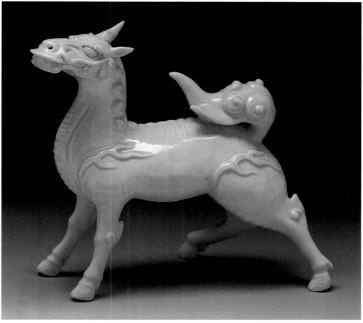

Hirado porcelain *kylin* with both raised and incised body detailing and the head and tail uplifted, 19th century. Height, 9"; length, 9,5". Courtesy of Flying Cranes Antiques Ltd., New York.

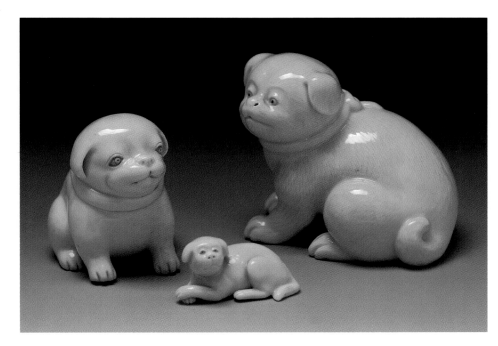

Three Hirado porcelain puppy figures with minute details, 19th century. Height of largest, 3.25". Courtesy of Flying Cranes Antiques Ltd., New York.

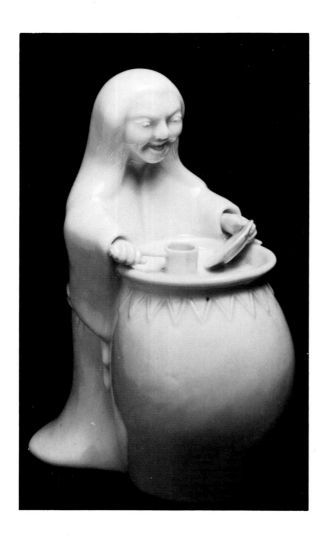

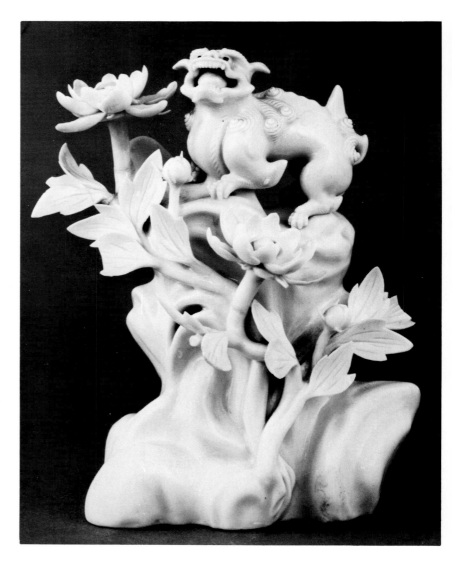

Hirado woman seated by a jar with ladle and dish, 19th century, Victoria and Albert Museum, London.

Hirado chestnut and log, 19th century, 3¼" long, British Museum, London.

Hirado lion-dog on a rock with three-dimensional floral vine, early 19th century, 6¾" high, British Museum, London.

Hirado paperweight in the form of a boy seated on a raft with flowers, circa 1870, Victoria and Albert Museum, London.

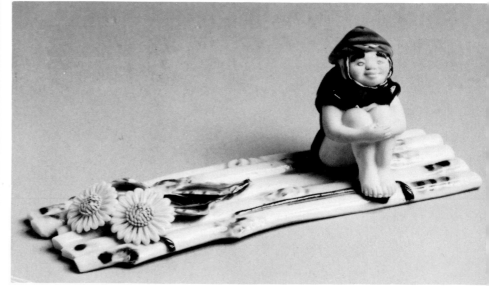

Hirado thistles bouquet, 19th
century, 7½" long.

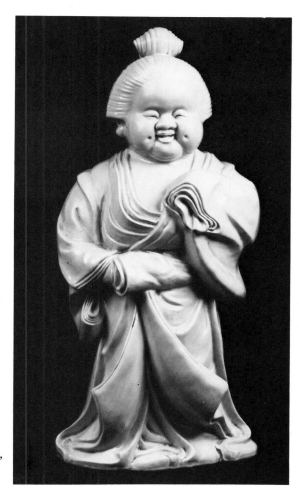

Hirado figure of legendary Okame,
late 19th century, 25¾" high,
Christies', London.

Hirado ginger shoot, 19th century,
4⅛" long, British Museum, London.

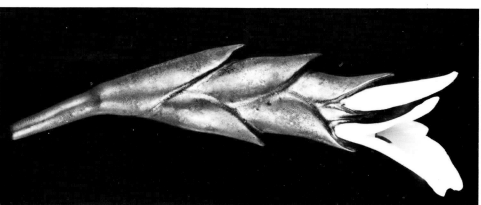

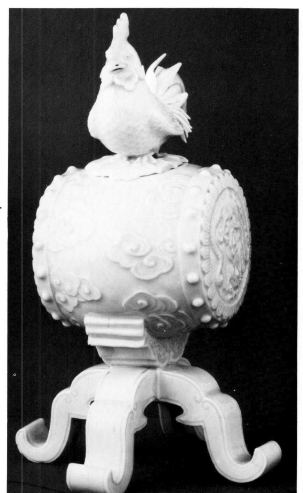

Hirado incense burner in the form
of a cock resting on a drum, early
19th century, 8¼" high, British
Museum, London.

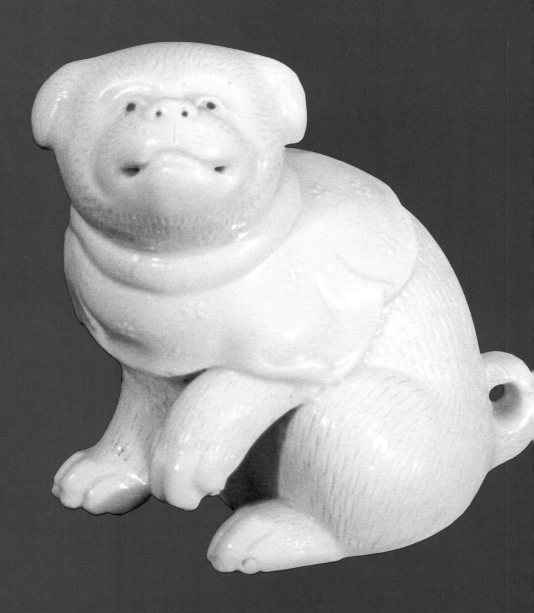

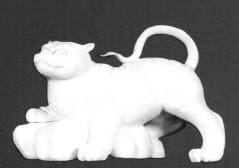

Hirado tiger, 19th century, 6½" high.

Hirado dog with a cape, 19th century, 6½" high.

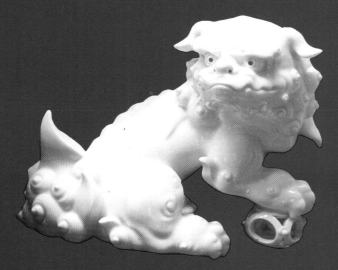

Hirado lion-dog at Plum House, Hirado Island.

Two Hirado paperweights of floral three-dimensional design, at Plum House, Hirado Island.

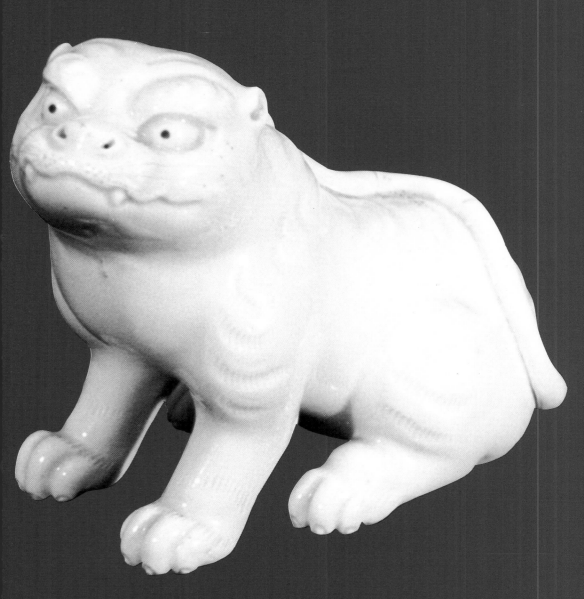

Hirado wrestling boys, early 19th century, 6" high, James Galley, Rahns, Pennsylvania.

Hirado seated lion, late 19th century, 6" high.

Hirado horse chestnuts, 19th century, at the Matsuura Historical Museum, Hirado Island.

Hirado figure of a hawk with metal claws at Plum House, Hirado Island.

Hirado rat, 19th century, 1'' high,
British Museum, London.

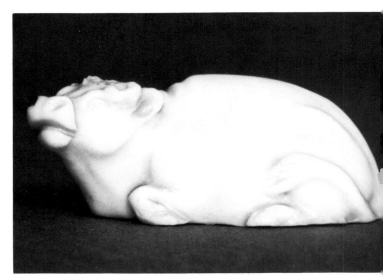

Hirado ox, 19th century, 1¼'' high,
British Museum, London.

Signs of the Zodiac

Hirado hog, 19th century, 1'' high,
British Museum, London.

Hirado puppy, 19th century, 1''
high, British Museum, London.

Hirado chicken, 19th century, 1¼''
high, British Museum, London.

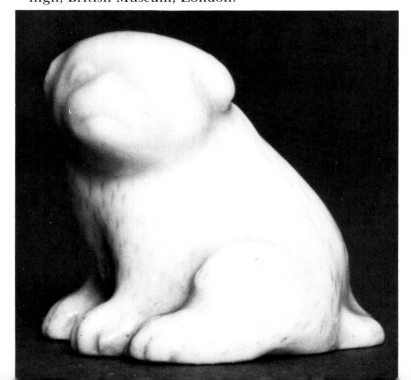

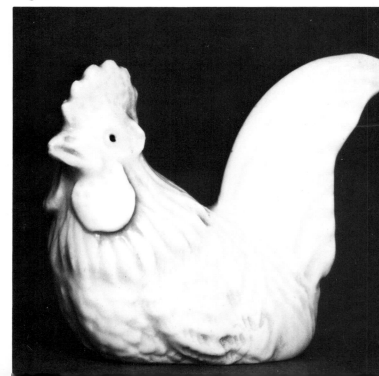

Hirado rabbit, 19th century, 1⅛"
high, British Museum, London.

Upper left:

Hirado tiger, 19th century, 1" high,
British Museum, London.

Hirado snake and dragon, each 1"
high, 19th century. The sign for the
horse is not shown.

Hirado seated monkey, 19th century,
1 2/3" high, British Museum,
London.

Hirado goat, 19th century, 1" high,
British Museum, London.

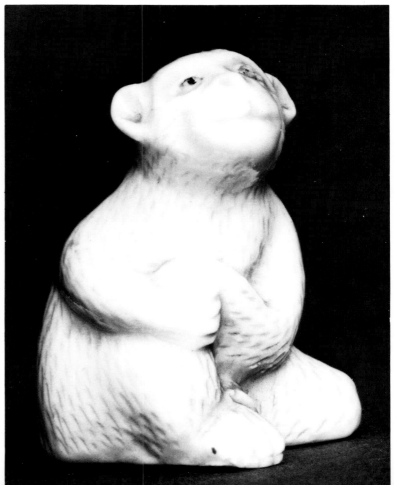

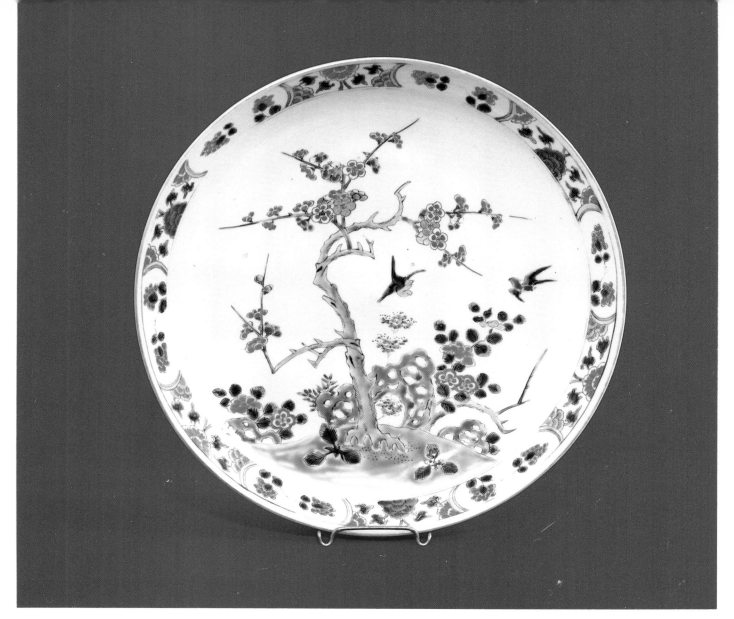

Left, Imari bowl in the Kakiemon style with baskets and quince in the decoration, 5¾'' long; *right,* Kakiemon plate with shaped rim, 19th century, 6⅛'' diameter, House of the Black Ship, New London.

Plate in Kakiemon style, 12'' diameter, probably late 19th century, Lyman Allyn Museum, New London.

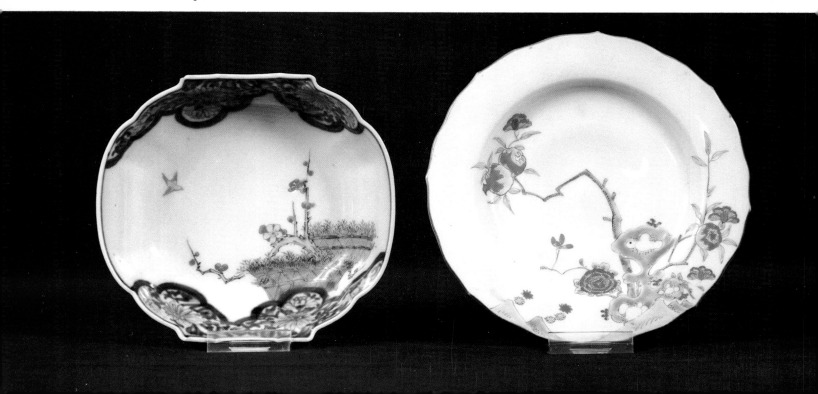

Kakiemon

Early History

Kakiemon wares, have been made at the Nangawara kiln at Arita under the direction of the Sakaida family from about 1643, with interruptions, to the present. There is room for discussion about the origins of the enamel decoration which characterizes this ware, as scholarly readings of old family records are showing in recent years. [Nagatake, *Kakiemon*] The still widely held belief and traditional story relates that about 1616, Ensai Sakaida (b. 1573-) and his son, Kozoemon (1596-1666), came to to Nangawara kiln at Arita, which was under the direction of the Nabeshima clan. The Sakaida family were probably owners and managers of the kiln, not potters themselves. By 1624-1644, white porcelain with blue decoration was made here, the body being pure white in contrast to other Arita wares, which are more grey-blue in color. This early porcelain could have been sold through dealers at Imari and also used by the Nabeshima family as gifts to their peers and overlords.

Recognizing the choice red colorings of some Chinese decorated porcelain, unlike any made at Arita then, the Nabeshima lords probably sought to have this style made at their own kiln, so they arranged to obtain the materials and techniques. About 1643, a pottery dealer from Iwari, Higashijima Jokuzaemon, purchased overglaze enamel materials from a Chinese merchant in Nagasaki and supplied them to Sakaida Kozoemon with whom he conducted business.

Kakiemon dish and bowl, 19th century, **left,** shell and leaf shaped dish, 6⅜" long, *right,* bowl with blue mark, 4⅜" diameter, Philip Van Brunt Collection.

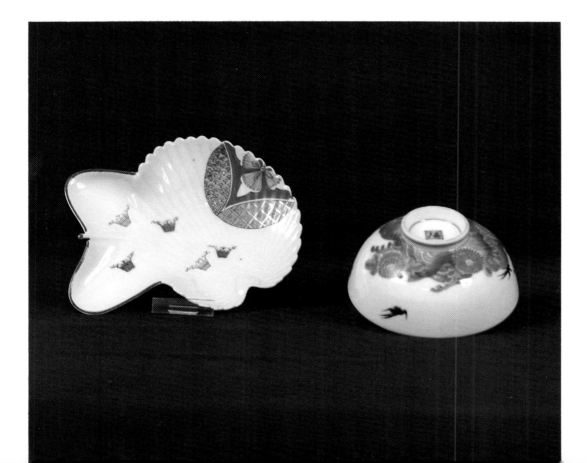

At the Nangawara kiln, Sakaida Kozoemon and Gosu Gombei, who was probably a potter or decorator at the kiln, experimented with the Chinese materials and achieved colored enamel decorations—the first of their kind in Japan. A particular red color they achieved was thought to resemble persimmon blossoms. The Japanese word for persimmon being "kaki", Kozoemon took, or was granted, the nickname "Kakiemon, which he used as his artist name.

Therefore, it was Kakiemon I who popularly is credited with the "discovery" of overglaze colored enamel decoration in Japan, and the first of fourteen generations of Sakaida family members who has been engaged with producing the special porcelain which bears his name.

Kakiemon ware was imported by members of the Dutch East India Company to Europe some time before 1680. This date is another area of scholarly discussion, since the evidence in European collections and written records is sketchy at best. What is important to the discussion here is that this family has perpetuated a high-quality ware for 300 years and these wares have influenced other porcelain types as they contributed greatly to the porcelain field. It was these early polychrome decorated Japanese porcelain imports that put Frederick Augustus I (1670-1733) (Augustus the Strong) into a fever for his own collection of Japanese and Chinese porcelain. By 1713, not content to merely collect it, he had the Meissen factory at Dresden established (started 1709) to make his own. Further, the French and English were not to be outdone. The ceramics works at St. Cloud (operating by c. 1700), Chantilly (c. 1725), Bow (1744), Sevres (1745), Derby (1745), Chelsea (1745), Longton Hall (c. 1751), and Worcester (1751) were established in turn where porcelain production was attempted.

Decorations

The Kakiemon style evolved gradually during the 17th century, both with blue and white wares and enamel decorated wares. H. Nishida's research of Kakiemon summarizes that the best quality, pure white bodies decorated with soft painting, was done approximately between 1705 and 1750. [H. Nishida, *Japanese Export Porcelain*...] Volker's study of the Dutch East India Company records suggests this best quality was at the end of the seventeenth century.

The characteristic Kakiemon decoration was on pure white porcelain with transparent glaze, sometimes underglaze blue, and enamel decoration of sparse and elegant design. The enamel decoration included light blue and orange-red commonly, with occasional turquoise, light green, pale yellow and a little gold.

The decorations are often floral motifs of un-naturalistic designs and a few well placed animals, fewer people, and rarely landscapes. There are no distinct designs particular to the Kakiemon wares, but certain groupings are recognizable in their products. These are included in, but not limited to, true Kakiemon ware.

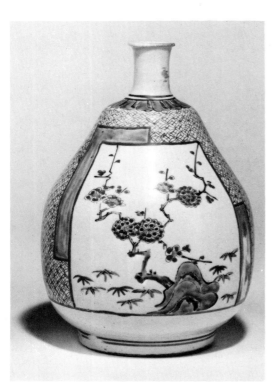

Imari vase in Kakiemon style, late 19th century, 9" high, © 1986 Sotheby's, Inc.

There are plant motifs such as:	Flower and bird motifs include:
rock and plum tree	plum tree and spring birds
rock and chrysanthemum	peony and phoenix
rock and autumn grasses	paulownia and phoenix
brushwood fence and ivy	chrysanthemum and wild bird

Some groups have a main subject to the right or left of center with a subordinate design diagonally across for balance such as:

millet and quail	bamboo and tiger

Other groupings include:

> pine, bamboo and plum (the 3 lucky plants or, 3 friends of summer)
> peony and chinese lion (Queen of flowers and King of beasts)
> bamboo and tiger
> Chinese boys and autumn grasses
> Chinese figures and flowering grasses
> flowering grasses and butterflies
> quail and flowering grasses
> maple and deer
> waves and plovers

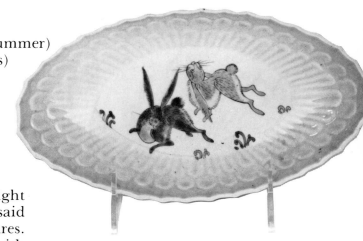

Imari oval dish in Kakiemon style with two rabbits in the decoration, Flying Cranes Antiques, New York.

These decorations were usually painted with utmost care and light touch by accomplished artists whose use of negative space—or said another way, their restraint in decoration—characterize these wares.

In the late 17th century, Kakiemon decorations are found with some Imari style influence on Kakiemon wares, for neither were created in a vacuum. But Kakiemon pieces in the Imari style remain restrained and very carefully painted on the pure white ground.

Later History

In about 1675, the official Nabeshima clan kiln was changed from the Nangawara kiln and Sakaida family (Kakiemon) to the Okawachi kiln, also at Arita, where Nabeshima ware was to become famous. The reason for this change is not clear at this time. From about 1700 until 1810 or so, production of Kakiemon porcelain by the Sakaida family seems to have slackened, and knowledge of creating the pure white body seems to have been lost. The once-glorious and influential porcelain ware entered a period of decline.

However, and important to our focus on nineteenth century wares, a revival took place about 1810 when the Nabeshima wares of Okawachi kiln were copied by Kakiemon decorators.

A fire at Arita in 1828 probably destroyed the Kakiemon kiln, for production declined again at this time. The Sakaida family records have been studied [Nagatake, *Kakiemon*] and interpreted to add that in the 1844-68 period, family members worked under a head person called Kakiemon in a semi-mass production system.

In the early twentieth century, interest in re-creating Kakiemon ware was again renewed. Two generations of Kakiemon (XII and XIII) combined their efforts and succeeded in reproducing the pure white body in 1953. They had the written family records with formulas and explanations of techniques to guide them, but the work was slow and tedious, and interrupted by the Second World War.

In March of 1971, Kakiemon XIII was publicly recognized by the Japanese government as an Important Intangible Cultural Treasure for perpetuating the pure white body of Kakiemon ware. This was a great personal honor, and culturally important to the country.

Kakiemon oval dish in the shape of a chrysanthemum with typical decoration.

The present Kakiemon (XIV), Sakaida Masashi, learned to mix colored enamels from Kakiemon XII and to make pottery from Kakiemon XIII. He continues to oversee the family kiln's careful production of high quality porcelain, which has its distinctive design characteristics derived from the traditional style.

The success of earlier Kakiemon ware in the late seventeenth and early eighteenth century naturally influenced other kilns and decorators of the Arita area to borrow some of it's designs for their own use. The pure white body and careful decoration of the work from Nangawara kiln by comparison became more coarse in body and decoration when interpreted by other kilns, especially in the nineteenth century. By the mid-twentieth century, as has been mentioned, the Sakaida family was once again in production of the true Kakiemon ware.

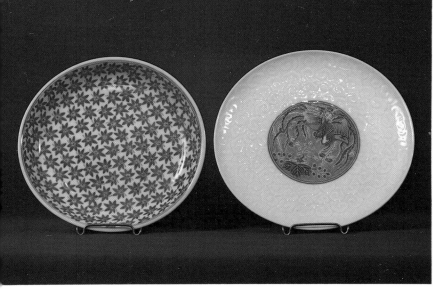

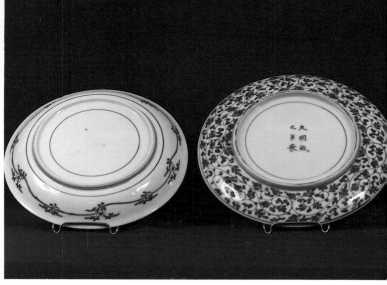

Two Kakiemon plates shown in front and back views, *left*, blue underglaze leaf pattern, 10'' diameter, *right*, polychrome center and relief modelling in rim, 11'' diameter, both 19th century, House of the Black Ship, New London.

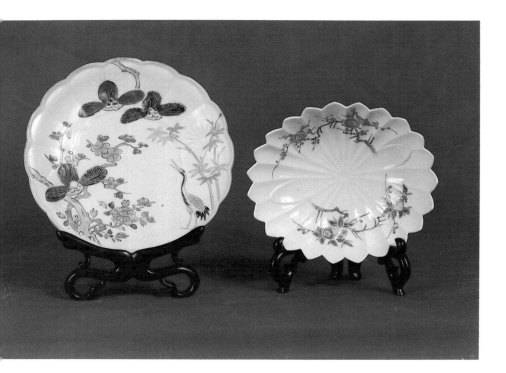

Left, Imari plate with scalloped rim in Kakiemon style, *right*, Kakiemon oval dish in the shape of a chrysanthemum with typical decoration in overglaze enamels, Flying Cranes Antiques, New York.

Front and back views of two Kakiemon plates, *left*, plate with shaped rim, blue birds and rocks, and overglaze floral decoration which may be a later addition, double fuku mark, 19th century, 10'' diameter, *right*, underglaze blue decoration with brown rim, four-character mark, probably 18th century, 7⅞'' diameter. House of the Black Ship, New London.

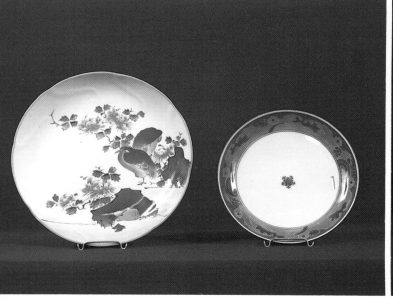

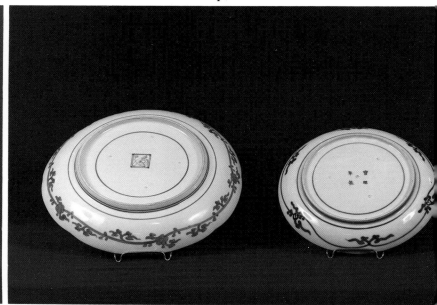

Nabeshima

History

Only a sketchy summary of the early phases of this ware can be attempted. There is some written evidence [M. Imaizumi, *Nabeshima*, p. 6] that the Nabeshima clan, which governed the western part of Kyushu around Arita, supported several ceramic kilns from the early 17th century. The locations and products of these kilns are subjects of considerable discussion and current research.

From about the year 1675, the Nabeshima clan oversaw operations at the Okawachi kiln north of Arita as their official kiln. Here porcelain ware was made from local Izumiyama clay for the exclusive use of the clan or as gifts to their peers and overlords. This porcelain has come to be known as Nabeshima ware. It was never available for sale either in Japan or as an export until very late in the nineteenth century after the clan system was abolished. Then a few pieces reached Europe in the antique trade.

Kakiemon plate, 17th century, 7¼" diameter; Kakiemon vase, 17th century, 6 2/3" high; Nabeshima plate, late 17th or early 18th century, 8" diameter, Christies', New York.

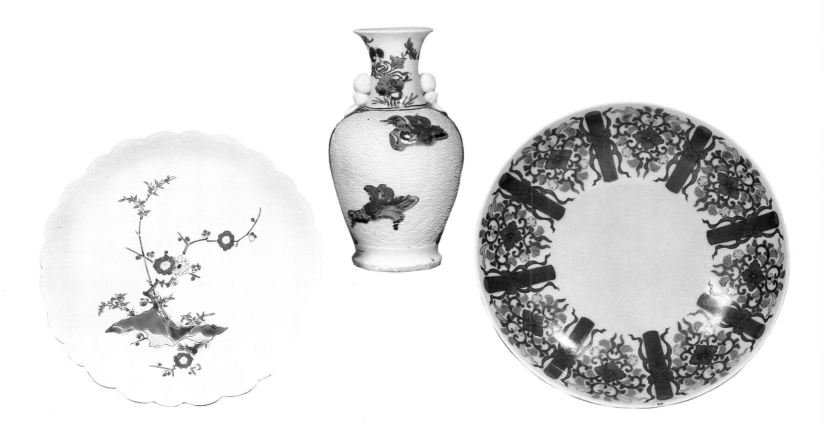

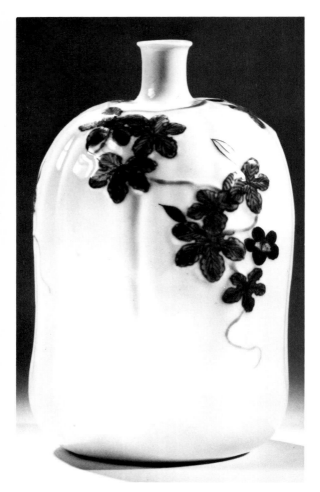

Nabeshima bottle with relief and enamel decoration, 19th century, 7" high.

Incense box in the shape of a persimmon in underglaze blue decoration, perhaps Nabeshima, early 19th century, 2" diameter, British Museum, London.

The Nabeshima clan supervised, supported and protected the porcelain industry in Arita because they recognized their unique position of having the only raw materials and technical skills for porcelain manufacturing in Japan, plus, the only access for trade with the West at Nagasaki. They held a monopoly in export porcelain that could not be challenged in Japan, and therefore, access to taxation revenues that no other clan could match. The money gained in taxation supported the porcelain industry. The porcelain industry contributed significantly to international trade. While the feudal system remained intact, the porcelain business flourished.

However, when the Meiji restoration took place in 1868, the political and economic system of Japan as well as the porcelain industry changed. By 1871, the Nabeshima clan, unable to levy taxes, could not support the business any longer. The workers were released without other employment. There was no longer any system to use their talents, and new systems took time to establish.

When the Nabeshima clan kiln was closed in 1871, the tenth generation Imaemon rose to maintain the heritage of his family's skill. His family had been decorators of Nabeshima ware since the seventeenth century as one of the sixteen privileged and protected families of decorators in Arita. As his goal, he set the preservation of the skills of enamel decorating in a new society where the skills no longer had a place.

To realize his goal, he and other members of his family had to learn how to form the pots from clay and how to fire them in kilns. All of the processes were undergoing "industrialization" at this time, but Imaemon Imaizumi X succeeded in bringing his family into private enterprise and they became the owners of a full-scale porcelain manufacturing business. Each successive generation of Imaizumi has contributed to the refinement of their trade and assumed the artistic name Imaemon in turn.

The eleventh Imaemon met with hardships during the first quarter of the twentieth century, but when the new government took over the country in 1926 (beginning of the present modern Showa era), economic policies began to have a beneficial effect on this business. The eleventh and twelfth (1897-1975) generation Imaemons worked together and successfully produced high quality porcelain. They seem to have succeeded to bring back to life the full technique of Nabeshima enamel decoration.

Imaemon XIII (b.1926) graduated from the Tokyo School of Fine Arts design section of the crafts department in 1949 and entered his family business. He has added some highly regarded design concepts to their wares. He helped to establish a society for the preservation of Nabeshima ware at the factory in 1970, and at his father's death, assumed his father's artist name. In 1976 he was designated the holder of an Important Intangible Cultural Property (popularly called a "Living National Treasure") by the Japanese government.

The Body

Nabeshima ware is made of highly refined white clay free of impurities and a glaze with a slight blue tint. Round plates predominate the production in standardized sizes of 3-, 5-, 7-, and 10-sun.

The decorations

Nabeshima ware is characteristically decorated with cobalt blue underglaze and overglaze enamels of red, yellow and green. Celadon wares are known, but rarely, and probably from an early period.

Naturalistic floral patterns and stylized geometric patterns derived from textiles usually compose the main decoration. The pieces that have made Nabeshima ware well known have stenciled underglaze blue patterns of various types and hand painted overglaze enamels. Striking about the group is its recognizable precision of decoration and use of strong designs in carefully arranged placement. The strongly contrasting enamel colors emphasize both the precision and the designs. Nabeshima plates usually have a tall foot rim that is decorated in one of a small number of repeating underglaze blue patterns; the comb-tooth pattern is the most frequent.

The comb-tooth foot pattern consists of repeating blue rectangular stripes extending in equidistant progression from a blue band at the junction of the rim with the dish.

Also found on Nebashima foot rims are:

a blade pattern

a heart pattern

a lattice pattern

a thunder pattern

a wave pattern

The backs of Nabeshima dishes often have underglaze blue decorations which echo, or are similar in character to, the enameled decoration on their fronts.

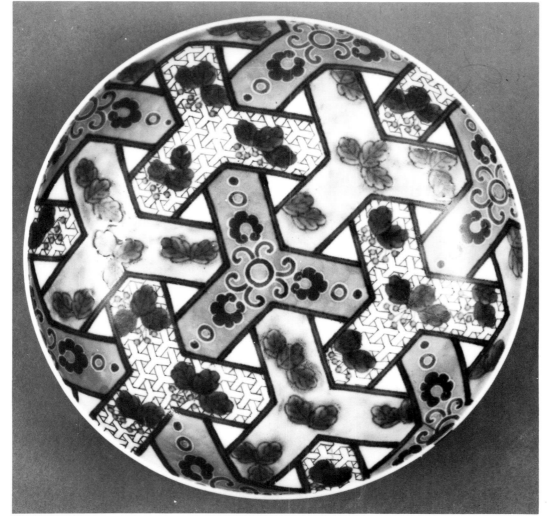

Nabeshima plate decorated with an interlocking pattern, which may be derived from textiles, and was used in bamboo mat weaving (see Ayers, *Baur Collection,* figure E52), probably early 18th century, 5 15/16" diameter, British Museum, London.

Nabeshima bowl possibly made for the Emperor with gold hoo birds in decoration, and later decorated with enamels for export, back with blue magic fungus and comb tooth foot rim decoration, 19th century, 10" diameter, Gibbons Collection.

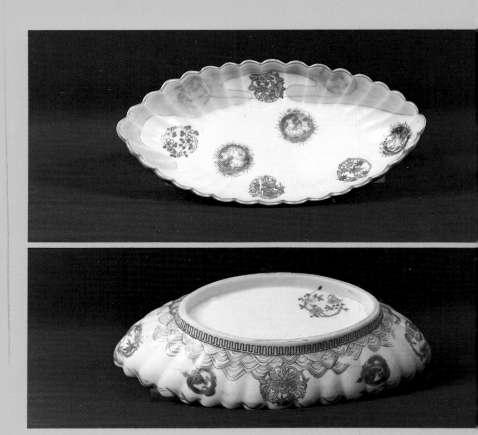

Nabeshima plate, Christies', New York.

Front and back views of Nabeshima oval dish with scalloped edge, late 18th century, 8¾" long, House of the Black Ship, New London.

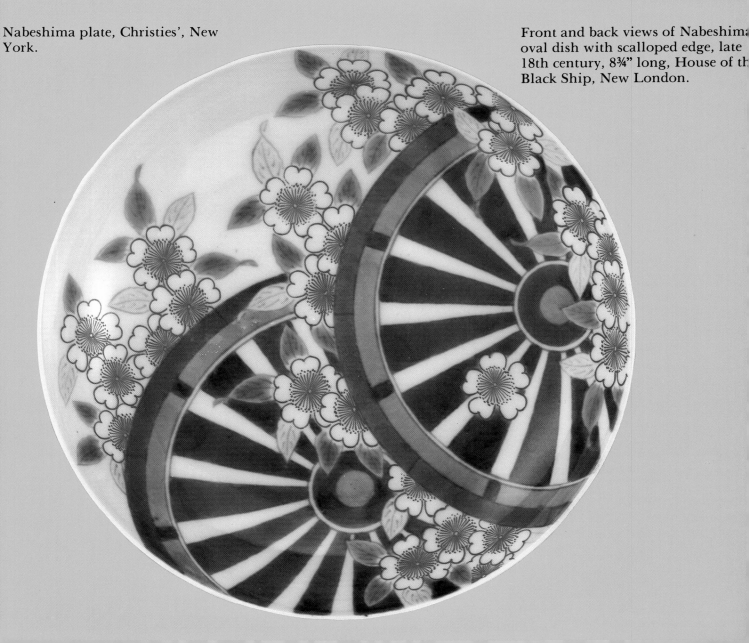

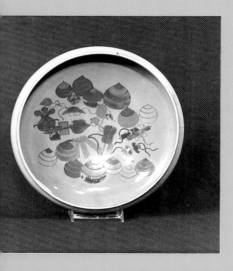

Nabeshima or Imari fish bowl in celadon with polychrome tops in the decoration, 19th century, 12" diameter, Norwich Free Academy, Norwich, Conn.

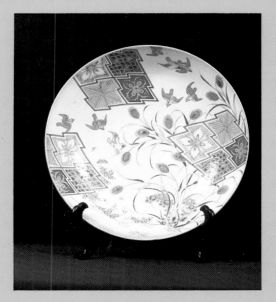

Imari dish in Nabeshima style of abalone shape with comb pattern foot rim design, with hat mark x on base, 19th century, 6½" long, The Oriental Corner.

Imari plate in Nabeshima style with broken brocade design showing wheat and sparrows, early 19th century, 12¾" diameter, Philip Van Brunt Collection.
p-189/13

Nabeshima plate, late 17th or early 18th century, 5¾" diameter, Christies', New York.

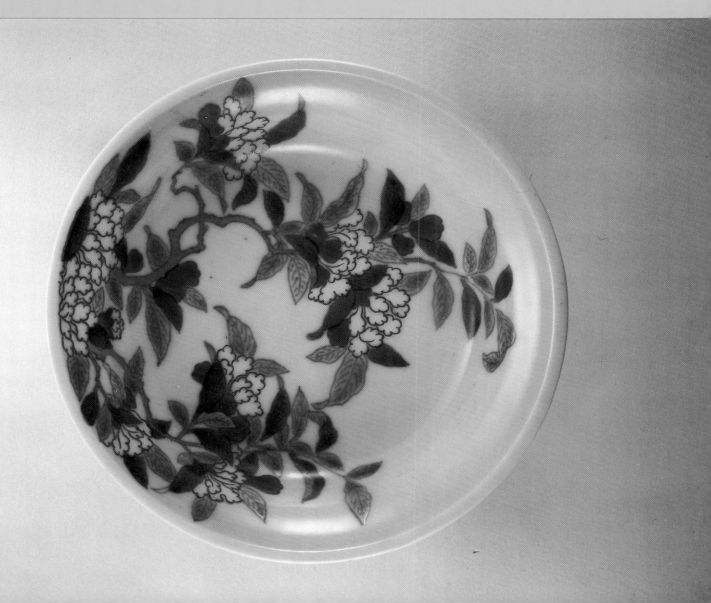

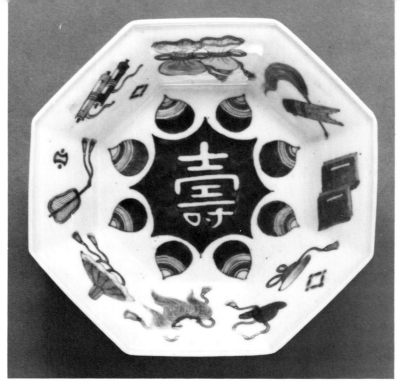

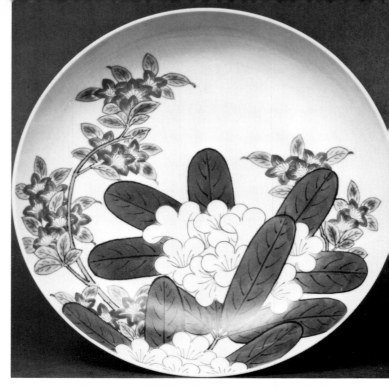

Imari octagonal dish in Nabeshima style with central good luck symbol and tops and symbols in the rim decoration, 19th century, 67/16" diameter, © 1986 Sotheby's, Inc.

Nabeshima plate, circa 1810, (see figure 270, Ayers, *Far Eastern Art in the Victoria and Albert Museum,*) Victoria and Albert Museum, London.

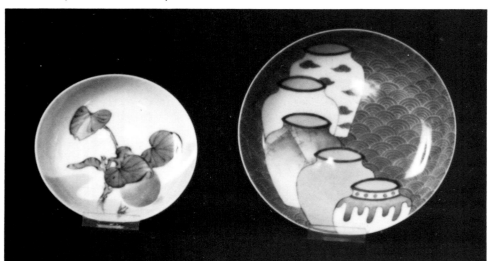

Two Nabeshima plates, 19th century, *left,* leaves in a vase decoration, 4⅝" diameter; *right,* five jars and clouds decoration, 6⅛" diameter, House of the Black Ship, New London.

Nabeshima plate with bamboo and prunus decoration, late 18th or early 19th century, Gibbons Collection.

Nabeshima plate with off-center flat rim, late 18th or early 19th century, 4¾" diameter, British Museum, London.

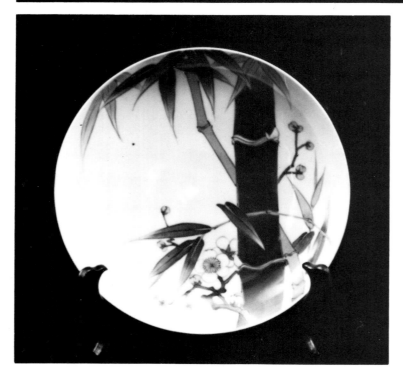

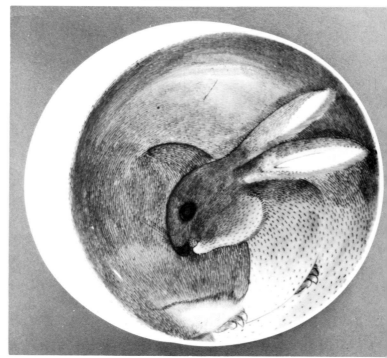

Kutani

History

Kutani (which means nine valleys) is in Kaga province, a rich rice-producing area of Japan. Some of the old Kutani ware looks so similar to Imari wares of the 17th century that their origin is suspicious. There is so much variety in the paste of old Kutani wares that one must assume they originate from a number of kilns.

It may be suggested that the ships which brought rice from Kaga to Hizen returned with undecorated porcelain from Arita. This porcelain may then have been decorated in Kutani. On June 6, 1986, Mr. Koji Ohashi of the Kyushu Ceramic Museum in Arita announced in the Arita newspaper that porcelain shards found during excavations over the last ten years at four Arita kiln sites of the 17th century, have been determined to have decoration of the Old Kutani style. Groups of shards from the Chokichidani, Dambagiri, Maruo and Yamabeta kilns have been found with underglaze blue outline decoration, usually called Old Kutani style. Old Kutani porcelain was previously thought to have been made at kilns in the Taishoji domain on Honshu Island and supported by the neighboring Kaga fief. This new information suggests a closer connection between Arita kilns and the Kutani style than was previously known, but it presents only one part of several theories about the origin of Kutani porcelain. [see Reichel, p. 401...& Kakiemon connection.]

Friedrich Reichel [*Early Japanese Porcelain*, p. 61] brings up the suggestion "that old Kutani porcelain was made by the first three Kakiemons." Jenyns shares this opinion to a certain degree [he claims], and refers to "pieces which can be regarded as transitional between Kutani style and the Kakiemon style known in Europe. Indeed, it would be unusual to achieve such a refined style right from the beginning, which is characteristic of a typical Kakiemon piece."

However, there is so much difference between the Kakiemon and Kutani wares of this or any period, that the idea of an evolution seems quite far-fetched at the moment.

Bowes and Audsley [*Keramic Art of Japan*, 1881, p. 183] relate,
> The earliest record of the existence of potteries in this province [Kaga] to be found in Japanese chronicles is that [not identified by them] which states that a factory was established about the 16th century by Iamora Gonzayemon, a Hizen potter [more fuel for the Arita connection], who made a ware decorated with dark green, purple and yellow; he was assisted by a painter named Kuzumi Morikage. It was not, however, until the year 1650 that the ware decorated with gold upon a red ground, now considered characteristic of Kaga [Kutani], was made. It was then that Godo Saijiro established a kiln at Kutani, where the clay is found from which the greater part of Kaga pottery is made.

These remarks seem to be more speculation than fact, which was only possible in the 1880's when they were writing.

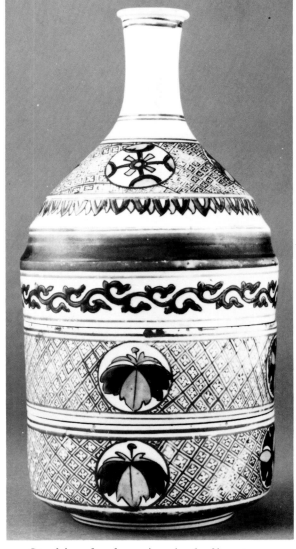

Stacking food carriers including two bowls and a bottle nested together in red, green and yellow enamels, possibly from Kaga province, 10½" high, British Museum, London.

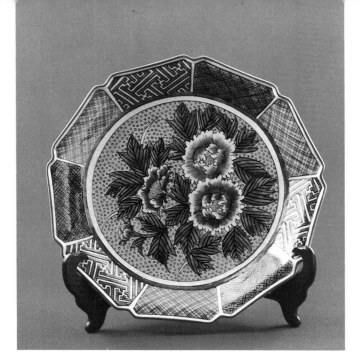

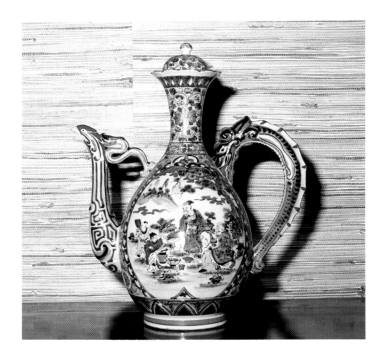

Kutani plate with nine rim panels and characteristic thick enamel decoration, 19th century, 12" diameter, Asian Fine Arts, Minneapolis.

Water ewer, probably made for the Turkish market, marked "Kutani", 19th century, 11½" high, The Oriental Corner, Los Altos, California.

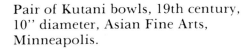

Pair of Kutani bowls, 19th century, 10" diameter, Asian Fine Arts, Minneapolis.

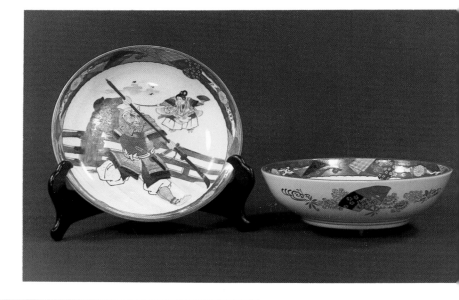

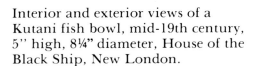

Interior and exterior views of a Kutani fish bowl, mid-19th century, 5" high, 8¼" diameter, House of the Black Ship, New London.

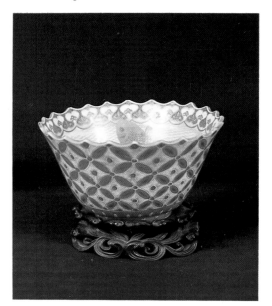

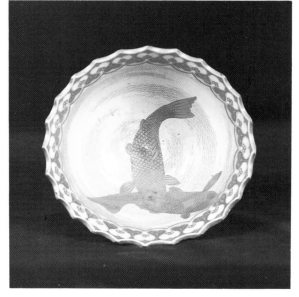

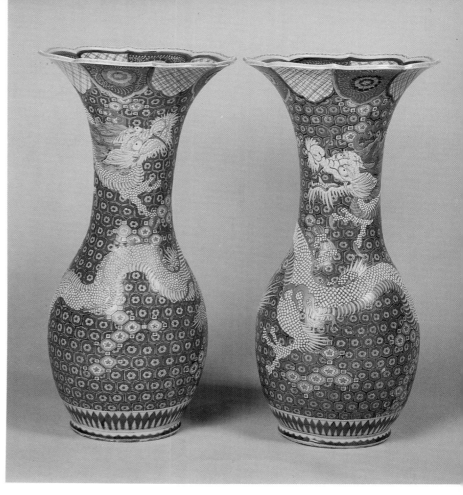

Covered pot marked "Kutani made", late 19th century. 5" diameter, 8" high, The Oriental Corner, Los Altos, California.

Pair of Kutani style vases, 19th century, 30" high, Charlotte Horstmann and Gerald Godfrey, Ltd., Hong Kong.

Kutani vase, circa 1850, 11" high, 9" diameter, Asian Fine Arts, Minneapolis.

Two Kutani dishes, 19th century, *left*, bowl with red background and gold, silver and black ginko leaves, 5⅜" long; *right*, soft paste dish with brocade and floral pattern, 6" long, House of the Black Ship, New London.

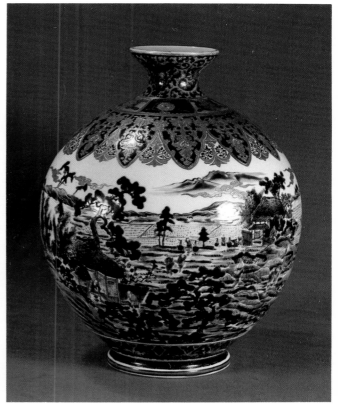

Excavations in 1969 and 1973 at Kutani kiln sites in Kaga revealed a history of ceramic production from medieval times, and evidence that these kilns were in operation in about 1670, but no shards of the Old Kutani type were found. [*Japanese Painted Porcelain*, p. 17-18] Takeshi Nagatake (writing about Kutani ware in the introductory remarks in his book, *Kakiemon*, Kodansha International, 1981, p.6) states his belief then "that this ware originated during the Meireki era (1655-58). The kilns then went out of production during the Genroku era (1688-1704) and were revived during the Bunka era (1804-18)."

In *Japanese Colored Porcelain*, Vol. 2, 1953, Yuzo Yamane suggested the history of Kutani originating with Maeda Toshiharu, the Prince of Kaga, head of the Taishoji clan, who loved ceramics and sent a potter named Goto Saijiro to travel (we don't know where and therein lies the question) and study porcelain making and decorating in the decade about 1642 to 1657. With a supply of local clay, Goto Saijiro apparently made or oversaw production of porcelain called Taishoji-ware for about 20 years until his death, at which time the kilns were closed.

Decorations

Kutani wares from the seventeenth century are now called Old Kutani, while those from the nineteenth century production are simply known as Kutani. The Old Kutani wares include a wide variety of styles. There are examples of apparent Kutani ware in the styles of Chinese porcelain, Persian taste, and blue and white porcelains. So much discussion persists about these early wares that it seems wise to refrain from conclusions at this time until further evidence has been found.

Old decoration

One style of Old Kutani is decorated with vivid green, purple, blue, yellow, and red tones in strong geometric areas. The colors may be Chinese in origin, applied with Chinese brushes, for the work is very bold and strong. If marked, they have the Chinese *Fuku* (good fortune) in a square.

It is not likely that the Kutani kilns ceased production altogether for a hundred years, but information about them is not generally known. The kilns were certainly run on a small scale, and perhaps made ware for local taste. It is remote that any export wares originated here in the eighteenth century.

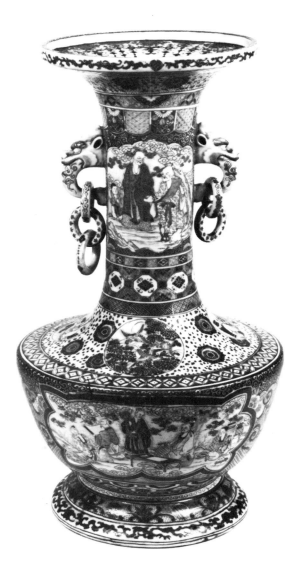

Vase, perhaps made for the Islamic market, signed on the base Tokyo Toki-gako Saiunro Kyozan, 19th century, 27¾" high, Christie's, London.

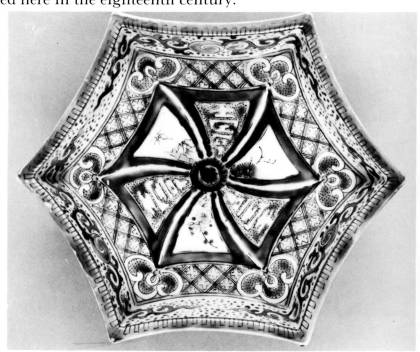

Kutani hexagonal dish with three fuku marks alternating with panels containing pine, plum and bamboo (three friends) motifs, early 19th century, 7½" diameter, British Museum, London.

A revival period in the nineteenth century for Kutani porcelain wares took place at various old and new kiln sites around Kutani. Many kilns of the area were opened and closed in the first half of the 19th century. The lord of the Kaga clan invited the painter and potter Aoki Mokubei (1767-1833) from Kyoto to oversee production at a new kiln at Kasugayama some time between 1808 and 1818. Here and later at the kilns of Yoshidaya and Wakasugi [*Japanese Painted Porcelain*, p. 18], Mokubei oversaw imitations of many ceramic styles then popular in Kyoto, including celadon, Imari, Siamese pottery, European painting, Korean wares, and the work of Ninsei, a very influential Kyoto ceramist, all from clay found at Kutani. [Yamane, p.23]

Another revival was attempted at the site of an earlier kiln. In 1810, the Yoshidaya kiln was established by a merchant called Yoshidaya Denyemon. Here potters tried to recreate Old Kutani wares by hiring talented artists. Their businesses lasted only a few years. However, production began anew in 1814, under the supervision of Miyamotoya Uyemon, whose son Riyemon, succeeded him in 1840. [Gorham, p. 133]

In 1822, Hayashi Hachibei, a potter from Wakasugi, borrowed money from Lord Mayeda and begun to manufacture wares in the Imari style known as Wakasugi wares. The kiln passed through several hands and produced a ware "decorated in red" by a potter named Yujiro.

In 1840 Iidaya Hachiroyemon introduced a new style of red and gold porcelain called red Kutani, which has gold design on a red background. In 1849 Hachiroyemon died. In 1866, Zengoro Wazen (Eiraku 12th) came to the kiln and made red Kutani and red designs on white background. Some of his work has blue and white inside decoration. In 1875 Wazen was invited to Daishoji in Kaga.

None of these kilns or potters were enormously successful, but as a group they had a distinctive style and continued the tradition of ceramics in this province.

After the Meiji restoration (1868), production at the Kutani kilns declined, but within just ten years they had recovered and were enjoying brisk activity. With technical improvements developed through Western influence, glazes and firing processes could be better controlled. In the late 19th century, export trade supported a large business here.

Kutani or Imari jar with polychrome geometric decoration, late 19th century, Victoria and Albert Museum, London.

Square bottle with demons in the decoration, possibly from Kaga province, early 19th century, 3" high, British Museum, London.

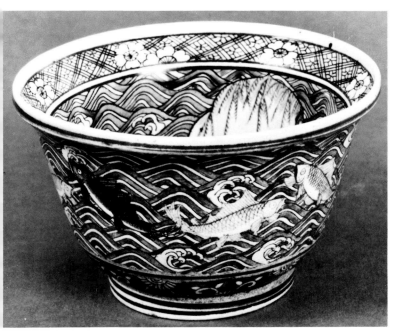

Kutani cup from the Wakasugi kiln marked Hayashi, 19th century, 3⅞" diameter, British Museum, London.

Kutani plate with 8-lobed rim and
scroll decoration, Flying Cranes
Antiques, New York.

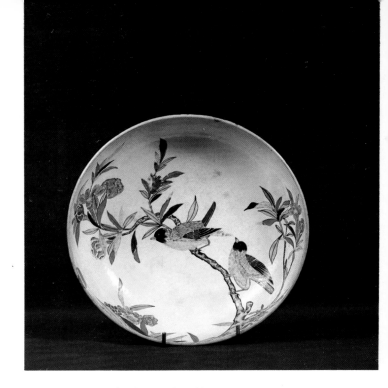

Kutani plate with finches on a
quince brance in the decoration and
the mark of the nine valleys on the
base, 19th century, 8½" diameter,
Philip Van Brunt collection.

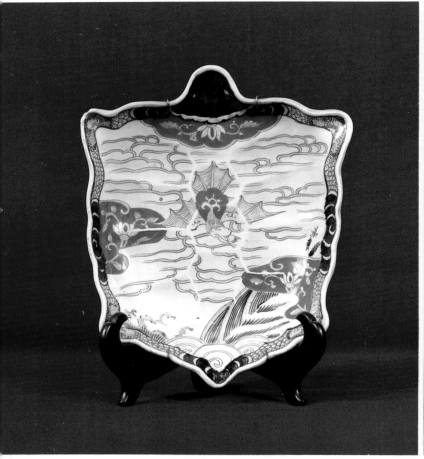

Kutani dish in the form of a turtle
with a stylized bird and clouds in
the decoration, late 18th or early
19th century, 9" long, House of the
Black Ship, New London.

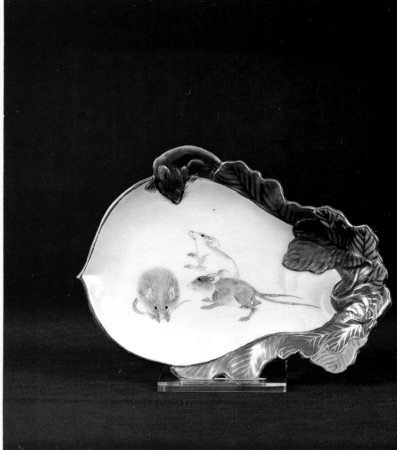

Kutani dish in the form of a radish
with four mice in the decoration,
19th century, 7½" long, Philip Van
Brunt collection.

196

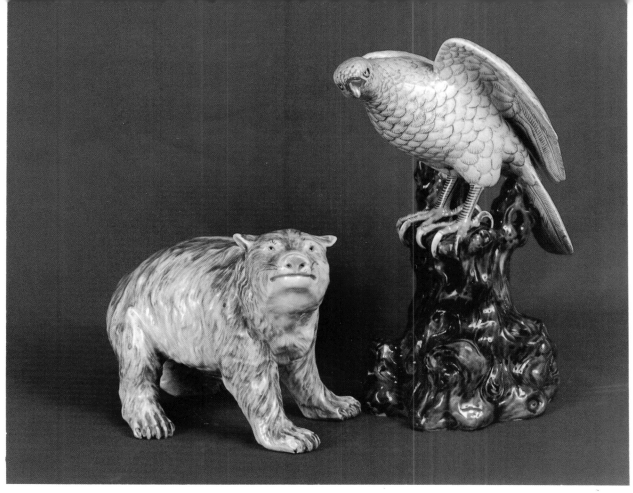

Kutani bear and Kutani hawk, 19th
century, Flying Cranes Antiques,
New York.

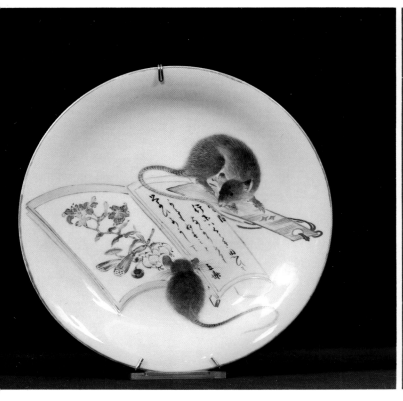

Kutani plate with rats and a book in
the decoration, 19th century, 9¾"
diameter, Philip Van Brunt
collection.

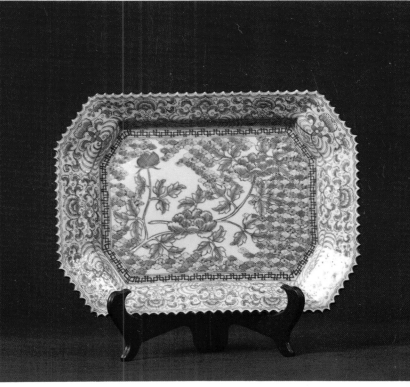

Kutani dish probably made for the
Persian market, 18th century, Philip
Van Brunt collection.

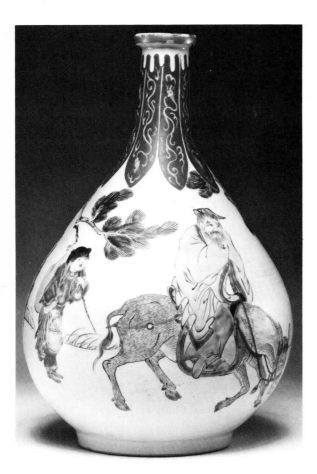

Kutani bottle with enamel decoration of a sage and attendant, 18th century, 14¾" high, © 1986, Sotheby's, Inc.

Jar in red and gilt decoration signed Kutani Keikichi, late 19th century, 11½" high, Christie's, London.

Another potter whose porcelain achieved some notoriety was Sozan Sua (1852-1922), who was born in Kanazawa. After working in Tokyo, he returned to Kanazawa and took over direction of the industrial school there. In 1900, he moved to Kyoto and worked at Kinkozan's kiln in the Awata district and then at his own kiln at Gojozaka. About 1912 he studied Korean ceramics, and became a member of the Imperial Fine Arts Academy.

At the several kilns in the Kutani area, individual potters worked and, increasingly toward the end of the century, marked their wares with their names, perhaps the date, and sometimes the place of manufacture. These marks are sometimes the only clues to organizing the wares today, since there was so much variety among the potters.

Yamane suggests four distinct phases of the 19th century Kutani ware. The first phase took place from the renewal of production by 1818 until about 1829. During this period the Japanese taste was for elegant styles, emphasizing pleasure and the good things of life. He sees the porcelain in production here at this time as frivolous, without dignity, with narrow lines, dull and indistinct colors, soft bodies, poor firing techniques and commonplace composition. [Yamane, p. 24]

In the Kutani ware of this first phase, Audsley & Bowes state:

> The pâtes are hard, and apparently between faience and porcelain, in some instances inclining to one and in some instances to the other. The tone, in the choicest examples, is of an ivory tint, and the glaze is soft, both to the eye and touch. The decorations are executed in a red of singular depth and refinement of tone, slightly hatched with gold." [Audsley & Bowes, p. 184-5]

Here Audsley & Bowes describe the gold used as having "the appearance of the metallic application; it is, however, not real gold, as the gradual tarnishing of the surface proves." [p. 185]

The second period in Yamane's scheme lasted roughly from 1830 until 1843—when classical Chinese literature was very popular. He sees the Kutani ware of this period influenced by Chinese red painted style coming through Kyoto artists and designs taken from Chinese books. Red and gold of this period is rather dull, and a yellow-toned background was used. The glazes were often left thick and half-baked as though from incomplete firings.

Audsley & Bowes do not confine their descriptions with dating bounds, but generally recognize this phase as a middle period. Here they acknowledge a different [paste] "of a hard and close-grained material, very nearly a perfect porcelain..(but with) no tendency towards translucency, like the fine porcelains of later works. (Later works from Kutani or elsewhere—we are made to wonder)...The decorations are of a deep full-toned red, in some instances approaching a ruddy brown and richly wrought with gold." The "various... artistic treatment" they recognize at this period include:

> overlapping medallions of different shapes, containing figure-scenes, landscapes, and floral compositions; belts composed of continuous figure subjects, or of compartments variously filled up; dragons coiling on grounds of minute and laboriously worked spiral-pattern; fish and seaweed on net-work grounds, and conventional and geometrical designs. Solid grounds of red, decorated with gold scroll-work or diaper, are also commonly introduced round the medallions; and leaf-borders are found almost invariably round the stands of basins and cups. [Audsley and Bowes, p. 185]

A third period is seen by Yamane as coinciding with the Meiji reform period, including the time when Japanese isolationism ended and international trade was vastly expanding—roughly 1843 to 1868. Now Oriental and Western ideas were mingling in confusion. Kutani ware from this period is seen using a deep Chinese style red, European style glazes in addition to the traditional Kutani style glazes, and increased use of dull black in the decoration.

Audsley and Bowes view this late period with mixed criticism. On the one hand, they recognize "a falling off in artistic excellence", but also:

> the greater perfection of potting and the employment of good porcelain. The red and gold decorations do not appear so refined and harmonious on the highly-finished and cold-looking surface of the pure white pâte as they do on the early ivory-tinted materials, and this probably induced the Kaga artists to introduce an additional colour—a warm brown—which appears for the first time in the late period works. The brown undoubtedly does much to soften the pronounced and rather staring effect of the red on the pure white, but it altogether destroys the marvellous richness obtained by the simple use of deep red and gold on the warm-toned pâtes. Much of the drawing of this period is characterised by great dexterity and laboured accuracy; and masses of minute dot work are distributed over the white grounds, with a view to a softening effect. We may remark that the dot-work is occasionally met with in early specimens. In addition to those we have above enumerated, another class of decoration sometimes appears on the works of this period; it consists of grounds of red covered with scrollwork and other designs executed in rather a solid manner in gold, similar in style to the celebrated works of Yeiraku, of Kioto. A member of the family of Yeiraku settled in Kaga about twenty years ago [circa 1860], and probably introduced this mode of decoration. Pieces are occasionally met with bearing marks signifying *Made in Yeiraku fashion in Kutani*. [Audsley and Bowes, p. 186]

Kutani ware was practically unknown in the West until a large group of pieces were shown at the Paris Exhibition of 1867. Here the red, gold and soft white tones were greatly admired. [Audsley & Bowes, p. 120]

The last period Yamane sites begins about 1868 and continues to the present. He sees this as a time of constant experimentation. European manufacturing techniques enabled mass production of daily utensils. These Kutani wares were not only sold throughout Japan, but were exported on a large scale to other parts of the world. By this time, the traditional characteristics of Old Kutani were entirely lost as the many new forms and designs were used.

At the beginning of the 20th century, many poor quality porcelain items were exported from the Kaga area with red decorations of Chinese figures and landscapes on a white ground. Some have a comb pattern on the foot, and some of them were decorated outside of Kaga, such as the Tokyo decorators workshops. There are also examples from this period with printed decorations and free standing figures.

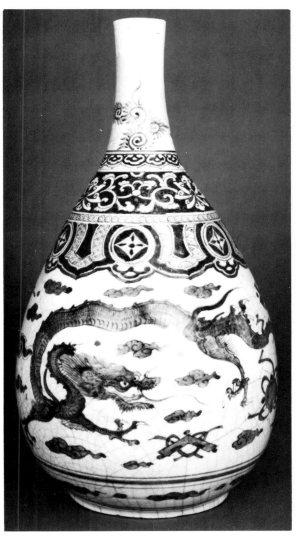

Bottle with underglaze blue decoration and Kutani mark, 19th century, 16⅝" high, British Museum, London.

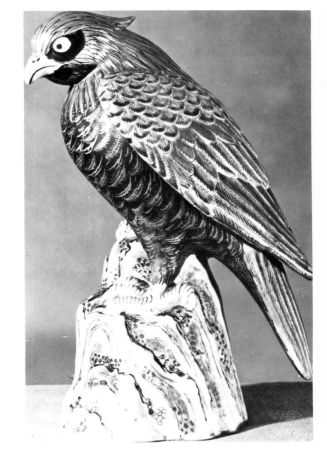

Eagle marked "Kutani made", early 19th century, 9⅞" high, Victoria and Albert Museum, London.

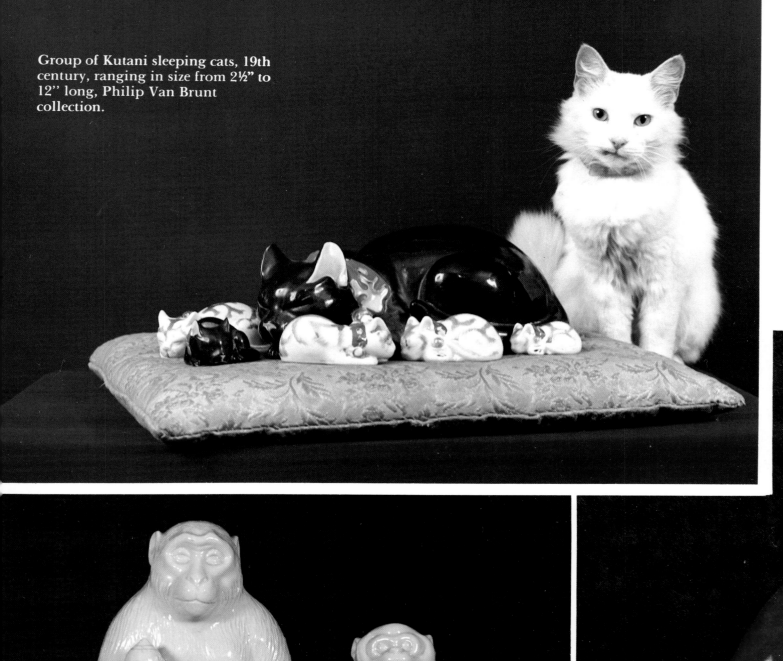

Group of Kutani sleeping cats, 19th century, ranging in size from 2½" to 12" long, Philip Van Brunt collection.

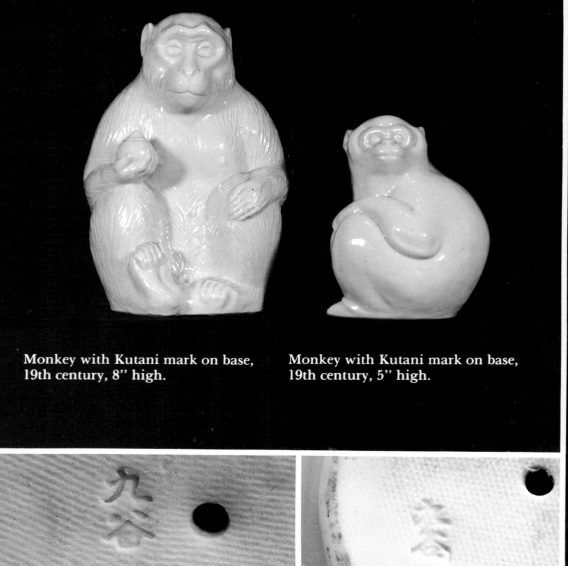

Monkey with Kutani mark on base, 19th century, 8" high.

Monkey with Kutani mark on base, 19th century, 5" high.

Rabbit with Kutani mark on base,
19th century, 5" high, James Galley,
Rahns, Pennsylvania.

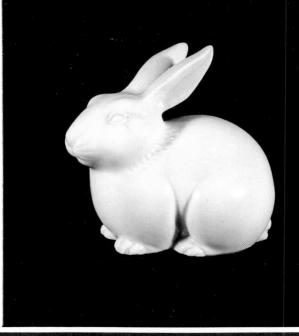

Kutani rabbit, 19th century, 3½"
high, Mr. and Mrs. Curtiss S.
Johnson, Jr.

Kutani cat, 6½" high, late 19th century.

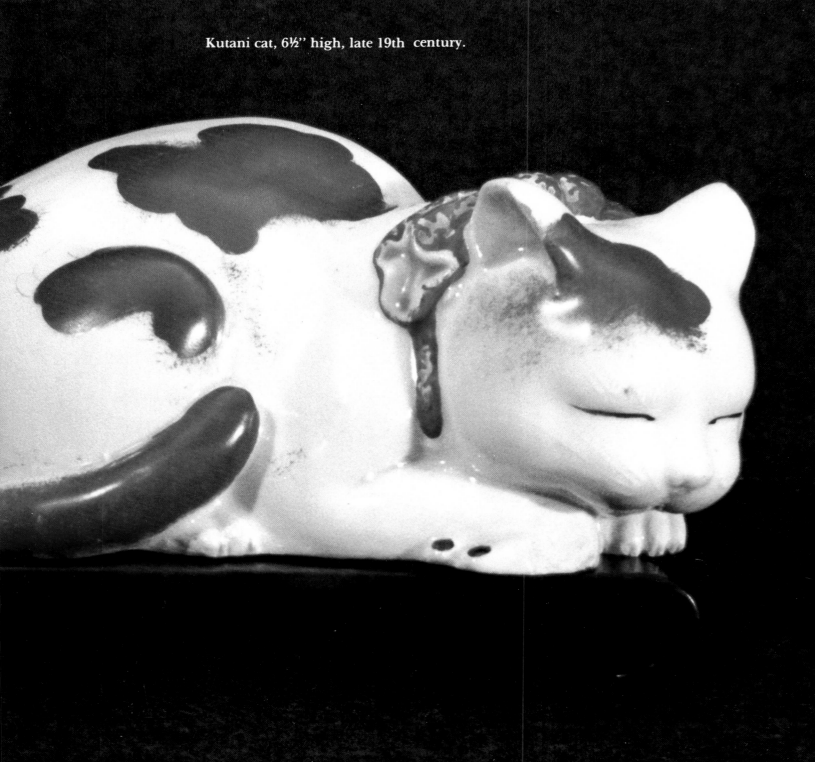

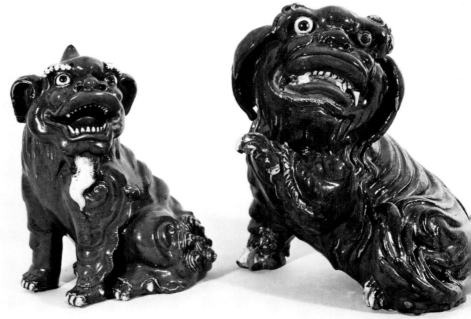

Two red glazed dog figures, 7'' high, probably late 19th century, Flying Cranes Antiques, New York.

Pair of Kutani vases with brown backgrounds, late 19th century, 31½'' high, © 1986, Sotheby's, Inc.

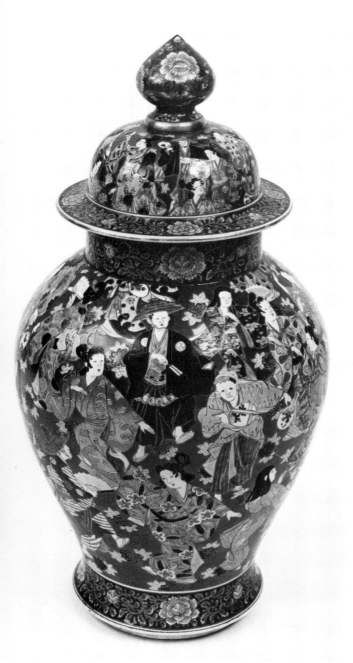

Kutani covered jar with red background and polychrome enamel decoration, circa 1850, 27'' high, Flying Cranes Antiques, New York.

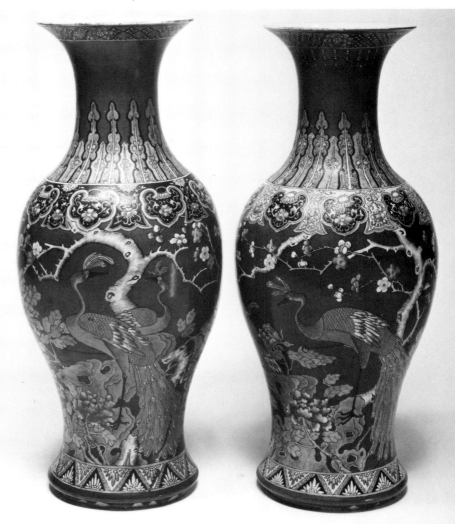

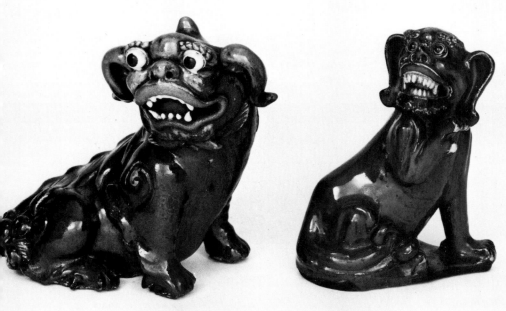

Two red glazed beasts, 6'' high,
probably late 19th century, Flying
Cranes Antiques, New York.

Incense burner with a seated scholar
on the lid, group of 8 Immortals
and their attributes, and elaborate
base with dragon figure signed
Kutani Togyokudo, late 19th
century, 14⅞'' high, Christie's,
London.

Pair of vases and incense burner,
perhaps made in Kaga province, late
19th century, *left and right*, vases
26⅞'' high, Christie's, London.

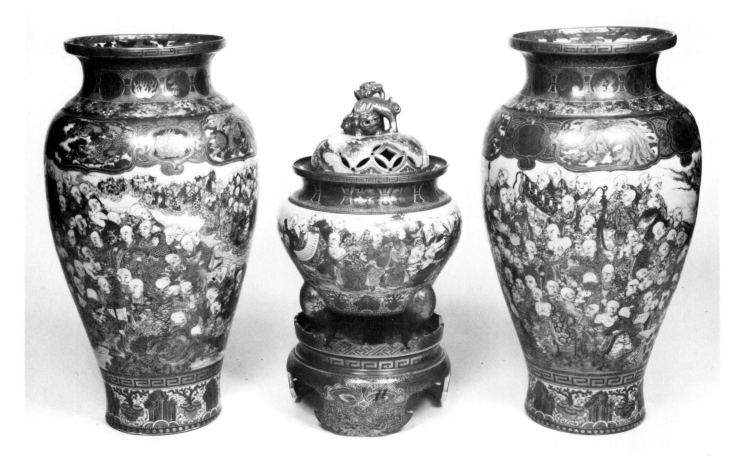

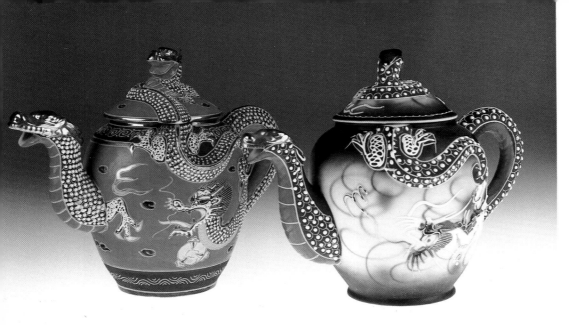

Two teapots made after 1921 for the United States market, each 8" high, *left*, grey background marked with red stamp "Kutani, hand painted, Japan", *right*, red background, marked with red stamp "Hand painted, Japan", Altemose collection.

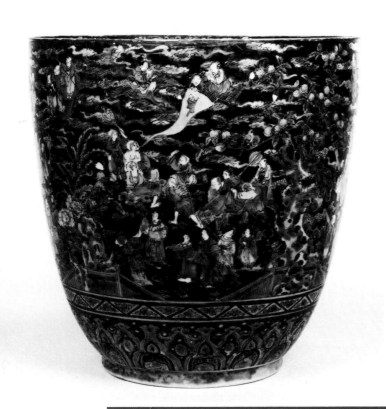

Kutani saki cup rinser, 19th century, 4¼" high, 5¾" diameter, Gibbons collection.

Kutani vase depicting Immortals and attendants, 19th century, 13⅛" high, Christie's, London.

Kutani oval tray, 19th century, Flying Cranes Antiques, New York.

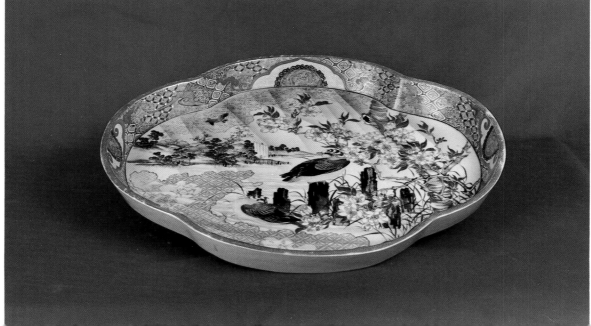

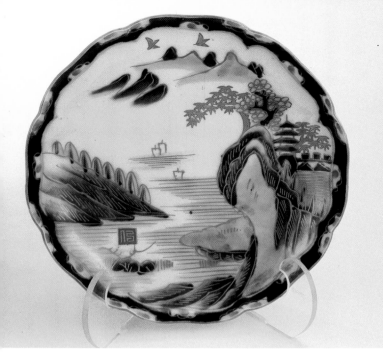

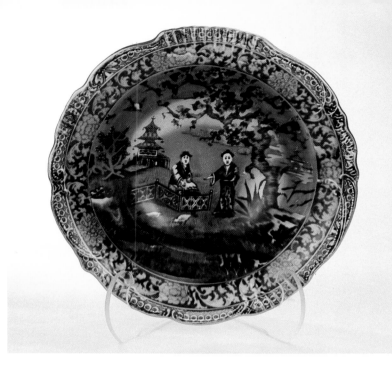

Kutani plate, early 20th century, 8½" diameter, Jacquelyne Y. Jones North collection.

Kutani berry bowl with transfer printed blue decoration, early 20th century, 9¼" diameter, Jacquelyne Y. Jones North collection.

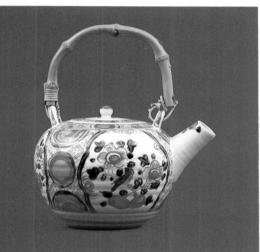

Kutani tea pot, 19th century, 4¼" high, 6¼" long, Gibbons collection. Richard Gibbons collection.

Two Kutani vessels, 20th century, *left*, vase 8¼" high, 6¼" wide; *right*, chocolate pot, 9¾" high, Jeannette and Sina P. Kurman collection.

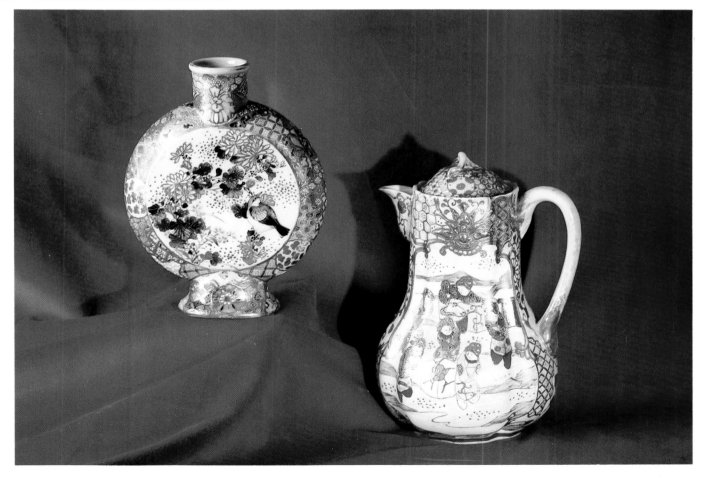

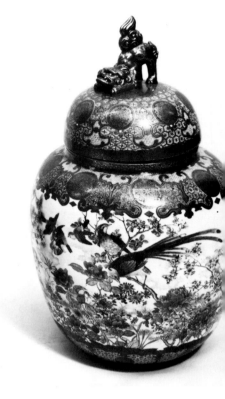

Kutani covered jar, 19th century, 30'' high, Albany Antiques, Hindhead, Surrey.

Kutani monkey and young, late 19th century, 11 15/16'' long, Christie's, London.

Kutani incense burner in the form of a sleeping cat, lid missing, 19th century, 3½" long, Victoria and Albert Museum, London.

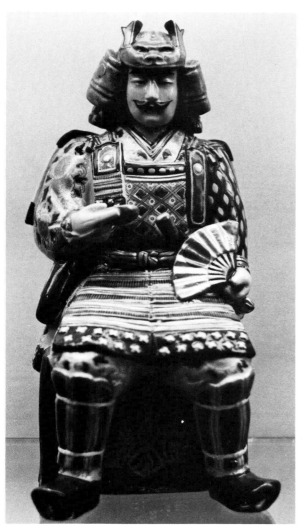

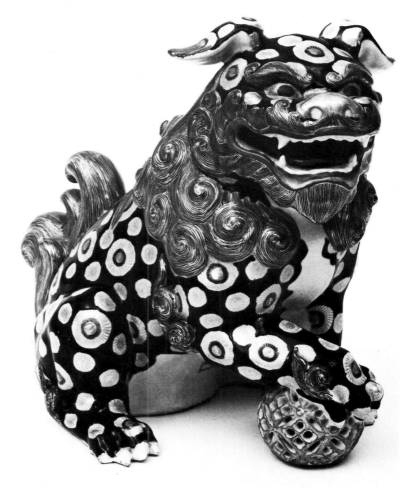

Kutani Samurai, late 19th century, 11" high, Flying Cranes Antiques, New York.

Kutani figure of a lion dog, 10" high.

Kutani unglazed dragon with impressed signature "Daikoku", late 19th century, 10½" high, © 1986, Sotheby's, Inc.

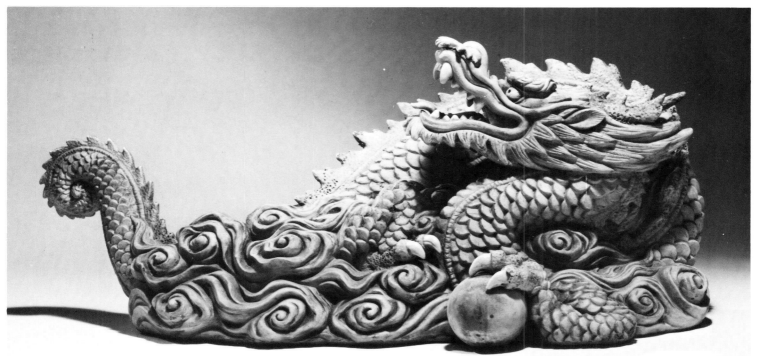

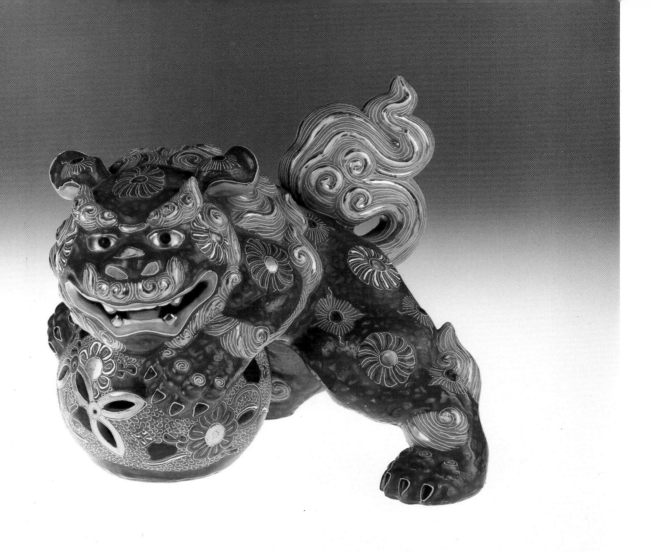

Lion-dog with ball marked twice, one impressed Kutani mark and circular red stamp reading "Handpainted, Japan, Yamazuki, China, Kutani Yeki", 20th century, 8" high, Altemose collection.

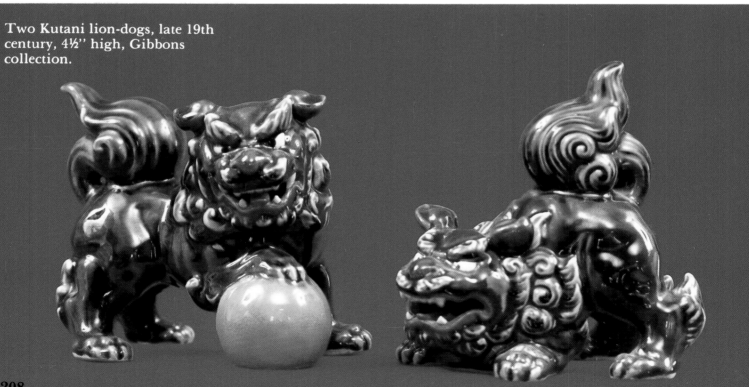

Two Kutani lion-dogs, late 19th century, 4½" high, Gibbons collection.

Satsuma

About the time of the arrival of the first Korean potters in Arita (about 1598, see Ceramic History section) a general of the Japanese army, the Prince of Satsuma, Shimadzu Yoshihisa, brought home with him 17 Korean potters and their families. They settled at Chiusa and Kagoshima, in the southern part of Kyushu Island (see map). Here the potters set to work to make ceramic vessels from local brown clay. When white clay was discovered near the village of Nawashirogawa, about 1630, the potters were gathered together there, and succeeded in producing Old Satsuma ware, after many experiments.

Customarily, Old Satsuma wares have a transparent glaze recognized by a fine network of cracks throughout. The cracks, or crackle, give pieces a soft appearance which acts as an effective background for the usual overglaze enamel decorations in many soft colors and gold. The clay is fired at temperatures which place the ware in the soft-paste porcelain group. None of the Old Satsuma ware is hard-paste porcelain as are pieces from the Arita areas.

Satsuma province kilns made whitewares with sparse decoration and very fine crackles. Osumi province kilns have a buff ground with defined crackels. Old Satsuma ware was seldom made in large pieces. Most were bowls, small dishes, saucers tea pots, and incense burners. Later, vases of moderate size were made. Seventeenth century Satsuma potters learned from the porcelain painters of Arita to use bright colors. Examples of this period are exceedingly rare.

It was not until the end of the 18th century that the wares we recognize today as "Satsuma" were developed. Around the 1790's two artists, Hoshiyama Chiubei and Kawa Yagoro were sent from the Kagoshima area to workshops in Hizen, Higo, Chikuzan, and Chikugo to learn about ceramic techniques. They also went to Seto to see Mifukai ware. At the Awata district of Kyoto they learned the methods for enameling faience. In the 17th century ceramists from Awata had visited kilns in Satsuma. Therefore, there was already a close affiliation between the two areas.

Back in Satsuma, the style of overglaze enamel and gold was refined. Most pieces of the early 19th century were decorated with scenes from nature, such as floral, bird, insect and animal designs. Not until the middle of the century did human figures appear, and sometimes these were in the forms of demons and warriors, as well as identifiable people from Chinese literature, theatrical characters and legendary heros. The decoration is usually composed of painted overglaze enamel with 1) geometric textile patterns; 2) birds, such as pheasants and peacocks; and 3) flowers, such as the chrysanthemum and peony, or a combination of them. The outlines of the decorations are usually delicate red and green, but thick gold lines of a dull color are occasionally used as outlines. Figure subjects are not found on true Satsuma wares from this period.

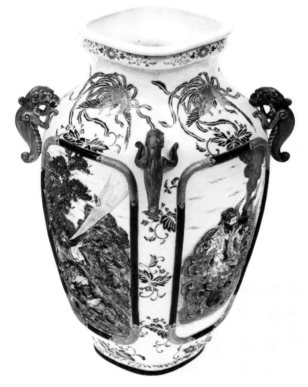

Satsuma vase with relief panels and insect figures on the shoulder, early 19th century, 16" high, Flying Cranes Antiques, New York.

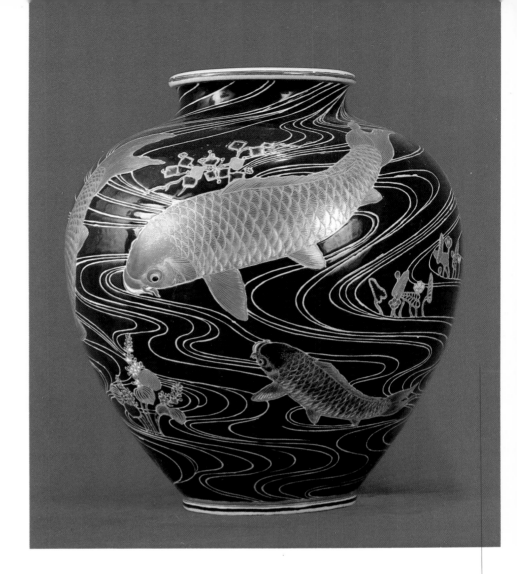

Satsuma vase with carp and water chestnuts in a blue glazed background, circa 1850, 13" high, Toyobi Far Eastern Art, Inc., New York.

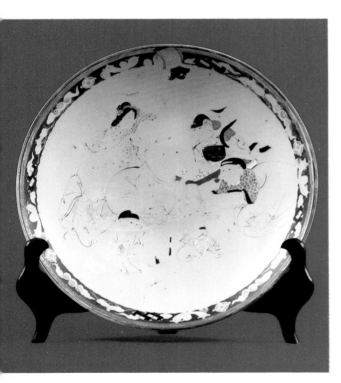

Satsuma plate with faded or incomplete decoration of six figures and a rice sac, 19th century, 15½" diameter, Gibbons collection.

In the second half of the 19th century, fine Satsuma ware continued to be made at the Tadeno factory in Kagoshima. Vases of exceptional height and difficult workmanship were manufactured for the Philadelphia Centennial.

In 1877, Sir Ernest Swatsow, a British minister in Peking included the following description of Satsuma wares in an address to the Asiatic Society of Japan: "At the pottery belonging to Chin Ju Kan [art name Gyokuzan], I saw a group being modelled in white clay, which after baking and glazing, assumes a light cream crackle. These articles were intended to be decorated later with gilding and colors." [Andacht, p.53]

About 1905, a ceramist named Masataro Keida of Kagoshima, was producing traditional Satsuma wares as well as a new style of pierced wares. Other Kagoshima potters of the 20th century include Togo Jusho, Sameshima Kunseki, Kumamoto Kinji and Uyeno Yachiro.

Satsuma style wares made around 1915 often have white or yellow outlines. Blank Satsuma ware was exported to the West between 1914-1918 when Europe was at war. These were decorated by hobbyists there. For example, in 1917, the Pickard Studios of Chicago decorated Satsuma style blanks with "Bouquet Satsuma" pattern. During the 1918-1928 period, Satsuma wares were predominantly decorated in Japan for export to the West with black outlining and gold, jewel-like enamel. Every surface was covered.

The mass-produced Satsuma style pieces of the 1920's often have a matt dark brown background, while those of the 1930's may have a more red-toned matt background.

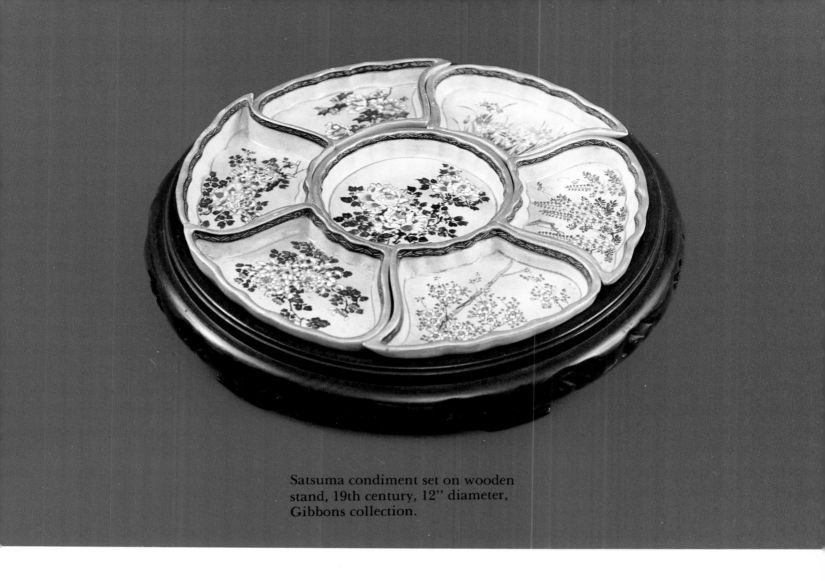

Satsuma condiment set on wooden stand, 19th century, 12'' diameter, Gibbons collection.

Satsuma plate with floral decoration and geometric border, 6¾'' diameter, Jacquelyne Y. Jones North collection.

Satsuma plate with landscape decoration and geometric border, 7'' diameter, Jacquelyne Y. Jones North collection.

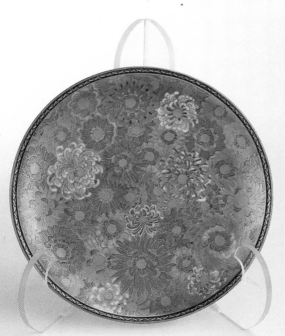

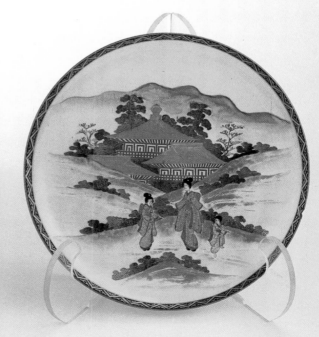

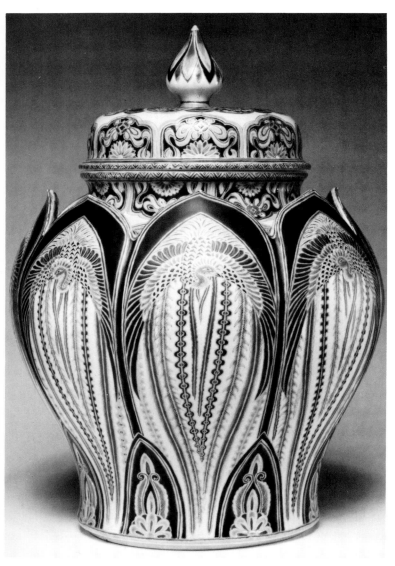

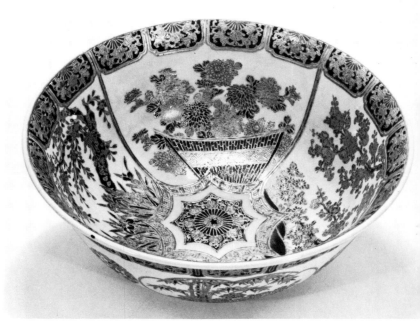

Satsuma bowl, circa 1810-1820, 10"
diameter, Flying Cranes Antiques,
New York.

Satsuma covered jar in the form of a
lotus flower, 19th century, 16" high,
© 1986, Sotheby's, Inc.

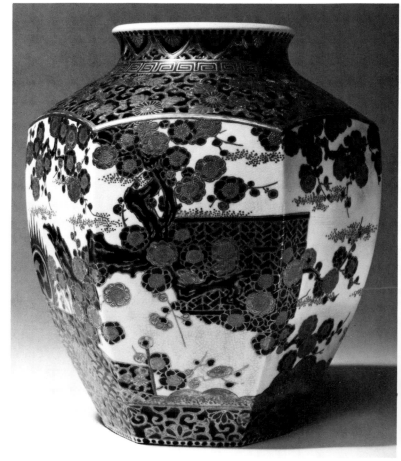

Hexagonal Satsuma vase with
brocade pattern borders and
Satsuma family crest, 10¼" high,
19th century, © 1986 Sotheby's, Inc.

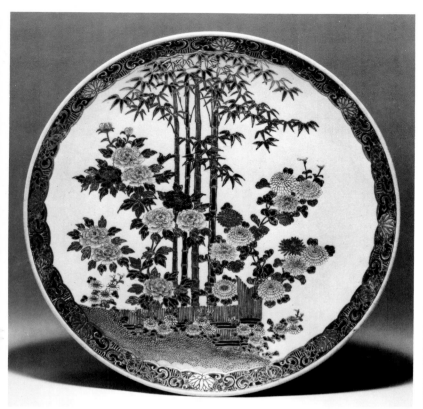

Satsuma plate with brush fence, bamboo and chrysanthemums in the decoration, signed "Made in Japan, Satsuma, Meigyokudo", late 19th or early 20th century, 9⅝" diameter, © 1986, Sotheby's, Inc.

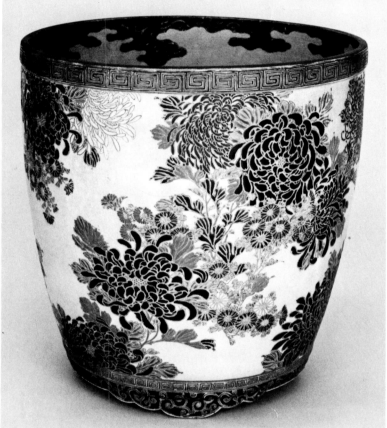

Satsuma jardiniere, early 19th century, 13" high, Flying Cranes Antiques, New York.

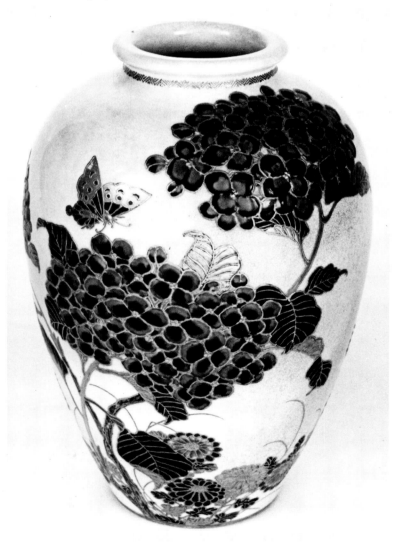

Satsuma vase, early 19th century, 10" high, Flying Cranes Antiques, New York.

213

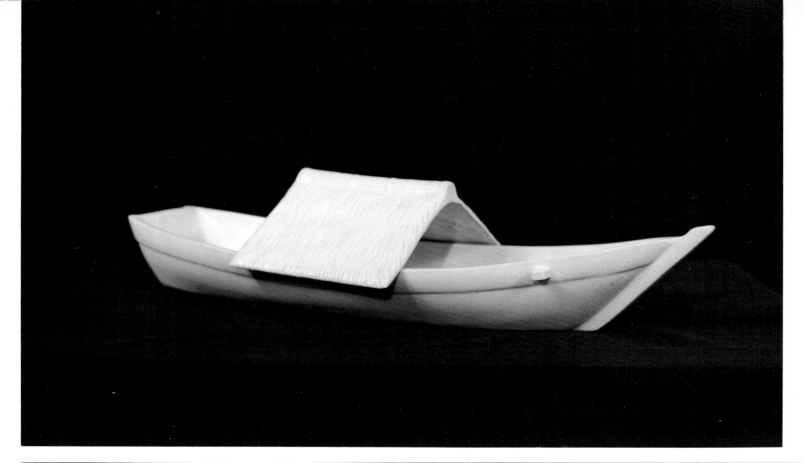

Boat shaped Ikebana flower container with mark identified as Banko, possibly Kyoto area, late 19th century, 25'' long. A similar boat 18'' in length has been reported. Philip Van Brunt collection.

Basket with mark identified as Banko, possibly Kyoto area, late 19th century, 8'' diameter, House of the Black Ship, New London.

Kyoto and Kyoto-Satsuma

Kyoto was the cultural center of Japan and an important commercial hub throughout the seventeenth, eighteenth, and nineteenth centuries.

The Kyoto potters were individual artists who mixed their own clay from many other places; natural clay deposits were not plentiful. Therefore, the bodies of each artist are different, and techniques of decoration are as numerous as the potters themselves. Rather than many specialists working together to produce many pots, the Kyoto artists were responsible for each process themselves. They had assistants, and students, but the process was controlled by the potter primarily.

Kyoto earthenware of the Raku style has a long and important history. Further information on Raku can be obtained from books on Japanese ceramics.

The porcelain wares from Kyoto fall into two primary groups: hard-paste porcelain of Kiyomizu ware, Celadon ware, and pieces in Shonsui style, and soft-paste porcelain called Awata ware and later Satsuma ware.

Kyoto tea bowl, late 19th century, 4½" diameter, 2⅝" high, The Oriental Corner, Los Altos, California.

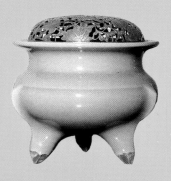

Celadon incense burner with pierced silver cover, possibly made in the Sanda area near Kyoto, 19th century, 3¼" high, 3¾" diameter, The Oriental Corner, Los Altos, California.

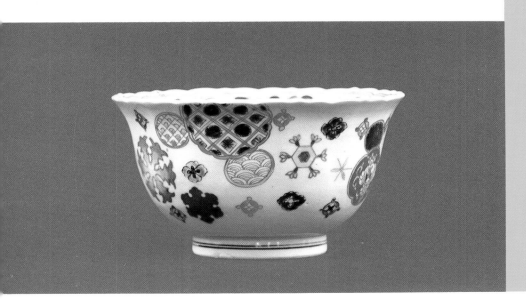

Kyoto bowl with enamel decoration over blue transfer, late 19th or early 20th century, 6½" diameter, 3½" high, Gibbons collection.

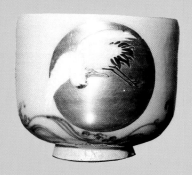

Kyoto tea bowl marked with impressed seal of Eiraku Wazen (died 1896), late 19th century, 4" high, 4⅜" diameter, The Oriental Center, Los Altos, California.

215

Kiyomizu wares

Augustus Franks [writing in 1880, *Japanese Pottery*] related that the Kiyomizu factory was started by Otawaya Kurobei in the 1751-63 era. Here several important potters made blue and white porcelain like those made at Arita with Izumiyama clay (apparently transported for the purpose from Arita). Among these potters were:

Takahashi Dohachi I	Kanzan Denhichi
Wake Kitei I	Muruya Sahei
Midsukoshi Yosobei	Kameya Bunpei

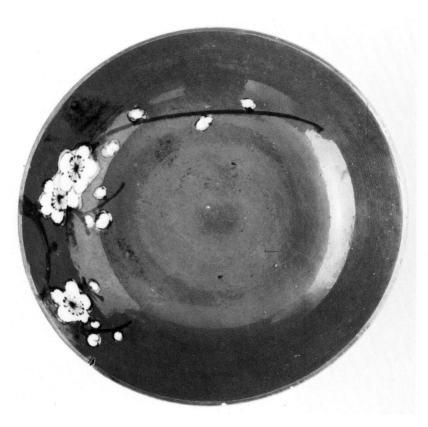

Water jar in the form of a well bucket, Kyoto area, 1850-1875, 8¾" high, British Museum, London.

Vase in the form of a well-head with blue fish and waves inside and brown wood grain outside, marked Taokuang (1821-1850) Nen Sei, 61/6" wide (see page 67 and plate 59, L. Smith, "Japanese Porcelain..."), possibly from the Kyoto area, British Museum, London.

Plate with brown background and white plum blossoms possibly from the Kyoto area, early 19th century, 6⅛" diameter, British Museum, London.

Kyoto fluted bowl, 19th century, 7⅛" diameter, British Museum, London.

Shonsui-style

The "Shonsui" wares were Chinese blue-and-white porcelains imported into Japan in the mid-17th century, and decorated with a repertoire of designs much to the Japanese taste in which a variety of diapered patterns are often juxtaposed with small pictures in roundels. (see L. Smith, *Japanese Porcelain*, p. 68)

Kyoto became the centre of appreciation and manufacture of the Shonsui wares.

In the 19th century Kyoto potters were making Chinese-style porcelain. The *big problem* is: what is actually Japanese copies of Chinese porcelain and what is Japanese in the Shonsui style? "The fact is that the number of Shonsui pieces with Japanese marks is large, and the number without marks indistinguishable from those is even larger, among which are some which everybody until now has called Chinese. [L. Smith, p. 68] Smith also claims "...polished pieces in the Shonsui style were being openly produced at Seto in the 19th century. ...Shonsui style [is] one of the great achievements of Japanese ceramics. The pieces at their best combine refined technique with freedom of decoration in a way which is typically Japanese. Many of the best potters of the period made Shonsui." [L. Smith, *Japanese Porcelain*, ..."]

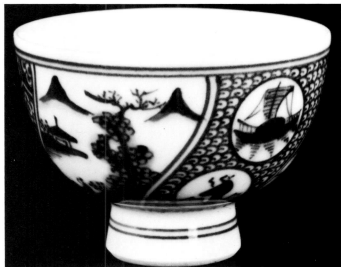

Kyoto tea bowl in Shonsui style marked Chikuzan, late 19th century, 2¾" diameter, British Museum, London.

Kyoto bowl, 19th century, 5¼" diameter, Rijksmuseum, Amsterdam.

Tea bowl marked "Made by Toyoken Heihachi", Kyoto, late 19th century, 3" diameter, British Museum.

Kyoto sake cup marked "Ch'eng-hua", late 19th century, 2¼" diameter, British Museum, London.

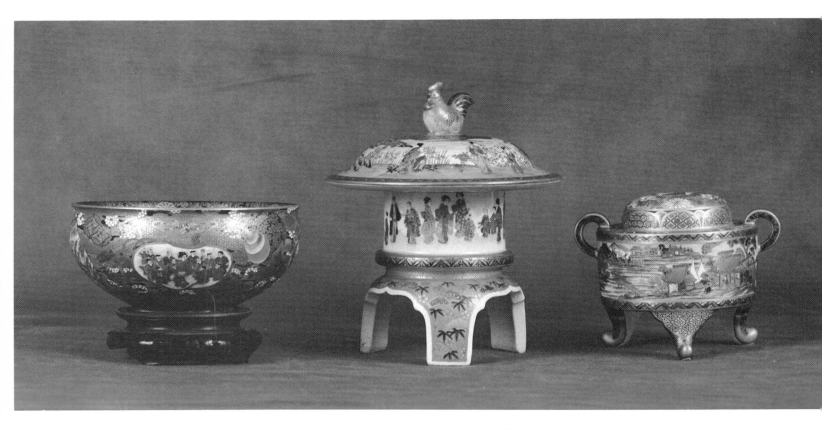

Three Kyoto Satsuma vessels, late 19th century, *left,* bowl signed Sei Kozan, 2½" high; *center,* incense burner, 6¾" high; *right,* incense burner signed Shizan, 3¾" high, Flying Cranes Antiques, New York.

Kyoto Satsuma incense burner signed Sozan, after 1900, 3" high, House of Crispo.

Satsuma Sac and planter, 19th century, 3½" high, 5" long, Philip Van Brunt collection.

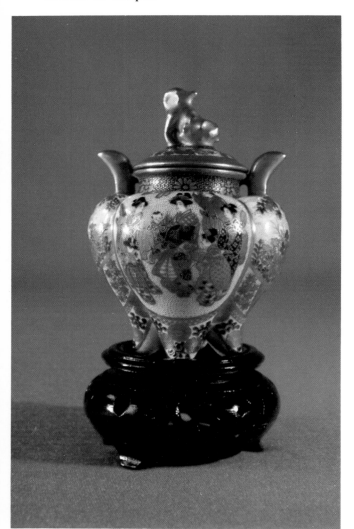

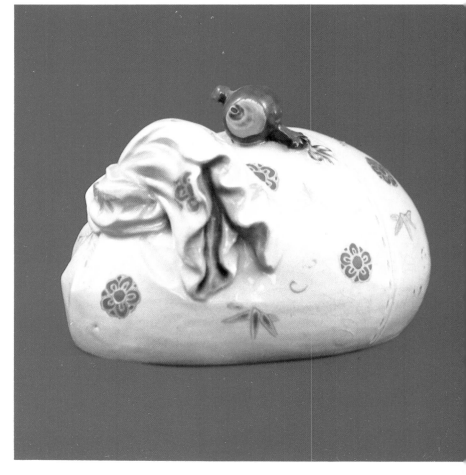

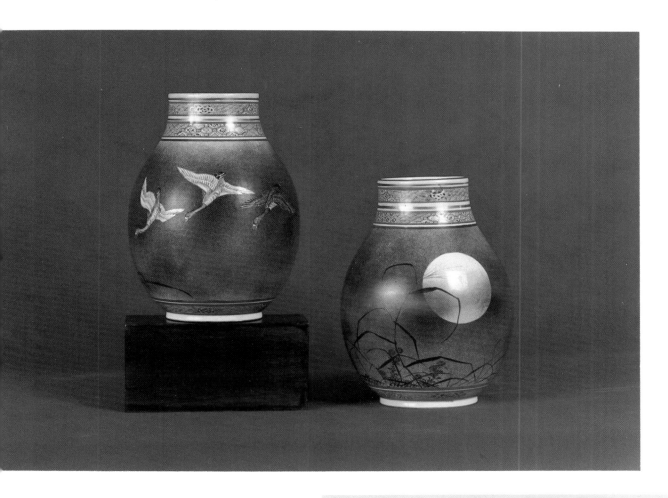

Pair of Kyoto Satsuma vases, late 19th century, 7¼" high, Flying Cranes Antiques, New York.

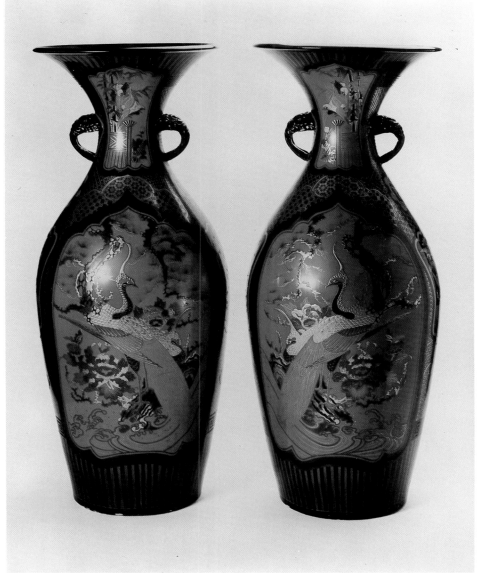

Pair of red lacquered vases, late 19th century, 35⅛" high, © 1986, Sotheby's, Inc.

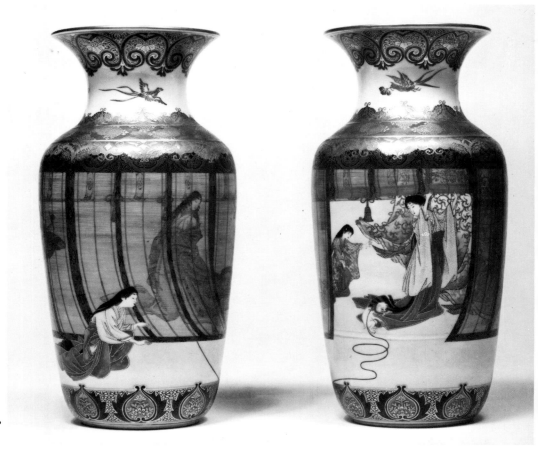

Pair of vases, late 19th century, 11½"
high, © 1986, Sotheby's, Inc.

Incense burner with a lion-dog on
the lid, marked "Koto", circa 1850,
7 1/6" high, British Museum,
London.

Ink screen possibly from the Kyoto
area, 19th century, 9⅛" high, British
Museum, London.

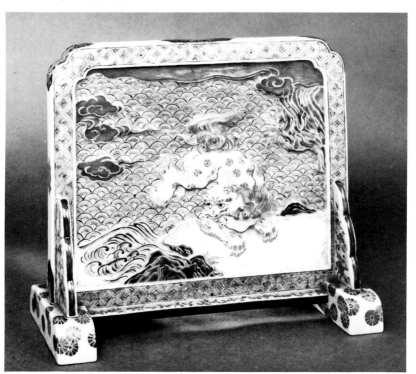

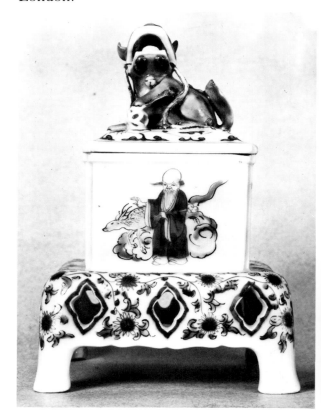

220

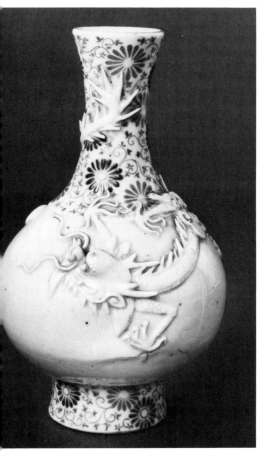

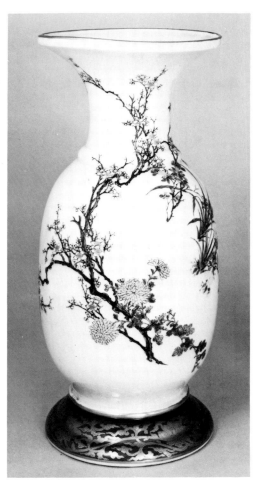

Kyoto vase marked "Made in Japan" by Fu Zo, late 19th century, 14" high, British Museum, London.

Lower left:
Kyoto placque signed *Dai Nipon Yokohama Imura Saizo*, 12" wide, 19" high. © 1986 Sotheby's, Inc.

Kyoto vase with relief decoration of dragon, 19th century, 6 2/3" high, British Museum, London.

Square vase with blue decoration, probably made in the Kyoto area, circa 1830-1850, Victoria and Albert Museum.

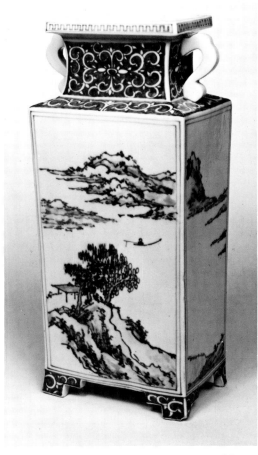

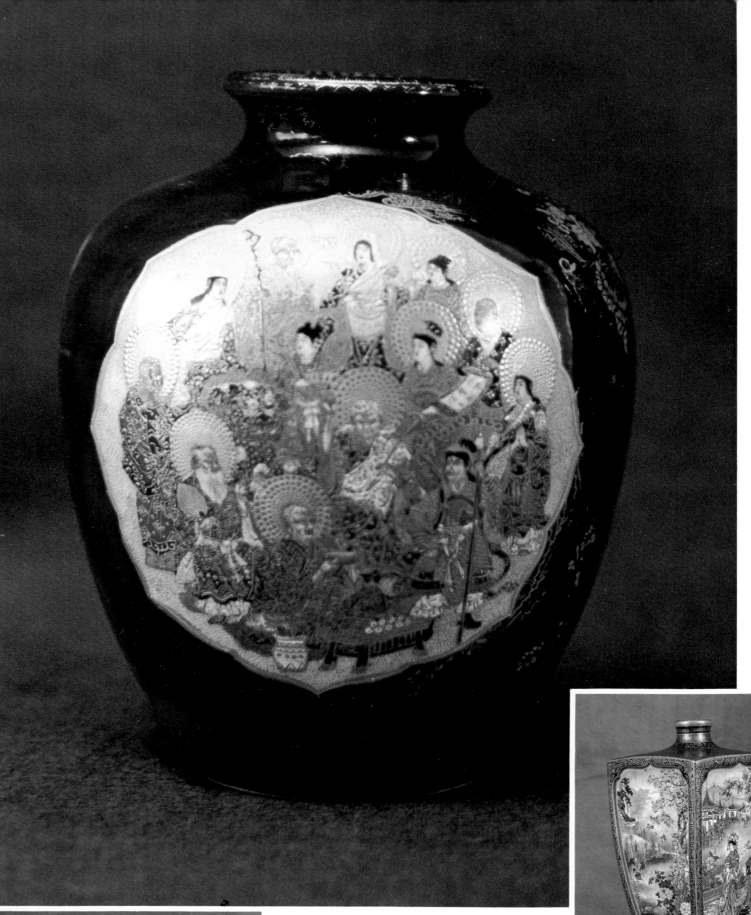

Kyoto Satsuma vase by Kinkozan,
late 19th century, 6¼" high, Flying
Cranes Antiques, New York.

Kyoto Satsuma vase and mark, 6½"
high, late 19th century.

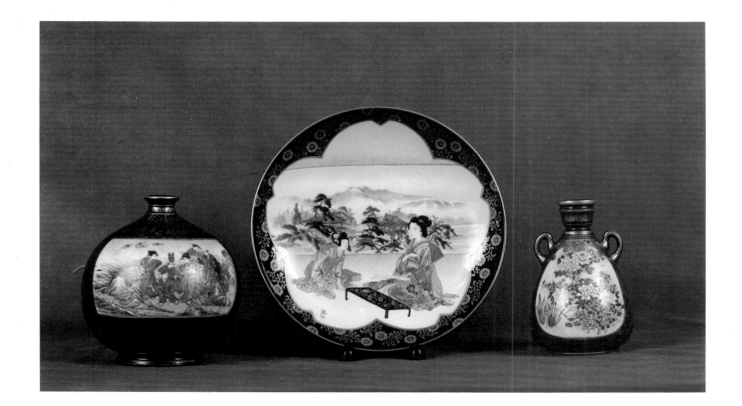

Two Kyoto Satsuma vases and a plate, each signed by Kinkozan, late 19th century, *left*, vase 5½" high, plate 8" diameter, *right*, vase 5¼" high. Flying Cranes Antiques, New York.

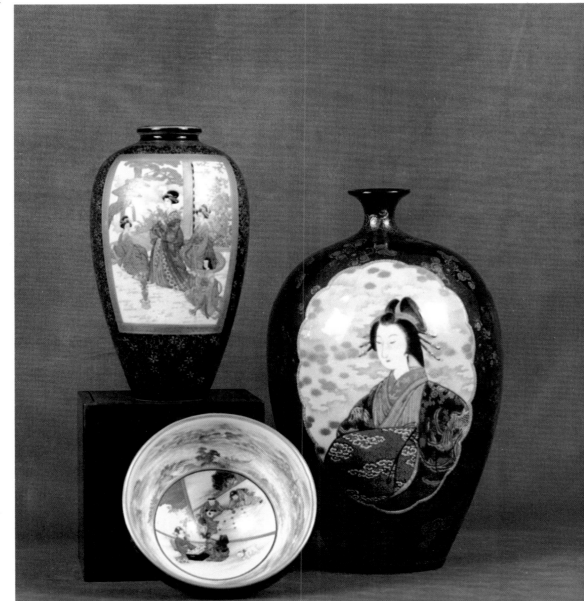

Three Kyoto Satsuma vessels, late 19th century, two vases signed by Kinkozan, 7¾" and 11" high, bowl by Seikozan with children playing games in the decoration, 5" diameter, 3" high, Flying Cranes Antiques, New York.

Celadon

The light green glazed porcelain known as celedon ware is derived from Chinese ware of this type from ancient times.

Most 19th century celadon from Japan is attributed to Sanda near Kyoto in Settsu Province where suitable materials are said to have been found nearby in 1801. [see page 69. L. Smith, *Japanese Porcelain*]

A Kyoto celadon specialist named Kamenosuke went to Sanda about 1811-1826. He had studied with Eisen. Near Sanda was Himeji, where a private clan kiln was set up about the Bunsei period (1818-1829) which produced a lot of Chinese-style wares.

Vase with fish handles and celadon glaze marked Himeji Sei, 6⅞" high, early 19th century (see L. Smith. p. 70), British Museum, London.

Satsuma incense burner and cover with a finial in the form of Hotei and his bag, 3" diameter, Flying Cranes Antiques, New York.

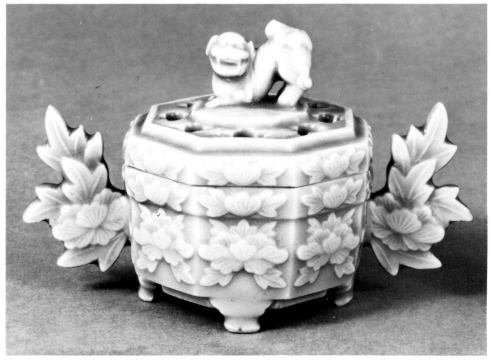

Kyoto celadon incense burner with lion-dog on the pierced lid, early 19th century, perhaps made by Mokubei (b.1767) who in 1806 was invited to start the kiln at Kasugayama in Kaga (see page 69. L. Smith, "Japanese Porcelain..") 31/3" long, British Museum, London.

224

Kyoto Satsuma ware

At Awata, where the old road from Edo (Tokyo) entered the city of Kyoto, there were old pottery kilns.

In the early 19th century Awata ware was made from soft paste porcelain of yellow tone with a clear crackled glaze decorated with flowers, birds, landscapes and gold.

Today, we recognize Awata ware as one of the types of "Satsuma". It is derived from the Old Satsuma ware of Kagoshima Prefecture in Satsuma Province on Kyushu Island, and has become a distinct style of Japanese soft-paste porcelain.

The pieces we recognize as Satsuma ware today were probably made during the second half of the eighteenth century at the earliest, and more likely from the nineteenth and twentieth centuries when the style fully evolved.

The new Satsuma ware has a clear glaze which shrinks more than the yellowish, soft-paste body to cause fine cracks all over the surface. Upon this base, gold and colored enamels were painted in naturalistic decorations. Floral motifs were predominant in the early phases, yielding to animal and figural subjects primarily by the twentieth century. The ware comprises all manner of forms—vases, dishes, bowls, boxes, incense burners ranging from small in the early times to large in the later.

Satsuma ware was made in Japan in five main locations:
- in Kagoshima Prefecture, Satsuma province
 (See section on Satsuma ware, Kagoshima)
- in Kyoto at Awata and other kilns
- on the island of Awaji
- in Yokohama
- in Tokyo

In Kyoto, Yohei Teizan (1856-1922) and Kinkozan Sobei (1824-1884) introduced Satsuma style to the Awata district. This Kyoto Satsuma style became extremely successful as export ware.

In the 1880's there were 12 families of potters at the Awata kilns including:

Kinkozan Sobei	Wake Kitei II
Taizan Yohei	Kichibei
Bunzo Hozan	Rokubei
Tanzan Seikai	Seifu Yohei
Takahashi Dohachi	Mashimidsu Zoruku

Besides the Awata area, Satsuma-style wares were made in Kyoto at Kyomidzu and Gojozaka where ceramists (Okumura Yasataro) Shozan, (Nakamura Tatsunosuke) Ryozan, and (Ito Koemon) Ito Tozan worked.

Awaji

In 1831 Kashui Mimpei, of the island of Awaji, built a kiln after he found ceramic clay there. With his son Sampei, he made export wares in Satsuma style similar to Awata wares and monochromes in yellow, green and brown-red with Chinese markings. At the 1876 Philadelphia Exposition, there was a tea service by Sampei with a gourd-shaped tea pot, a sugar bowl and lid, a milk jug and 2 cups and saucers, all in European shape.

Celadon incense box in the shape of a persimmon with decoration under the glaze, marked Zuishi, early 19th century, 1¾" diameter, British Museum, London.

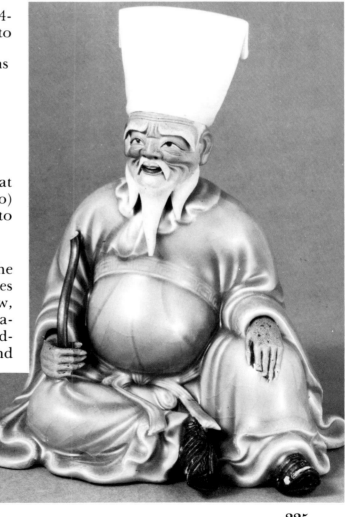

Sanda celadon figure of Jurojin with white hair and hat and bisquit hands, signed by Kinkodo Kamenosuke and dated 1824, (see p. 69, L. Smith, *"Japanese Porcelain..."*) 9½" high, British Museum.

225

Tokyo

At Tokyo, decoration was painted on wares brought in blank. The decoration was fired in low temperature finishing or "muffle" kilns. There were also muffle kilns at the export trade centers of Yokohama, Osaka, and Nagasaki. Because so many kilns supplied this ware, most is untraceable.

Brinkley wrote about Satsuma wares in the Paris Exhibition of 1867:

Food bowl and cover in yellow glaze with white streaks, probably from Awadji Island, mid-19th century, British Museum, London.

In this field thus newly opened to Western collectors, the first place has, by common consent, been assigned to the faience (earthenware) of Satsuma. In its combined softness and richness it has no peer.

In 1880, Audsley and Bowes stated:

A ware, in imitation of [old] Satsuma faience, has, during the last few years, been manufactured in Ota. A suburb of Yokohama, by a potter named Kozan, and sometimes it bears his impressed mark in a gourd-shaped cartouch. The pâte is not so close an imitation as to deceive anyone experienced in Japanese wares; but it may be said to generally resemble genuine Satsuma, so far as its external appearance goes. It is not so hard as Satsuma usually is, and accordingly is more easily scratched with a steel instrument, or fractured by a blow. It is usually whiter in tone than the genuine ware, and is not so minutely or regularly crackled in its glaze. [p. 168]

Audsley and Bowes (1881) also identify

vases and hibatchi [incense burners] of important size and beautiful decoration...ornamented with exquisite figure subjects, religious processions, and so forth, painted in quiet toned enamels, with a free use of gold...these pieces are modern Tokio work, produced at the factory of Shiba...in no sense imitations of ancient Satsuma faience, for it is well known that such ware was only made in small pieces, and was never decorated with figure subjects. [Audsley & Bowes, p. 168]

226

Artists in the late 19th century were competing for individual recognition at International Exhibitions and usually identified their work with a mark or signature.

Audsley and Bowes also states that

> Large quantities of modern [1880] Kioto ware, made by a well-known living potter, and bearing his impressed mark, are shipped to this country [England] as Satsuma fience, and sold as such...The modern Kioto ware...is, however, easily distinguishable from [old] Satsuma faience, being of a full buff tint, light and porous in its body, and covered with a bright glossy varnish, crackled. [Audsley & Bowes, p. 169]

Therefore, we would be more accurate to speak of most of the 19th century semi-porcelain enameled ware as "Kioto ware", or at least "Satsuma-type" to differentiate it from the wares made in Southwestern Kyushu.

The styles of porcelain made at kilns in Kyoto are seen as imitators and translators of various styles that were in turn communicated throughout Japan during the nineteenth and early 20th centuries. By this, we look at the work of several very influential potters who experimented with a wide range of old styles, introduced new styles, and went out to work in different places in Japan transmitting their experience to other potters.

In the following group, the artists names are given first in bold face type, followed in parentheses by the family and given names, and life dates.

Ninsei (Nonomura Seiemon, 1574-1660)

Ninsei was the first and perhaps preeminent of Kyoto potters. He lived and worked in Kyoto and learned his pottery at Seto. Ninsei was invited to the Omuro kiln in Kyoto. [Tazawa, p. 561] He is known to have experimented copying Chinese, Kakiemon and Imari overglaze-decorated porcelains, celadons, and other styles, but his work is chiefly known for non-porcelain ware.

Kenzan I (Ogata Kozemasa, Ogata Shinsho, 1661-1742 or 1663-1743)

Kenzan I was a very famous Kyoto potter from a family of cloth merchants. He experimented with all types of pottery, porcelain, glazes and over glaze enamels, and copied Gosu ware, but is best known for his non-porcelain ware. He worked at his own Izumidani kiln, and was the most important potter of the mid-Edo period. Between 1699 and 1712, his brother, the famous artist Korin, made underglaze paintings on some of Kenzan's early work, and these designs continued in Kenzan's work. He used white slip, painted iron oxide, blue underglaze and other pigments. Kenzan I's overglaze enamel techniques and use of gold and silver demonstrates traditional Japanese elegance.

In 1712, Kenzan quit his kiln at Izumidani and went to the center of Kyoto where he painted designs on other potters' wares. In 1720 or 1731, he left Kyoto and moved to Edo (presently Tokyo) to paint and write.

Kenzan I influenced the whole school of Kyoto potters. He not only made pottery with underglaze decoration but also porcelain with overglaze decoration.

Kenzan II (-1768)

Kenzan II was the son of Ninsei and adopted by Kenzan I for whom he worked as an assistant.

Dôhachi I (Takohashi, 1737-1804)

Dôhachi I lived in Ise and was the second son of Hachirodaya, a samurai of Kameyama. He studied under Eisen and worked at a kiln at Awata using the additional artist name Kuchu.

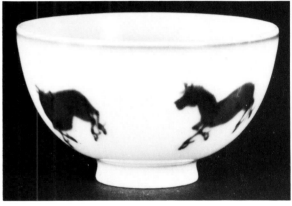

Kyoto tea bowl with underglaze blue horses and the mark of Kenzan Shunsei, 18th century, 2½" diameter, British Museum, London.

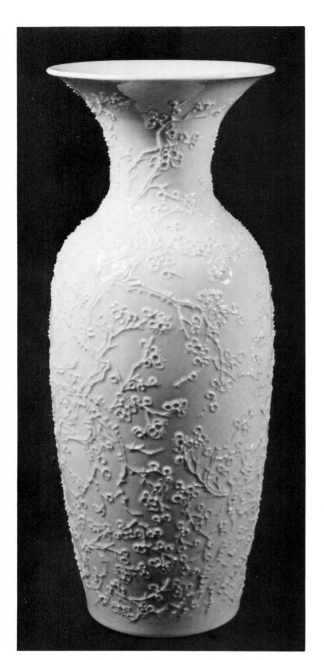

Dôhachi II (Takohashi Mitsutoki, 1783-1855)

Dôhachi II was the most important potter of the late Edo period and was also a pupil of Eisen in Kyoto. He was influenced by Chinese-made pieces in many different styles—blue and white Shonsui ware, Raku pottery, Shigaraki, Iga, and in the styles of his predecessor Kenzan I.

Dôhachi II made pottery and porcelain. In 1824 he became a monk and took the name Ninnami. He also used the names Kuchu, Hosambun, Horasanjin (means Big Talker), and used 6 different seals [Gorham p. 145].

Dôhachi III (1845-1897)

Vase with plum blossoms in relief, Kiyomidzu ware from Kyoto, signed by Dohachi II (died 1855), early 19th century, Victoria and Albert Museum.

Flower pot with red background and cut out inscription showing white body, Kiyomidzu ware from Kyoto made by Dohachi II (died 1855), early 19th century, Victoria and Albert Museum, London.

Kyoto bowl of imitation Shonsui ware signed "Kuchutei Dohachi" (I; died 1804), circa 1800, 8" diameter, British Museum, London.

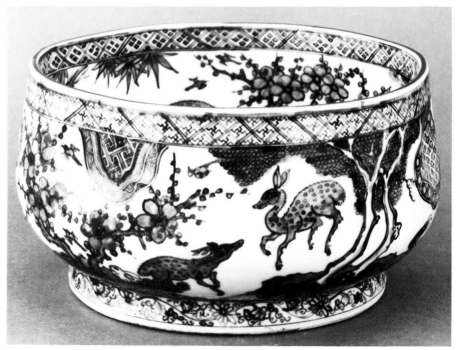

228

Shuhei (Takahashi Ogata, 1788-1839)

Shuhei began by helping his younger brother, Dôhachi II, however, he was strongly influenced by the work of Kenzan I, so he dropped his Takahashi family name and adopted Ogata. Shuhei traveled about and worked at several kilns in present-day Osaka, Wakayana, and Hyogo. His work includes copies of Chinese, Korean and Indo-Chinese styles of overglaze enamels, blue underglaze gold and enamel and celadon, but not a distinctive style of his own.

Eisen (Okuda Isunenori, 1753-1811)

Eisen was skillful in reproducing overglaze decorated porcelains of several Chinese styles. He was professionally a pawnbroker and member of the upper class who collected Chinese pottery, then began making ceramics himself, having studied under Rokubei.

Eisen established the first porcelain-producing kiln in the Kyoto area and made overglaze enamel wares. He copied Chinese originals like late Ming Swatow. He was a teacher of Mokubei and Dôhachi and was also called Yotoku and Moemon.

Eisen inscribed or engraved his name on his work either with a plain inscription in red pigment over the glaze or engraving under the glaze.

His porcelain has a dull finish and is thick having unglazed spots and rough surfaces with heavy edges and base.

His painting is usually of birds and flowers.

Mokubei (Aoki, 1767-1833 or 1763-1832)

Mokubei was skillful in reproducing overglaze decorated porcelains of several Chinese styles.

He was a pupil of Eisen, a potter and a Nanga style painter. In 1801 Mokubei was invited to work at the Kii fief as a potter by its lord, Tokugawa Harutomi. He also founded two kilns: one at Kasugayama, c. 1807-1817, where he made reproductions of old Kutani wares. [Gorham, p. 133] He founded the Awata kiln in Kyoto in 1805 or 1808 which was sponsored by Prince Shoren'in-no-Miya.

From 1824 on he concentrated on painting landscapes. He was also known as Kiya Sahei, Kukurin, Hayaku-raku-sanjin, Kokikan, and Robei. Mokubei worked not only in imitation, but also in his own style.

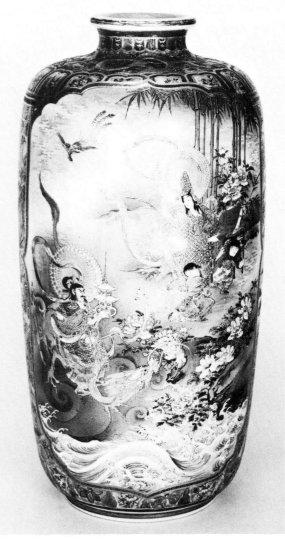

Kyoto Satsuma vase signed Ryozan, 15" high, late 19th century, Flying Cranes Antiques, New York.

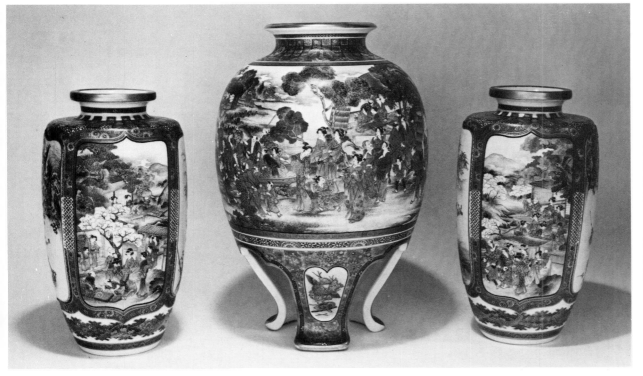

Pair of Kyoto Satsuma vases and footed bowl made by Ryozan, early 19th century, vases 10" high, bowl 12" high, Flying Cranes Antiques, New York.

Kyoto Satsuma vase by Ryozan,
early 19th century, 18" high, Flying
Cranes Antiques, New York.

Ryozan (Zengoro, -1841)
From Kyoto, Ryozan was the 10th generation of the Nishimura
Zengoro family. They are noted for making earthenware receptacles
for holding charcoal fire, "furo", a special kind of brazier used for
heating water in the tea ceremony. Ryozan also made copies of other
pottery.

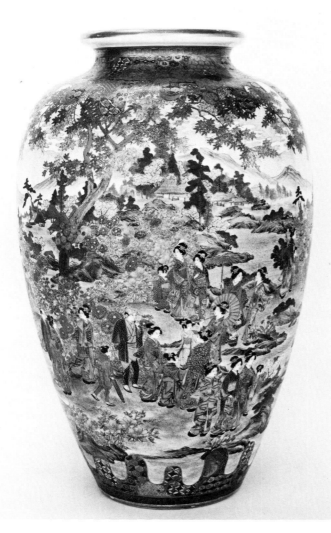

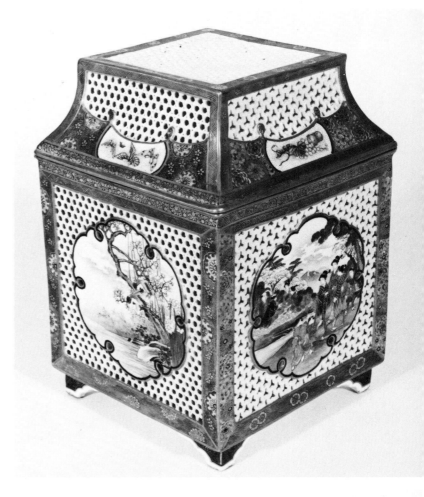

Above right:
Kyoto Satsuma cricket cage made by
Ryozan, early 19th century, 7¾"
high, 5" wide, Flying Cranes
Antiques, New York.

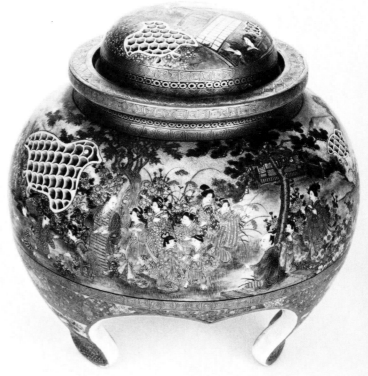

Kyoto Satsuma incense burner made
by Ryozan, early 19th century, 9"
high, Flying Cranes Antiques, New
York.

Eiraku (Zengoro Hozen, 1795-1854)

Eiraku was a Kyoto potter and the 11th generation Zengoro family. He was the adopted son of potter Ryozan, known for his tea ceremony wares. Eiraku had the family name of Nishimura Zengoro, but he used several names, at different times. As a young man he used *Hozan* as his artist name.

He studied at the Awata kilns from 1801-1803, and created several different techniques:—celadon, Chinese blue and white and copies of Kochi ware of China. Eiraku was very skilled in the Kinrande style, solid red glaze with gold details.

In 1827 he was invited by Tokugawa Chiho, daimyo of Kishu, to set up a kiln in his garden. Wares from this phase of his life are known as "garden kiln wares." It was here he was given the artist name *Eiraku* by his patron.

Later, he traveled and taught other potters until the 1840's when he set up another kiln at Nara which his son inherited and continued. In 1850, he moved near Lake Biwa and made underglaze red wares in a style popular in China during an earlier period. Eiraku was then known as *Butsuyu*. He had two sons: Wazen, who became Zengoro 12th, and Zenshiro who became Zengoro 13th. (For marks see Gorham p. 54)

Eiraku ware, named after its inventor, was produced at Kyoto. It consists of porcelain painted over with red oxide of iron on which all kinds of mythological ornaments were applied in gold.

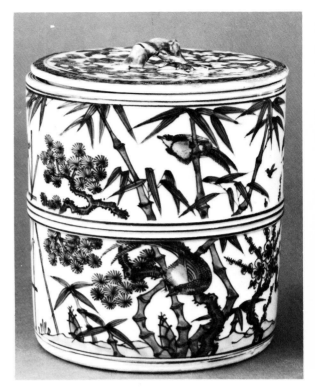

Shonsui style cylindrical lidded jar marked by Eiraku (died 1854) in 1844 (see p.69, L. Smith, "Japanese Porcelain..."), 4½" high, British Museum, London.

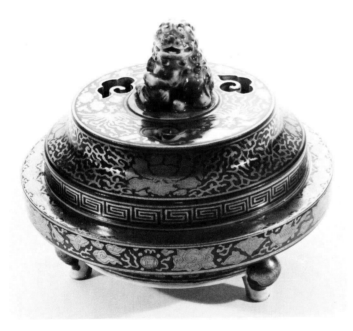

Eiraku ware bowl with red background and gold dragon, marked by Eiraku (died 1854), early 19th century, 6" diameter, British Museum, London.

Eiraku ware incense burner with red background and gold decoration with lion-dog finial by Eiraku (died 1854), early 19th century, 6" high, 6½" diameter, Flying Cranes Antiques, New York.

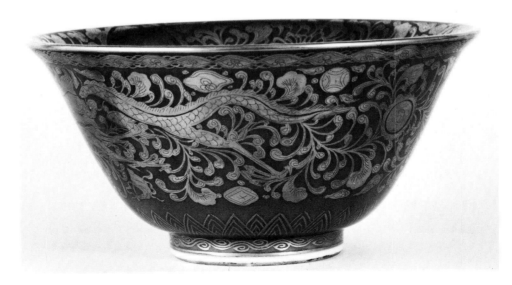

231

Eiraku Wazen (Zengoro, 1824-1897 or 1821-1896)

Eiraku Wazen was the 12th generation Zengoro family, son of Eiraku. He inherited his father's business in 1853, and at some time later took his father's artist name Eiraku. He was exceptionally particular in his ceramics work, which earned him the commission to make the tea ceremony utensils for the trousseau of Imperial Princess Kazu who married the Tokugawa Shogun.

In 1866, Eriaku Wazen was invited to work at Kaga by the Maeda family head, Lord of Aishoji. He stayed here five years. The wares he made are called Kaga Eiraku, and have influenced Kutani ware ever since.

In 1871, he built a kiln at Okazaki in Mikawa and worked here for 3 years. He also built a kiln on the bank of the Kikutani River for the Mitsui family in 1875. All of the various seals he used during his life to mark his ware were buried with him, as his death wish.

Eiraku Tokuzen (Zengoro, 1854-1910)

Eiraku Tokuzen was the 14th generation Zengoro family who made beautiful pottery. He was succeeded by his widow Myozen who carried on the family business, making pottery with distinction, until she died in 1928.

Eiraku Shozen (Zengoro, -1933)

Eiraku Shozen represents the 15th generation Zengoro family, but actually is a nephew of the 14th Zengoro, Tokuzen. He carried on the kiln after Tokuzen's wife, Myozen died, and succeeded to the Eiraku family in 1929 using the artist name Shozen.

He was given a commission to commemorate the 100th anniversary of Eiraku Hozen, the 11th generation Eiraku potter who died in 1854, but he died in 1933 before this could be completed.

Eiraku ? (Zengoro)

This 16th generation member of the Zengoro family is working in Kyoto under the various names Eiraku, Nishimura Zengoro or Hozen both in his family's traditional style, and in his own. (See Gorham p. 60, 61 for description of wares)

Rokubei I (Shimiza, Kiyomizu, 1740-1799)

Rokubei I was a potter from Settsu who came to Kyoto and made wares with colored enamel decorations in reserves and underglaze blue and white. Between 1764 and 1772 he built a kiln in Kyoto.

Rokubei II (Seishi, 1797-1860)

Rokubei II made blue and white wares using his father's seal as well as his other names Shoun and Guami.

Rokubei III (Shichibei, -1883)

Rokubei III was the son or nephew of Rokubei II.

Rokubei IV (Shorin, Shemiz, 1848-1920 or 1842-1914)

Rokubei IV was the son of Rokubei III.

Rokubei V (Kiyomizu, Rikuwa 1874-1959)

Rokubei V was the son of Rokubei IV and made pottery and porcelain.

Rokubei VI (Shotaro, 1901-1980)

Rokubei VI graduated in 1922 from the Kyoto Municipal College of Painting. In 1976 he received the Order of Cultural Merit Award.

Rokubei VII

Rokubei VII is the present head of the family.

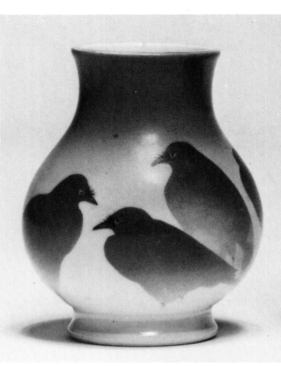

Kyoto vase with grey doves on a shaded blue background signed by Seifu III, late 19th century, 3¾" high, © 1986, Sotheby's, Inc.

Seifu I (Yohei, 1803-1861)

Seifu I was a potter from Kanazawa who moved to Kyoto in 1815 and set up business in 1828 at the Gojozaka kiln. Seifu was a student of Dôhachi II, and made pottery and porcelain of blue and white, gold and enamel decoration.

Seifu II (Yohei, 1844-1878)

Seifu II made white porcelain relief decoration. In 1873 he served the government and furthered the Kyoto pottery style.

Seifu III (Yohei, 1851-1914)

Seifu III succeeded his brother-in-law Seifu II and made the name Seifu famous. Seifu III also used the artist name Baihin, and made primarily small porcelain wares with Chinese influence, including blue and white, monchromes, underglaze with low relief patterns, and often floral designs in slip glaze.

His numerous accomplishments include prizes won at the 3rd Domestic Exhibition in Japan in 1890. He became the first potter to be made the court artist in 1893 as a Member of the Imperial Household. Seifu III had his work exhibited at the Chicago International Exhibition in 1893, the 4th Domestic Exhibition of Japan in 1895, and the Paris Exposition in 1900. His work declined with illness from 1910 until his death in 1914.

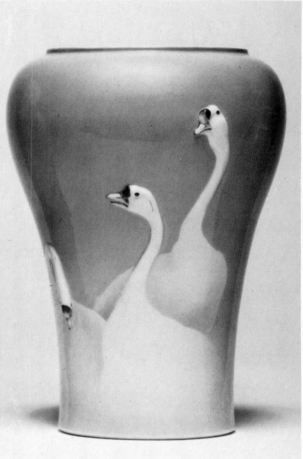

Kyoto vase molded in high relief decoration of geese, signed Seifu II, (died 1878), 10'' high, © 1986, Sotheby's, Inc.

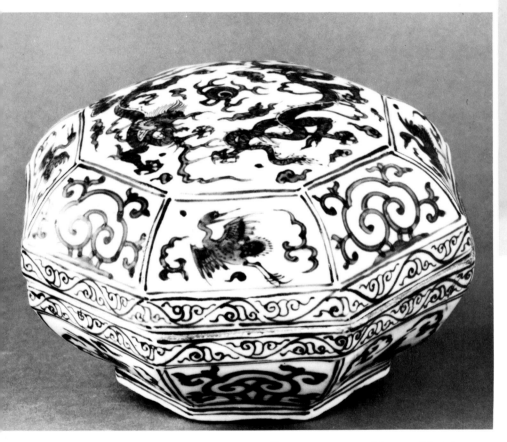

Kyoto octagonal box with blue Ch'ing style decoration marked by Seifu, mid-19th century, British Museum, London.

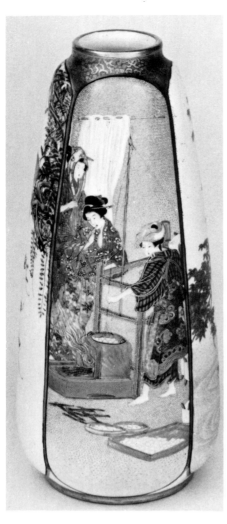

Kinkozan IV (Kobayashi Sobei 1824-1884)

Kinkozan IV was the 4th generation to use the artist name Kinkozan and the 6th generation head of the Kobayashi family, part of a family of potters who made Awata ware in Kyoto. Kinkozan IV, along with Taizan Yohei, introduced to Kyoto, Satsuma wares of the gold and overglaze enamel style which became enormously successful as export ware. His work was very precise, and his descendants continue to use the Kinkozan name. In 1877 he began making pottery for export. Between 1877 and 1895, some *cloissoné* on Satsuma was also tried, but not successfully.

Kinkozan V (Kobayashi Sobei, 1868-1927)

Kinkozan V was a very well known and respected potter. He added gold and silver to his Satsuma style wares which were popular with the Western markets.

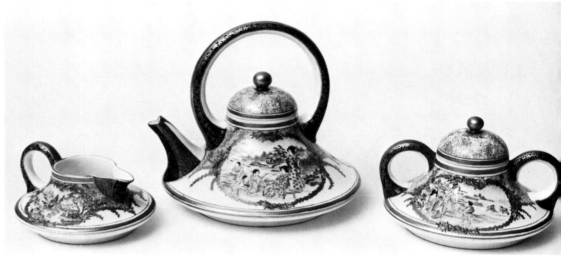

Three-piece Kyoto Satsuma tea set marked "by Kinkozan for Schreeve", late 19th century, Flying Cranes Antiques, New York.

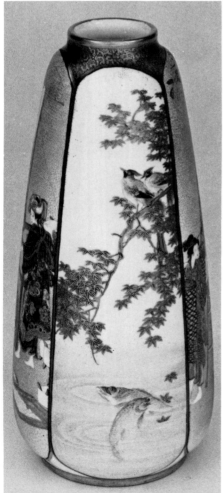

Kyoto Satsuma vase, birds in a bamboo grove in the decoration with impressed seal mark of Kinkozan, late 19th century, 12½" high.

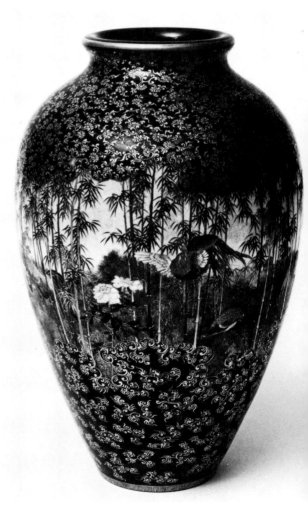

Two views of a Kyoto Satsuma vase with two panels depicting the silk-making process, by Kinkozan, late 19th century, 6½" high, Flying Cranes Antiques, New York.

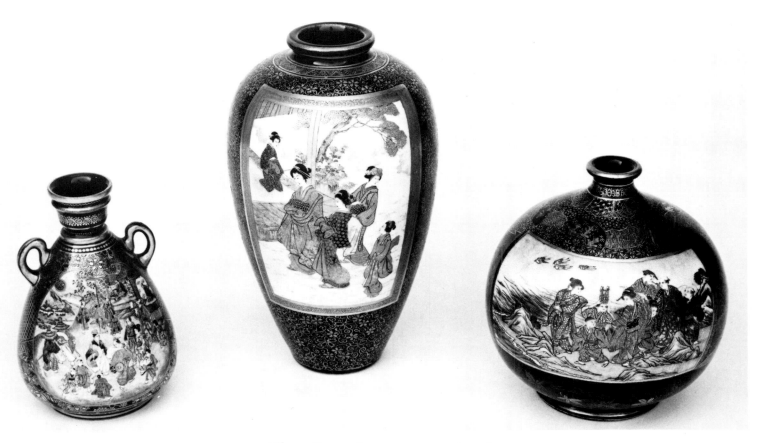

Three Kyoto Satsuma vases signed
by Kinkozan, late 19th century, *left*,
5¼" high; *center*, 8" high; *right*, 6"
high, Flying Cranes Antiques, New
York.

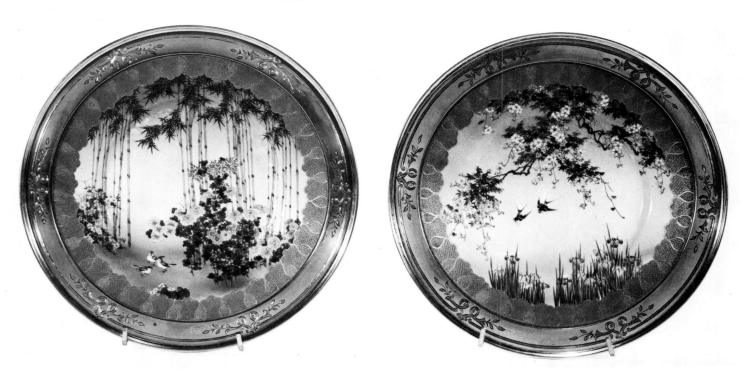

Pair of Kyoto Satsuma plates with
the gilt mark of Kinkozan, late 19th
century, mounted in sterling silver
rims, circa 1900, 8¾" diameter,
Flying Cranes Antiques, New York.

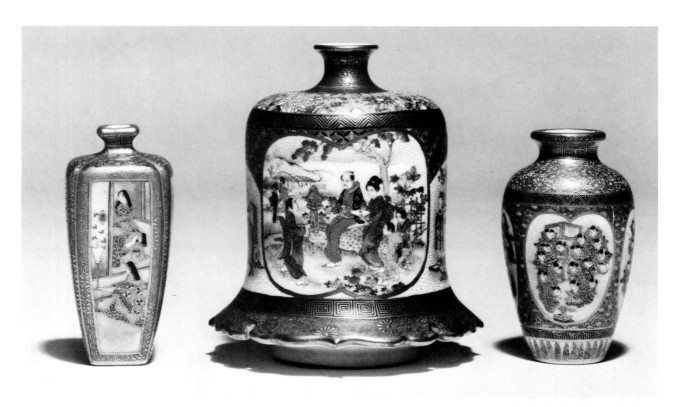

Three Kyoto Satsuma vases, late 19th century, *left*, tapering square shape signed by Kinkozan, 3'' high; *center*, bell shape, signature not identified, 4½'' high; *right*, round shape signed by Kinkozan, 3'' high, © 1986, Sotheby's, New York.

Kyoto Satsuma ewer with a procession in the decoration, signed by Kinkozan, late 19th century, 6'' high, Flying Cranes Antiques, New York.

Kyoto Satsuma incense burner by Kinkozan, late 19th century, 3½'' high, Flying Cranes Antiques, New York.

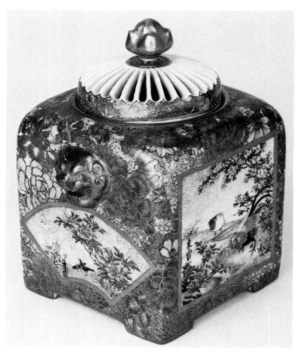

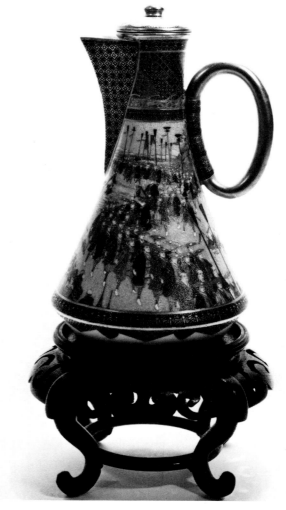

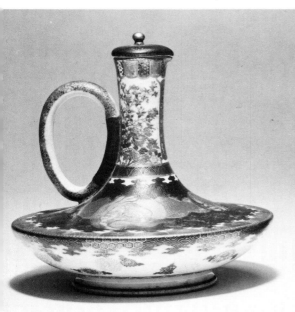

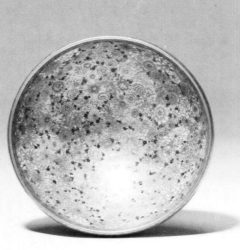

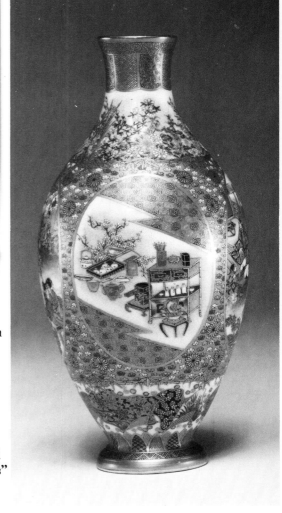

Two Kyoto Satsuma vessels by Kinkozan, late 19th century, *left,* ewer 6⅜" high; *right,* bowl 5" diameter; © 1986, Sotheby's, Inc.

Kyoto Satsuma vase with dishes in the decoration, marked by Kinkozan V, circa 1900, 6¾" high, © 1986, Sotheby's, Inc.

Kyoto Satsuma vase showing laundering along the shore against brown background, marked with the impressed seal of Kinkozan, late 19th century, 8" diameter, Flying Cranes Antiques, New York.

Kyoto Satsuma covered box marked by Kinkozan, early 20th century, 5⅞" long, Victoria and Albert Museum, London.

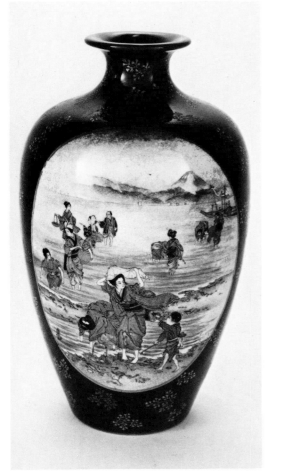

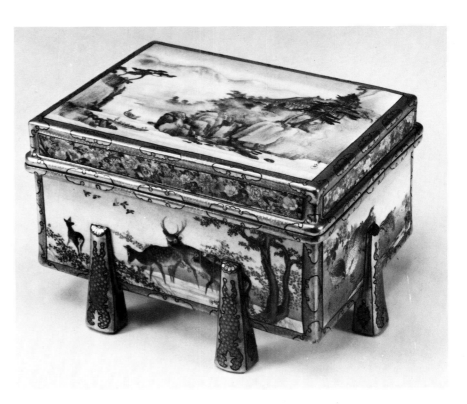

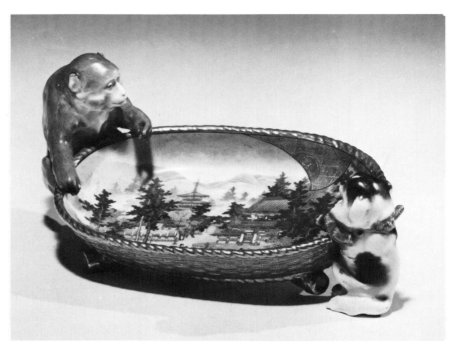

Kyoto Satsuma dish with basket
weave exterior and landscape
painted interior supported by three-
dimensional figures of a monkey
and a dog, signed by Kinkozan, late
19th century, 6½" long, © 1986,
Sotheby's, Inc.

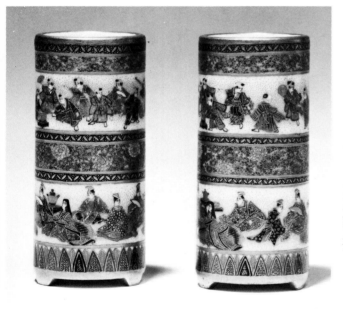

Pair of miniature Kyoto Satsuma
brush pots marked by Kinkozan, late
19th century, 3" high, © 1986,
Sotheby's, Inc.

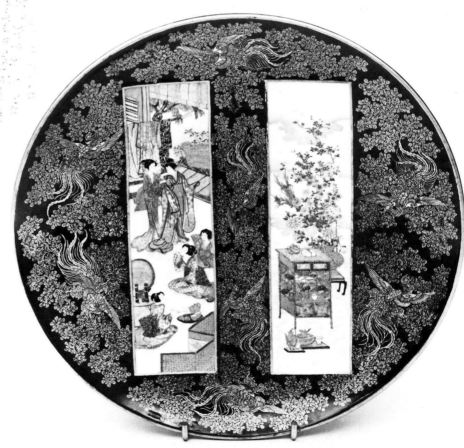

Kyoto Satsuma plate with dishes in
the decoration, by Kinkozan, late
19th century, 10" diameter, Flying
Cranes Antiques, New York.

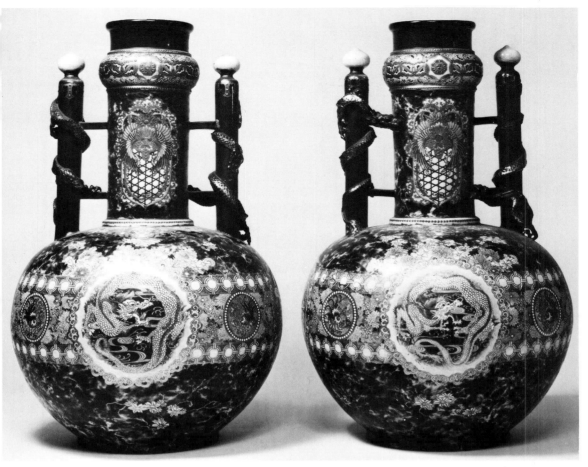

Pair of Kyoto Satsuma vases marked
Kinkozan, late 19th century, 23½"
high, © 1986, Sotheby's, Inc.

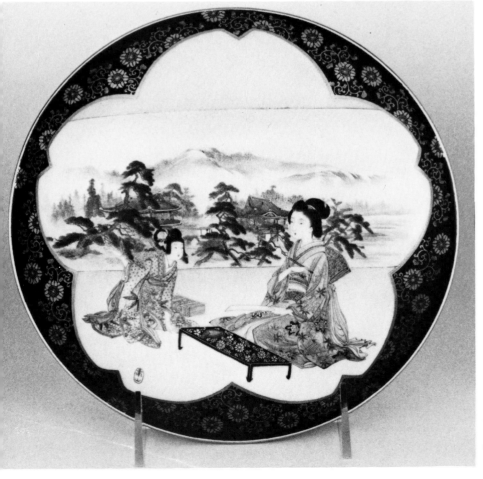

Kyoto double gourd vase with red
net pattern, impressed with the seal
of Kinkozan, late 19th century, 8½"
high, © 1986, Sotheby's, Inc.

Kyoto Satsuma plate, signed
Kinkozan, late 19th century, 8"
diameter, Flying Cranes Antiques,
New York.

239

Vase with painted and relief wisteria blossoms, signed Makuzu Kozan, late 19th century, 10½" high, © 1986, Sotheby's, Inc.

Three vessels signed by Makuzu Kozan, late 19th century, *left,* vase with red carp in green sea behind fishnet design, 8" high; *center,* incense burner with flying cranes decoration, 9½" high; *right,* vase with crane on a plum branch, 7¼" high, © 1986, Sotheby's, Inc.

Kozan (Miyagawa Chozo, 1797-1860)

Kozan is believed to have been the 10th generation head of his family. His forebearers are thought to have sold glaze for Raku pottery and taught its methods.

He studied with Mokubei and established a kiln in the Makuzugahara section of Kyoto and called his ware Makuzu ware. He also used the artist name Makuzu Chozo. Particularly skilled at copying Ninsei style, he added a vine leaves pattern to identify it as his own.

Miyagawa Kozan (Miyagawa Toranosuke, 1842-1916)

Miyagawa Chozo's fourth son, Toranosuke became famous under his artist name Miyagawa Kozan, sometimes referred to as Makuzu Kozan. Born in Kyoto, he learned pottery from his father.

In the 1860's he was making Satsuma style pottery with clay transported from Kagoshima in Satsuma province.

In 1871, he moved to Ota near Yokohama where he was asked to direct a kiln built for export ware. Here Miyagawa Kozan made pieces for export and experimented with a wide variety of ceramic styles including soft-and hard-paste porcelain.

His experimentation led to the developments of new body mixtures and a wide assortment of new over-and under-glaze colors. Kozan succeeded in making monochrome glazed pieces derived from Chinese originals, then went beyond this process with the aid of the new technologies spreading to Japan from the west during this time. His work displays his versatility and knowledge of many Japanese and Chinese styles including Awata style "Satsuma".

He exhibited at the following International Exhibitions:
1876 Philadelphia
1877 1st Domestic Exhibition
1878 Paris
1890 3rd Domestic Exhibition
1893 Chicago
1900 Paris
1903 5th Domestic Exhibition
1904 St. Louis
1910 Japan-British
1915 San Francisco

In 1896, Miyagawa Kozan was made a Member of the Imperial Household (Arts and Crafts). His studio was continued by his son Hanzan until the events of the Second World War forced its closing.

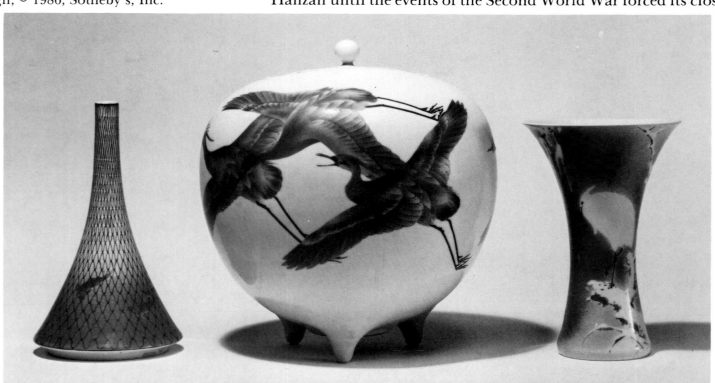

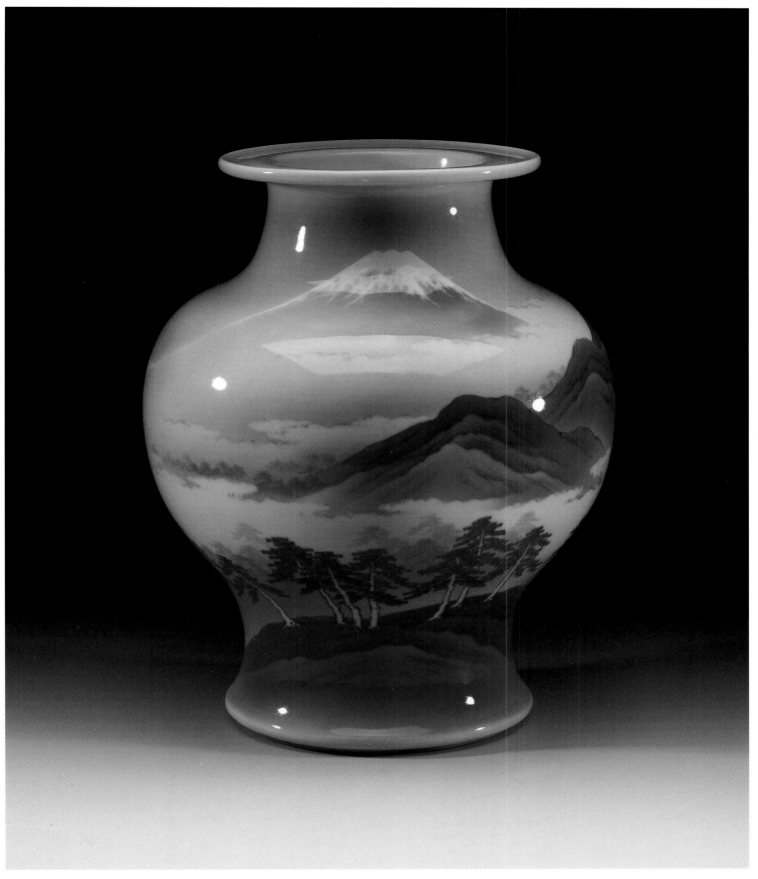

Japanese porcelain globular vase with snow-capped Mt. Fuji towering over swaying pine barrens in tones of blue, pink, white — all against a mauve ground. Height, 12". Meiji Period. Signature Makuzu Kozan Sei in a cartouche on the base. Courtesy of Flying Cranes Antiques Ltd., New York.

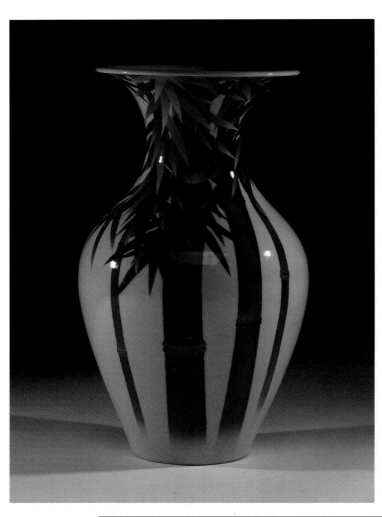

Baluster-shaped vase with vertical bamboo stalks and leaves in graduated shades of blue on a white ground. Signature Makuzu Kozan Sei in a cartouche on the base. Height, 21". Meiji Period. Courtesy of Flying Cranes Antiques Ltd., New York.

Studio porcelain double vase, square form with openings for mounting, delicately painted in *musen-shippo* style with swimming fish, flowering trees, and mountains. Signature Makuzu Kozan Sei. Height, 8"; width, 10.5". Meiji Period. Courtesy of Flying Cranes Antiques Ltd., New York.

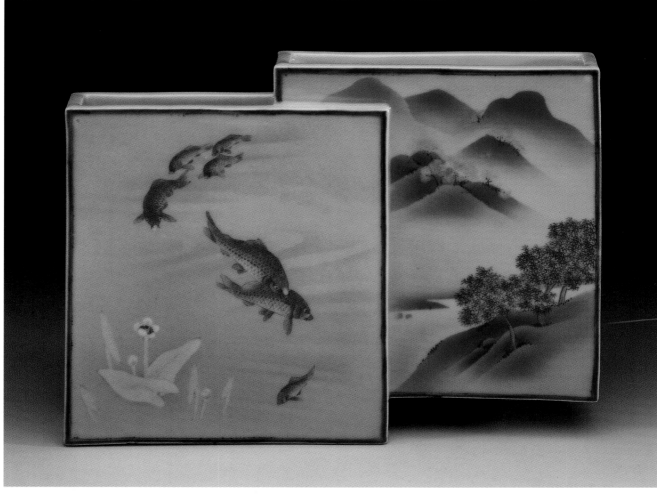

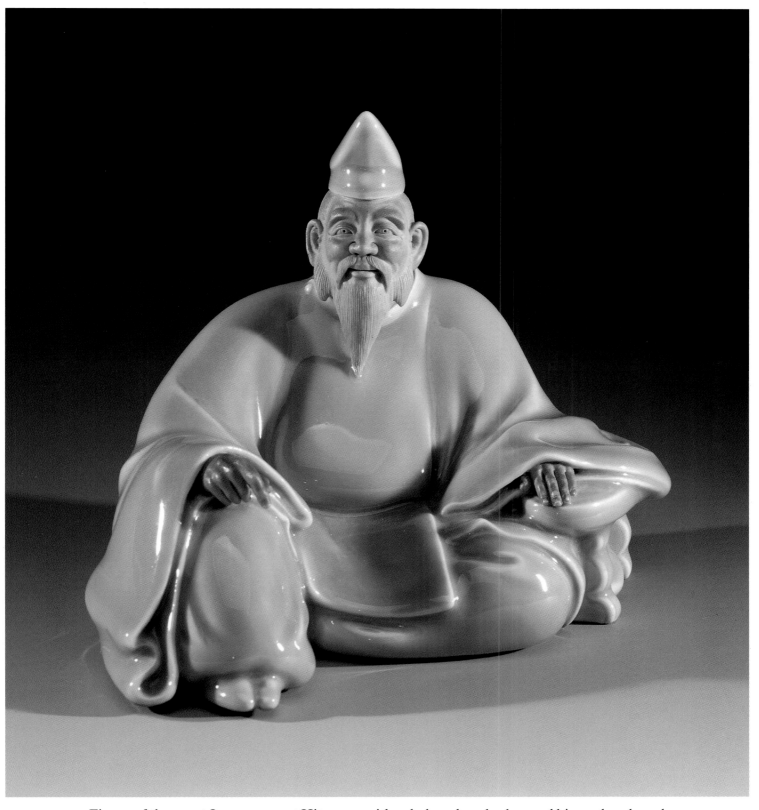

Figure of the great Japanese poet Hitamaru with celadon glazed robes and bisque hands and face. Signature Makuzu Kozan. c. 1900. Height, 12". Original *tomobaku*. Courtesy of Flying Cranes Antiques Ltd., New York.

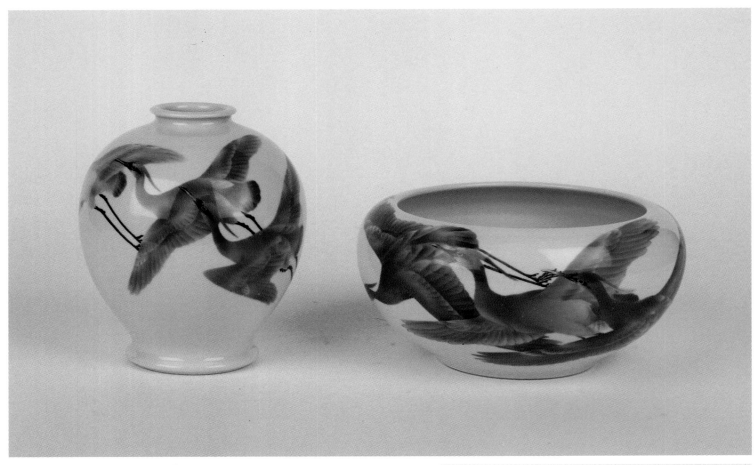

Globular vase painted with blue cranes in flight against a white ground, signature Makuzu Kozan. Height 7 1/4". Bowl decorated with blue cranes in flight against a white ground, signed Makuzu Kozan. Height, 4 1/4"; diameter, 8". Courtesy of Flying Cranes Antiques Ltd., New York.

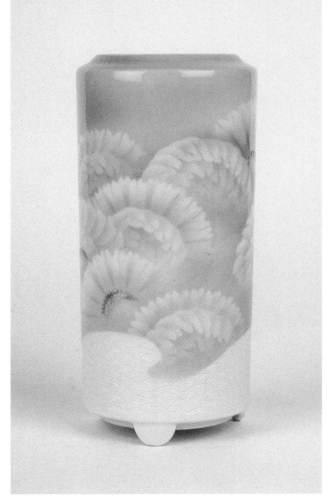

Cylinder vase on three feet with mauve background and carved white wave pattern, by Makuzu Kozan, 7 1/2" high. Courtesy of Flying Cranes Antiques Ltd., New York.

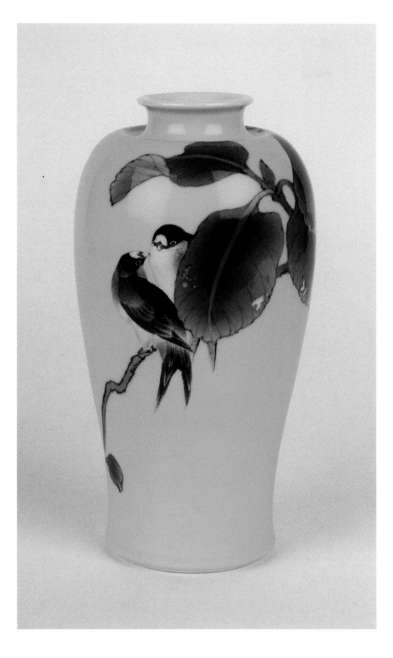

Studio porcelain vase with yellow ground and blue birds and ginko tree design, by Makuzu Kozan, 8 1/2" high. Courtesy of Flying Cranes Antiques Ltd., New York.

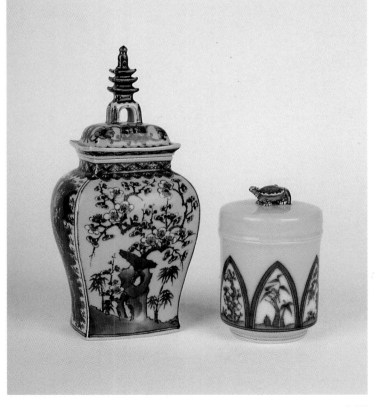

Pagoda-shaped covered square vase with rounded corners in yellow ground and blue landscape design, by Makuzu Kozan, 9" high. Covered round box with yellow background and blue and white design, lid with turtle (minogame) finial, by Makuzu Kozan, 5" high. Courtesy of Flying Cranes Antiques Ltd., New York.

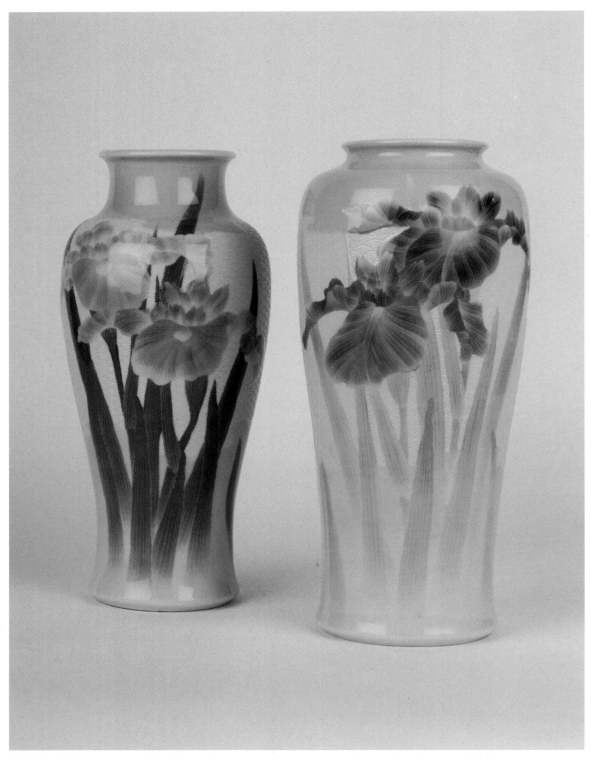

Two vases, each with irises design against a carved wave background, by Makuzu Kozan, 1860s blue mark, (left) 11 3/4" high and (right) 12" high. Courtesy of Flying Cranes Antiques Ltd., New York.

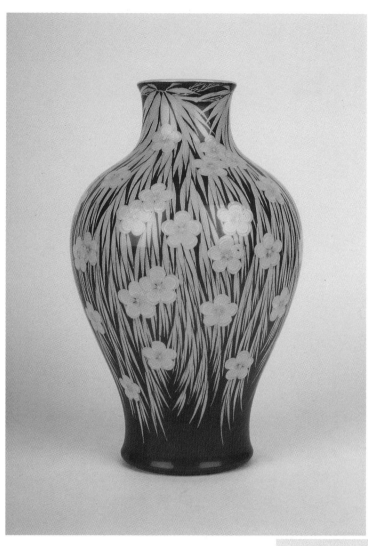

Bulbous vase with cream-colored prunus blossom design on an iron red background, by Makuzu Kozan. Courtesy of Flying Cranes Antiques Ltd., New York.

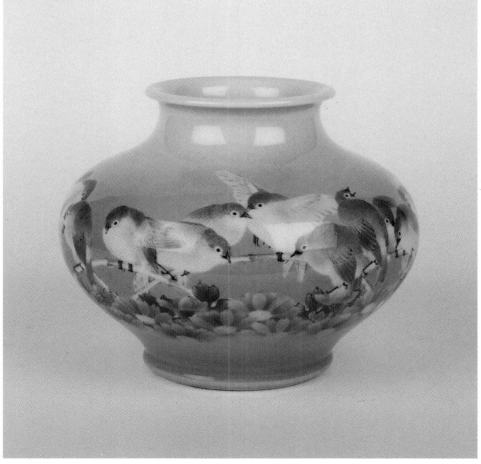

Small bulbous vase of underglaze pastel blue graduated background with green-winged birds over mauve kiku flower heads, mark of Makuzu Kozan. Courtesy of Flying Cranes Antiques Ltd., New York.

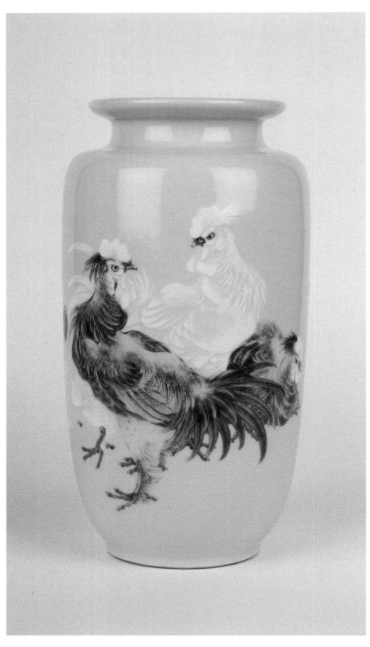

Studio vase of cream background with black crackled glaze and "frizzled chickens" decoration, 11" high. Courtesy of Flying Cranes Antiques Ltd., New York.

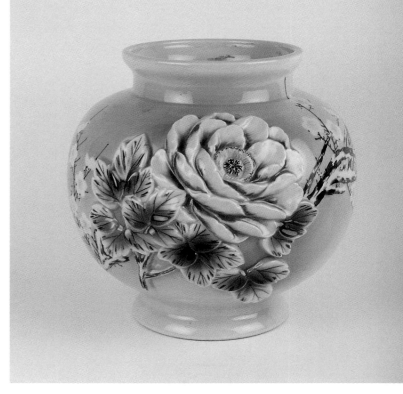

Jar of a studio potter with repousse floral design in powder blue background with butterfly, peony and prunus, c. 1900, unsigned. Courtesy of Marvin Baer, The Ivory Tower, Ridgewood, New Jersey.

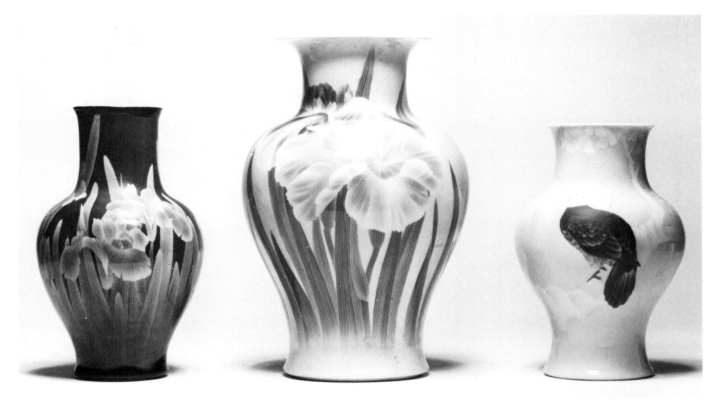

Three vases, each signed by Makuzu Kozan, late 19th century, *left*, blue and white, 11'' high; *center*, green background, 13¾" high; *right*, blue done on pink background, 10½" high, © 1986, Sotheby's, Inc.

Celadon flower container in the form of a phoenix, signed Makuzu Kozan in underglaze blue, 17'' long, late 19th century, © 1986, Sotheby's, Inc.

Three vessels, each signed by Makuzu Kozan, late 19th or early 20th century, *left*, vase with green dragon on coral background, 14'' high; *center*, tea pot with underglaze blue decoration, 8¾" high; *right*, green dragon with yellow eyes on a green background, 10'' high, © 1986, Sotheby's, Inc.

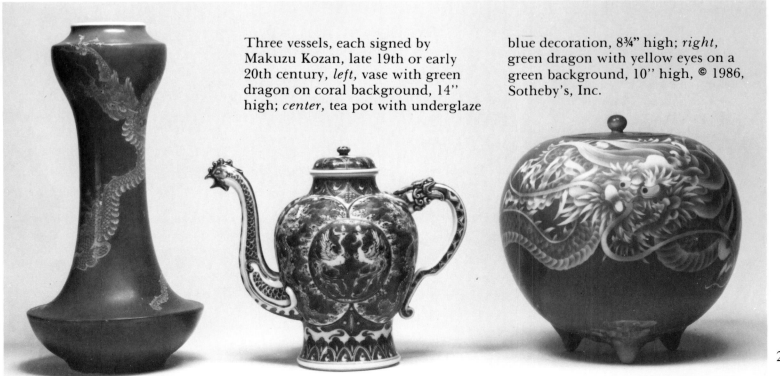

Vase in the form of an ice-covered cavern with two polar bears inside the rocks painted brown and touches of blue in the glaze, impressed seal of Makuzu Kozan, 8¾" high, 6" diameter, (see D. King, "Hirado Porcelain..." p.30, who sites this as Royal Copenhagen style), Victoria and Albert Museum, where it has been since 1910.

Dish and bowl, each signed by Makuzu Kozan, late 19th or early 20th century, *left*, dish in underglaze blue, 6¼" diameter; *right*, bowl with coral background, 5" diameter, © 1986, Sotheby's, Inc.

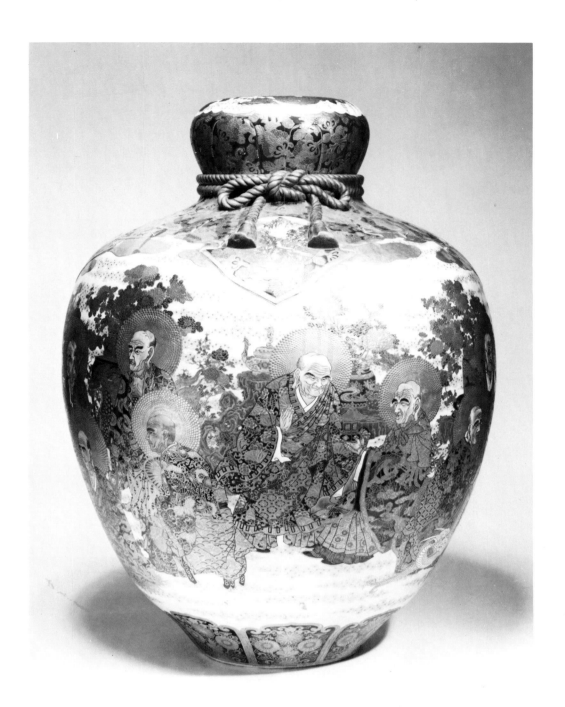

Kyoto Satsuma tea caddy and cover decorated with 16 Important Persons and their attributes below enamel decoration resembling brocade cloth tied with a cord, as traditional with jars, signed by Kanzan, 1693 (not an accurate making date), Tatsumine Chikusho and blue Satsuma crest, late 19th century, 34⅝" high, © 1986, Sotheby's, Inc.

Hayada Takemoto (1848-?)

Hayada Takemoto worked with Inoue Ryosai and established a kiln in Tokyo for Satsuma-style wares. In 1873 at the Vienna International Industrial Exposition, he won first prize for a Satsuma-style incense burner.

Kanzan (Denhichi, 1821-1890)

Kanzan was a potter in Kyoto who excelled in Kiyomizu ware and Kyoto Satsuma styles.

Tanzan I (Yoshitaro)

Tanzan I was a potter at the Awata district of Kyoto in 1854, creating in the Satsuma style.

Tanzan II (Rokuro, 1852-1897)

Tanzan II was the son of Tanzan I and also from the Awata district of Kyoto. He specialized in European style decoration. The work of Tanzan II was shown at the 1873 Vienna Exhibition.

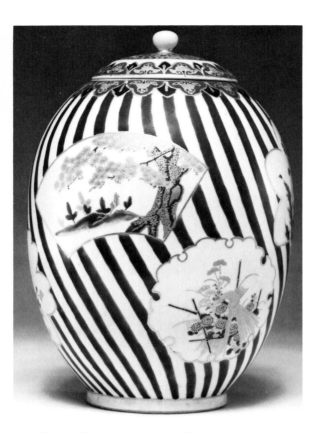

Kyoto Satsuma covered jar with blue stripes and six medallions impressed Taizan (VIII or IX), late 19th century, 10¼'' high, © 1986, Sotheby's, Inc.

The Takahashi family are well known potters from the Awata district of Tokyo. They succeeded through nine generations, the last three working in porcelains.

Taizan I (Takahashi Yohei)

Taizan I worked from 1716 to 1735 as a painter and potter.

Taizan II (Takahashi Yohei, c. 1755)

Taizan II is known for his use of Mazarin blue in his decorations.

Taizan III (Takahashi Yohei)

Taizan III worked until 1800 specializing in making tea ceremony wares.

Taizan IV (Takahashi Yohei)

Taizan IV worked as a potter for the Imperial Court from 1801-1820.

Taizan V (Takahashi Yohei)

Taizan V made fiaence for the Imperial family from 1830-1843.

Taizan VI (Takahashi Yohei)

Taizan VI worked until 1853 as a potter.

Taizan VII (Takahashi Yohei)

Taizan VII worked until c. 1875 making pottery and porcelain.

Taizan VIII (Takahashi Yohei)

Along with Kinkozan IV, and Sobei, Taizan VIII introduced Kyoto to the Satsuma style of gold and overglaze enamel decoration which was so successful as an export ware beginning in 1872.

Taizan IX (Takahashi Yohei, 1856-1922)

Taizan was head of the last generation of the Takahashi family of Awata potters from Kyoto. He made pottery and porcelain wares.

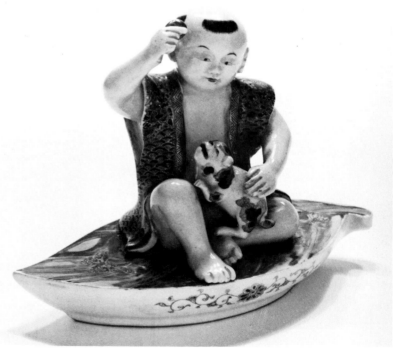

Kyoto Satsuma figure of a boy and dog seated on a leaf-shaped base, signed Taizan, late 19th century, 4' high, 6'' long.

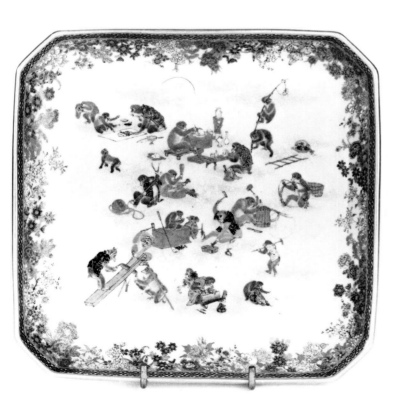

Kyoto Satsuma octagonal dish with monkeys engaged in various trades: painting, pottery, coopering, rope making, carpentry, Flying Cranes Antiques, New York.

Yabu Meizan (1853-1934)

Surprisingly little information has been found on this artist whose name appears on a large number of well decorated late-19th century Satsuma wares.

Sandra Andacht mentions him only once in her *Treasury of Satsuma* but does not mention the source of her information. This paragraph is quoted hoping that more information will be forthcoming.

Perhaps the most important modern decorator was Yabu Meizan of Osaka. At age sixty, in 1910, he was still acting as an artist. However, he did employ decorators (pupils) in his studio...The Satsuma wares attributed to Yabu Meizan may not have always been decorated by his own hand, but the great and delicate manner of his execution of motifs and their balance with the overall contours of specific articles have not been surpassed by any other of the "modern" decorators. His interpretations were of the highest merit. [p.83]

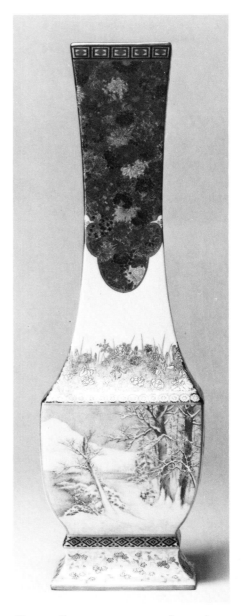

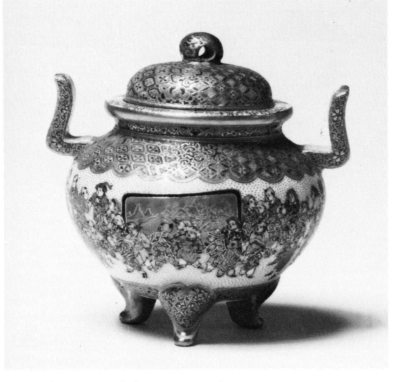

Kyoto Satsuma miniature covered incense burner, marked Yabu Meizan, late 19th century, 2¾" high, © 1986, Sotheby's, Inc.

Kyoto Satsuma square shaped vase, marked Yabu Meizan, late 19th century, 11" high, © 1986, Sotheby's, Inc.

Pair of Kyoto Satsuma oval plates with summer and winter landscapes, marked Yabu Meizan, late 19th century, 8" long, Flying Cranes Antiques, New York.

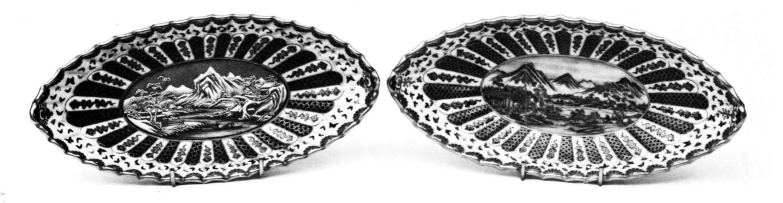

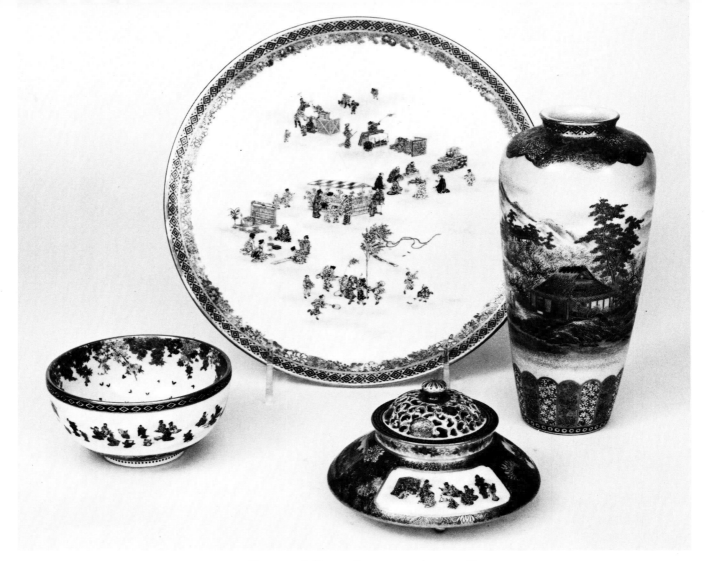

Group of Kyoto Satsuma pieces, all marked Yabu Meizan, late 19th century, plate 8'' diameter, bowl 3'' diameter, Flying Cranes Antiques, New York.

Kyoto Satsuma bowl with procession of warriors around a group viewing cherry blossoms, marked Yabu Meizan, 4⅞'' diameter, © 1986, Sotheby's, Inc.

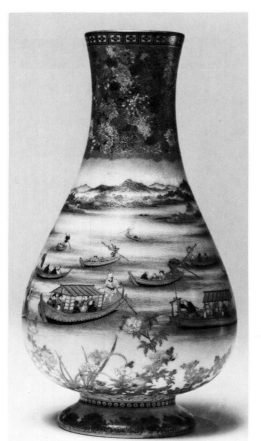

Kyoto Satsuma vase with boating scene, marked Yabu Meizan, late 19th century, 9½'' high, © 1986, Sotheby's, Inc.

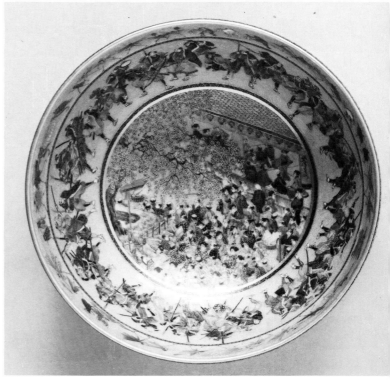

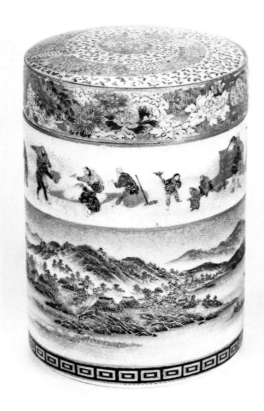

Kyoto Satsuma covered jar and covered box, both marked Yabu Meizan, late 19th century, jar 4" high, box 3" x 2", Flying Cranes Antiques, New York.

Kyoto Satsuma vase marked Yabu Meizan, late 19th century, 4⅛" high, © 1986, Sotheby's, Inc.

Kyoto Satsuma plate, marked Yabu Meizan, late 19th century, 14" diameter, Flying Cranes Antiques, New York.

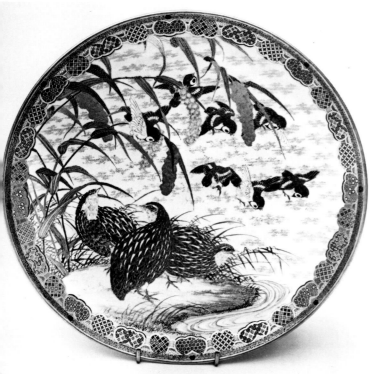

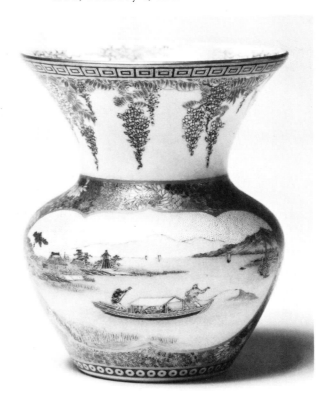

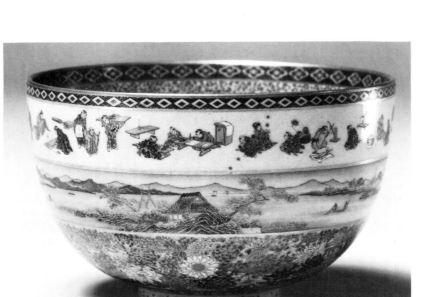

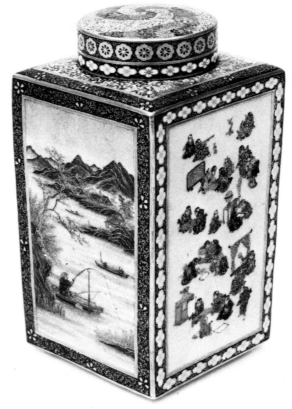

Kyoto Satsuma bowl decorated with a procession of children, marked Yabu Meizan, late 19th century, 4¾" diameter, © 1986, Sotheby's, Inc.

Kyoto Satsuma bowl decorated with three bands of childrens' activities, landscape and flowers, marked Yabu Meizan, late 19th century, 4⅞" diameter, © 1986, Sotheby's, Inc.

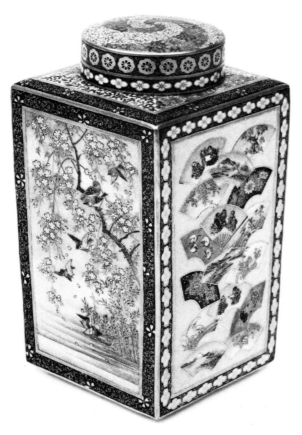

Kyoto Satsuma tea jar and lid, marked Yabu Meizan, late 19th century, 7" high, Flying Cranes Antiques, New York.

Ito Tozan

Ito Tozan worked from c. 1900-1940 at the Gojozaka area of Kyoto. By 1910, he had won many International medals for his Satsuma style wares.

Tomimoto Kenkichi (1886-1953)

Tomimoto Kenkichi was an architect and a potter. In 1915 he built a kiln for making predominently earthenwares and Raku. Later, he expanded into porcelain. Tomimoto Kenkichi used white with blue calligraphy and combined gold and silver mixed with platinum.

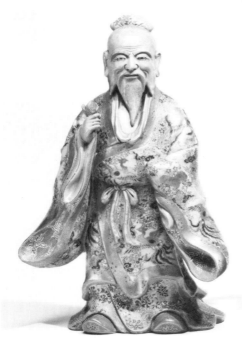
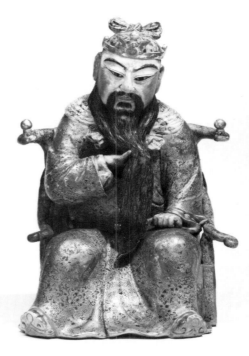

Two Satsuma figures of Chinese Sages, late 19th century, 13½" high, © 1986, Sotheby's, Inc.

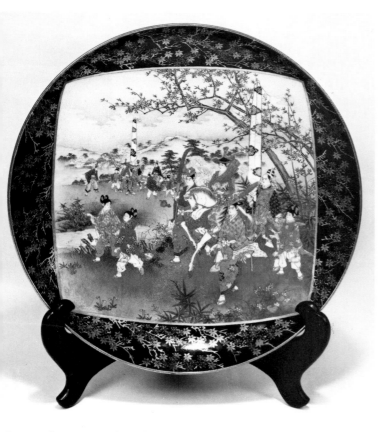

Pair of Kyoto Satsuma vases with brown monkeys and peaches, late 19th century, 6⅜'' high, © 1986 Sotheby's, Inc.

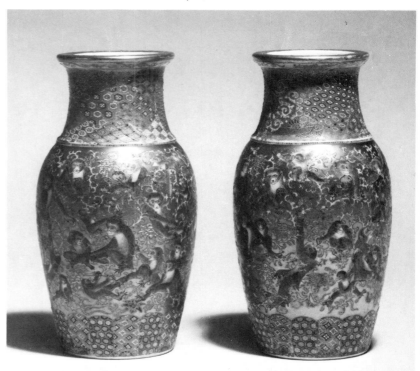

Kyoto Satsuma plate by Sozan, after 1900, 12½" diameter, Flying Cranes Antiques, New York.

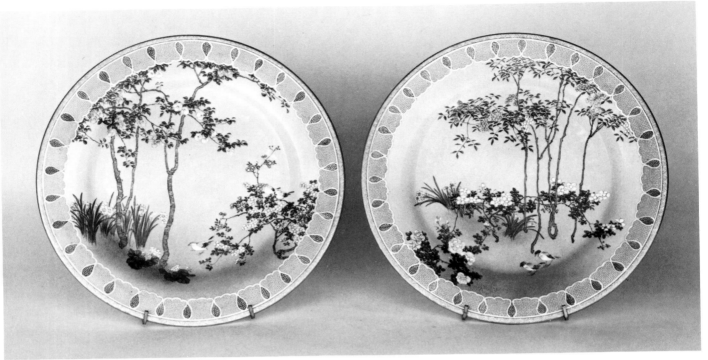

Kyoto Satsuma vase, late 19th century, 10'' high, Flying Cranes Antiques, New York.

Pair of Kyoto Satsuma plates, 10'' diameter, late 19th century, Flying Cranes Antiques, New York.

Kyoto Satsuma plate with silver overlay in the decoration, late 19th century, 3'' high, 6¾'' diameter, Flying Cranes Antiques, New York.

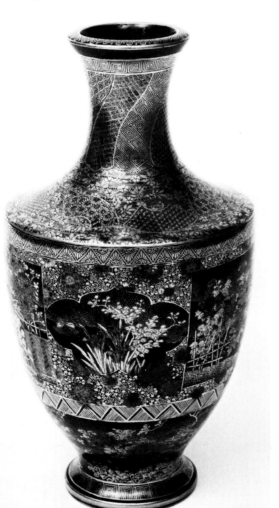

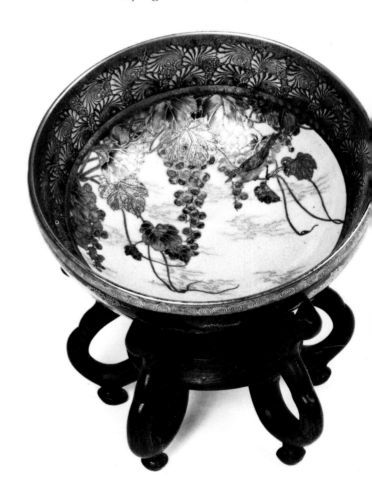

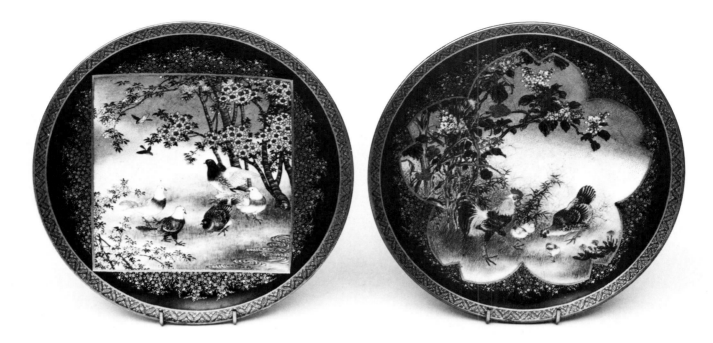

Two Kyoto Satsuma bowls, late 19th
century, 5'' diameter, Flying Cranes
Antiques, New York.

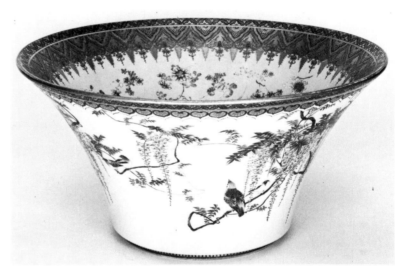

Kyoto Satsuma bowl, late 19th
century, 12'' diameter, Flying
Cranes Antiques, New York.

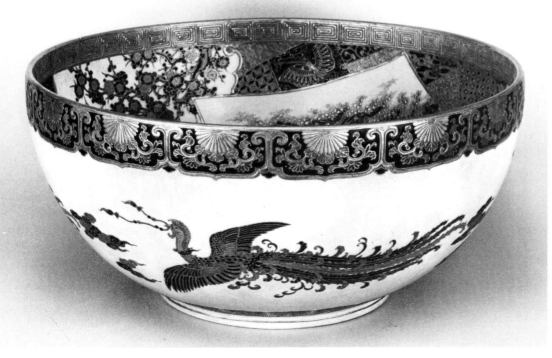

Kyoto Satsuma bowl, late 19th
century, 14'' diameter, Flying
Cranes Antiques, New York.

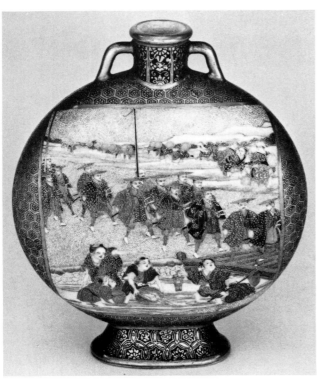

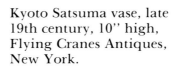

Kyoto Satsuma vase, late
19th century, 4" high, Flying
Cranes Antiques, New York.

Kyoto Satsuma vase, late
19th century, 10" high,
Flying Cranes Antiques,
New York.

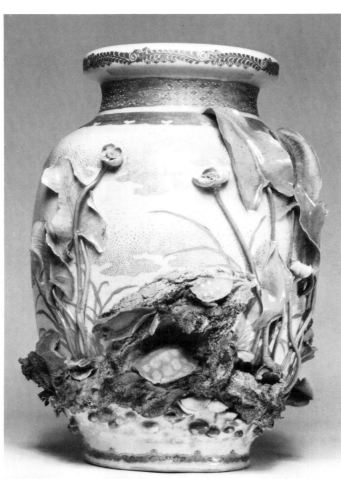

Kyoto Satsuma vase with relief
decoration of sea life, circa 1900,
13¼" high, © 1986, Sotheby's, Inc.

Kyoto Satsuma incense burner, late
19th century, 6" high, Flying Cranes
Antiques, New York.

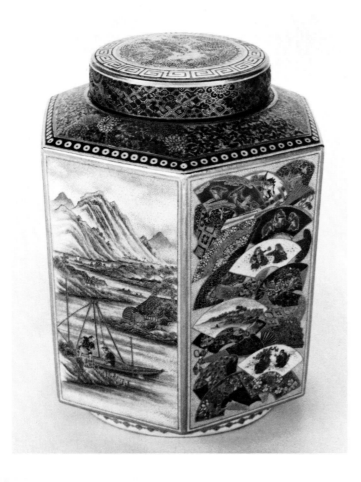

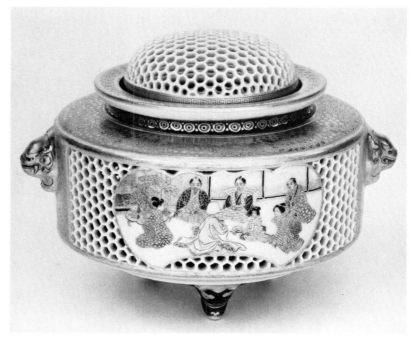

Kyoto Satsuma incense burner with pierced sides and lid, late 19th century, 5'' diameter, Flying Cranes Antiques, New York.

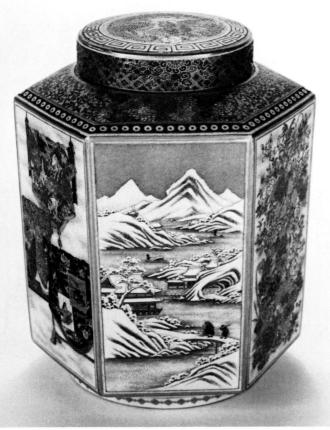

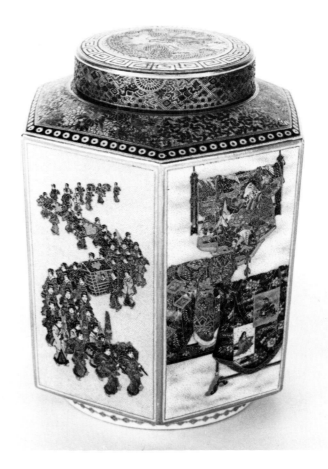

Three views of a Kyoto Satsuma hexagonal covered tea caddy, late 19th century, 8'' high, Flying Cranes Antiques, New York.

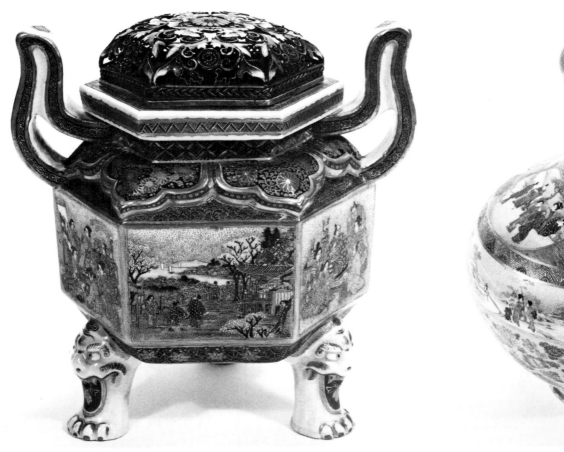

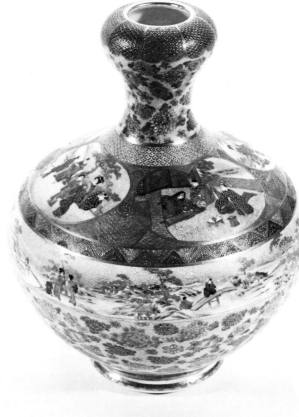

Kyoto Satsuma incense burner with silver and enamel pierced and decorated lid, late 19th century, 6'' high, Flying Cranes Antiques, New York.

Pair of Kyoto Satsuma plates with the Nikko Shrine in Kyoto as part of the decoration, late 19th century, 12'' diameter, Flying Cranes Antiques, New York.

Kyoto Satsuma vase, late 19th century, 8'' high, Flying Cranes Antiques, New York.

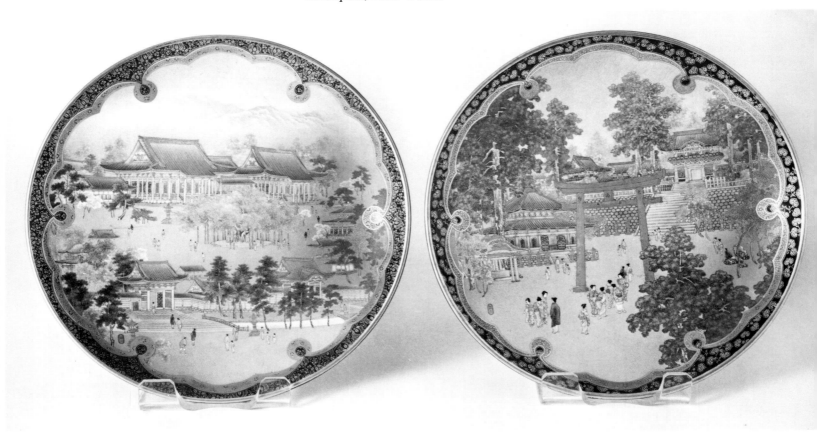

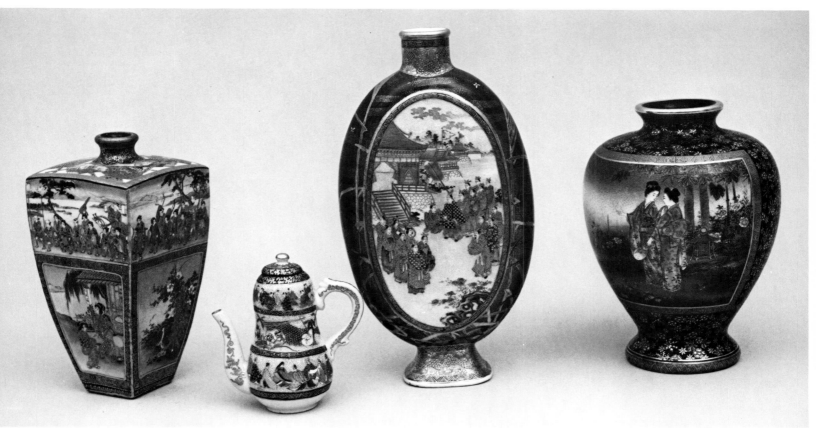

Kyoto Satsuma vase, late 19th
century, 6" high, Flying Cranes
Antiques, New York.

Four Kyoto Satsuma vessels, late
19th century, Flying Cranes
Antiques, New York.

Kyoto Satsuma ewer, late 19th
century, 5" high, Flying Cranes
Antiques, New York.

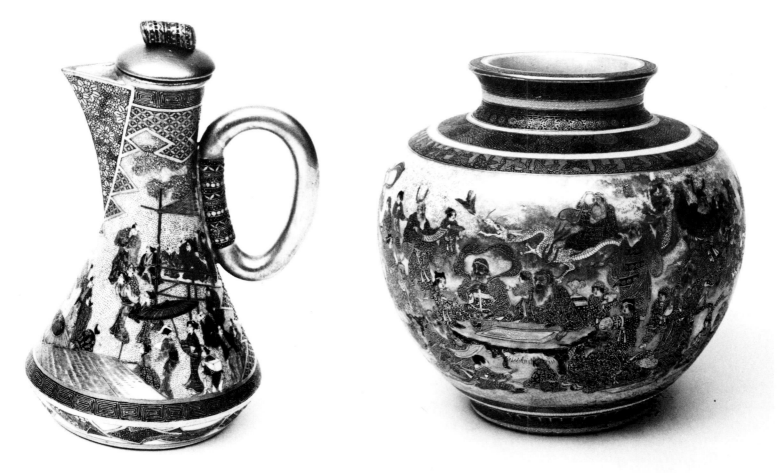

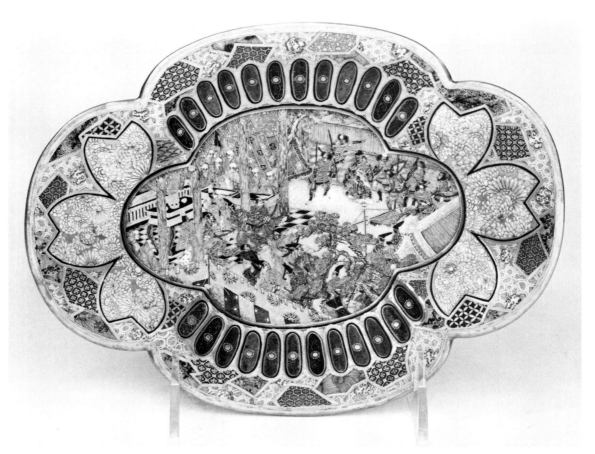

Oval Kyoto Satsuma plate with four lobes and decorative scene looking into an enclosed garden with many warriors and scholars in an alcove, late 19th century, 7" long, Flying Cranes Antiques, New York.

Pair of Kyoto Satsuma covered bottles with relief cords and tassels on stands, late 19th century, stands 3" high, bottles 12" high, Flying Cranes Antiques, New York.

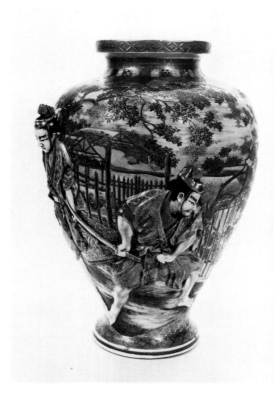

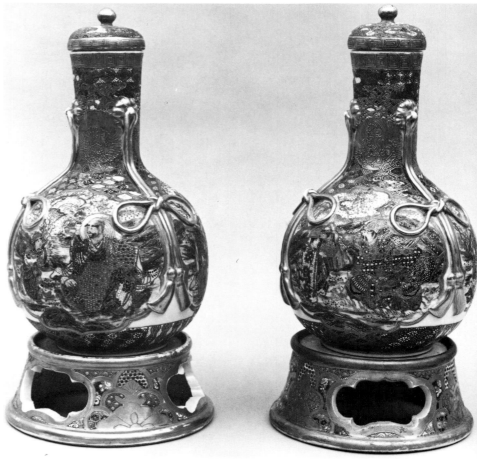

Kyoto Satsuma vase with men in relief, late 19th century, 22" high, Flying Cranes Antiques, New York.

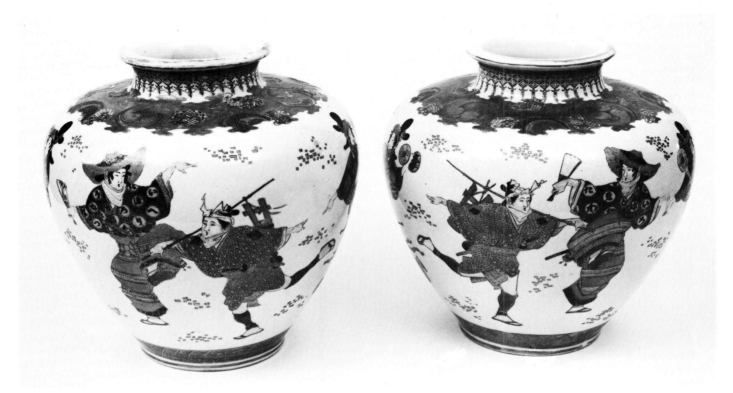

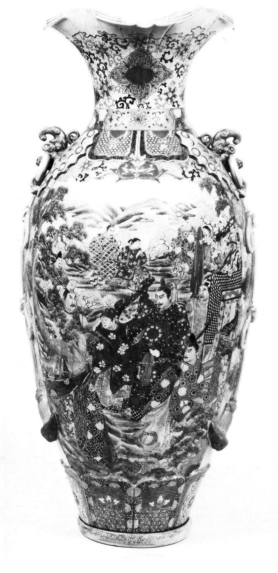

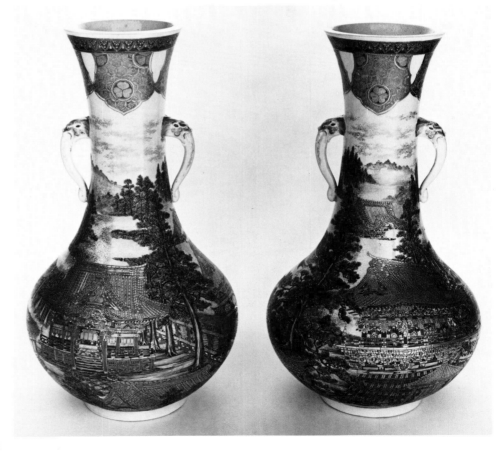

Pair of Kyoto Satsuma jars with decorations in mirror image, late 19th century, 12½" high, Flying Cranes Antiques, New York.

Pair of Kyoto Satsuma vases with the Nikko Shrine in Kyoto and Tokugawa family crest as part of the decoration, late 19th century, Flying Cranes Antiques, New York.

Kyoto Satsuma vase, circa 1900, 64" high, © 1986 Sotheby's, Inc.

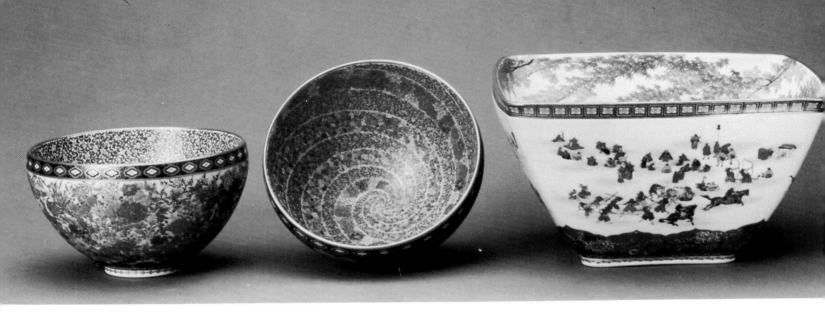

Kyoto Satsuma belt with fourteen circular decorated medallions in metal settings and chains, late 19th century, Flying Cranes Antiques, New York.

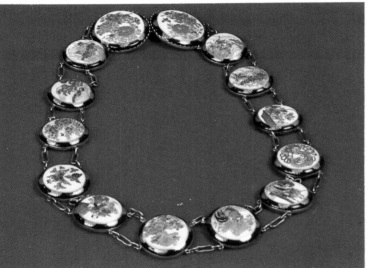

Three Kyoto Satsuma bowls, each marked Yabu Meizan, late 19th century, *left,* square bowl with scenes of craftsmen in groups including carpenters, weavers, farmers, warriors and merchants of vegetables, utensils and models, the interior with painted maple branches, marked Yabu Meizan; *center,* interior spiral design of butterflies and flowers, 4⅞" diameter; *right,* interior of butterflies and exterior of flowers, 4⅞" diameter, © 1986, Sotheby's, Inc.

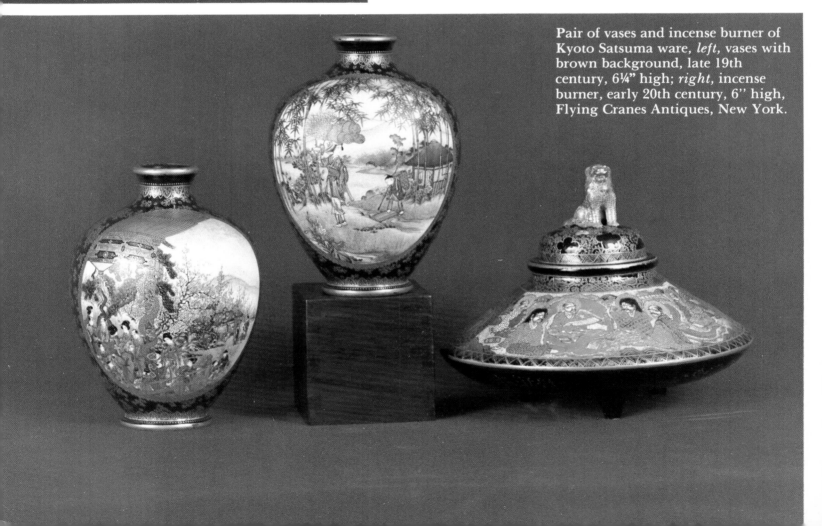

Pair of vases and incense burner of Kyoto Satsuma ware, *left,* vases with brown background, late 19th century, 6¼" high; *right,* incense burner, early 20th century, 6" high, Flying Cranes Antiques, New York.

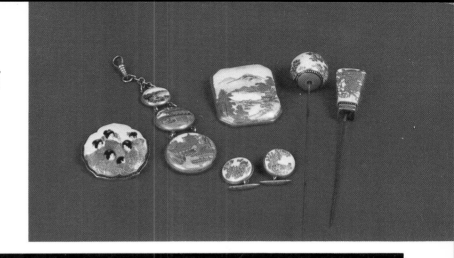

Kyoto Satsuma buttons, watch fob, cuff links, and hat pins with metal settings, late 19th century, Flying Cranes Antiques, New York.

Kyoto Satsuma jar decorated with monkeys, marked by Yabu Meizan, 7½'' high, late 19th century.

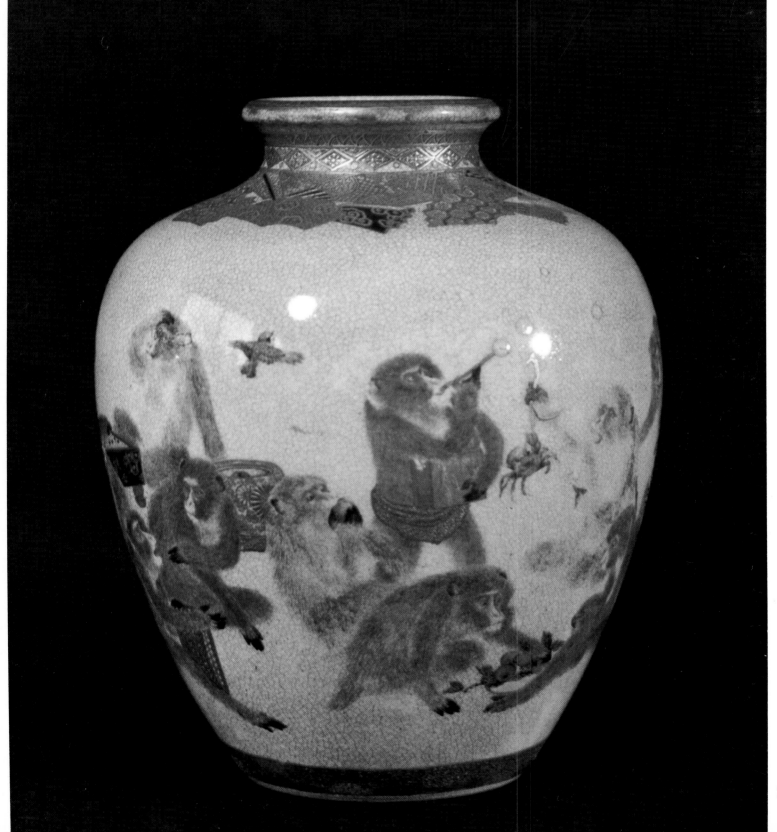

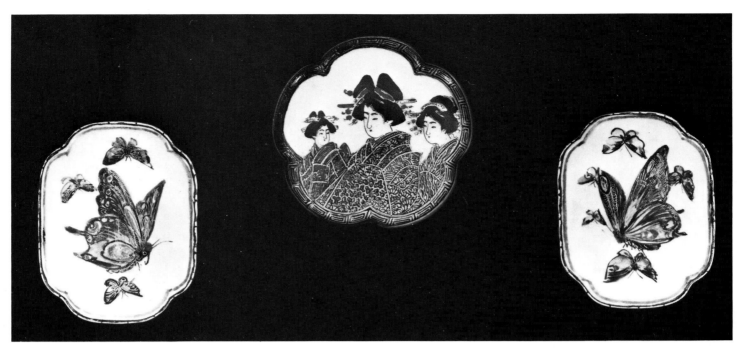

Pair of Satsuma buttons and a
Satsuma buckle, late 19th century,
Flying Cranes Antiques, New York.

Two views of a Kyoto Satsuma vase,
late 19th century, 10'' high, Flying
Cranes Antiques, New York.

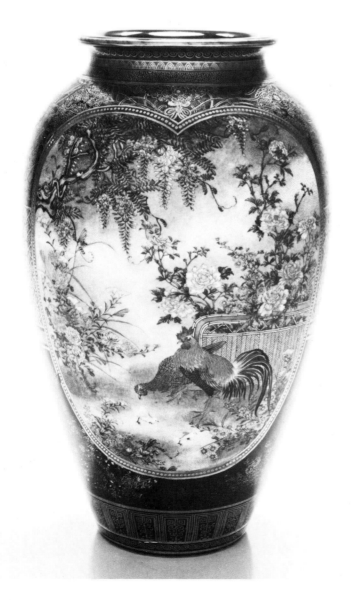

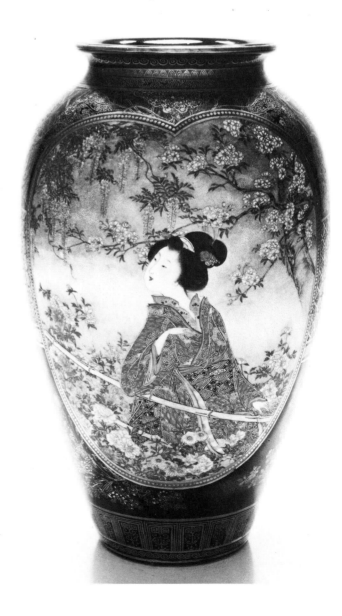

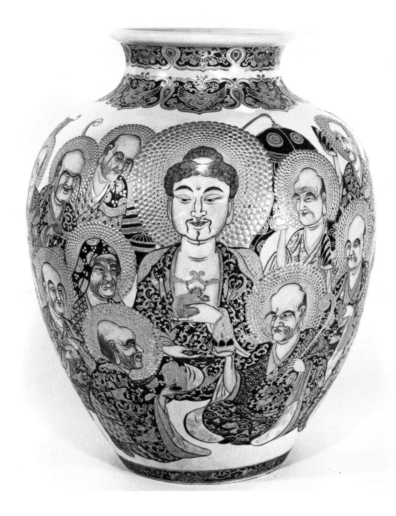

Kyoto Satsuma vase with
Buddah and Immortals in
the decoration, circa 1900,
18" high, Flying Cranes
Antiques, New York.

Kyoto Satsuma bowl depicting
Urashima Taro, a legendary figure
who lived under water, late 19th
century, 9" diameter, Flying Cranes
Antiques, New York.

Kyoto Satsuma plate with an
elephant in procession, 6" diameter,
late 19th century, Flying Cranes
Antiques, New York.

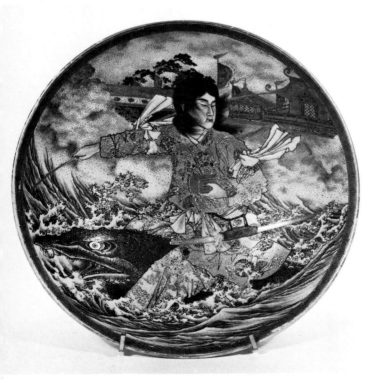

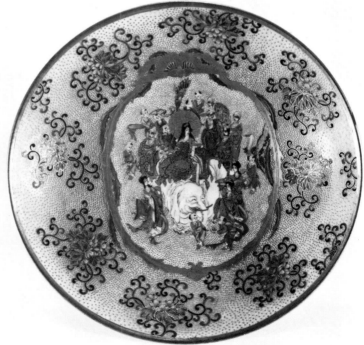

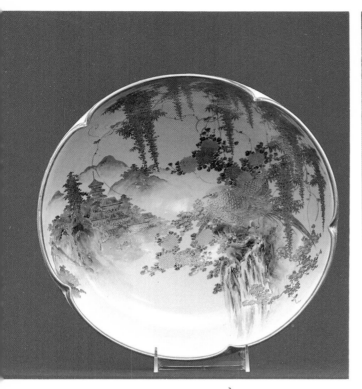

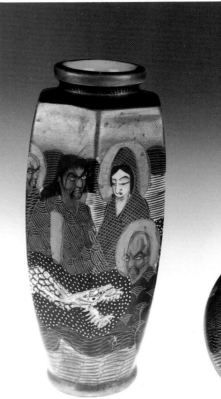

Kyoto Satsuma bowl, late 19th century, 12" diameter, Gibbons collection.

Two Kyoto Satsuma vessels, late 19th century, *left*, covered patch box on a stand, 1⅝" high; *right*, vase 6" high, Lyman Allyn Museum, New London.

Kyoto Satsuma vase and covered round box with matching decoration of the eight Immortals, early 20th century, vase 6¼" high, box 3⅝" diameter, Altemose collection.

Kyoto Satsuma vase marked Yabu Meizan, late 19th century, 3½" high, House of Crispo.

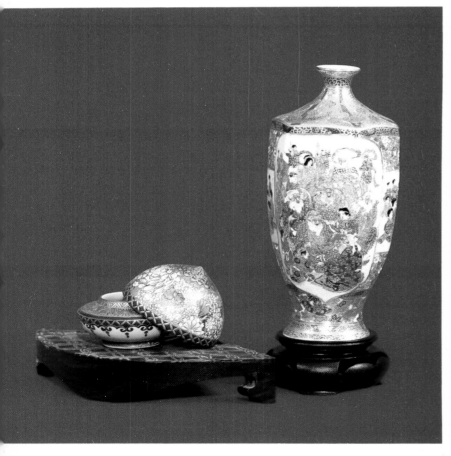

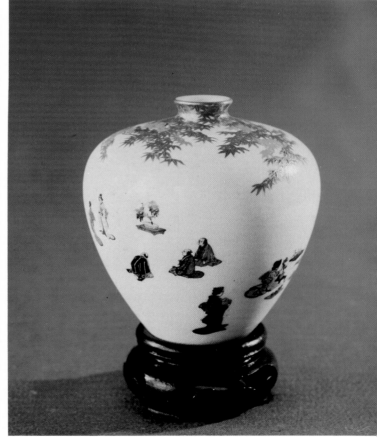

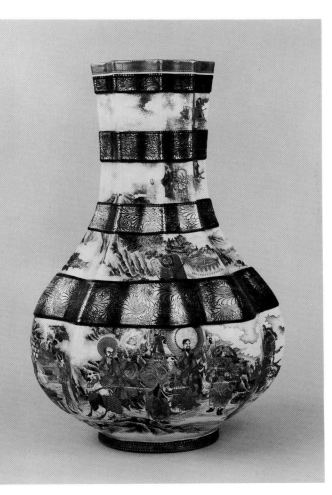

Imari vase with green landscape and overlapping basketweave band, green mark ''Hand Painted Imari'' with 4 characters, early 20th century, 4½'' high, Jeanette and Sina P. Kurman collection.

Kyoto Satsuma vase with landscape scene, signed by Taizan, circa 1890, 6'' high, Jeannette and Sina P. Kurman collection.

Kyoto Satsuma ribbed vase with silver inlay, late 19th century, Flying Cranes Antiques, New York.

Kyoto Satsuma tile and pair of vases, the tile depicting a cricket cage maker selling a cage to two children, 8'' square, circa 1900, Flying Cranes Antiques, New York.

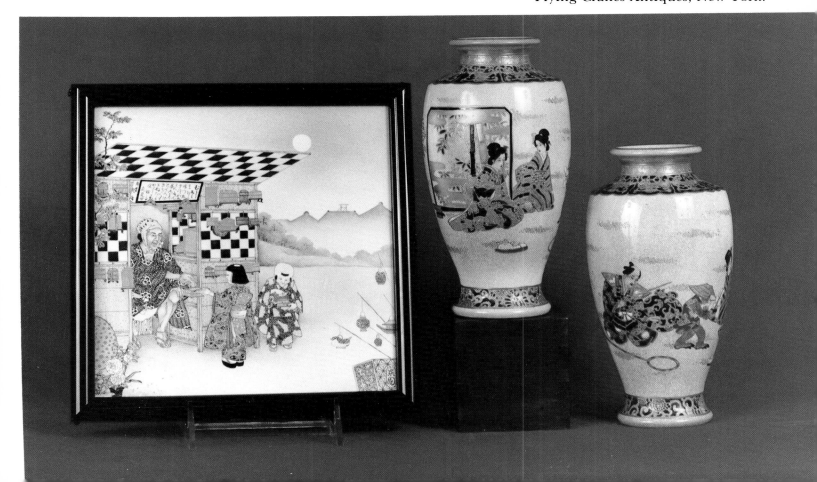

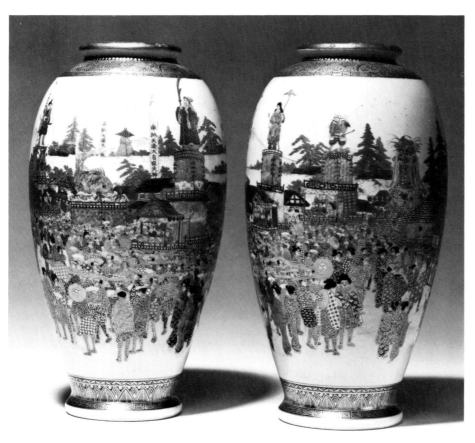

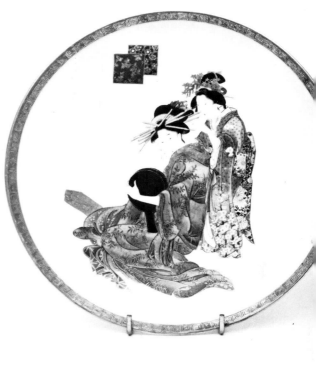

Pair of Kyoto Satsuma vases decorated with villagers in a procession with floats bearing giant carp and representative figures, marked "Made in Japan, Yozan", late 19th century, 9⅛" high, © 1986, Sotheby's, Inc.

Two of a set of twelve Kyoto Satsuma plates, each with a different scene of figures in gardens, late 19th century, 12" diameter, Flying Cranes Antiques, New York.

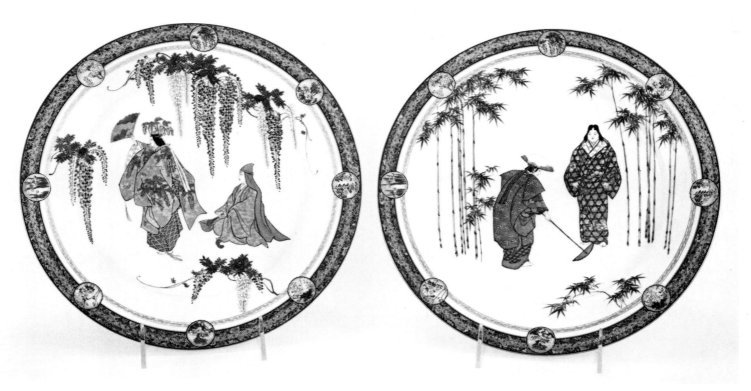

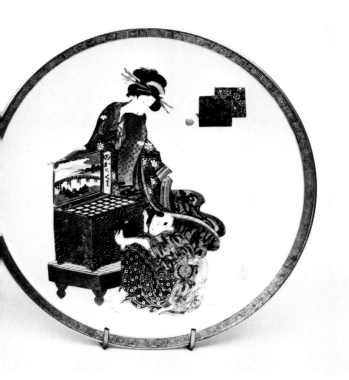

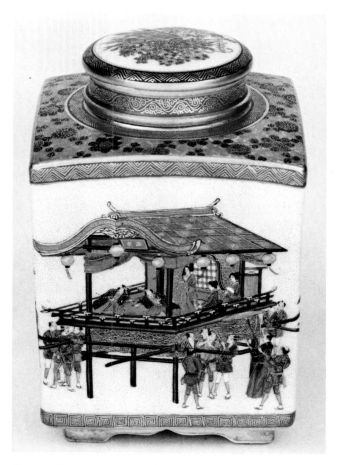

Pair of Kyoto Satsuma plates, *left,* woman holding mirror and applying cosmetics, while her attendant grooms her hair; *right,* woman with compartmentalized box and two playing children, both marked, 8" diameter, late 19th century, Flying Cranes Antiques, New York.

Pair of Kyoto Satsuma plates, each with a different scene of Oriental ships, late 19th century, 10" diameter, Flying Cranes Antiques, New York.

Kyoto Satsuma tea caddy and lid with portable building, carriers and courtiers in the decoration, late 19th century, 6" high, Flying Cranes Antiques, New York.

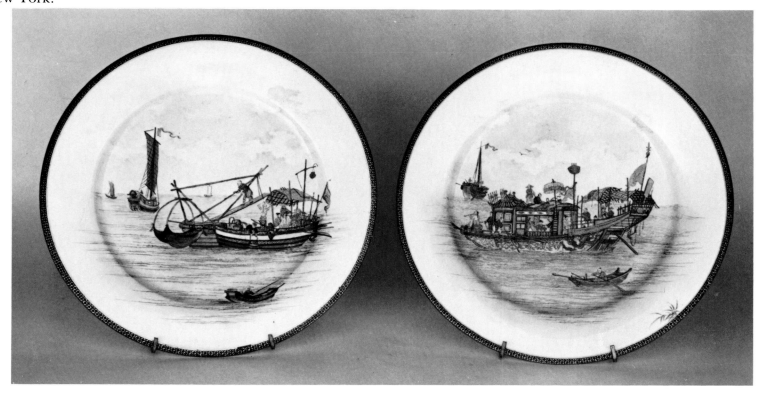

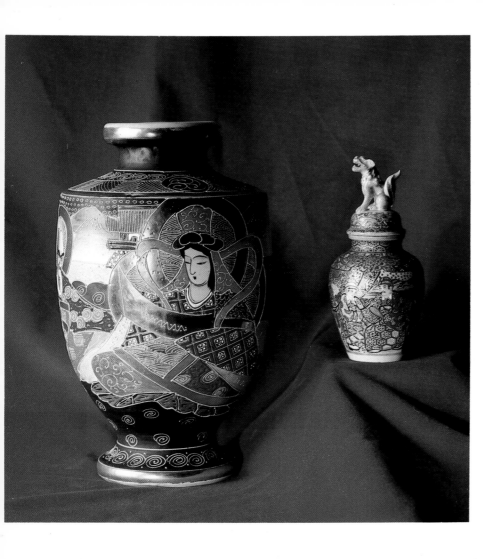

Two Kyoto Satsuma vessels, early 20th century, *left,* vase with raised yellow slip outlines, 13" high, 7" diameter; *right,* covered jar with lion-dog finial and raised outline of two figures, 7½" high, 3½" diameter, Jeanette and Sina P. Kurman collection.

Two Kyoto Satsuma plates by Kinkozan, late 19th century, one with geese decoration 8½" diameter; one of a set of twelve with floral rims, 9" diameter, Flying Cranes Antiques, New York.

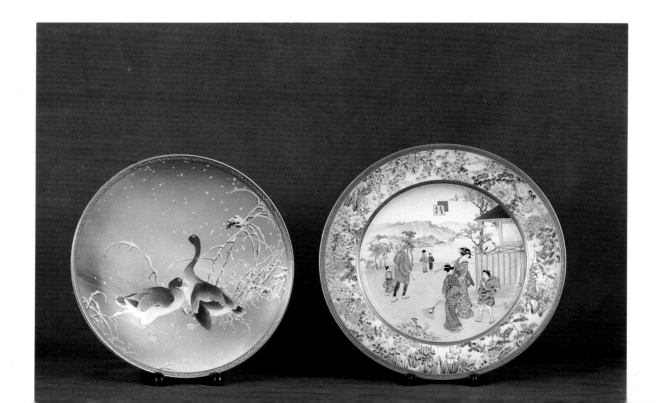

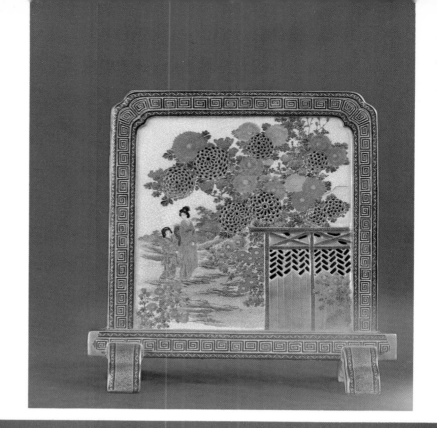

Kyoto Satsuma table screen with pierced areas in the garden decoration, late 19th century, 7" high, Flying Cranes Antiques, New York.

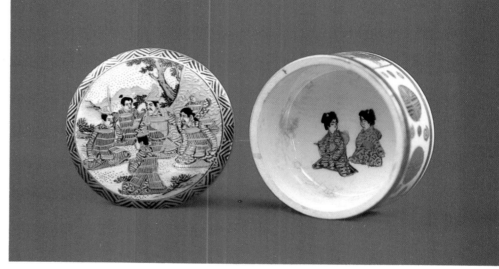

Kyoto Satsuma covered box, late 19th or early 20th century, 2¼" diameter, Mr. and Mrs. Curtiss S. Johnson, Jr. collection.

Kyoto Satsuma tray with an exhibition of fighting skills in front of a landscape scene, late 19th century, 9" high, 12" long, Flying Cranes Antiques, New York.

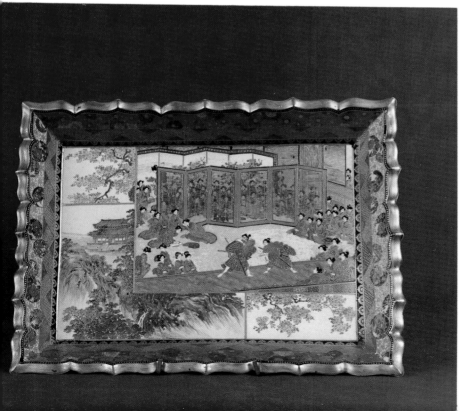

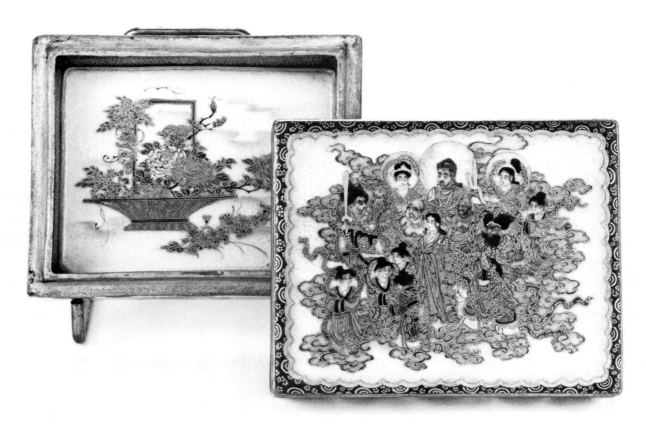

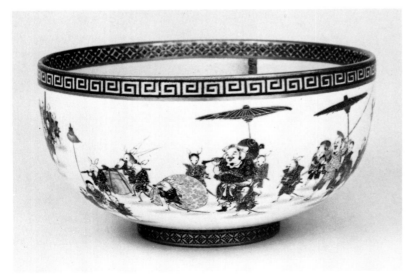

Kyoto Satsuma box, signed [but not identified], late 19th century, 3'' wide, 2½'' deep, Flying Cranes Antiques, New York.

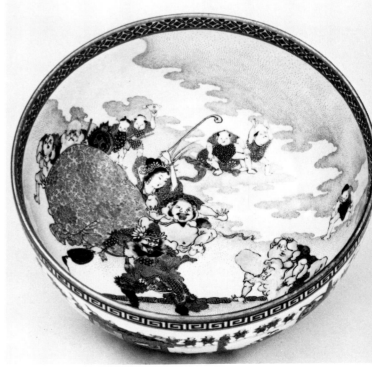

Two views of a Kyoto Satsuma bowl with scenes of Hotei and his sac and in procession with mice dressed as attendants, late 19th century, 5'' diameter, Flying Cranes Antiques, New York.

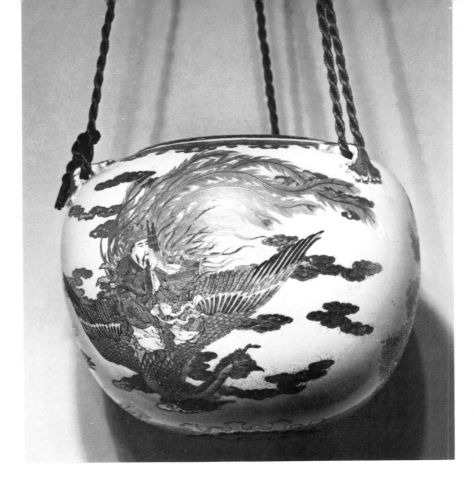

Kyoto Satsuma hanging jardiniere with decorated base, 19th century, 12'' diameter, Flying Cranes Antiques, New York.

Kyoto Satsuma plate with three women and a child reading and a 2-panel screen in the background, 9'' diameter, late 19th century, Flying Cranes Antiques, New York.

Kyoto Satsuma plate with woman and two children by a fish bowl in the decoration, signed, late 19th century, 8'' diameter, Flying Cranes Antiques, New York.

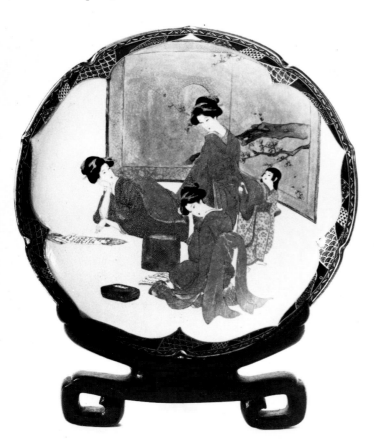

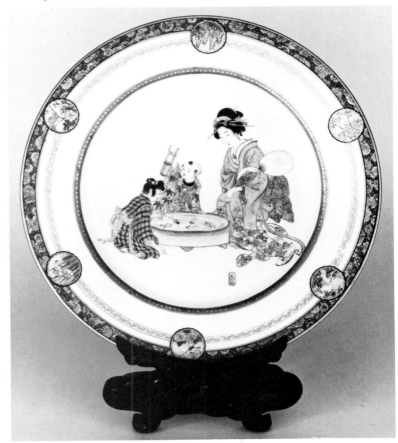

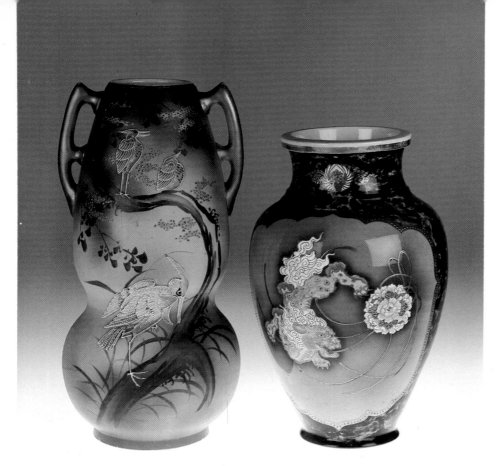

Two Nagoya vases, early 20th century, *left*, matt finish with slip decoration, 16" high; *right*, lion-dog and bouquet in the decoration, 13½" high, Altemose collection.

Group of Kyoto Satsuma vases, *left foreground*, black background for a man and a woman with halos, base marked with Shimazu family crest, late 19th or early 20th century, 13" high; *second*, square shouldered vase marked with red "Made in Japan", circa 1925, 6¼" high; *third*, man and woman in landscape, marked in brown "Made in Japan", circa 1925, 6" high, *right*, blue background and red plum blossom mark, circa 1925, 7¾" high, *back row*, pair of vases with flower on one side and three men on the other side, circa 1900, 12" high, Jeanette and Sina P. Kurman collection.

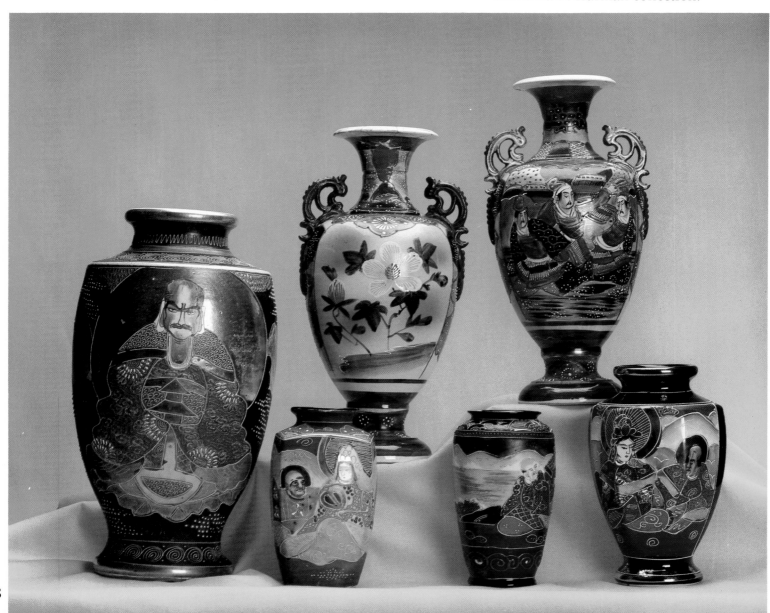

Seto and Nagoya

Seto ware

Seto (or Owari) porcelain was made in the village of Seto in Owari Province, a small area six miles inland from the port of Nagoya.

Archaeological excavations here have determined very early shards from the Seto kiln in Chinese style from about 1230 A.D. These may be Japan's first glazed ceramics. [Tozawa, Y., *Biographical Dictionary of Japanese Art*, p. 550]

In support of this speculation are legends about the founder of the Seto kiln, a potter named Kagemasa Kato Shirozaemon who lived during the Kamakura period (1185-1392). The legend claims he traveled to China for a year or two to study the techniques of making tea caddies, and that he traveled with the founder of the Soto Sect of Zen, Dogen, who apparently left Japan in 1223, studied pottery making, and returned in 1228. Kagemasa found excellent clay at Seto and established a kiln there. If the legend is factual, Kagemasa would be the founder of the Kato family of potters who continue today.

About 1798, some Seto potters moved to Nagoya because of changing laws but were in a few years able to return to Seto.

Seto porcelain ware, in modern time, is traced back to its founder Kato Tamikichi (1771-1824). He revitalized his family's old kiln by producing porcelain there. After studying porcelain production in Arita, he returned to Seto, began his porclain kiln operation in 1807,

Group of Nagoya vessels with dragon in slip decoration, early 20th century, *left*, pitcher 9½" high; *center*, jardiniere with green Noritake mark, *right*, vase with top handle and "Nippon Hand Painted" blue mark, 9¼" high; *back left*, dark vase with Nippon green mark, 6¼" high; *back right*, light vase with Nippon Hand Painted blue mark, 8¼" high, Altemose collection.

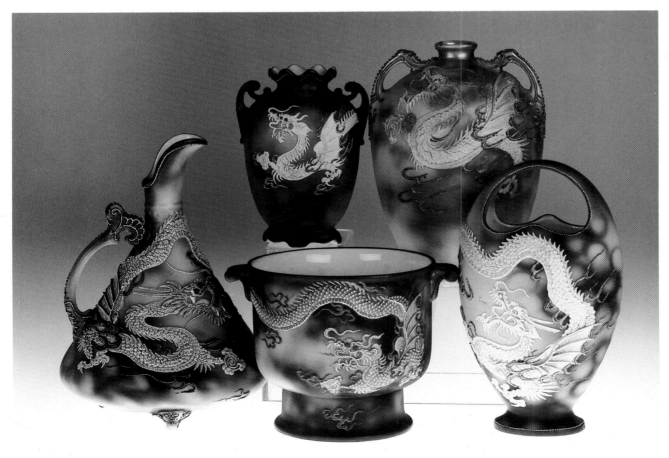

and taught the techniques to the local potters. Tamikichi's works are impressed with stamps reading:

Cho Choshu Owari Bunka choshu zo

and his good underglaze blue pieces with cobalt from the Seto mountains are stamped:

Kyowa bisei (1801-1803), made in Owari Province
Banka bisei (1804-1817), made in Owari Province
Banka nensei (1804-1817), made in the Banka era

Toward the end of the 19th century, Seto potters were strongly influenced by Western styles and made large quantities of ware for export. Many pieces were made at kilns in Seto and other nearby places of Owari province, and sent to Tokyo for decoration and export. By the early 20th century, Seto villages produced the largest volume of porcelain in Japan, most of it for export.

Shuntai (Kato Soshiro, 1802-1877)

Shuntai became the most important Seto potter of his time. He was born in Seto and as a youth worked at the Ofuke kiln, later being awarded the artist name Shuntai by the Owari daimyo. Apparently some trouble later developed, for he was banished from Seto and moved to Imao where he established a kiln and used a seal mark "Imao Shuntai". Later he was pardoned for his trouble and returned to the Ofuke kiln. He worked in the traditional style of the Seto and Mino kilns while combining influences of these styles and underglaze blue.

Inoue Ryosai I (1828-?)

Ryosai was born in Seto. He first made his pottery at Inuyama near Nagoya, then moved to Tokyo. In 1866, he opened a kiln at Asakusa in Tokyo, and used another artist name, Togyokuen Ryosai.

Inoue Ryosai II (1888-?)

Inoue Ryosai II was born in Tokyo, worked at Asakusa with his father, Inoue Ryosai I, and then moved to Yokohama in 1913. He produced both traditional white-glazed ware and designs influenced by the West.

Kato Tomotaro (1851-1916)

Kato Tomotaro was an important late 19th century potter who went to Tokyo in 1874, worked with Inoue Ryosai I in the Kangyuryo laboratory, and in 1882 began his own kiln in Tokyo. He experimented with underglaze colors and won prizes at several domestic and international exhibitions.

Kato Tokuro (1898-?)

From the Kato family of Seto, Kato Tokuro had his own kiln in 1914. His early work includes a revival of early Seto earthenware style from which he developed his own style based on old techniques. His historical study of old wares led to a pottery dictionary (the *Toki daijiten*). He was appointed director of the Japan Ceramics Association (Nihon Toji Kyokai) when it was established after World War II, and was part of the founding of the Japan Craft Society (Nihon Kogei Kai). He has continued to work as an artist-potter into the 1980's.

Kato Hajime (1900-1968)

Born in Seto, Kato Hajime worked at the Gifu Prefecture Ceramic Testing Laboratory. In 1940, he built a kiln at Yokohama and potted professionally in a wide range of styles. He is particulary well known for his revivals of Chinese Ming style technique of a red design in a yellow background and his versions of celadon, white porcelain and gold-painted porcelain. He was a professor at the Tokyo National University of Fine Arts and Music, and was designated an Important Cultural Property for his knowledge of enameled porcelain.

Seto or Kameyama (Nagasaki) box for writing tools with Chinese derived blue decoration (see page 65, L. Smith, "Japanese Porcelain..."), 19th century, 9⅜" long, British Museum, London.

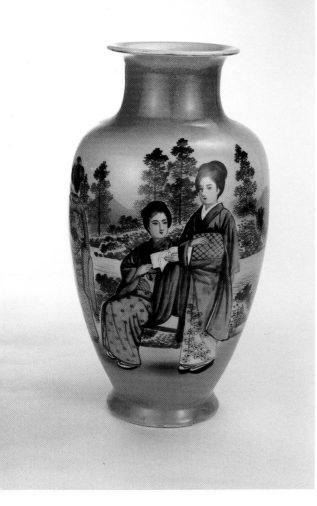

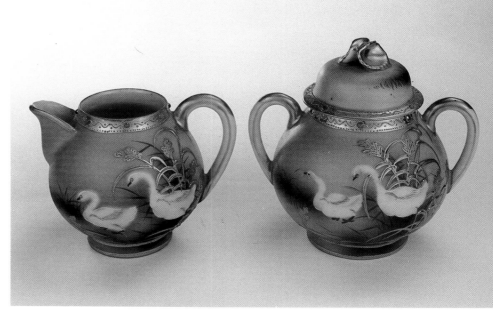

Nagoya vase blending
Japanese scene with Western
painting style, early 20th
century, 12" high,
Jacquelyne Y. Jones North
collection.

Nagoya cream pitcher and covered
sugar bowl marked Nippon, before
1921, pitcher 3¾" high; bowl 5½"
high, Dr. and Mrs. Bernard F.
Adami collection.

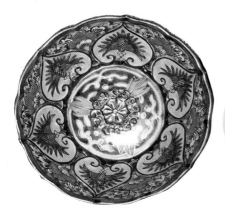

Pair of Imari style plates possibly
made in the Nagoya area in the
early 20th century, 7" diameter.
Asian Fine Arts, Minneapolis.

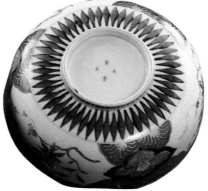

Pair of Imari style bowls possibly
made in the Nagoya area in the
early 20th century, 10" diameter.
Asian Fine Arts, Minneapolis.

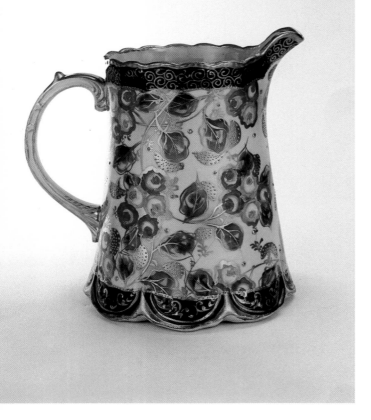

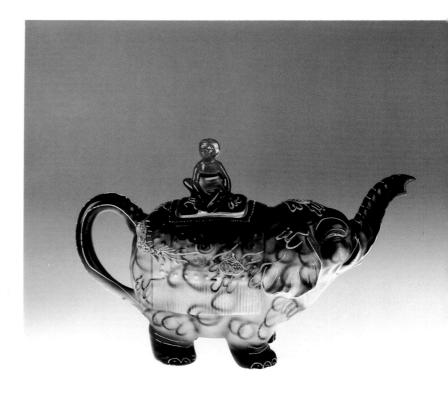

Nagoya pitcher, early 20th century, 8¼" high, Dr. and Mrs. Bernard F. Adami collection.

Three Nagoya teapots with dragon in slip decoration, early 20th century, *left,* marked black T.T., 8½" high; *center,* marked "Nippon" before 1921, 6¼" high; *right,* marked "Hand Painted, Victory China", 7½" high, Altemose collection.

Nagoya teapot in the form of an elephant with rider and slip decoration, early 20th century, Altemose collection.

Nagoya vase marked Nippon, before 1921, 7½" high, Dr. and Mrs. Bernard F. Adami collection.

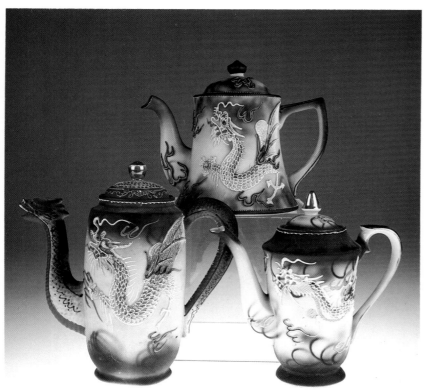

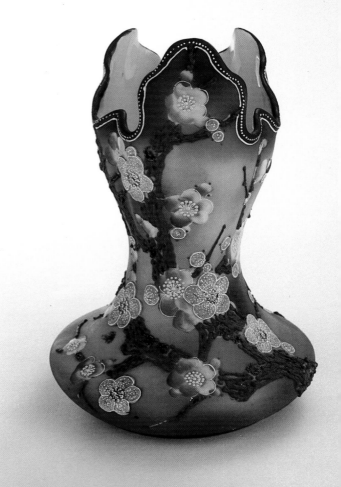

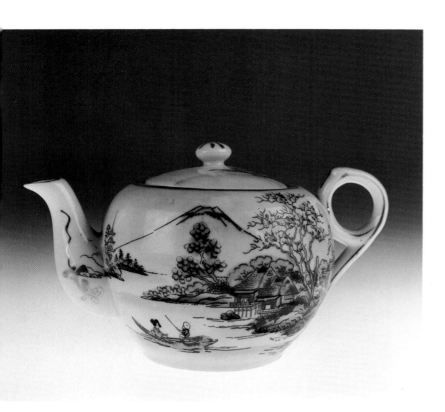

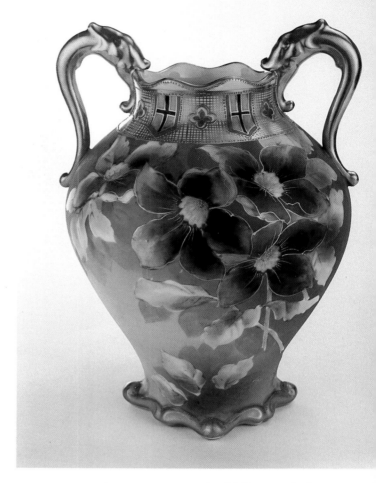

Nagoya tea pot with Mount Fuji landscape decoration, early 20th century, 4½" high, Altemose collection.

Nagoya vase marked Nippon, before 1921, 13¼" high, Jacquelyne Y. Jones North collection.

Nagoya vase marked Nippon, before 1921, 9¼" high, Dr. and Mrs. Bernard F. Adami collection.

Nagoya tea pot and cream pitcher with dragon in slip decoration, tea pot 8¼" high; cream pitcher with iridescent pink glaze 4" high, early 20th century, Altemose collection.

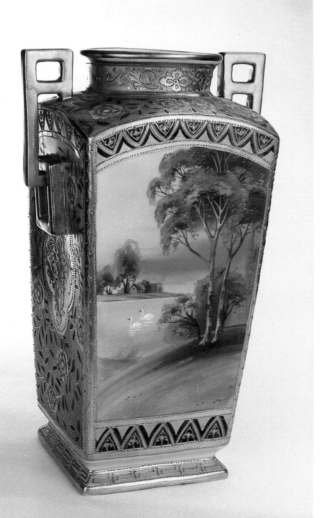

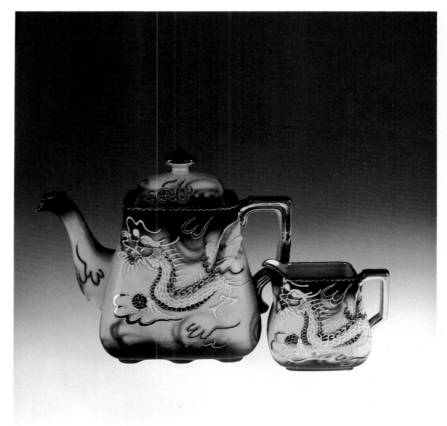

Nagoya dish marked Nippon, before 1921, 7¼" long, Jacquelyne Y. Jones North collection.

Nagoya ware

Ichizaemon Morimura (1839-?), from a Japanese merchant family, was a member of the Japanese delegation to the United States in 1859. Here he saw a potential market for Japanese exports. In 1876 he and members of the Okura family founded an export trading firm Morimura-Kumi in the Ginza district of Tokyo to export traditional Japanese style potteries, bamboo items and gifts. By 1879, Morimura Bros., Inc. had offices in New York city and were sending the finest quality ceramics to the United States from potteries throughout Japan. The company tried to appeal to the taste for art in the United States. By 1884, the Morimura company decided to specialize in ceramic wares, and saw the opportunity for a Japanese factory to export chinaware designed specifically for the United States market. They used decorating shops in Tokyo, Nagoya, and Kyoto.

To control ceramic manufacturing, the Noritake company (Nippon Taki Kabushiki Kaisha) was founded in Nagoya on January 1, 1904 by six men: Ichizaemon Morimura, Mogobei Okura, Jitsuei Hirose, Kazuchika Okura who served as President of Noritake from 1904-1922, Yasukata Murai and Kootaro Asukai. They developed modern machinery to produce high quality wares in volume.

Noritake also made ceramics for industrial uses, and these were split off into separate companies as they became larger. An early competitor in the dinnerware field was the Meito Company which went out of business in the 1940's.

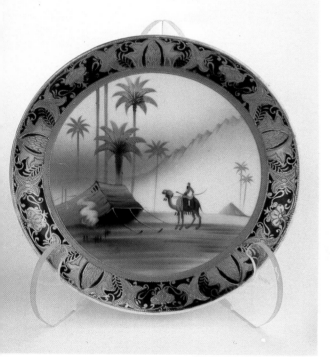

Nagoya plate marked Nippon, before 1921, 7½" diameter, Jacquelyne Y. Jones North collection.

Nagoya plate, 10" diameter, early 20th century, Jacquelyne Y. Jones North collection.

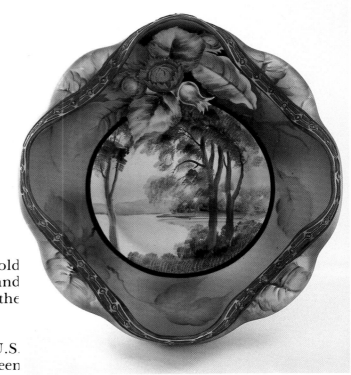

Nagoya bowl of undulating square shape marked Nippon, before 1921, 9½" diameter, Dr. and Mrs. Bernard F. Adami collection.

Early Noritake decorations include fruit, flowers, foliage with gold and low relief details. Later, some pieces incorported French and English transfer-printed patterns to give a European touch to the designs.

Nippon ware

Until 1921, the pieces were marked, in accordance with U.S. import laws, "Nippon"—and so this time period has popularly been called the Nippon period for these U.S. imports.

The Noritake ware was sold with inventive thinking. In 1911, five Japanese grocery store companies also sold some Noritake wares. Dinnerware services were sold only in Japan at this time.

With Europe going to war in 1914, traditional supplies of European dinnerware were not able to be sent to the United States. The first Noritake dinnerware pattern made for the United States was shipped this year. Soon, Noritake received many order from Japanese hotels and restaurants for full services of the American pattern.

The Noritake Company also exported many undecorated pieces which were later painted by hobbyists in Europe and the United States. Therefore, old Noritake-marked pieces now can be found with hand decorations of quite original designs.

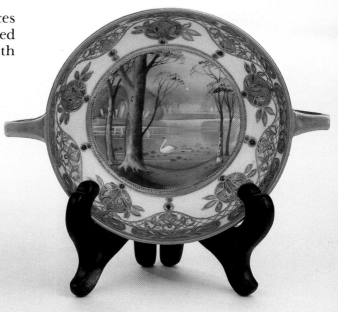

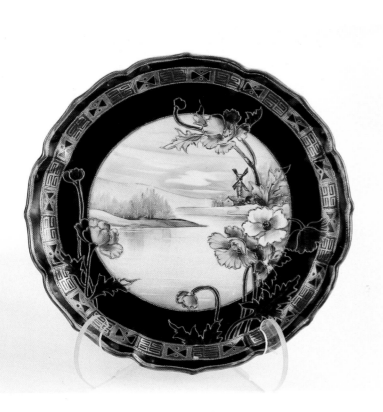

Nagoya plate combining Western landscape with Japanese stylized floral and geometric decoration, marked Nippon, before 1921, 10" diameter, Jacquelyne Y. Jones North collection.

Nagoya plate with Western style landscape and stylized border decoration marked Nippon, before 1921, 5" diameter, Jacquelyne Y. Jones North collection.

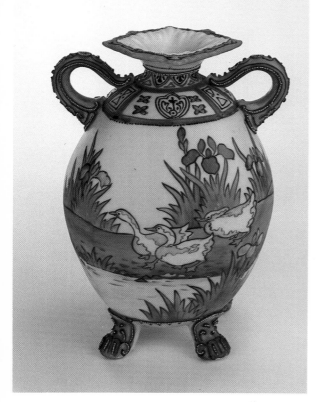

Nagoya vase marked Noritake, early 20th century, 7½" high, Jacquelyne Y. Jones North collection.

Okura Art China

Okura Art China was first created in 1919 near Tokyo by Magobei Okura and his son Kazuchika who were also among the six founders of the Noritake Company. Okura Art China is made by hand from choice material and in limited production. Some of it is marked "O.A.C. Noritake" or with their own 5-lobed trademark. Okura China Inc. is still in production today.

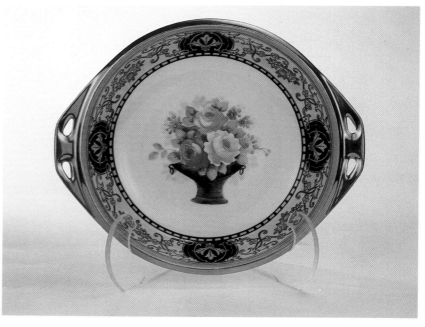

Group of Nagoya vessels, *back left,* vase with green mark reading "Japan I. & E.C. Co." in a wreath and "Hand Painted", 1925 and after, 6" high; *back right,* condiment set of round tray with salt and pepper shakers and mustard pot with lid and spoon marked with green

Noritake mark, 1921 and onward, tray 4¼" diameter; *front,* condiment set with rectangular tray, salt and pepper shakers, mustard pot with lid and spoon marked with Noritake green mark, 1911 to 1921, all Jeanette and Sina P. Kurman collection.

Nagoya plate marked Noritake, early 20th century, Mel Mitchell and Gene Galloway collection.

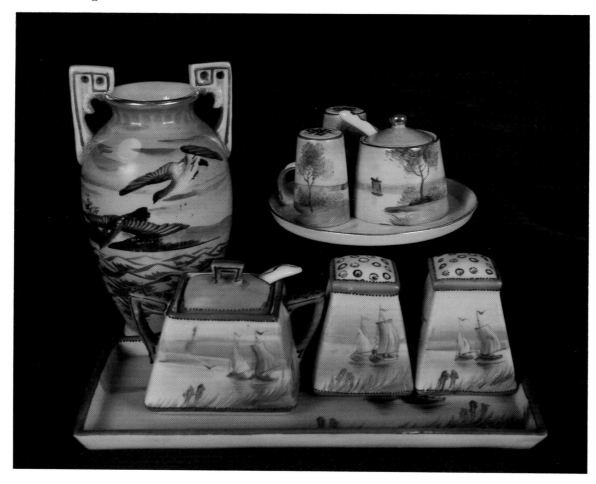

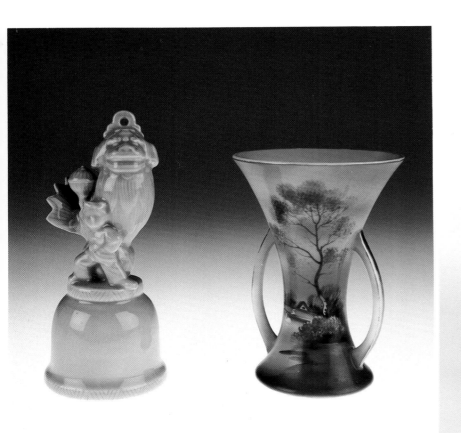

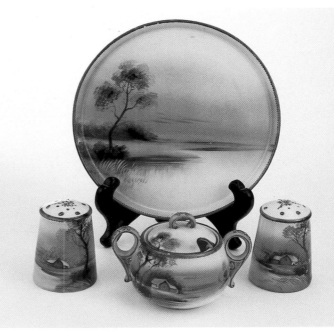

Nagoya condiment set with round tray, salt and pepper shakers and mustard pot with lid, marked Noritake, early 20th century, Jacquelyne Y. Jones North collection.

Nagoya celadon bell, 6½" high, and vase with red Noritake mark, 5½" high, both early 20th century, Altemose collection.

Three Nagoya vessels, *top,* miniature tureen with lid and spoon marked with reversed crossed flags and Japanese characters, circa 1920, 5½" long; *lower left,* basket with Noritake green mark, after 1911, 4" high, Jeanette and Sina P. Kurman collection; *lower right,* vase or candleholder, with Noritake green mark, after 1911, 5" high, Jeanette and Sina P. Kurman collection.

Nagoya plate marked Noritake, early 20th century, Mel Mitchell and Gene Galloway collection.

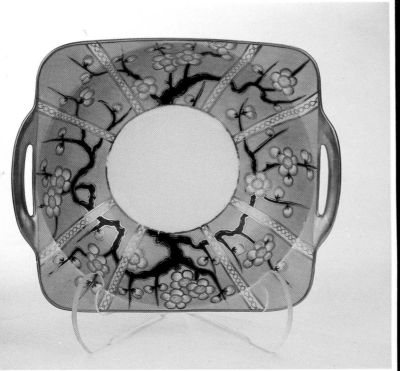

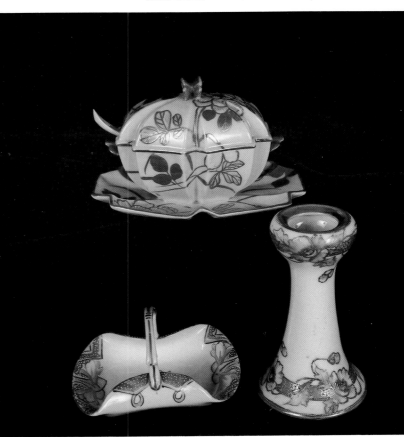

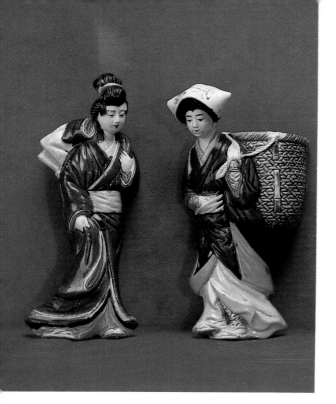

Pair of Nagoya hanging figures, hollow and open at the tops, each marked "Made in Japan", after 1921, 9½" high, Jeanette and Sina P. Kurman collection.

"Made in Japan" ware

In 1921, U.S. law changed and thereafter all imports were marked "Japan" or "Made in Japan." Besides Noritake, other potteries in Nagoya, Seto and Arita made large quantities of exports marked "Japan", and even some of these were decorated in Tokyo or Kaga. If the "Japan" marks were fixed to paper stickers instead of the ceramics itself, the pieces may have lost the stickers and appear unmarked.

From about 1921 to the 1930's, Noritake made a luster ware using a metallic film over the glaze. Some pieces have hand painted floral and landscape decorations which reflect the Art Deco styles popular at this time in the West. Also during this time copies of earlier patterns from the pre-Nippon and Nippon periods and many figurines were made.

The company continued in business, although on a more limited basis, between the war years 1941 and 1945. The factory sustained serious bomb damage in this time.

In 1946 and 1947, the Noritake products carried the name "Rose China", not "Noritake" since quality was not up to factory standards because of materials and equipment shortages. Many orders were sent to the United States Army Procurement Office and distributed to the U.S. Army bases throughout the Far East and sold in U.S. Military exchanges. In November of 1947, Noritake, Inc. of the United States was organized in New York with other offices opening throughout the country up to the 1970's. The company has expanded its exports to include crystal glassware. Stainless steel flatware, and melamine products.

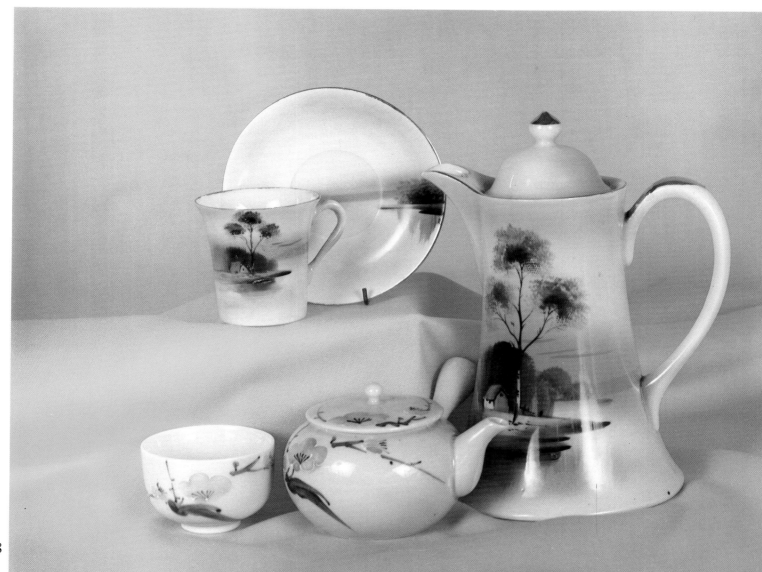

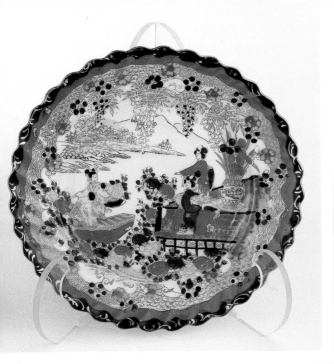

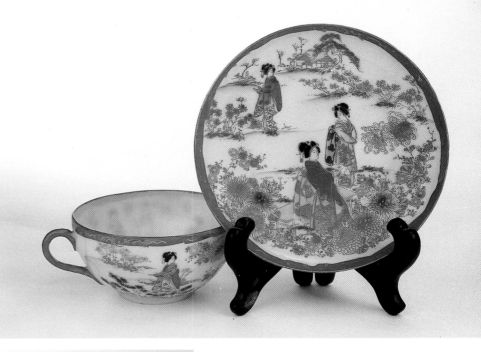

Nagoya eggshell cup and saucer with geisha girl decoration, early 20th century, Jacquelyne Y. Jones North collection.

Nagoya plate with scalloped and spiral ribbed edge and geisha girl decoration, 7¼" diameter, early 20th century, Jacquelyne Y. Jones North collection.

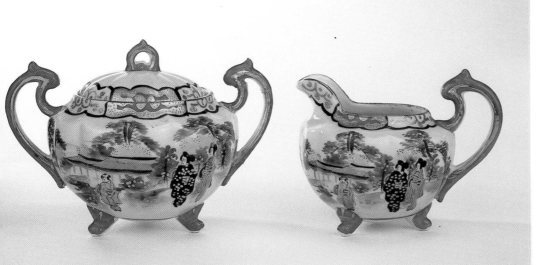

Nagoya covered sugar bowl and cream pitcher, with geisha girl decoration, early 20th century, Jacquelyne Y. Jones North collection.

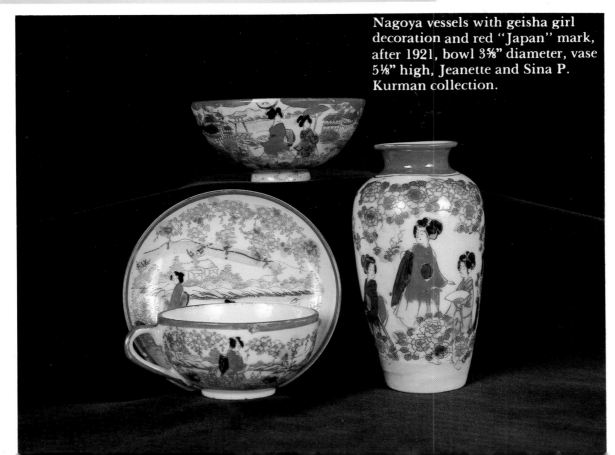

Nagoya vessels with geisha girl decoration and red "Japan" mark, after 1921, bowl 3⅝" diameter, vase 5⅛" high, Jeanette and Sina P. Kurman collection.

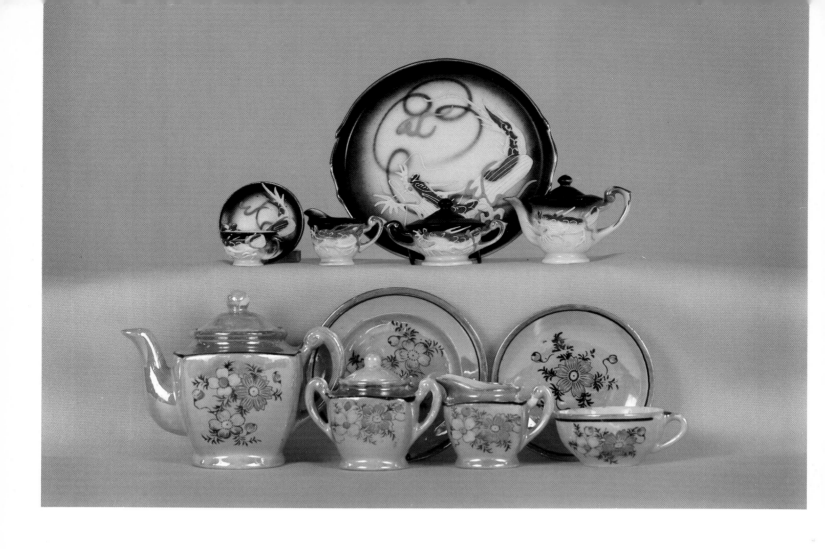

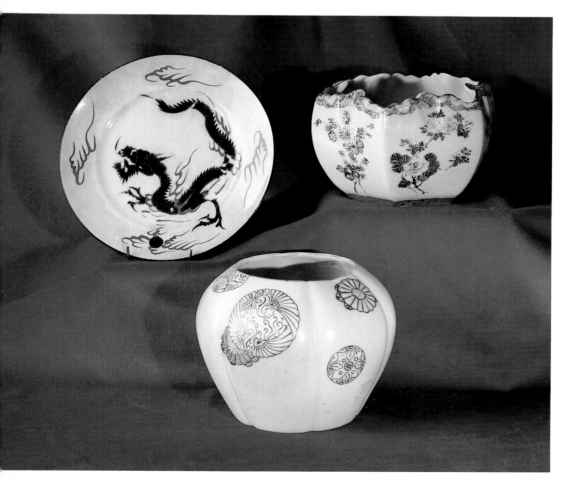

Two Nagoya miniature tea services with a plate, cup and saucer, tea pot, cream pitcher and sugar bowl shown, each with red "Japan" mark, 1921 and onward, top tea pot 4" high, bottom tea pot 4⅝" high, Jeanette and Sina P. Kurman collection.

Left back, Nagoya plate marked "Made in Japan", after 1921, 7⅜" diameter; *right back*, Nagoya six-sided bowl, early 20th century, 4¼" high, 6" wide; *front*, Kyoto six-lobed bowl with blue character marks, 5¼" high, 6½" wide, all Jeanette and Sina P. Kurman collection.

Occupied Japan ware

Between 1947 and 1952, export pieces from Nagoya destined for the United States had one of the following four markings: "Japan," "Made in Japan," "Occupied Japan," or "Made in Occupied Japan." American occupation of the country began at the conclusion of war in 1945, but the porcelain business in Nagoya was not fit for production right away. Damaged factories were rebuilt, necessary materials were procured, and personnel were readied so that production could resume. Exports to the United States began again in 1947.

Today, porcelain marked "Occupied Japan" and "Made in Occupied Japan" are collected. These pieces represent only a portion of the production of the time, since wares made at this time also can bear only the "Japan" and "Made in Japan" markings. The productions of this period were molded with thin walls, had Western shapes, and were decorated with Western-style decorations. They do not stem from the traditions of Japanese porcelain, but were intended as export ware only. The variety of Occupied Japan items is immense, including figures, tea and dinner services, and miniature forms. The popularity of Occupied Japan wares has given rise to lighter-weight copies appearing in the West.

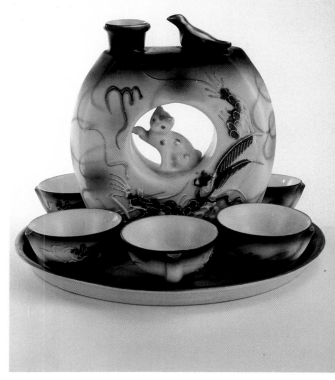

Nagoya saki pot and whistling cups on a tray marked "Occupied Japan", 1947-1952, pot 5½" high, Dr. and Mrs. Bernard F. Adami collection.

Nagoya cup and saucer marked "Occupied Japan", 1947-1952, Jacquelyne Y. Jones North collection.

Six Nagoya plates of Occupied Japan ware decorated with copies of famous European portrait paintings, each marked "SGK", 4" diameter, 1947-1952, Margaret Bolbat collection.

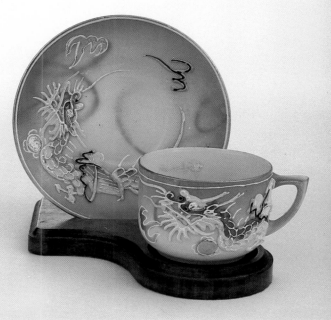

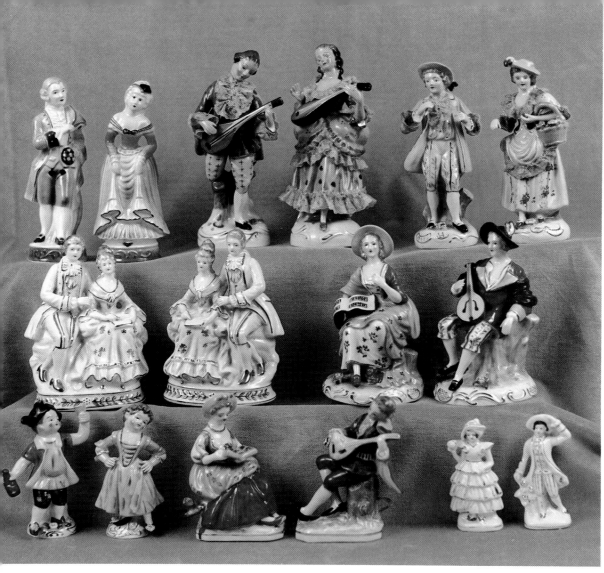

Nagoya pairs of Colonial figures of Occupied Japan ware, *top row*, pink coat and dress marked "Moriyama", Mandolin players and pair with basket marked "Made in Occupied Japan"; *middle row*, double pairs marked "Moriyama", musicians marked "Made in Occupied Japan"; *bottom row*, boy with bottle and girl marked with a T over an S, other pairs marked "Made in Occupied Japan", 1947-1952, Margaret Bolbat collection.

Four Nagoya plates with pierced rims of Occupied Japan ware, *left*, flamingoes marked "Made in Occupied Japan", 7¼" diameter; *top*, landscape signed T. Miyake and marked Ucago China 9⅛" diameter; *right*, ladies marked "S.G.K. China, 8¼" diameter; *front*, ladies marked "S.G.K. China" 9¼" diameter, 1947-1952, Margaret Bolbat collection.

Four Nagoya plates of Occupied Japan ware, *left*, Dresolina pattern marked "Aladdin Fine China" 10" diameter; *top*, Springtime pattern marked "Meito China" 10" diameter; *right*, Burmese pattern marked "Crown China" 10½" diameter; *bottom*, Blue Gallon pattern marked "Made in Occupied Japan", 9½" diameter, 1947-1952, Margaret Bolbat collection.

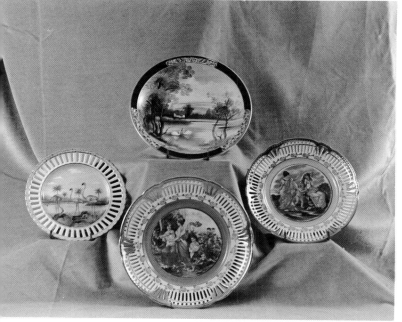

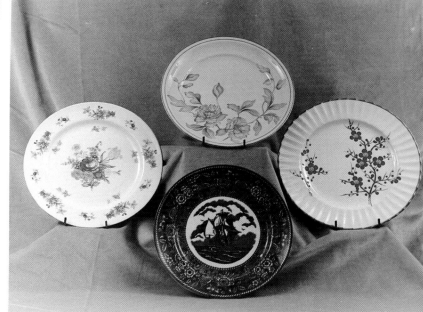

Nagoya bisque figures of Occupied Japan ware, *top row*, swan sleigh marked "Andrea", lady marked "Ardalt" 9¾" high, shell and three figures marked "Andrea"; *middle row*, all marked "Made in Occupied Japan", *bottom row*, boy with hat marked "Moriyama", boy with planter marked "Paulux", cigarette holder marked "Ardalt", boy and flower marked "Andrea", 1947-1952, Margaret Bolbat collection.

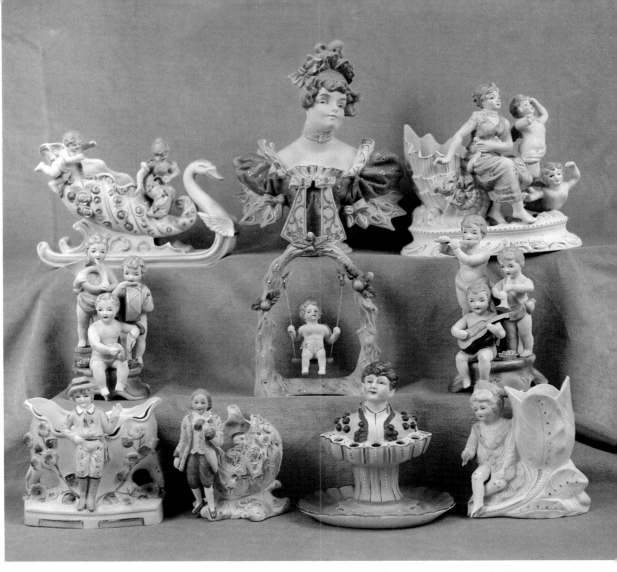

Four Nagoya plates with landscape decorations of Occupied Japan ware, each signed Fuerei (or Fulali or Tuboil) *top and bottom*, marked "Shofu China", 10" diameter; *left*, marked "Hand painted: Made in Occupied Japan" with round medallion with tree, 9 3/16" diameter; *right*, marked with elephant head on a shield, 9" diameter, 1947-1952, Margaret Bolbat collection.

Four Nagoya plates and a cup of Occupied Japan ware, *left*, Orchid pattern marked with an elephant head on a shield, 7½" diameter, *top*, with blue and green leaves marked "G" in half a wreath, 8¼" diameter; *right*, Manchu pattern marked "Narumi China", 7½" diameter; *bottom*, cup and saucer marked with an elephant head on a shield, 7½" diameter, 1947-1952, Margaret Bolbat collection.

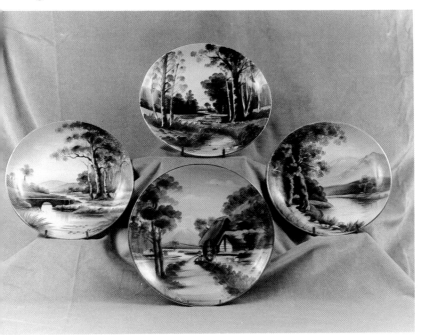

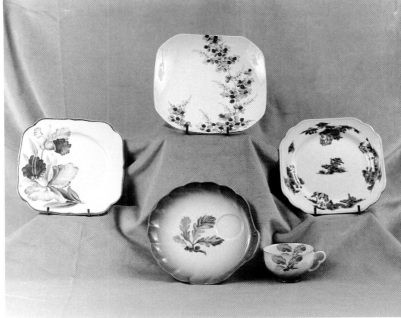

293

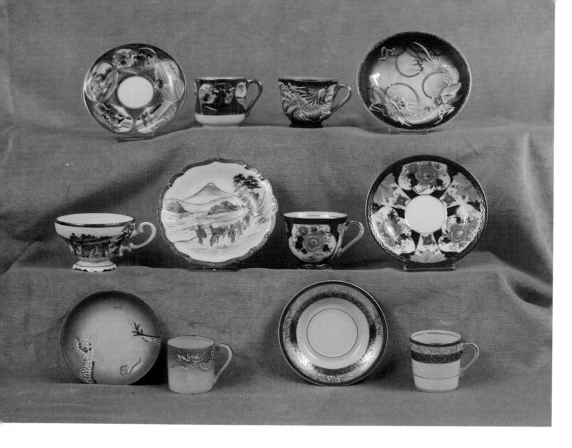

Nagoya cups and saucers of Occupied Japan ware, *top row left*, marked with deer and letters G E I C, saucer 4½" diameter; *right*, marked "Made in Occupied Japan", saucer 4⅞" diameter; *middle row left*, marked with gold characters on a red square over "Made in Occupied Japan", saucer 4¾" diameter; *right*, marked "Hand Painted Gold China"; *bottom row left*, marked "Made in Occupied Japan", saucer 3⅞" diameter; *right*, marked "Hand Painted" over crown, saucer 4⅛" diameter, 1947-1952, Margaret Bolbat collection.

Group of Imari style vessels of Occupied Japan ware, all marked "Occupied Japan", and the toothpick holder at the left on the middle row also marked "Hokutosha", 1947-1952, Margaret Bolbat collection.

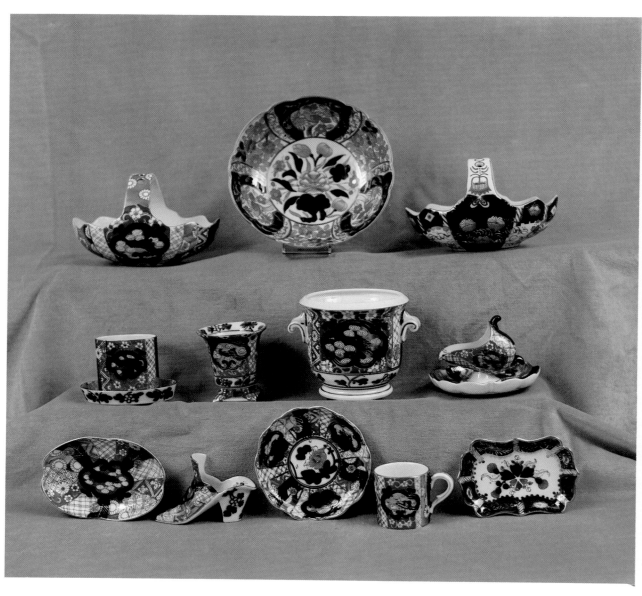

Nagoya dishes of Occupied Japan ware, *top row*, divided dish marked "Ucago China"; square dish marked "Rossetti, Chicago, U.S.A., leaf shaped dish marked "Chubu China", *middle row*, Belleek style sugar bowl marked "Made in Occupied Japan", set with tray marked with a K in a circle; salt and pepper in holder marked with a T in a circle; *bottom row*, leaf shaped dish marked "Shofu China", 8 coasters and holder marked "DIN" in wreath, cigarette holder and 4 nesting ash trays marked "Ardalt", 1947-1952, Margaret Bolbat collection.

Nagoya tea sets of Occupied Japan ware, *top row*, Sairey Gamp cup and saucer, tea pot 6" high, cream pitcher, all marked with a T in a circle; *middle row*, Windmill sugar bowl, tea pot 5" high, cream pitcher, all marked "Made in Occupied Japan", *bottom row*, blown out cup and saucer man winking marked with a T in a circle, Toby teapot marked "Made in Occupied Japan", 4½" high, blown out cup and saucer man marked with a T in a circle, 1947-1952, Margaret Bolbat collection.

Nagoya figures of Occupied Japan ware, *top row*, American Children Series Shoemaker, girl with carrots 6¼" high, girl with basket, American Children Series Goose girl; *middle row*, seated boy, boy with goose, girl with dog, American Children Series Little Knight, American Children Series News, *bottom row*, boy with basket, girl with chicks, girl on sled 3¼" high, boy on skis, 1947-1952, Margaret Bolbat collection.

Nagoya blue and white Occupied Japan ware, *top row*, cup and saucer marked "Maruta", egg cup marked "Made in Occupied Japan", cup and saucer marked "Made in Occupied Japan", *middle row*, cup and saucer marked "Made in Occupied Japan", windmill marked "Made in Occupied Japan", cup and saucer marked "Maruta", *bottom row*, cup and saucer marked "Made in Occupied Japan", cup and saucer marked "Ironstone ware", cup and saucer, 1947-1952, Margaret Bolbat collection.

Bibliography

Andacht, S. 1981. *Treasury of Satsuma*. Des Moines: Wallace-Homestead.

_____ , Nancy Garth and Robert Mascarelli. 1981. *Price Guide to Oriental Antiques*. Des Moines: Wallace-Homestead.

Appleton, D. and Company. 1877. *Gems of the Centennial Exhibition*. New York.

Archambault, F. 1980 through July, 1986. Newsletter. *The Upside Down World of an O.J. Collector*. Newport: The O.J. Club.

Arita Board of Education, ed., 1981. *Chokichi-dani, Old Kiln Site*. Arita.

Arts, P.L.W. 1983. *Japanese Porcelain*. Lochem-Poperinge, Netherlands: Uitgeversmaatschappij De Tijdstroom.

Audsley, G. and J. Bowes. 1881. *Keramic Art of Japan*. London: Henry Sotheran & Co.

Ayers, J. 1980. *Far Eastern Art in the Victoria and Albert Museum*. London.

_____ . 1982. *The Baur Collection*. Geneve: Collections Baur.

Beurdeley, M. 1962. *Porcelain of the East India Companies*. London: Barrie and Rockliff.

Brown, R.F. 1965. *Art Treasures from Japan*. Los Angeles: Los Angeles County Museum of Art; Detroit: Detroit Art Institute; Philadelphia: Philadelphia Museum of Art; Toronto: The Royal Ontario Museum.

Bushell, S.W. 1980. *Oriental Ceramic Art*. New York: Crown Publishers Inc.

Castile, Rand, ed. 1986. *The Burghley Porcelains*. New York: Japan Society.

Chaffers, W. 1946. *Marks & Monograms on European and Oriental Pottery and Porcelain*. Los Angeles: Borden Publishing Co.

Cleveland, R. 1970. *200 Years of Japanese Porcelain*. St. Louis: St. Louis City Art Museum.

Donahue, L.A. 1979. *Noritake Collectibles*. Des Moines: Wallace-Homestead.

Florence, G. 1979. *The Collector's Encyclopedia of Occupied Japan Collectibles, Second Series*. Paducah: Collector Books.

Freer Gallery of Art Handbook. 1976. *Masterpieces of Chinese and Japanese Art*. Washington: Freer Gallery of Art.

Garner, H. 1964. *Oriental Blue and White*. London: Faber and Faber.

Gorham, H.H. 1978. *Japanese and Oriental Ceramics*. Rutland, Tokyo: Charles E. Tuttle Co., Inc.

Hauge, V. and T. 1978-1979. *Folk Traditions in Japanese Art*. Cleveland: International Exhibitions Foundation and the Japan Foundation; New York: Japan House; San Francisco: Asian Art Museum.

Hickman, M. and P. Fetchko. 1977. *Japan Day by Day*. Salem: Peabody Museum of Salem.

Hobson, R.L. 1937. *Handbook of the Pottery and Porcelain of the Far East in the British Museum*. London.

Honey, W.B. 1945. *The Ceramic Art of China and Other Countries of the Far East*. London.

Imaizumi, M. 1981. *Famous Ceramics of Japan, Nabeshima*. Tokyo, New York and San Francisco: Kodansha International, Ltd.

Imari Board of Education. 1975-1978. *Okawachiyama Kiln: Summary of a Report on the Excavation of the Old Kiln Site of Nabeshima Clans Kiln*. Imari.

Impey, O.R. 1972. A Tentative Classification of the Arita Kilns. *International Symposium on Japanese Ceramics*. Seattle: Seattle Art Museum.

_____ . Undated, ca. 1985. Some Categories of Early Arita Enamelled Porcelain. "Ceramics". *Essays in Honour of Prof. Dr. Tsugio Mikami on His 77th birthday*. Tokyo.

International Exhibition, 1876, Official Catalogue of the Japanese Section, and descriptive notes on the Industry and Agriculture of Japan. Philadelphia: The Japanese Commission.

Jenyns, S. 1979. *Japanese Porcelain*. London, Boston: Faber and Faber.

King, D. 1981. Hirado Porcelain; It's Dating. *Transactions of the Oriental Ceramic Society*. London: The Oriental Ceramic Society.

Klamkin, M. 1976. *Made in Occupied Japan, A Collector's Guide*. New York: Crown Publishers.

Koizumi, H. 1984. *Excavate Edo*. Tokyo.

Koyama, F. 1960. *2,000 Years of Oriental Ceramics*. New York: Harry N. Abrams, Inc.

————., ed. 1961. *Japanese Ceramics from Ancient to Modern Times*. Oakland: Oakland Art Museum.

Kurita, H. 1975. *Kurita Museum*. Tokyo and Ashikaga Halls: The Kurita Museum.

Kyushu Ceramic Museum, ed. 1980. *Excavated Ceramics of Hizen in Japan*. Saga.

Lang, G. Undated, ca. 1983. *The Wrestling Boys: An Exhibition of Chinese and Japanese Ceramics from the 16th to the 18th Century in the Collection at Burghley House*. Stamford: Burghley House.

Lawrence, L. 1981. *Hirado Porcelain*. London: Tempus Antiques, Ltd.

Mew, E. Undated, ca. 1915. *Japanese Porcelain Masterpieces of Handicraft*. London: T.C. & E.C. Jack; New York: Dodd-Mead & Co.

Mikami, T. 1972. *The Art of Japanese Ceramics*. New York, Tokyo: Weatherhill/Heibonsha.

————. 1973. *The Way of Ceramics*. Tokyo.

Miller, R.A. 1960. *Japanese Ceramics*. Rutland, Tokyo: Charles E. Tuttle Co., Inc.

Moes, R. 1979. *The Brooklyn Museum, Japanese Ceramics*. Brooklyn: Brooklyn Museum.

Morse, E.S. 1979. *Catalogue of the Morse Collection of Japanese Pottery*. Rutland, Tokyo: Charles E. Tuttle Co., Inc.

Munsterberg, H. 1975. *The Folk Arts of Japan*. Rutland, Tokyo: Charles E. Tuttle Co., Inc.

————. 1983. *The Ceramic Art of Japan, A Handbook for Collectors*. Rutland, Tokyo: Charles E. Tuttle Co., Inc.

Nagatake, T. 1981. *Famous Ceramics of Japan, Kakiemon*. Tokyo, New York, San Francisco: Kodansha International Ltd.

————. 1982. *Famous Ceramics of Japan, Imari*. Tokyo, New York, San Francisco: Kodansha International Ltd.

National Museum of Modern Art, Tokyo. No date. *Japanese Painted Porcelain*. New York, Tokyo: Weatherhill-Tankosha.

Nishida, H. 1976. *Nihon Toji Zenshu, vol. 23*. Tokyo.

Norton, C.B., ed. 1877. *Treasures of Art Industry and Manufacture Represented in the American Centennial Exhibition at Philadelphia, 1876*. Buffalo: Cosack & Co.; Philadelphia: S.T. Souder & Co.; San Francisco: James T. White & Co.; London: Trubner & Co.

Okada, B. and V. Reynolds. 1983. *Japan, the Enduring Heritage*. Newark: Newark Museum.

Oriental Ceramic Society. 1956. *Loan Exhibition of Japanese Porcelain*. London.

Penhola, M. 1980. *A Survey of Japanese Ceramics*. Netherlands: Interbook International.

Reichel, F. 1981. *Early Japanese Porcelain*. London: Orbis.

Roberts, L.P. 1976. *A Dictionary of Japanese Artists, Painting, Sculpture, Ceramics, Prints, Lacquer*. New York: John Weatherhill Inc.

Sanders, H. 1967. *The World of Japanese Ceramics*. Tokyo, Palo Alto: Kodansha International, Ltd.

Schuster, F. 1974. *Vases of the Sea*. New York: Scribner.

Sensaku, N. 1979. *Kutani Ware*. New York: Kodansha International, Ltd.

Smith, L. 1973. Blue and White and Celadon, Japanese Porcelain in the First Half of the 19th century. *Transactions of the Oriental Ceramic Society*. London: Oriental Ceramic Society.

————and V. Harris. 1982. *Japanese Decorative Arts from the 17th to the 19th Centuries*. London: British Museum Publications Ltd.

Smith, W. 1876. Industrial Art, Vol.II. *Masterpieces of the Centennial Exhibition, 1876*. Philadelphia: Gebbie & Barrie.

Tazawa, Y. 1981. *Biographical Dictionary of Japanese Art*. New York: Harper & Row.

Tilley, W. 1984. Japanese Blue and White Porcelain. *Arts of Asia*. Vol.14.

Tokyo National Museum. 1985. *Special Exhibition Japanese Ceramics, 1985*. Tokyo.

Trubner, H. and T. Mikami. 1981. *Treasures of Asian Art from the Idemitsu Collection*. Seattle: Seattle Art Museum.

Van Patten, J. F. 1979. *The Collector's Encyclopedia of Nippon Porcelain*. Paducah: Collector Books.

————. 1982. *The Collector's Encyclopedia of Nippon Porcelain, Second Series*. Paducah: Collector Books.

————. 1984. *The Collector's Encyclopedia of Noritake*. Paducah: Collector Books.

Volker, T. 1954. *Porcelain and the Dutch East India Company 1602-1682*. Leiden: E.J. Brill.

———. 1959. *The Japanese Porcelain Trade of the Dutch East India Company After 1683*. Leiden: E.J. Brill.

Wardwell, A. 1981. *Handbook of the Mr. and Mrs. John D. Rockefeller, 3rd Collection*. New York: The Asia Society.

Watson, W., ed. 1981. *The Great Japan Exhibition, Art of the Edo Period 1600-1868*. London: Weidenfeld and Nicolson/Royal Academy of Arts.

Williams, C.A. 1974. *Outlines of Chinese Symbolism and Art Motives*. Shanghai: Kelly and Walsh, Ltd.

Yamane, Yuzo. 1953. *An Illustration of Japanese Coloured Porcelain*, Vol.I. *Japanese Coloured Porcelain*, Vol.2. Kyoto: Kyoto-Shoin Co., Ltd.

Yosuki, S. 1959. *Old Imari Blue and White*. Kyoto: Heiando Co. Rokkaku Kawaramachi.

Index

Imari, Satsuma and Other Japanese Export Ceramics. Nancy N. Schiffer. Imari, Satsuma, Banko and Sumida wares, the best known of the old Japanese export ceramics, are shown here in 600 photos of variations by skilled decorators. Makers' and decorators' marks, unusual shapes, design variations, and hard-to-find examples appear with identifying captions and concise text.
Size: 8 1/2" x 11" 600 color photos 204 pp.
Price Guide Index
ISBN:0-88740-944-X hard cover $49.95

Chinese Export Porcelain, Standard Patterns and Forms, 1780–1880. Herbert, Peter, and Nancy Schiffer. Chinese export porcelains of the late 18th to late 19th centuries are fully discussed in this book. Lists and photography profusely illustrate all of the standard patterns: over 1000 items illustrated in black and white and more than 100 in color. Covers Canton, Fitzhugh, Rose Medallion, Bird and Butterfly, and the other associated patterns.
Size: 8 1/2" x 11" 682 photos 256 pp.
ISBN:0-916838-01-3 hard cover $37.50

China for America, Export Porcelain of the 18th and 19th Centuries. Herbert, Peter, and Nancy Schiffer. Porcelain dishes made in China for 18th- and 19th- century American families from Maine to South Carolina and west to Mississippi and California are presented with family crests, initials, names, and original decorations.
Size: 8 1/2" x 11" 289 photos 224 pp.
Index
ISBN:0-916838-01-3 hard over $37.50

The Wonderful World of Nippon Porcelain, 1891–1921. Kathy Wojciechowski. Thousands of Nippon Japanese porcelain items well known by their different styles of decoration-Moriage, Coralene, Cobalt, molded-in-relief, and tapestry. Included are plaques, dishes, lamps, dolls, vases, smoking accessories, and other forms. Over 830 photos with identifying captions, text, and 130 different manufacturers' marks.
Size: 8 1/2" x 11" 963 photos 280 pp.
Value Guide
ISBN:0-88740-377-8 hard cover $49.95

British Ceramic Art, 1870 to 1940 John A. Bartlett. British art potteries from Arts and Crafts naturalism through pre-atomic Modernism with histories, artists, designers, and craftsmen. All the potteries, arranged alphabetically, with detailed text, captions, glossary, registries of marks and numbers, and bibliography.
Size: 8 1/2" x 11" 336 photos 240 pp.
Price Guide
ISBN:0-88740-456-1 hard cover $69.95

The Book of Meissen. *Revised and Updated*. Robert E. Röntgen. Now the standard reference. More than 1200 illustrations, 282 in color, show the history of the Meissen porcelain manufactory in Germany and its products. Years of meticulous research in the Meissen archives have culminated in this unexcelled reference book. Special attention is given to the 19th and 20th century products of the manufactory, which have been neglected in most books on Meissen.
Size: 9" x 12" 1,283 illustrations 333 pp.
Index
0-7643-0170-5 hard cover $95.00

Marks on German, Bohemian and Austrian Porcelain: 1710 to the Present. *Revised and Expanded*. Robert E. Röntgen. The source book for identifying marks used by porcelain manufacturers, factories and decorators in Germany, Bohemia and Austria from the beginning to the present. More than 3,300 marks, many of them previously unpublished, over 1,300 porcelain products, producers, and decorators are identified, including marks which American importers had applied. Includes marks of Continental and American origin which easily confused with other famous marks. English and German text.
Size: 7" x 10" 3300 Marks 640 pp.
Index
ISBN: 0-7643-0353-8 hard cover $95.00

European Majolica. D. Michael Murray. Majolica produced in the German states, Austria, Czechoslovakia, Hungary, and Poland are featured with explanations of initials and numbers which have baffled collectors for years, enabling readers to properly identify the maker of particular majolica pieces. The detailed text provides useful information on the makers, location, preservation, and collecting of European majolica.
Size: 8 1/2" x 11" 374 color photos 176 pp.
Value Guide
ISBN: 0-7643-0228-0 soft cover $29.95